THE LITERATURE OF PHOTOGRAPHY

AN ARNO PRESS COLLECTION

THE LITERATURE OF PHOTOGRAPHY
AN ARNO PRESS COLLECTION

Advisory Editors:

PETER C. BUNNELL
PRINCETON UNIVERSITY

ROBERT A. SOBIESZEK
INTERNATIONAL MUSEUM OF PHOTOGRAPHY
AT GEORGE EASTMAN HOUSE

NATURALISTIC PHOTOGRAPHY
FOR STUDENTS OF THE ART

THE DEATH
OF NATURALISTIC PHOTOGRAPHY

PETER HENRY EMERSON

ARNO PRESS
A NEW YORK TIMES COMPANY
NEW YORK ★ 1973

Reprint Edition 1973 by Arno Press Inc.

The Death of Naturalistic Photography was reprinted
from a copy in The George Eastman House Library

The Literature of Photography
ISBN for complete set: 0-405-04889-0
See last pages of this volume for titles.

Manufactured in the United States of America

LIBRARY OF CONGRESS CATALOGING IN PUBLICATION DATA

Emerson, Peter Henry, 1856-1936.
 Naturalistic photography for students of the art. The death

 (The Literature of photography)
 Reprint of the 3d ed., 1899, of Naturalistic
photography for students of the art, issued in The
Scovill photographic series, and of the 1890 ed of
The death of naturalistic photography.
 1. Photography. 2. Art. I. Emerson, Peter
Henry, 1856-1936. The death of naturalistic
photography. 1973. II. Title. III. Title: The
death of naturalistic photography. IV. Series.
TR145.E53 1973b 770'.28 72-9197
ISBN 0-405-04906-4(clothbound) 0-405-04953-6(paperbound)

NATURALISTIC PHOTOGRAPHY.

NATURALISTIC PHOTOGRAPHY

FOR

STUDENTS OF THE ART

BY

P. H. EMERSON, B.A., M.B. (CANTAB.)

FELLOW OF THE ROYAL PHOTOGRAPHIC SOCIETY

Third Edition, revised, enlarged and re-written in parts.

" Beauty is truth that is all
Ye know on earth, and all ye need to know."
KEATS,—*Ode to a Grecian Vase*

NEW YORK:
THE SCOVILL & ADAMS COMPANY OF NEW YORK,
60 AND 62 EAST ELEVENTH STREET.
1899.

DEDICATED TO ALL
NATURALISTIC PHOTOGRAPHERS
WHO HAVE, IN SPITE
OF THE
STUPID MALICE
OF
ENVIOUS DULLNESS
RAISED
PICTORIAL PHOTOGRAPHY
TO A PLACE
WORTHY THE CONSIDERATION
OF
MASTER ARTISTS.

PREFACE TO AMERICAN EDITION.

The withdrawal of the second edition of this book, some years ago, is too well known to dwell upon. The reasons for the retraction have been fully given in a paper read before the Photographic Society of Great Britain and herein reprinted; and in the same paper it is clearly stated what portions of the original work were discarded and what retained. Those portions retained and expanded form this third edition now published for the first time in New York—they having been previously run through the pages of the *Photographic Times.*

All through my career as a photographer I am pleased to say I have had the kindly appreciation of the chief *gentlemen* and men of ability of the Photographic World—a support which has made " Naturalistic Photography," or the new photography, *un fait accompli—*notwithstanding the hordes of vain and mischief-making critics. The most recent " craze "—the " Gum-Bichromate " process of printing—I have noted as fully as it deserves, for there is no need to " slay the slain "—and Mr. T. Bedding, the able editor of the *British Journal of Photography.* completely shattered all pretensions of that bungling process, which at best produced stupid imitations of other media.

<div align="right">P. H. EMERSON.</div>

CONTENTS.

BOOK I.

BOOK II.

TECHNIQUE AND PRACTICE.

CONTENTS

BOOK III.

PICTORIAL ART.

L'ENVOI.

PHOTOGRAPHY—NOT ART.

APPENDICES.

INTRODUCTION.

AT a meeting of the French Academy of Sciences, held in Paris on the 19th day of August, 1839, Louis Jacques Mandé Daguerre, in the presence of the flower of Parisian art, literature and science, gave a demonstration of *his* (?) new discovery—the Daguerreotype. The success of the *séance* was complete, and the gathering of illustrious men was intoxicated with enthusiasm in favor of the Daguerreotype. It is, then, more than fifty years ago that the result of the work of the father of photography, Joseph Nicéphore de Nièpce, who had died six years previously, and of the business partner of his latter days—Daguerre—was given to the French public, for though Arago declared that "France had adopted the discovery and was proud to hand it as a present to the whole world," Daguerre, sharp and mean business man that he was, had already taken out a patent for his process in England on the 15th of July, 1839.

It may be said, then, that for more than fifty years the influence of photography has been working among the people for better and for worse ; in a short half century has photography had to develop, and we naturally feel a little curious to know what it has been doing all that

time. Has it been lying idle and stagnating,
or has it been developing and extending its
roots into all the industrial, scientific and pic-
torial fields of enterprise ?

Let us see what this cool young goddess,
born of art and science, has been doing these
fifty years.

In the fields of science she has been most
busy. She has been giving us photographs of
the moon, the stars, and even of the *nebulæ*.
She has recorded eclipses and a transit of Venus
for us. She has drawn, too, the sun's corona,
and registered those great volcanic explosions
that take place there periodically. She has
shown us that there are stars which no tele-
scope can find, and she has in another form
registered for us the composition of the sun
and of many of the planets ; and now she is
busy mapping out the heavens. Like an all-
powerful goddess, she plays with the planets
and records on our plates, with delicate taps,
the constellations. She runs through the vast
space of the kosmos doing our biddings with a
precision and delicacy never equalled—in short
she is fast becoming the right hand of the
astronomer.

Not content with her vast triumphs in space
over the infinitely great, she dives down to the
infinitely small, and stores up for us portraits
of the disease-bearing generation of *Schizomy-
cetes*, the stiff-necked *bacteria*, and the wriggling
vibrio, the rolling *microccus*, and the fungoid
actinomycosis—with deadly tresses ; these she

pictures for us, so that we may either keep
them on small plates, or else she throws them
on large screens so that we are enabled to study
their structure. On these screens, too, we can
gaze on the structure of the Proteus-like white
blood corpuscle, and we are able to study the
very cells of our tongues, our eyes, our bones,
our teeth, our hairs, and to keep drawings of
them such as man never had before. So the
kindly bright goddess stints us in nothing, for
wherever the microscope leads there will she
be found at our bidding. With the greatness
of an all-seeing mind, it matters not to her
whether she draws the *protococcus* or the blood-
cells of an elephant, whether she depicts the
eroding cancer cell or the golden scale on the
butterfly's wing—anything that we ask of her
she does ; and we will be patient.

But the little goddess, the light-bearer, is not
content with these sciences, but she must needs
go and woo chemistry and register the belted
zones of the spectrum and tell us some of the
mysterious secrets of the composition of matter.

Meteorology, too, has claimed her, and she
draws for the meteorologist the frowning
nimbus and the bright-rolling *cumulus*. She
scratches quickly on his plate the lightning's
flash, and even measures the risings and fall-
ings of the mercury in his long glass barome-
ters and thin-stemmed thermometers, so that
the meteorologist can go and rest in the sun;
and good-naturedly, too, she hints to him that
his registerings are but fumblings after her

precise and delicate work. This versatile little
goddess, too, is playing with and hinting to the
surveyors how she will not be coy if they will
woo her, for, says she, "Have I not already
shown you how to measure the altitude of
mountains, and how to project maps by my
aid?"

The geographer, too, is another lover well
favored by the dainty goddess; he always takes
her on his travels now-a-days, and brings us
back her reliable drawings of skulls, savages,
weapons, waterfalls, geological strata, fossils,
animals, birds, trees, landscapes, and men, and
we believe in him without hesitation when we
know the light-bearer was with him, and
soon in all his geographies, in all his botanies,
in all his zoölogies, in all his geologies, his
entomologies, and all the rest of his valuable
"ologies," we shall find the crisp and exact
drawings of his dainty companion.

The engineer, too, is wooing her; he makes
love to her away down in dark caissons half-
buried in river beds; while above ground she
scatters his plans far and wide. He uses her
to show how his works are growing beneath
the strong arms of his horny-handed gangs, and
he even uses her to determine the temperature
of the depths of the sea, and the direction of
oceanic currents; yes, she does the work for
him and he loves her.

The earnest doctor and the curious biologist
are among her lovers, and the dainty one does
not disdain their work, for she knows it to be

good. For them she goes into the mysterious globe of the eye; down into the hollow larynx; into the internal ear; and even into the hidden recesses of the bladder, and drags forth drawings. The tumor-deformed leg, the tossing epileptic, the deformed leprous body, the ulcerous scalp, the unsightly skin disease, the dead brain, the delicate dissection, the galloping horse, the flying gull, and erring man does she with quick and dainty strokes draw and give her lovers the physician and biologist.

Then like the Valkyrie she too delights in dire war. For her heroes she writes so finely that her letters are carried in a quill beneath a pigeon's wing into and out of beleagured cities. She draws hasty notes of the country for the leaders of an invading army; she preserves a record of the killed, and she gives truthful drawings of the fields of battle, and of the poor jaded and mangled men after a battle; while in times of peace she draws for the scientific officer the effects of the explosion of a shell, the path of a bullet through the air, or the water thrown on high, like a geyser, by a hidden torpedo. She is the warder's friend, too, for she draws the skulking thief, the greedy forger, and the cruel murderer; she draws, too, the knife that stabbed in the dark, and the dress all blood-besmirched; she detects the forged bank note, and draws without quibble the position of the overturned and splintered railway car; and she shows the scorched and gutted ruins of the burnt house for the insurance agent.

She has her fun, too, for she twits the libra-
rians with the ever increasing deluge of books,
and hints laughingly they must one day come
to her, for she will show them how to keep a
library in a tea-caddy. The haggling trades-
man she does not disdain; she will draw por-
traits of his fabrics to be circulated all over the
world, she will copy the bad paintings and
drawings done for him as advertisements by
the pariahs of art. She reproduces trade-marks
and signatures, and oh, naughty goddess! she
even, on the sly, copies on old yellow paper
old etchings and engravings so that the con-
noisseur does not know the new from the old.
She helps in all kinds of advertising, reproduc-
ing the scenery by permanent ways for the
railway companies, sketching topographically
for tourists, drawing mothers and fathers and
children for the world, so that the loved ones
can go across the seas and leave themselves
behind in form and feature. And so that the
dead may not be forgotten she soothes the
living with their dear faces done in her pretty
way. Nay, she even goes so far as to allow her
works to be burnt on porcelain and sold in
brooches, on plates and other ware.

Nor do the children love you in vain, pretty
goddess, for you give them magic lanterns, and
hidden pictures of yourself; to be made visible
by a little secret you tell them. You give them
magic cigar-holders and stereoscopes, all this
out of your bountiful lap do you scatter; but,
pretty, dainty light-bearer, have you no love

dearer to you than all these ? Yes, it is the lover
of natural beauty who sees in you a subtle hand-
maid. To him you give your delicate drawings on
zinc to illustrate his books, or on copper to fill his
portfolios; for him you preserve copies of poems
of the winds whispering among the reed-beds,
of the waves roaring in the grey gloaming, of
the laughing, bright-eyed mortal sisters of
yours. To him you give the subtlety of draw-
ing of the wind-shorn and leaf-bare oak, the
spirit of the wild colts on the flowery marsh,
the ripple of the river and the glancing flight
of the sea fowl. Together you and he spend
days and nights, mid the streams and the woods,
culling the silvery flowers of nature. Oh! bright
generous little goddess, who has stolen the light
from the sun for mortals, and brought it to
them, not in a narthex reed as did Prometheus
bring his living spark, but in silvery drops to be
moulded to your lover's wish, be he star-gazer,
light-breaker, wonder-seeker, sea-fighter or land-
fighter, earth-roamer, seller-of-goods, judger-of-
crimes, lover-of-toys, builder-of-bridges, curer-
of-ills, or lover of the woods and streams.

The influence of photography on the sister
arts of sculpture, painting, engraving, etching
and wood-cutting during these fifty years has
been incalculable, and, as a rule, harmful.
Sculpture has been, perhaps, least influenced, al-
though without photography thousands of post-
humous statues, which now disgrace the streets
and the squares of the world, could not have
been modelled at all, or could only have been

more conventional and unsatisfactory than they
are. The effect of sculpture on photography
has been to induce experimentalists to attempt
the production of models in clay by means of an
instrument called a pantograph. It is reported
that this method succeeded, but we never saw
any of the productions and have little faith in
the method so suggested. Some years ago we
suggested that plaster bas-reliefs from swollen
gelatine moulds might be effective, but we feel
sure now that such would be poor, mean-looking
things to any artist.

The influence of photography on painting, on
the other hand, has been temporarily nothing
short of disastrous, as can be seen by the work
of the so-called ' tonists.' It is a common practice
for some painters to take photographs of their
models or landscapes slavishly and throw en-
largements of these on to a screen, when the out-
lines are boldly sketched in. Again, it is a
practice for some painters to study the delicate
gradations of photography, which is, of course,
quite legitimate, as this graduation can be
equalled only by charcoal. Another influence of
photography on painting is that the painter often
tries to emulate the detail of the photograph. But
this was more noticeable in the early days of
photography, and it had a bad effect on painting,
for the painter did not know enough of photog-
raphy to know that what he was striving to imi-
tate was due to an abuse of the tools. He
thought, as many people think nowadays, that
there is an absolute and unvarying quality in

all photographs. The effect on miniature paint-
ing was disastrous; it has been all but killed by
photography. And it must be remembered that
photography killed it notwithstanding the fact
that many of the best miniature painters
adopted the new discovery as soon as they could.
Newton was a photographer. Photography,
however, fortunately killed the itinerant por-
trait painter, who used to stump the country
and paint hideous portraits for a few shillings
or a night's lodging. We think, moreover, that
when the true history of the so called ' value '
movement in painting, which has reached its
highest development in France, shall come to be
written, it will be found that nearly every new
step of that mistaken and overrated movement
will be found to owe its ideals to photography.
But fortunately the so-called impressionists of
France killed the ' tinted-photo ' movement.

Photography, too, has, unfortunately, been
the cause of a vast production of weak and
feeble water-colors, oil-paintings, etchings, and
pen-and-ink drawings ; second and third rate
practitioners of these arts have simply traced
photographs and supplied the shading or color-
ing from their imagination, and thousands of
feeble productions has been the result; this is
a dishonest use of photography, but one by
no means uncommon. We often have food
for reflection on the gullibility of man, when
we see poor paintings, etchings, and pen-and-
ink drawings exhibited at " one-man " exhibi-
tions and elsewhere, which are nothing but

ruined photographs; the very drawing proves their origin, and the time in which such a collection is executed also hints at the method. All the drawing has been done by the photographic lens, and transferred to the panel or canvas or paper. These are often the very men who decry photography. Such work is only admissible if confessed, and traced from photographs *taken by the draughtsman himself*, but of course, such people as this usually keep their methods secret. The etchings, woodcuts and pen-and-ink drawings done in this way are simply impudent. On the other hand, again, the influence of painting on photography has been great and good as a factor in the cultivation of the æsthetic faculty, but the painter's conventionality as often expressed has been as harmful.

As we have said, by the aid of photography feeble draughtsmen are able to produce fairly passable work, where otherwise their work would have been disgraceful. Wood-cutters and line engravers, too, gain much help from us, but they find photography, as a reproductive process, a rival that will surely kill them both. One of the best and most noted wood engravers since Bewick's time has given it as his opinion that there is no need for engraving now that the " processes " can so truly reproduce pictures, for, as he says, no great original genius in wood-cutting will ever be kept back by process work, and it is a good thing that all others should be killed. On the other hand, again, the revival

and development of pen-and-ink drawing is entirely due to photographic reproductive processes.*

Such, briefly, are the effects of photography on her sister arts and of them on her.

Incredible indeed seems the all-pervading power of this light-bearing goddess. Photography is a most valuable weapon given to mankind for his intellectual advancement. The strides made by this science in its first fifty years of development are interesting, and we feel sure if any one will take the trouble to inquire briefly what photography has done and is doing in every department of life he must acknowledge its usefulness.

From what has been said it is very evident that the practice of photography must be very different in the different branches of human knowledge to which it is applied.

The application of its practice and principles has been most ably treated in some of these branches, especially the scientific branches, but hitherto there has been no book which gives only just sufficient science for students, and at the same time treats of the pictorial side.

The photographic student, whose aim is to produce decorative work, will find in this book many suggestions, such as the choosing of apparatus, the science which must be learned, the pictures and sculpture recommended for study,

* See "Pen Drawing and Pen Draughtsmen," by J. Pennell. 1889. (Macmillan & Co.)

the "art" canons which are to be avoided, the
technique to be learned, including manipula-
tions; the philosophic principles of art, to-
gether with a critical *résumé* of conventional,
" art" canons, including sundry other informa-
tion.

In addition to this the book is an argument
for the Naturalistic school of photography,
of which we published the first germ in an
address delivered in London in March, 1886,
although we had been advocating our views by
precept and letters many years before.

The necessity of this book may not be patent
to those artists who do not know the photo-
graphic world, but if they will consider for a
moment the present position of a student of
photography, whose aim is to produce pictorial
work, they will see the necessity for some such
work. The position of the photographic world
at present is this : nearly all the text-books
teach how to cultivate the scientific side of pho-
tography, and they are so diffuse that we find
photo-micrography, spectrum analysis, and "art"
all mixed up together. And when we assure
the artistic reader that the few books and
articles published with a view to teaching art,
contain nothing but *résumés* of Burnet's teach-
ings, as set forth in his well-known archaic and
pedantic " Treatise on Painting ;" that some of
these books lay down laws for the sizes of pic-
tures as advocated by that "great authority
(*sic*) Norman Macbeth ;" caution the student
not to take pictures on gray days ; suggest the

formation of a "property" collection, and contain various other erroneous ideas; we say when artists know this, and in addition that the noisiest of these tutors has again and again declared that the chief feature of photography is "definition," they will perhaps understand the necessity for some such book as this one.

To give the student a clear insight into the first principles of pictorial work is of course, as we have said, the chief aim of the book, but besides that it is an attempt to separate entirely from the scientific side of photography. This separation* must be made, and the time is now ripe. It should be clearly and definitely understood, that although a *preliminary* scientific education is necessary for all photographers, after that preliminary education the paths and aims of the pictorial, scientific, and industrial photographer lie widely apart. This matter should be kept constantly in view, and specialists in one branch should not meddle with other branches. Photography has so extended its field for work that there is scope, even in a sub-branch of the scientific division to occupy the full energies and attention of able men. At exhibitions, too, the three great divisions into which photography falls should be kept rigidly separated. The writer sees in all these branches equal good and equal use, but he sees also the necessity of keeping their aims and methods separate. That this differentiation is now possible and necessary is, from the evolu-

* This separation has now been made,

tionary standpoint, the greatest sign of development. The author feels convinced that if any student is going to succeed in any one branch he must not scatter his energies, but devote himself with singlemindedness to that particular branch. Directly the aims and methods of the separate branches of photography are fully recognized there will no longer be the hapless misunderstandings of first principles. We shall not hear a first-rate lantern slide described as "artistic," *because* it is untouched, and we shall not hear of a "high-art" photographer criticizing photo-micrographs of *bacteria*, matters that none but a medical microscopist can adequately criticize. Nor shall we have the hack-writer talking of our "art-science."

We have drawn up a rough table of classification to illustrate our meaning, but of course, it must be remembered that this division is arbitrary, but it would, we think, be a good working classification for exhibitions.

PICTORIAL PHOTOGRAPHY.

A.—*Pictorial Division.*

In this division the aim of the work is to give æsthetic pleasure *alone*, and the photographer's only wish is to produce pictorial decorative works. Such work can be accordingly judged only by men of artistic instincts, and the aims and scope of such work can be *fully* appreciated only by trained artists. Photographers who qualify themselves by training, or prove by their works

they have art instincts alone belong to this class. Included in this class would be original pictorial photographers, first-rate photo-etchers and typo-blockmakers whose aim is to reproduce in facsimile all the artistic quality of *original works of art.* Such photographers should have some artistic training, as all the best have had.

B.—*Scientific Division.*

In this division the aim of the work is to investigate the phenomena of nature, and by experients to make new discoveries, and corroborate or falsify old experiments. The workers in this great and valuable department of photography may be divided into—

Scientific experimentalists in all branches of science :

a. Chemists and spectrum-analysts.
b. Astronomers.
c. Microscopists.
d. Engineers.
e. Military and naval photographers.
f. Meteorologists.
g. Biologists.
h. Geographers.
i. Geologists.
j. Medical men.
k. Physicists.
l. Anthropologists, etc.

These sub-divisions include all that vast host of *trained* scientific men who are photographers

in connection with their work. Their aim is the advancement of science.

C.—Industrial Division.

This class includes that great majority of the photographic world. These men have learned how to use their tools, and go on from day to day meeting the industrial requirements of the age, producing good useful work, and often filling their pockets at the same time. Their aim is utilitarian, but in some branches they may at the same time aim to give æsthetic pleasures by their productions, but this is always *subordinated to the utility* of the work.

Among these craftsmen are included photographers who will take any one or anything if paid to do so, in a word, tradesmen.

All reproducers of pictures, patterns, etc., by photo-mechanical processes, in which the aim is not solely æsthetic pleasure, as in reproducing topographical views. All plate makers. Transparency, opal, lantern-slide, and stereoscopic slide makers. All *facsimile* photographers ; photographers of pictures, statuary, etc. All makers of invisible photographs, magic cigar photographs. All operators who work under the guidance of artists or scientists for pay, they not having artistic and scientific training themselves, as in the preparation of lantern slides for a biologist. All enlargers, operators, spotters, printers, retouchers, mounters, etc. Producers of porcelain pictures. Producers of facsimile type blocks and copper-plates, with no

artistic aim, *et id genus omne.* All photographs
produced for amusement by the untrained in art
or science. All photographers who produce pat-
tern photographs, "bits" of scenery, and ani-
mals for journeymen draughtsmen to work from.

It will thus be clear to the student that all
these photographers serve useful purposes and
each is invaluable in his way, but we repeat, the
aim of the three groups of photographers is
very different and quite distinct, as distinct as
in draughtmanship are the etchings of Rem-
brandt, the scientific drawings of Huxley, and the
pattern plates of a store catalogue. All are useful
in their place, and who shall dare to say which
is more *useful* than the other ; but all are dis-
tinct, and can in no way be compared with one
another or classed together any more than can
the poems of Mr. Swinburne, the text of some
scientific treatise and the Blue-books. All can
be good in their way, but the aims and methods
of the one must not be confounded with the
aims and methods of the other. We hope that
a college of photography may one day be in-
stituted, where a sufficient art and science train-
ing may be obtained, where regular classes
will be held by masters and regular terms
kept, and where some sort of distinguish-
ing diploma as Members of the Royal Photo-
graphic College will be given to all who pass cer-
tain examinations. The M. R. P. C. would then
have a status, and a profession would exist,
able to draw up wholesome laws for the govern-
ment and protection of its members, and the

status of photography would be everywhere
raised. The diploma of F. R. P. C. (Fellow of
the Royal Photographic College) could be given
to distinguish photographers at home and
abroad as an honorary title.*

But if such an institution is to have weight it
must procure a charter. Money must be ob-
tained to give honorariums to the lecturers, and
the lectureship must be held by trained and able
men. To begin with, all photographers in
practice could be admitted upon passing a very
simple examination in the subjects of element-
ary education and photography. If ever such
a thing is brought about, and we trust it may
be—we should find many men of education
would join the ranks, as indeed, they are
doing now; and with the taste and culture
they brought to the work, we should see them
working quietly in studios like painters, and the
" show case " and the vulgar mounts with
medals and other decorations, and the "shop-
windows," and the "shop-feeling" would all
disappear. We need not despair if we will all
do what is in us to kill "vulgarity," for painters
were once not so well off as most photographers
are now. What gives us hope for these days is
the fact that we number in our ranks, in some
branch or the other, many intellectual men.

Here, then, we end our introductory remarks,
wishing the student who comes to the study of
photography with capacity and goodwill, all
success.

* This is now in a fair way of realization, 1895.

TERMINOLOGY.

IT were better at the outset to define our terms, for nothing leads more certainly to confusion in studying a subject than a hazy conception of the meanings of words and expressions. For this reason we wish clearly to define the words and art expressions in use in this book. Not, be it understood, that we claim in any way for any definitions that they are the rigid and final definitions of the expressions used, but we define what *we* mean by certain words and terms, so that the reader may understand clearly the text in which such words occur, our aim being to be clear and to avoid all empty phraseology.

Separating the essentials from an object, and rendering these essentials, has been called analyzing nature; and the essentials so rendered are an analysis. That this can be done only in a very humble way in photography is one of its chief defects.

Art-Science is a compound term applied by some writers to photography, and by others to all crafts founded upon science. It is a clumsy term, and its use should be discouraged. It is an unmeaning expression.

Breadth is the proper subordination of detail to the effect of the whole. All great work has breadth : all petty work is devoid of it ; for niggling minds cannot see the breadth in nature, so they are naturally unable to get it into their work.

Masterly works of art become classical as time goes on. A classical work is a work of

the first rank. Classical is used in two ways in
the arts. In a deprecatory sense it is applied
to works whose aim is to reproduce old schools,
or to works copied from old masters. The best
works of ancient Greece are classical, and when
a modern artist copies their methods and
school, his work is rightly sneered at as
'classical.'

A masterly modern work may be called a clas-
sic, and by this may be meant great praise. It
means a chaste and correct piece of work, and
one likely to become a masterpiece "for all
time"; but when weak persons copy the manner
of this work they become "classical" in the
bad sense. Strong men make real classics,
and weak persons coming after them say every-
thing should be done as they did it, whereas as
art proceeds new classical works will be added
to the old, though quite different in every way.

I think the confusion and disputes among
painters and the public as to what is "fine
color" is easily explicable, and result from con-
fusion of aim and want of analysis. Color is an
internal sensation, and has no external and ob-
jective existence. That is clear enough, yet
so difficult is the subject that we have no
scientific analysis or nomenclature of color to-
day—nay, color standards are wanting. But to
return to the confusion. A study of sociology
proves that primitive races and children have a
strong love of pure, bright primary and second-
ary colors. As we go higher we find more deli-
cate colors are used for *decorative* purposes,

in schemes, harmonies, contrasts, etc. In short,
as the late Mr. Jones says in his "Grammar of
Ornament," if an artist has a love of color
per se he should become a "*decorative*" (?) artist.
The painters who translate natural scenes upon
their canvases feel that the colors of nature
are pale, and that their pigments are not pure,
so that the wiser painters try to express the
colors of nature as they appear to them, while
the muddle-headed of each generation bow
to convention with rules of decorative color
ringing in their heads, and so they attempt a
compromise, with the usual result, mediocrity.
Herein, then, lies the source of all this con-
fusion as to what is *fine coloring*. Fine coloring
in art depends on its harmonies, contrasts, purity
and subtlety. Personally I rejoice in a bed
of brightly-colored flowers or a richly-decorated
room, but I am pained by the incongruity and
falseness of unnatural colors in a landscape
painting. Color is after all a superadded
luxury. We could even get on in the world
quite well if everything appeared to us in
monochrome, and Nature is really almost mon-
ochromatic on grey days. It is significant, too,
that the thorough appreciation of monochrome
is a late development.

There is a misconception as to the use of
the word "creator" in the arts. Some think
only those persons who paint mythological or
story-telling pictures are creators. Of course
such distinction is absurd ; any artist is a
creator when he produces an original picture or

poem ; he creates the work by which he appeals to others. He is the author, creator, or whatever you like to call him ; he is responsible for its existence. A photographer is therefore rather a discoverer than a *creator*.

A work of art is conventional when it depends upon tradition or accepted models for its qualities. It was a convention to paint trees " fiddle brown " till custom threw it over. It is conventional to compose works of art according to the formal and illogical rules (?) of Burnet. But the best men often adopt a good convention—for we can establish new conventions.

Versifying, Prose-writing, Music, Sculpture, Painting, Etching, Engraving, and Acting are all arts, but none is in itself a fine art, yet each and all can be raised to the dignity of a fine art when an artist, by any of these methods of expression, raises his art by his genius to a fine art. For this reason every one who writes verse and prose, who sculpts, paints, etches, engraves, is not necessarily an artist at all, for he does not necessarily have the artistic ability. It has long been customary to call all painters and sculptors artists, as it has long been customary in Edinburgh to call all medical students ‘ doctors.’ But in both cases the terms are equally loosely applied. Our definition, then, of an artist is a person who, whether by verse, prose, sculpture, painting, etching, engraving, or music, raises his art to a fine art by his work, and the works of such an artist are works of art. Photographers can never be artists.

In a word, high and low art are loose terms; no art is high or low. Art is either good or bad art, not high or low, except when skied or floored at exhibitions. "High art" and "higher artistic sense" we shall not use, because they are meaningless terms, for if they are not meaningless then every picture falls under one or other category, high or low ; if so let some one classify all pictures into these two divisions and he will find himself famous—as the laughing-stock of the world.

A volume might be written on the word ideal, but it would be a volume of words with little meaning. As applied to art, the meaning of "ideal" has generally been that of something existing in fancy or in imagination, something visionary, an imaginary type of perfection. G. H. Lewes says, "Nothing exists but what is perceived;" we would say, nothing exists *for us* but what is perceived. A work of pictorial art is no abstract thing, but a physical fact. If a man draws a monster which does not exist, what is it ? It is but a modified form of some existing thing or combination of things, and is, after all, to us not half so terrible as many realities. What is more terrible than some of the snakes, than the octopus, than the green slimy crabs of our own waters ? Certainly, to us, none of the dragons and monsters drawn from the imagination is half so horrible. Did the great Greek artist, Æschylus, describe a dragon as gnawing at the liver of Prometheus ? No, he simply drew the picture of a vulture as being sufficiently emble-

matic. But let us assume, for the sake of argu-
ment, that the dragon appears more dreadful than
any reality, even then the pictorial and glyptic
artist should not use it, for as he has no model to
work from, his technique will probably be bad,
there will be no subtleties of tone, of color, of
drawing, all which make impressionistic pictures
so wonderful and beautiful. The dragon will be
a caricature, that is all. Again, some people con-
sider it wonderful that a painter takes a myth
and renders it on canvas, and he is called
"learned" and "scholarly" for this work. But,
what does he do? Let us say he wishes to paint
the Judgment of Paris. He, if he be a good
painter, will paint the background from physical
matter, shaped as nearly like the Greek as pos-
sible, and he will paint the Paris and the ladies
from living models—sham Greek. The work
may be perfect technically, but where is the
Greek part of it? What, then, does the painter
rely upon? Why, the *Greek story*, for if not,
why does he not call it by a modern name ?
But no, he relies upon the well-known story—
the Judgment of Paris—*in fact he is taking the
greater part of the merit that belongs to another
man.* The story of the Judgment of Paris is not
his, yet it is that partly draws the public ; and
these men are called original, and clever, and
learned. M. Maris in one of his landscapes has
more originality than all these others put to-
gether. Many people, not conversant with the
methods of art, think artists draw and paint and
sculpt things "out of their heads." Well, some

do, but the best artists never did. We have in our possession a beautiful low relief in marble, done from a well-known Italian model in London. It was done by one of the sternest impressionistic sculptors of to-day. A highly educated friend, an old Oxford man, called on us not long ago, and was greatly taken with the head; after looking at it a long while, he turned to us and said, "An ideal head, of course?" So it is the *cant* of "idealism" runs through the world. But there is a legitimate ideal work, cases in which the constructive imagination is used. In such a case several ideas may be combined into a harmonious whole—thus the idealist from various ideals may transcend nature, so the vase is produced !

But no photographer can be an *idealist;* idealism implies the *personal*, so we will not discuss it further, for photography is *impersonal.*

Ideal work (*q. v*).

To us, impressionism means the rendering by art of a personal view of nature, even to the verging on absurdity. An impressionistic painter can always claim that he sees so much, and only so much of nature ; and each individual painter thus becomes a standard for himself. A genius often despises old views of Nature which is legitimate, but when weak imitators take up his "manner" and have not his genius, the result is eccentricity.

Impressionism is thus a personal art-expression, and, therefore, it is a contradiction of terms to talk of "impressionistic photography" and as

a corollorary every artist must be either idealist or impressionist. No artist can be a naturalist or realist, therefore, too, all photographers must be either naturalists or realists ; no photographer can be either idealist or impressionist. But this we shall make clearer later on.

A face may, under certain conditions of light and shade, appear pink in color; that is its local color. If we look more closely we may see the lips are red, the forehead bluish, the temples yellowish and so on — these are *accidental* colors.

Naturalism is an *impersonal* method of expression, a more or less correct *reflection* of nature, wherein (1) truth of sentiment, (2) illusion of truth of appearance (so far as is possible) and (3) decoration are of first and supreme importance. Photographers only can be naturalistic, not painters, as we shall show later on.

Since I began to write and exhibit naturalistic photography many wild excesses and absurdities have been committed in the name of naturalism, one dealer even advertizing "naturalistic papers." Throwing a background out of focus, making fuzzy pictures, printing on rough paper, do not make naturalistic photographs. A naturalistic photograph must, I repeat, be

1. True in natural sentiment.
2. True in appearance to the point of illusion.
3. Decorative.

Without any of these qualities it is not what I call "naturalistic ;" thus a photograph may

be decorative, yet realistic, but not naturalistic. This will be explained more fully later on.

Original is a mightily misused word. Only those artists can be called original who have something *new to say*, no matter by what methods they say it.

Some of the best writers and journalists of the day have adopted the use of the word "photographic," as applying to written descriptions of scenes which are absolutely correct in detail and bald fact, though they are lacking in sentiment and poetry. What a trap these writers have fallen into will be seen in this work, for what they think so true is often utterly false. The word "photographic" should not be applied to anything except photography. No written descriptions can be "photographic," or absolutely *impersonal*. The use of the word, when applied to writing, leads to a confusion of different phenomena, and, therefore, to deceptive inferences. This cannot be too strongly insisted upon, as some cultured writers have been guilty of the wrong use of the word "photographic," and therefore of writing bad English.

Quality is used when speaking of a picture or work which has in it artistic properties of a special character, in a word, artistic properties which are distinctive and characteristic of fineness and subtlety.

By Naturalism it will be seen that we mean a very different thing from Realism. The realist is satisfied with the motes and leaves out the

sunbeam. He will, in so far as he is able, pho-
tograph all the veins of the leaves of a tree as
they really are, and not as *they look* as a whole.
For example, the realist, if photographing a tree
a hundred yards off, would strive to render the
tree as sharply as any lens could make it—prefer-
ring, mayhap, a tele-photographic lens. Where-
as the naturalistic photographer would care for
none of these things, he would endeavor to ren-
der the tree as it *appeared* to him when stand-
ing a hundred yards off, the tree taken as a
whole, and as it looked, modified as it would be
by various phenomena and accidental circum-
stances. The naturalist's work we should call
pictorially true to nature; the realist's false
to nature. The work of the realist will be *true*
for botany, but not for a picture.

In a word, in realistic photography truth of
sentiment, truth of appearance and decoration
are ignored. It is an impersonal mathematical
"plotting" by a lens of objects before it. A
painter cannot be a realist; he must be more
or less personal.

The terms "relative tone" or "value" are
used to express the appearance of the masses as
light and shade in any object studied, without
attempting to discriminate whether it is light,
shade, or local color which produces the effect,
but simply considering the relative planes these
tones occupy in the scale from dark to bright.

Artists speak of the "sentiment of nature"
as a highly desirable quality in a picture. This
means that naturalism should have been the

leading idea which has governed the general
conception and execution of the work. Thus
the sentiment of nature is a healthful and, to
me, a highly desirable quality in a picture.
Thus "true in sentiment" is a term of high
praise. "Sentiment" is really normal sympa-
thetic "feeling."

As opposed to sentiment, is a highly unde-
sirable quality, and a quality to be seen in all
bad work. It is an *affectation* of *sentiment*, and
relies by artificiality and mawkisness upon ap-
pealing to the morbid and uncultured. It is
the bane of English art. The one is normal,
the other morbid.

Soul = Vis medicatrix = Plastic force = Vital
force = Vital principle = O. The word is, how-
ever, used by some of the most advanced think-
ers in art, and when asked to explain it they say
they mean by it "the fundamental." From
what we can gather, the word "soul" is the
formula by which they express the sum total of
qualities which make up the life of the individ-
ual. Thus, a man when he has got the "soul"
into a statue, has not only rendered the organic
structure of the model, but also all the model's
subtleties of harmony, of movement and ex-
pression, and thought, which are due to the
physical fact of his being a *living* organism.
This "life" is of course the fundamental thing,
and the first thing to obtain in any work of art.
In this way, then, we can understand the use of
the word "soul" as synonymous with the "life"
of the model. The "soul" or life is always

found in the model, and the artist seizes upon
it first and subdues all things to it. "Soul,"
then, to us, is a term for the expression of the
epitome of the characteristics of a living thing,
but the word "mind" is more philosophical.
The Egyptians expressed the "soul" or life of
a lion, Landseer did not.

By technique is meant, in photography, a
knowledge of optics and chemistry, and of the
preparation and employment of the photographic
materials by the means of which pictures are
secured. It does in no way refer to the *manner*
of using these materials, that is the "practice."

Photographers invariably use the word tone
in a wrong sense. What photographers call
"tone" should properly be color or shade, thus:
a brown shade, a purple shade, or color.

Transcript of Nature is a term of contempt
used by superficial critics. We think that the
idea in the mind of these persons who use this
cant phrase is the idea of realism; that is, their
"mere transcript" means realism.

But instead of it being an easy thing to portray
"a mere transcript of nature," we shall show it
to be *utterly impossible.* No man can do this
either by painting or photography, as Leonardo
da Vinci said long ago.

CHAPTER II.

In this chapter we shall endeavor to trace briefly the influence of the study of nature on all the best art up to the present day. In order to do this it will be necessary to follow in chronological order the history of art. What we propose, then, is briefly to compile a mere outline, consisting of the salient facts in the history of art, in so far as they bear on our subject, that is, how far the best artists have been influenced by nature, and how true in impression is their interpretation of nature. We feel much diffidence in advancing any critical remarks upon the arts, for we are convinced, after a long and practical study of the subject, that no one can criticise any branch of art technically, *and the criticism be authoritative,* unless he be a *practical master artist* in the branch of art which he is criticizing. We offer them, standing always ready to be corrected by any good technical artist on any points connected with his particular art. As to who are good artists is again another wide question. Certainly their name is not legion.

Our object in traversing all this ground, then is one of inquiry, to really see how far a study

of nature is the only wear for all good art, and
we have done it in an impartial spirit, arriving
at the conclusion that in all the glyptic and
pictorial arts the touchstone answers. How far
this is the case with the arts of fiction, poetry,
etc., is a more complex matter, and one we
cannot now deal with, but we feel that in the
literary arts the matter is very different, for in
those arts we are not confined, as we are in the
pictorial and glyptic arts, to physical facts and
their representation; for there is no such thing
as absract beauty of form or color. Art has
served as a peg on which to hang all sorts of
fads—fine writing, very admirable in its place—
morality, not to be despised—classical know-
ledge and literature generally, both often of the
highest æsthetic value, but in no way legiti-
mately connected with the glyptic and pictorial
arts.

Our object is, by these notes, to lead our
readers to the works of art themselves, hoping
that by this means they will, to some extent,
educate themselves. Much of the lamentable
ignorance existing on these subjects is due to
the acceptance of the dicta of writers on pictures,
without the readers seeing the pictures them-
selves, and asking the opinion of good artists
upon them. We earnestly beg, therefore, of
any one who may be sufficiently interested in
the subject as to read this book, that he will go
and see the original pictures and sculptures
cited; all of which are within easy reach. It
was our original intention to introduce photo-

graphic reproductions of the best pieces of sculpture, and the best pictures into this work, but we have decided against so doing, fearing that the reader might be tempted to look at the reproductions and neglect the originals, and a translation, however good, is but a small part of the truth.

Art Works by Egyptians.

On examining specimens of Egyptian art, whether it be their paintings, architecture, sculpture or book illustrations (the papyri), one is struck by the wonderful simplicity, decision and force with which they expressed themselves. The history of Egypt has been so little read, save by students of history, and the old popular stories concerning the nations of the past are so inaccurate and misleading, that one is at first surprised to find such power in the works of those whom we were taught, not so long ago, to look upon as Philistines ; so that we might gaze on the Pyramids of Gizeh, the statues of Rameses, and the granite lions, with the wonderment of incomprehension. But now, of course, every one knows that Egyptians were masters in certain directions, where we are but in our infancy. Even in their *cavi relievi* and wall paintings, though these latter are but tinted outlines they are not the outlines of childish draughtsmen, weak and unmeaning, but they show the force of a powerful skill that in one bold outline can give all the essentials of a man, bird, or beast, so that the

picture looks living and doing. All through
their work there is a bigness of conception, a
solid grip of nature, which makes their work
surpass many of the elaborately finished and
richly detailed pictures of our modern art
galleries.

Let us call the reader's attention to such
examples as are easily to be seen, namely, the
granite lions, the *cavi relievi* and the papyri
in the British Museum. The lions, which are
remarkable for strength of character and truth-
fulness of impression, may be taken as repre-
sentative of the greatest period of Egyptian
art, a period which ended about the time of
Rameses II.; for after that time the artists
began to neglect the study of nature, and
gradual decadence set in.

We strongly advise all our readers to go to
the British Museum and look well at these
lions. They are hewn from granite, or por-
phyry, the hardest of stones; they have conven-
tional moustaches, and are lying in conventional
positions; yet withal, there is a wonderful ex-
pression of life and reserved strength about
them which makes you respect them, stone
though they be; and they convey to you, as
you look on their long, lithe flanks so broadly
and simply treated, the truthful impression of
strong and merciless *animals*. Your thoughts
involuntarily turn from them to Landseer's
bronze lions guarding Trafalgar Square. In
them you remember all the tufts of hair cor-
rectly rendered, even to the wool in the ears,

the mane, the moustaches. Even the claws are there, and yet you feel instinctively you would rather meet those * tame cats of Trafalgar Square, with all their claws, than the Egyptian lions in the British Museum. The reason of this is that the Egyptians knew how to epitomize, so as to express the fundamental characteristics of the lion; they cared not to say how many hairs went to make up the tufted tail, nor yet how many claws each paw should have, but what they tried to do, and succeed in doing, was to convey a sense of the beast, his power and animalism; to convey, in short, an impression of *his nature.*

These lions were the outcome of the best period of Egyptian sculpture. The Egyptian artists who carved those lions had been striving to interpret Nature, and hence their success; but as soon as their successors began to neglect nature, and took to drawing up art rules, they went wrong, and produced caricatures. We read that after the time of Rameses II. "every figure is now mathematically designed according to a prescribed canon of numerical proportions between the parts."

All this we can trace for ourselves in the plates supplied with Wilkinson's learned work, entitled "The Ancient Egyptians." We see in those plates that something has happened to the people and objects represented, something that makes them no longer tell their own story,

* Since this was written Mr. Frith has written that Landseer modelled these lions from a tame cat. Third volume of " Reminiscences."

they no longer look alive, but are meaningless; the reason of this falling off was that the artist no longer used his eyes to any purpose, but did what was then supposed to be the right thing to do, namely, followed the laws laid down by some men of narrow intellect—laws called as now the " canons of art." The very life of the Egyptian artists of that period was against good work, for they were incorporated into guilds, and the laws of caste worked as harmfully as they now do in the Orient. There is, then, distinct evidence that on the one hand the Egyptian artists of the best period, when untrammelled by conventionality, created works which, though lacking the innumerable qualities of later Greek art, yet possessed, *so far as they went,* the first essential of all art—truth of sentiment. Again, on the other hand, directly anything like "rules of art" appeared, and the study of nature was neglected, their art degenerated into meaningless conventionality, and as this conventionality and neglect of nature were never cast aside, the art of Egypt never developed beyond the work done by the artists who carved the stone lions.

MONARCHIES OF WESTERN ASIA.

Assyrian art differed from that of Egypt in that the outline of the figures was much stronger, and that they painted their bas-reliefs ; but we read that the "imitation of nature was the watchword" in Assyria, as it was in Babylon.

In studying the Assyrian bas-reliefs, those interested in the subject should go to the Assyrian rooms in the basement of the British Museum, and look at the reliefs of Bani-Pal— the famous lion-hunting scenes. There is, of course, much conventionality in the work, as there was in that of the Egyptians; but no observer can fail to detect that the Assyrians were observant to a degree that strikes us as marvellous when we consider the subjects they were treating. Note the lioness, wounded in the spine, dragging her hindquarters painfully along. Does this not give a powerful impression of the wounded animal? and does it not occur to you how wonderful was the power of the man who in so little expressed and conveys to you so much. Consider when those Assyrian sculptors lived. Look, too, at the bas-reliefs numbered 47 and 49 ; and in 50 note the marvellous truthfulness of impression of the horseman, who is riding at a gallop. There is life and movement in the work. Look, too, at the laden mules in bas-reliefs numbers 70 and 72. Such works as these were done by great men in art, and though crudeness of methods and observation prevented them from rivalling some of the later Greek work, their work is good. The work does not say all that there is to say about the subject ; but it does say much of what is *most essential,* and by doing that is artistically greater than work done by scores of modern men. In addition to their artistic value, how interesting are these works as records of history.

ANCIENT GREEK AND ITALIAN ART.

In discussing Greek *painting* we shall rely
entirely upon the erudite historical work of
Messrs. Woltmann and Woermann, giving a
short *résumé* of their remarks on the subject.
This is absolutely necessary, as not one speci-
men of Greek painting has come down to us.*
But on the other hand, in dealing with Greek
and Græco-Roman sculpture we shall base our
remarks on the Greek and Græco-Roman sculp-
ture in the British Museum.

Beginning, then, with Greek painting, let us
see what the historians tell us. They begin by
saying, in painting "the Greeks effected noth-
ing short of a revolution by right of
which they deserve the glory of having first
made painting a truthful mirror of realities."
This fact, that their pictorial art reached such
perfection, is not generally known, for the
reason that the assertion rests on written
testimony—but it is reliable testimony. The
historians "insist on the fact that no single
work of any one of the famous painters
recognized in the history of Greek art has
survived to our time." Let us, then, briefly
trace the rise of Greek painting till it culmin-
ated in Apelles.

Polygnotos (B.C. 475–55) is the first name we
hear of, and of his works we are told, "they
were just as far from being really complete
pictorial representations as the wall-pictures

* Some paintings quite recently discovered in Egypt are apparently
the work of Greek artists, and tend to confirm this written testimony.

of the Assyrians and Egyptians themselves,"
although in some particulars there must have
been a distinct advancement on the work of
the orientals. For example, we are told Polyg-
notos painted the "fishes of Acheron shadowy
grey, and the pebbles of the river-bed so
that they could be seen through the water."
Polygnotos painted imaginative pictures. We
are told he "was a painter of heroes," some of
his school attempted portraiture, "but paint-
ing though in this age was still a mere sys-
tem of tinted outline design." Then followed
Agatharchos, "the leader of a real revolution, a
revolution by which art was enabled to achieve
great and decisive progress towards a system
of representation corresponding with the laws of
optics and the full truth of nature. Agathar-
chos was a scene-painter, and was no doubt led
by striving for truth in his scenery to study
nature generally. As the historians remark,
"In scene-painting as thus practised, we find
the origins not only of all representations of
determinate backgrounds, but also, and more
especially, of landscape painting. It is impos-
sible to over-estimate the importance of the
invention of scene-painting as the most decisive
turning-point in the entire history of the art,
and Agatharchos is named as the master who,
at the inspiration of Æschylus, first devoted
himself to practising the invention." This
painter, it is said, also paid great attention to
perspective, and left a treatise which was after-
wards used in drawing up the laws of perspec-

tive. It is said his manner of treatment was
"comparatively broad and picturesque." Next
came Appollodoros, a figure-painter, who also
combined landscape and figure subjects, and of
whom Pliny says "that he was the first to give
the appearance of reality to his pictures, the
first to bring the brush into just repute, and
even that before him no easel-picture (*tabula*)
had existed by any master fit to charm the eye
of the spectator." Apollodores was the first to
give his pictures a natural and definite back-
ground in true perspective; he was the first, it
is emphatically stated, "who rightfully managed
chiaro-oscuro and the fusion of colours . .
. . He will have also been the first to soften
off the outlines of his figures. For
this reason we may, with Brunn, in a certain
sense, call Apollodoros "the first true painter."
We are told, however, that his "painting was,
in comparison with his successors, hard and
imperfect," and that the innovations made by
him in the relation of foreground and back-
ground cannot be compared to the improve-
ments effected by the brothers Van Eyck in
modern times. We now read of Zeuxis, Parr-
hasios, and Timanthes, who, we are told, "per-
fected a system of pictorial representation,
adequately rendering on the flat surface the
relief and variety of nature, in other particulars
if not in colour." The endeavour of Zeuxis
was "by the brilliant use of the brush to rival
nature herself," and from anecdotes related of
him and of Parrhasios, we gather that they

"laid the greatest stress on carrying out to the
point of actual illusion the deceptive likeness
to nature." Many of Zeuxis' subjects were
taken from everyday life—another step in the
right direction. We now come to the Dorian
school, and Eupompos as its founder; and here
we find a determination to study painting
scientifically, and to conscientiously observe
nature, for we are told Eupompos expressed
the opinion "that the artist who wished to
succeed must go first of all to nature as his
teacher." Pamphilos, a pupil of Eupompos,
brought this school to maturity, and insisted
on the "necessity of scientific study for the
painter." He was followed by Melanthios, who
pursued the same lines of scientific investiga-
tion; and was in his turn succeeded by Pausias,
of whom we hear, "It is quoted as a novel and
striking effect, that in one of his pictures the
face of Methê (or personified Intoxication) was
visible through the transparent substance of
the glass out of which she drank." His work
was considered to have great technical excell-
ence, his subjects were taken from everyday
life, and his pictures were all on a small scale.
Pliny says "his favourite themes were 'boys,'
that is, no doubt, scenes of child-life.
He developed, it seems, a more natural method
of representing the modelling of objects by the
gradations of a single colour." We read, too,
that his paintings drawn fresh from life "were
much appreciated by the Romans." There was
a third school of Greek painting, that called the

Theban-Attic, and of this we read there was "a great ease and versatility, and an invention more intent upon the expression of human emotion," but no painter of this school made any very great advance. At length we come to Apelles, the most famous of all Greek painters. He, although already well known and highly thought of, went to the Sikyonian school, to study under Pamphilos, and we afterwards hear of him as court painter to Alexander the Great. We are told that at court his "mission was to celebrate the person and the deeds of the king, as well as those of his captains and chief men." This was at any rate legitimate historical painting. Woltmann and Woermann say, "In faithful imitation of nature he was second to none; he was first of all in refinement of light and shade, and consequent fulness of relief and completeness of modelling." And again we read, "Astonishing technical perfection in the illusory imitation of nature" distinguished Apelles. Thus we see that the great aim of the greatest of Greek painters was to paint the appearances of nature, or as glib critics would say, to paint "mere transcripts of nature." Contemporary with Apelles was Protogenes, whose aim was to reach the "highest degree of illusion in detail." The cycle of development seemed now to have reached its highest point because by inferior men the imitative principle was not kept subservient to artistic ends, and in the hands of Theon of Samos the principle of illusion became and end in itself,

and art degenerated into *legerdemain*. This same tendency is now showing its hydra-head, and in London, Brussels, and other places are to be seen inferior works hidden in dark rooms, or to be viewed through peep-holes. We only want the trumpets of Theon or the music of the opera bouffe to complete the degradation. Following Theon, and probably disgusted with his phantasies, came painters of small subjects ; the rhyparographi of Pliny, or the rag-and-tatter painters, "who painted barbers' shops, asses, eatables, and such-like." "We see, therefore, that about B.C. 300 Greek painting had already extended its achievements to almost all conceivable themes, with the single exception of landscape. Within the space of a hundred and fifty years the art had passed through every technical stage, from the tinted profile system of Polygnotos to the properly pictorial system of natural scenes, enclosed in natural backgrounds, and thence to the system of trick and artifice, which aimed at the realism of actual illusion by means beyond the legitimate scope of art."

"The creative power of Greek painting was as good as exhausted by this series of efforts. In the following centuries the art survived indeed as a pleasant aftergrowth in some of its old seats, but few artists stand out with strong individuality from among their contemporaries. Only a master here and there makes a name for himself. The one of these whom we have here especially to notice is Timoma-

chos, of Byzantium, an exception of undeniable importance, since even at this late period of Greek culture he won for himself a world-wide celebrity."

Timomachos neglected the study of familiar subjects, and returned to the "imaginative" style, producing such works as "Ajax and Medea," and "Iphigenia in Taurus." Curiously enough, it was during this period that the only branch of painting not yet tried by the Greeks, namely, landscape painting, was attempted. Woltmann and Woermann suggest a reason for this new departure when they say, "We can gather with certainty from poetry and literature that it was in the age of the Diadochi (the kings who divided amongst them the kingdom of Alexander) that the innate Greek instinct of anthropomorphism, of personifying nature in human forms, from a combination of causes was gradually modified in the direction of an appreciation of natural scenes for their own sake, and as they really are." Landscape painting, we are told, "scarcely got beyond the superficial character of decorative work."

With this period ends the true history of Greek painting, though it still lingers on, and becomes so far merged into that of Roman art that between the two it is not possible to draw a line of distinction. Roman art had a character of its own, and even two painters, whose names, Fabius and Ludius, and in the case of the latter of whose works, have been handed down to us.

Besides the written testimony referred to,

the state of art can be gathered from the vases,
bronzes, mosaics, paintings on stone, and mural
decorations which have come down to us.
These were many of them the work of Greek
journeymen, and though there is much that is
excellent in these productions, their period of
decadence very soon set in. It is a gauge of
the art knowledge of to-day to watch the gullible
English and Americans purchasing third-rate
copies of the works of Greek journeymen house-
decorators, and taking them home and hoard-
ing them as words of art—works which were
only valuable in their own time, in connection
with the life and architecture then existing,
but which at the present day are interesting
merely from an historical point of view, for no
really artistic mind can possibly find satisfac-
tion in much of such work for its own sake.
Did these uncultured buyers but reflect and
study for a while the natural beauties around
them, they would soon see the error of their
ways.

In their conclusion on Græco-Roman art,
Woltmann and Woermann say that they " have
no doubt that Greek painting had at last fully
acquired the power to produce adequate sem-
blances of living fact and nature," which could
not be said of any painting up to that time.
Here, then, we have traced a quick development
of Greek painting, and an almost equally quick
decline, and all through we find the never-
failing truth—that so long as nature was
studied, so long did the national art grow and

improve till it culminated in the statues of
Pheidias and the paintings of Apelles.

Let us now proceed to the British Museum,
and look at the best specimens of Greek and
Græco-Roman sculpture as exhibited there.

Taking for examination the specimens near-
est at hand; we refer to those to be seen in the
gallery leading out of the entrance-hall of the
British Museum. The busts which strike us
most forcibly are those of Nero, Trajan, Publius
Hevius Pertinax, Cordianus Africanus, Cara-
calla, Commodus, and Julius Cæsar. The bust
of Nero (No. 11) strikes one by the simplicity
and breadth of its treatment, combined as these
qualities are with the expression of great
strength and energy. The sculptor has evi-
dently gone at his work with a thorough knowl-
edge of the technique, and hewn the statue
straight from the marble, a custom, by the way,
followed by but few modern sculptors. Look
at the broad treatment of the chin and neck of
this bust of Nero. Nowadays one rarely meets
with even living awe inspiring men, but that
marble carries with it such force, that, all cold
and stony as it is, it creates in you a feeling of
respect and awe. It should be studied from
various distances and coigns of vantage, and if
well studied it can surely never be forgotten.
It gives the head of a domineering, cruel,
sensual, yet strong man. In the bust of Trajan
(No. 15), we have the same powerful technique
employed this time in rendering the animal
strength of a powerful man. With his low

forehead, small head, and splendid neck, the embodiment of strength, Trajan looks down on us somewhat scornfully. Then, too, No. 35, the bust of Publius Hevius Pertinax, is no mask, but a face with a *brain behind it.* You feel this man might speak, and if he did, what he had to say would be worth listening to. Perhaps for grip of life this is the best of all these busts. Compare it with the mask (it can be called nothing else) on the shelf above it, and you will see the difference. The portrait busts of Cordianus Africanus (No. 39) and Caracalla are also marvellous for life-like expression. Look well at the cropped head and beard of Cordianus from a little distance, and see how true and life-like the *impression* is; then go up close and see how the hair of the beard is rendered. It is done by chipping out little wedges of marble. Here is a very good example of the distinction between great and niggling *impressionism.* If all the detail of that beard had been rendered, every hair or curl correctly cut to represent a hair or curl, and this is what the modern Italian sculptor would have done, we should have had bad art. This should be borne in mind in portrait photography: the fundamental is all that counts.

Let us turn to No. 33—the sensual face of Commodus—he re-lives in the marble. Another very notable bust is that of Homer (No. 117), in the corner of the gallery at right angles to that we are leaving. Look how truly the impression is rendered of the withered old literary man;

how the story of his long life is stamped on his
face, the unmistakable look of the studious,
contemplative man.

Pass we now to the next gallery, and stop at
the wonderfully fine torso, No. 172. Look well
at this beautiful work, so feelingly, sympa-
thetically, and simply treated by the sculptor.
You can almost see the light glance as the
muscles glide beneath the skin. This is a
marvellous work, as is also the boy pulling out
a thorn from his foot. The young satyr (No. 184)
is also a wonderfully fine piece of sculpture, and
well worth close study. The student will have
ample opportunity for studying, side by side, in
this gallery, bad stone cutting and fine sculpture,
for many of the fine marbles have been barbar-
ously restored. As an example, we cite the
lifeless, stony arms of No. 188, which compare
with the rest of the figure, look at the india-
rubber fingers of the right hand, and you will
understand what bad work is, if you did not
know it already. Before leaving the gallery let
the reader look at No. 159, the Apotheosis of
Homer. Now, as can be imagined, this is the
delight of the pedantic critic, and more futile
rhapsodies have been written on this work than
perhaps on any other piece of sculpture. Of
course, as any candid and competent observer
will see, this is, as a work of art, very poor, and
hardly worth talking about. In passing into
the gallery where are the remains of the Par-
thenon frieze, notice an archaic nude torso
which stands on the left, and see how the artist

was feeling his way to nature. All portions of
the Parthenon frieze should be most carefully
studied. The student must now look at the
"Horse of Selene," one of the most marvellous
pieces of work ever done by man. It was a
long time before we could see the full beauty of
this work, and the reason was due to a simple
physical fact. We stood too near to it. To see
it well you should stand about twenty or thirty
feet off, and out of the gray background you
will see the marble horse tossing its living head,
and you will be spell-bound. Having observed
the truhfulness of impression, go close up,
and note the wonderful truth with which the
bony structure of the skull is suggested beneath
the skin. We can say no more than that it is a
true impression taken direct from nature, for in
no other way could it have been obtained.

Much has been written, too, about "idealism"
in Greek coins. To us they seem simply im-
pressions taken from busts or other works; but
to make assurance doubly sure, we have taken
the opinion of two of the best modern sculptors,
and they agree with us.

We do not attempt to give a detailed technical
criticism of sculpture as executed by the Greeks,
for, as we have said before, none but a *first-rate
sculptor* can do that; and as they have quite
enough work to do at present, we fear the pub-
lic will have to wait some time for such criticism.
In the meantime those interested in the subject
cannot do better than study the works men-
tioned, and then, if they want a bit of fun let

them walk into the Gibson Gallery at Burlington
House

There is one point to be borne in mind when
we look at the surpassing beauty of the Greek
statues, and that is the natural beauty of the
Greek race, and the number of excellent models
the Greek sculptors had before them to choose
from. Taine, in his charming but atechnical
volume on "La Philosophie de L'art Grec," goes
as thoroughly into this question as a historian
and philosopher can enter into the life of the
past.

EARLY CHRISTIAN ART.

Leaving Greek art, we now come to the art of
the early Christians. Woltmann and Woermann
tell us that "Early Christian art does not differ
in its beginnings from the art of antiquity.... The
only perceptible differences are those differ-
ences of subject which betoken the fact that
art has now to embody a changed order of
religious ideas, and even from this point of view
the classical connection is but gradually, and
at first imperfectly, severed. . . . At the outset
Christianity, as was inevitable from its Jewish
origin, had no need for art. In many quarters the
aversion from works of material imagery. . .
—the antagonism to the idolatries of antiquity
—remained long unabated. Yet when Chris-
tianity, far outstepping the narrow circle
of Judaism, had been taken up by classically
educated Greeks and Romans, the prejudice
against works of art could not continue to be

general, nor could Christendom escape the crav-
ing for art which is common to civilized man-
kind. The dislike of images used as objects of
worship did not include mere chamber decora-
tions, and while independent sculpture found
no footing in the Christian world, or at least
was applied only to secular and not to religious
uses, painting, on the other hand, found encour-
agement for decorative purposes, in the execu-
tion of which a characteristically Christian
element began to assert itself by degrees.

The pure Christian element began to assert
itself silently in decorative work in the cata-
combs, and "these cemeteries are the only places
in which we find remains of Christian paintings
of earlier date than the close of the fourth
century." These works, however, "constituted
no more than a kind of picture writing," as any
one who has seen them can certify. But this
symbolism got very mixed with pagan stories,
and we get Orpheus in a Phrygian cap, and
Hermes carrying a ram, both representing the
Good Shepherd. At other times the artists
seem to have set themselves to represent a
Christ constructed on their knowledge of the
attributes ascribed to him, and we get a beard-
less youth, approaching "closely to the kindred
types of the classical gods and heroes." "Mary
appears as a Roman matron, generally praying
with uplifted hands. Peter and Paul appear as
ancient philosophers."

The mosaics of Christian art were also handed
down from classical antiquity. Though rarely

found in the catacombs, this art was being much
used above ground for architectural decoration.
This art, as Woltmann and Woermann rightly
say, was "only a laborious industry, which by
fitting together minute colored blocks produces
a copy of a design, which design the workers
are bound by. They may proceed mechanically,
but not so flimsily and carelessly as the decora-
tive painters." From about A.D. 450 we are told
that church pictures become no longer only
decorative, but also instructive. Here then was
a wrong use of pictorial art—it is not meant to
be symbolic and allegorical, or to teach.

A new conception of Christ it seems now
appeared in the mosaics—a bearded type—and
this time we get the features of Zeus repre-
sented. By means of the mosaics a new impulse
was given to art, and in A.D. 375 a school was
founded by the Emperors Valentinian, Valens,
and Gratian, of which we read, "The schools of
art now once more encourage the observance of
traditions; strictness of discipline and acade-
mical training were the objects kept in view;
and the student was taught to work, not inde-
pendently by study from nature, but according
to the precedent of the best classical methods."

At this time art, though lying under the
influence of antique traditions, held its own for
a longer time in Byzantium, where the decora-
tive style of the early Christians lived on after
the iconoclastic schism in the eighth century,
and where we read that this ornamental style
began to be commonly employed. After the

age of Justinian (which itself has left no crea-
tion of art at Rome), many poor and conven-
tional works were executed at Ravenna. We
read that for "lack of inner life and significance,
amends are attempted to be made by material
splendor, brilliancy of costume, and a gold
groundwork, which had now become the rule
here as well as in Byzantium." Thus we see
the artists became completely lost in confusion
since they had left nature, grew ascetic, and
they knew not what to do, but, like many weak
painters of the present day, tried to make their
work attractive by meretricious ornaments, and
true art there was none. This is carried out
to-day to its fullest development by many men
of medium talent, who make pictures in far
countries, or of popular resorts, or religious
subjects, and strive to appeal, and do appeal to
an uneducated class, through the *subject* of their
work, which in itself may be a work of the
poorest description.

We read that in the year 640, "the superficial
and unequal character of mosaic workmanship
increased quickly." The miniatures of the
early Christians, however, we are told, showed
considerable power, but the iconoclastic schism
brought all this to an end. "The gibes of the
Mohammedans" were the cause of Leo the
Third's edict against image worship in A.D. 726.
All the pictures in the East were destroyed by
armed bands, and the painters thrown into
prison, and so ended Byzantine art. This
movement did not affect Italian art.

MEDIÆVAL ART.

We have followed Messrs. Woltmann and Woermann closely in their account of the decadence of art from the greatest days of Greek sculpture and painting to the end of the Christian period; but as our object is avowedly only to deal with the best art—that which is good for all time—and to see how far that is impressionistic or otherwise, we shall speak but briefly of the main points connected with mediæval art, which has but little interest for us until we come to Niccolo Pisano, and Giotto. During the early years of what are called the Middle Ages, miniaturists were evolving monstrosities from their own inner consciousness, but with Charlemagne, who said, "We neither destroy pictures nor pray to them," the standard adopted was again classical antiquity. So art continuously declined until it became a slave to the Church, and the worst phase of this slavery was to be seen in the East, under Ivan the Terrible, for we read that "artists were under the strictest tutelage to the clergy, who chose the subjects to be painted, prescribed the manner of the treatment, watched over the morality of the painters, and had it in their power to give and refuse commissions. Bishops alone could promote a pupil to be a master, and it was their duty to see that the work was done according to ancient models." Here was indeed a pretty state of things, a painter to be watched by a priest; to have his subjects selected for him! One cannot imagine anything more certain to

degrade art. " Religion " has ever been on the
side of mental retrogression, has ever been the
first and most pernicious foe to intellectual
progress, but perhaps to nothing has she been so
harmful as to art, unless it has been to science.

During the period of this slavery, the Church
used art as a tool, as a disseminator of her tenets,
as a means of imparting religious knowledge.
Very clever of her but very disastrous for poor art.

How conventional art was during the Roman-
esque period can be seen in the glass paintings
that decorate many of the old churches, to ad-
mire which crowds go to Italy and waste their
short time in the unhealthy interiors of churches,
instead of spending it at Salerno or Capri.
These go back to their own country, oppressed
with dim recollections of blue and red dresses,
crude green landscapes, and with parrot-like
talks of " subdued lights," " rich tones mellowed
by time," and such cant.

The Romanesque style of architecture was
superseded in the fourteenth century by the
Gothic. A transformation took place in art,
and France now took the lead. The painters
of this period emancipated themselves from
the direction of the priesthood—a great step
indeed. The masters of this age were special-
ists; the guilds now ruled supreme in art mat-
ters. We read that "now popular sentiment
began to acknowledge that the artist's own
mode of conceiving a subject had a certain
claim, side by side with tradition and sacerdotal
prescription. . . . They took their impres-

sions direct from nature," but their insight into
nature was scanty. As Messrs. Woltmann and
Woermann very truly remark, " If for the pur-
pose of depicting human beings, either separ-
ately or in determined groups and scenes, the
artist wishes to develop a language for the ex-
pression of emotion, there is only one means
open to him—a closer grasp and observation of
nature. In the age which we are now approach-
ing, the painter's knowledge of nature remains
but scanty. He does not succeed in fathoming
and mastering her aspects; but his eyes are
open to them so far as is demanded by the ex-
pressional phenomena which it is his great
motive to represent; since it is not yet for their
own sakes, but only for the sake of giving ex-
pression to a particular range of sentiments that
he seeks to imitate the realities of the world."

There was a struggle at this period for the
study of nature, and the tyranny of the Church
was being thrown off; there was then hope
that art would at last advance, and advance it
did. What was wanting was a deeper insight
into nature, for nature is not a book to be read
at a glance, she requires constant study, and
will not reveal all her beauties without much
wooing. And though we read of a sketch-book
of this time, the thirteenth century, in which
appears a sketch of a lion, which "looks ex-
tremely heraldic," and to which the artist has
appended the remark, "N. B.—Drawn from
life," this in no way surprises us, for have we
not been seriously told in this nineteenth cent-

ury by the painters of catchy, meretricious
water-colors, with reds, blues and greens such
as would delight a child, that they had painted
them from nature; pictures in which no two
tones were correct, in which detail, called by
the ignorant, finish, had been painfully elabo-
rated, while the broad facts of nature had been
ignored. Such work is generally painted from
memory or photographs. Happily work of this
kind will never live, however much the gullible
public may buy it.

Next we read that " artists venture upon a
closer grip of nature." Here, then, were the
signs of coming success, and the great effect of
these gradual changes was first manifested in
the work of Niccola Pisano, who " made a
sudden and powerful return to the example
of the antique." All honor to this man, who
was an epoch-maker, who based his con-
ception " upon a sudden and powerful return
to the example of the antique, of the Roman
relief." His work, it is true, is really an imita-
tion of the Roman Sarcophagi, but it was
enough for one man to do such a herculean
task as to ignore his own times and rise superior
to them. Painting, however, took no such
quick turn, but Cimabue was the first of those
who were to bring it into the right way. The
principal works ascribed to him, however, are
not authenticated.

Another epoch-maker, Giotto, now appears.
He seems to have been a remarkable man in
himself, which, however, hardly concerns us.

The historian of his works says, " The bodies
still show a want of independent study of
nature; the proportions of the several members
(as we know by the handbook of Cemieno here-
after to be mentioned) were regulated by a
fixed system of measurement;" again, " The
drawing is still on the whole conventional, and
the modeling not carried far." His trees and
and animals are like toys. Yet we read that
" their naturalness is the very point which the
contemporaries of Giotto extol in his creations,"
but this must be accepted according to the
notion entertained of what nature was, and we
are by this means able to see how crude the
notions of nature can become in educated men
when they neglect the study of it. But from
all this evidence we gather that Giotto's instincts
were right and that his strides toward the
truthful suggesting of nature were enormous.
His attempts, too, at expression are wonderful
for his age, see his " Presentation," the figures
have a natural air, notwithstanding their crude
drawing; he got some of the charm and life of
the children around him. We read that in
some of his pictures, he took his models direct
from nature, as also did Dante in his poetry,
but like Dante he attempted at times the doc-
trinal in his pictures, as in the " Marriage of
St. Francis and Poverty," he tried in fact what
many moderns are still trying to do, and daily
fail to do, namely, to teach by means of their
pictures. Doctrinal subjects are unsuitable for
pictorial art. Who cares now for Giotto's

"Marriage of St. Francis and Poverty?" but who would *not* care for a landscape or figure subject taken by Giotto from the life and landscape of his own times?—it would be priceless. Owing to circumstances, we hear that he had to put "much of his art at the service of the Franciscans," and though not a slave to them, yet we read this disgusted him with the monkish temper. In 1337 Giotto died, but he had done much. Without Kepler there might have been no Newton, so without Giotto there might have been no Velasquez.

Artists at this time belonged to one of the seven higher of the twenty-one guilds into which Florentine craftsmen were divided, namely, that of the surgeons and apothecaries (medici and speziali). Here art and science were enrolled in the same guild. Together they have been enslaved, persecuted, and their progress hampered; together they have endured; and now to-day together they stand out glorious in their achievements, free to study, free to do. The one is lending a hand to the other, and the other returns the help with graceful affection. Superstition, priestcraft, tyranny, all their old persecutors are daily losing power, and will finally perish.

We thus leave the art of the Middle Ages, as we left the catacombs, with a wish never to see them more. One feels the deepest sympathy for great men like Giotto, and his greatest followers, whose lots were cast in times of darkness, and we cannot but respect such as

struggled with this darkness, and fought to gain the road to nature's fountains of truth and beauty. But at the same time, though we may in these pictures see a graceful pose here, a good expression there, or a beautiful and true bit of color or quality elsewhere, yet we cannot get away from the subject-matter of many of the pictures, which, allegorical and doctrinal as they are, do not lie within the scope of art, and above all one cannot in any way get rid of the false sentiment and unloveliness of the whole work. Such works will always be interesting to the historian and to the philosopher, but beyond that, to us, they are valueless, and we would far rather possess an etching by Rembrandt than a masterpiece by Giotto.

When abroad, and being actually persuaded of their great littleness, we have been moved with pity for the victims we have met, victims of the pedant and the guidebook, who are led by the nose, and stand gaping before middle-age monstrosities, while some "serious person" pours into their ears endless cant of grace, spirituality, lustrous coloring, mellifluous line, idealism, *et id genus omne*, until, bewildered and sick at heart, they return home to retail their lesson diluted, and to swell the number of those who pay homage at the shrine of pedantry and mysticism. Had these travellers spent their short and valuable time in the fields of Italy, they would have learnt more "art," whatever they may mean by that term of theirs, than they ever did in the bourgeois Campo Santo or

dark interior of Santa Croce or Santa Maria
Novella.

Alas ! that the painters of the Middle Ages
were unable to paint well. Had they painted
the beautiful life and landscape around them,
there would have been the pictures, the history,
and the idyllic poetry of a bygone age ; and
what have we now in their place ? Diluted
types of repulsive asceticism, sentimental types
of ignorance and credulity, demoniacs often
hideous and horribly true and painful to gaze
upon, the lies and sores on our beautiful world,
and on our own race. And whom have we to
thank for this ? Religion—the so-called en-
courager of truth, charity, and all that is beau-
tiful and good.

EASTERN ART.

Before beginning the renascence we must
glance through Mohammedan, Chinese, and
Japanese art. With Mohammedan art we have
little to do, as it was purely geometric. It is
seen at its best in the Alhambra. The Arabian
mind seems to have been unable to rise beyond
a conventional geometrical picture-writing.
Such minds are seen to-day in all countries
amongst the undeveloped. Quite recently we
have seen some of the best modern negro work
from the West Coast of Africa ; there too was
the love of geometrical ornamentation as strong
as in the Arabian art. We repeat, this artisti-
cally-speaking low standard of development is
often seen among the people of to-day, and

though highly educated in all else, in the art
they are uneducated, in short they are sur-
vivals; and the mischief is, that they judge
pictures by their survival standard ; they look
for bright colors placed in Persian-rug juxta-
position, and talk of "glorious coloring." It
never seems to occur to them what art really is,
and what the artist has tried to express, and
how well and beautifully he has expressed it.
They seem to imagine there are abstract stand-
ards of color and form. "Glorious colorings"
are oftener than not meretricious lies dressed
out in gaudiest, vulgarest apparel, and when com-
pared with tender and chaste "colorings" will be
found veritable strumpets. Look carefully at
many of the much-vaunted water colors, and then
carefully study the same scene in nature, or in
the works of a sensitive artist, and if many of
those water-colors please you afterwards—well,
in matters artistic, you have the taste of a fru-
givorous ape. But "water-color" serves the
turn of a host of men—but not artists, who,
with their pretty paints, make pot boilers, of
which the forms and ideas are often stolen—
stolen, perhaps, from a photograph. Do such
ever study nature or art? No. They sit at
home, and coin vulgar counterfeits with no
more of art in them than the perpetrators have
of honesty. It is time that it was clearly and
distinctly understood that the man who copies
a photograph not taken by himself is as despic-
able as the man who copies a painting. Yet
the "cheap" work of these men sells well, and

the gulled public talk glibly over them of
"strength" and "tone" and "coloring," and
what not.

Nature herself is so subtle and astonishing
in her facts that but few even of those who
do study her can come anywhere near her
when she is at her best, whereas, those who
do not study her at all, who have never painted
coram se, fake and fake, and by faking they lie,
and set the example to others to lie, and, if not
fought against, this sort of thing would speedily
take us back to the art of the Middle Ages,
when we should be under the tyranny of Crœsus,
instead of Clericus.

CHINESE AND JAPANESE ART.

In China and Japan things were very differ-
ent. Following Mr. Anderson's invaluable work,
the "Pictorial Arts of Japan," we find that their
history of pictorial art begins about A.D. 457.
Mr. Anderson thinks, however, that art was
only actually planted in Japan with the intro-
duction of Buddhism in the sixth century.
Then it begins badly, for it was under the in-
fluence of religion, and in fact we read that the
earliest art consisted of Buddhist images and
mural decorations. This religious influence,
together with a servile imitation of the Chinese
masters, so enslaved art, that no development
of importance took place till the end of the
ninth century.

Looking at the plate of the "Ni Ō,"—a
wooden statue—considered the greatest work of

the time, we can see the artist had really
struggled to interpret nature, and no doubt
studies were made from the nude, for the work
on the anatomy could not otherwise have been
so well expressed; but, good as it is, it runs in
the Michael Angelo spirit, is exaggerated, and
lacks entirely all the greatness of the Greek
sculpture. This work—the greatest of what Mr.
Anderson has called the first period—shows that
there had been a struggle towards the expression
of nature.

The second period, we learn, ends with the
fourteenth century, and is parallel, therefore,
with the European mediæval period. On com-
paring plates of the Japanese work with that of
the same period in Europe, we are forced to give
the palm to the Japanese artists; they were, in
fact, vastly superior. In looking at the plate of
" The Death of Kosé No Hirotaka" we cannot
but feel there was much more respect for nature
and art in Japan than there was in Europe at that
time, notwithstanding the fact that Buddhism
bore the same relation to art in Japan as Christi-
anity did in Europe. We read also that in the
twelfth century there was one, Nobuzané, who
had a brilliant reputation for "portraits and
other studies from nature." The specimen shown
of Nobuzané's work is admirable in expression;
he has caught the living expression of his
model, but the rest is conventional. We are
told that the Chinese renascence began about
1275, and that the painters of this movement
worked on " Ink sketches of birds and bamboos,

portraits and landscapes," though these were only a kind of picture-writing.

Coming now to Mr. Anderson's third period, from the end of the fourteenth century to the last quarter of the eighteenth, we find that Meicho seems to have been to Japanese art what Giotto was to European art, and at about the same period. We read further on that in the early part of the fifteenth century the revived Chinese movement referred to made its influence felt in Japan. An example given by Mr. Anderson of Shiubun's idealized landscape painting, while far from satisfactory or even pleasing to us, is, we venture to think, superior to the work of Giotto. Therein is shown some power, and there is not the childishness which is visible in Giotto's work. Much more powerful, and pleasing are the works of Soga Jasoku, fifteenth century Chinese school. These landscapes show the artist had a feeling for nature, and although he attempted in the upper plate (Plate 16) what we consider to be beyond the scope of art, yet in the lower the master-hand shows itself. There is atmosphere in the picture. Close observation of nature resulted in a grasp of subtlest movement and expression. Witness the "Falcon and Egret" by Soga Chokuan (sixteenth century), where the power shown in depicting the grasp of the falcon's talon as it mercilessly crushes the helpless egret, is very great. Then look at the paintings of birds in any of our books, and see how wooden, how lifeless they are, compared with even the six-

teenth-century Japanese representation of bird
life

Sesshiū, we are told, was another great painter,
and the founder of a school (1420–1509). This
great man, we are told, "did not follow in the
footsteps of the ancients, but developed a style
peculiar to himself. His power was greatest in
landscape, after which he excelled most in
figures, then in flowers and birds," and later on,
we are told, in animals. He preferred working
in monochrome, and it is said asserted "the
scenery of nature was his final teacher."

Then came the Kano School, all of whose
artists had great power of expression of move-
ment but not of form. The leader, we are told,
was an eclectic, and painted Chinese landscapes
in Japan. The best men of this period were
decidedly impressionists, and their chief aim
seems to have been to give a large impression
of the scene, and it is perfectly marvellous how
well they succeeded in depicting movement by
a very few lines. The "Rain Scene," by Kano
Tanyu, is a fine example of this.

We are told that Matahei tried to found a
school whose followers should go direct to na-
ture for their subjects, but the movement did
not receive any hearty impulse. However it
was taken up afterwards by a series of book
illustrators. Next we read of Kôrin whose
"works demonstrate remarkable boldness of
invention, associated with great delicacy of col-
oring, and often masterly drawing

and composition." The work of this seven-
teenth century artist is quite marvelous.

Winding up his account of the third period,
Mr. Anderson says, "But three-quarters of the
eighteenth century were allowed to pass with-
out a struggle on the part of the older schools
to elevate the standard of their art, and paint-
ing was beginning to languish into inanition
when the revolutionary doctrines of a few arti-
san book illustrators brought new aims and new
workers to inaugurate the last and most char-
acteristic period of Japanese art."

Mr. Anderson says, "The fourth and last era
began about thirty years before the close of the
last century, with the rise of the Shijo school of
painting in Kioto, and a wider development of
the artisan popular school in Yedo and Osaka,
two steps which conferred upon Japanese art
the strongest of those national characteristics
that have now completed its separation from
the parent art of Amia."

He goes on to say "that the study of nature
was admitted to be the best means of achieving
the highest result in art by the older painters
of China and Japan, but they limited its inter-
pretation"

We are told that Maruyama Ōkio was the
first painter who seriously endeavored to estab-
lish the study of nature (1733—1795). He
preached radical ideas in art at Kioto, the cen-
tre of Japanese conservatism and gathered a
school around him. In summing up this school,
Mr. Anderson remarks, "The chief characteris-

tics of the Shijo school are a graceful flowing
outline, freed from the arbitrary mannerisms
of touch indulged in by many of the older mas-
ters ; comparative, sometimes almost absolute,
correctness in the interpretation of the forms of
animal life ; and lastly, a light coloring, sug-
gestive of the prevailing tones of the objects
depicted, and full of delicate harmonies and
gradations." The work has a *verve* which ren-
ders it very fascinating.

One great man, Hokusai, appears as the last
of the race purely Japanese and uninfluenced
by European ideas, as all the Japanese artists
are now.

So we find that through various phases the
Japanese developed to impressionistic landscape
painting.

Since writing this section, a collection of Jap-
anese and Chinese art has been opened at the
British Museum, which the student must by all
means study, for there he will see works of
most of the masters cited in these notes.

We feel, however, that wonderful as Japanese
art has been, yet there is a great gulf between
it and the best Greek and modern art. To us
Japanese art is the product of a semi-civilized
race, a race in which there is strong sympathy
with nature, but a very superficial acquaint-
ance with her poetry. In short, we feel the
Japanese need a deeper and more scientific
knowledge of nature, and that their work
falls far short of the best European work. At
the present day there is a craze for anything

Japanese, but like all crazes it will end in bringing ridicule upon Japanese work ; for their work, though fine for an uncivilized nation, is grotesque in many points, and this stupid craze by indiscriminate praise will only kill the qualities to be really admired.

The earliest authentic records of Chinese painting date about A.D. 251. The earliest painters were painters of Buddhist pictures. Mr. Anderson mentions as one of the best known of the early masters, one Wu-Tao-Tsz', whose animals were remarkable. He thinks that the art of China of to-day is feeble compared with that which flourished 1100 years ago. We are informed too that the " artistic appreciation of natural scenery existed in China many centuries before landscapes played a higher part in the European picture than that of an accessory," and judging from the specimens he gives in his book of the work of the Sung Dynasty (960—1279 A.D.), the Chinese artists had a great feeling for landscape. We are told that the painters of the thirteenth century "studied nature from the aspect of the impressionist," and their subjects were all taken from nature, landscape especially delighting them. In the fifteenth century we read " decadence began by their neglect of nature and their cultivation of decorative coloring and caligraphic dexterity." We are told, and can readily believe it, that in painting of bird life they were unequalled save by the Japanese, and that down to 1279 the Chinese were at the head of the

world in painting, and their only rivals were
their pupils, the Japanese. Korean art seems
also to have degenerated since the sixteenth
century.

THE RENASCENCE.

This is a period of a return to the study of na-
ture, a carrying out of the feelings which seemed
to have been developing even in Giotto's time. No
longer now was the artist to be separated from
nature by the intervention of the Church, and
though natural science was not advancing as
fast as art was, still a growing regard for nature
was the order of the day. This feeling first
showed itself strongly in the Netherlands, with
the brothers Van Eyck. We are told that the
Van Eycks "mixed the colors with the medium
on the palette and worked them together on the
picture itself, thus obtaining more brilliant
effects of light as well as more delicate grada-
tions of tone, with an infinitely nearer approach
to the truth of nature."

The Van Eycks regarded nature lovingly, and
tried truthfully to represent her, and though
many of their works were of sacred subjects,
yet they were evidently studied from nature
with loving conscientiousness; and so success-
ful were they that to this day the picture by
one of the brothers (a portrait of a merchant
and his wife), in the National Gallery, remains
almost unsurpassed. It is well worth a journey
to the National Gallery on purpose to see it,
and we trust all those who do not already know

the picture will take the trouble to go and study
it well. It is wonderful in technical perfection
in sentiment, in truthfulness of impression.
Note the reflection of the orange in the mirror,
with what skill it is painted. In fact, the whole
is full of life and beauty. It is a master piece
good for all time, and yet it is but the portrait
of a merchant and his wife. No religious sub-
ject here inspired John Van Eyck, but a mere
merchant family, yet in many ways the picture
remains, and will remain, unsurpassed. Such
powerful minds as the brothers Van Eyck, of
course, influenced all art, and they had many
followers, but it does not seem that these fol-
lowers had the insight into nature and art that
characterized the Van Eycks, and the work falls
off after the death of the brothers, whose names
represent, and ably represent, all that was best
of the fifteenth century.

In the sixteenth century Quinten Massys was
the greatest and most impressionistic painter.
He was said to be the "originator of a peculiar
class of *genre* pictures, being, in fact, life-like
studies from the citizen life of Antwerp." Here
was an honorable departure from convention-
ality. His followers, however, having no mind
to see how he was so great, were led away from
the study of nature, and where are they now?
Their names we all know, but who cares to see
their works? Massys, the greatest painter of
this period in the Netherlands, was content to
take his subjects from the life of his own times,

as all great men have been, from the Egyptians
downwards.

Turning now to Germany, we shall see what
the best men there thought of impressionism.
The movement towards the study of nature
seems to have begun in the methods of engrav-
ing as practised by the goldsmiths, who were
trained artists. The earliest plates we find are
of subjects illustrating the life of the times, a
hopeful augury for Germany, which was fulfilled
by the work of the master, Albert Durer. We are
told he had " unlimited reverence for nature."
What strikes us most after an examination of
his plates at the British Museum, is the wonder-
ful strength and direction with which the man
tells his tale. His engravings are, of course,
without tone, and when he does natural land-
scapes, as was often the case, this lack of tone
is a serious fault; but for draughtsmanship he
is marvelous, and it is with joy we learn that
such a master said, "Art is hidden in nature,
those who care have only to tear it forth," which
is often true, if not always so. Every one inter-
ested in art, and who is not already well
acquainted with Durer's work, should make a
point of going to the print room in the British
Museum, and studying carefully all examples
of his work. They will, perhaps, at the same
time notice what struck us, namely, that one of
the best draughtsmen on *Punch's* staff has evi-
dently been a great admirer of Durer.

Woltmann and Woermann, speaking of
Durer's landscapes illustrative of his travels

south of the Alps, says that "he reveals himself as one of the founders of the modern school of landscape painting."

His "Mill" is remarkable. His pen and ink drawings are mostly of familiar subjects of every-day life. The great danger of a man like Durer is the bad effect of his influence in later times, for inferior men imitate his faults and not his merit, as is always the case with imitators, and they forget that though Durer was a genius, yet did he live to-day he would probably work very differently and interpret different subjects. An artist's time and environment must always be reckoned with.

The next great German was Hans Holbein the younger. He had advantages over Durer, for he was born when the feeling for independent study was strong, and thus started with a clear mind, and arrived at achievements never yet surpassed. Hans Holbein stands out as a master for all time. His portraits are wonderful. He, again, threw all his energy into the study of nature and art, and his works are chiefly representative of the life of his own times, portraits of merchants and fellow-citizens. There is the full-length portrait of a gentleman in the National Gallery, whose name has not come down to us; yet is the interest less great for that? The dead Christ at Basle, too, is wonderful for observation, as every one who has dissected a dead body will affirm, but the anatomy of the skeleton in Holbein's " Dance of Death" would make a first year's medical

student laugh. It must have been drawn from memory.

Much of Holbein's best work was done in London, and is at present in England, and we cannot leave this part of the subject without begging our readers to take every opportunity of seeing the work of this wonderful master, opportunities, which, alas! will be rare enough.

Turning to Switzerland, we find no name worth mentioning; and here we would ask those who trace the effects of sublime mountain scenery on the character of men, why there has been no Swiss art worth mentioning? Of course the explanation is simple—because art has nothing whatever to do with sublime scenery. The best art has oftenest been done with the simplest material.

In Spain and Portugal at this time was being felt the influence of the work of the Van Eycks. In France the Clouets, some of the so-called Fontainebleau school, were struggling towards nature and art, but no genius arose. But in Italy there arose Leonardo Da Vinci. Never has there been such an instance of the combination of scientific knowledge and artistic capacity in one man. In the Louvre is his best work, the portrait of Monna Lisa, to us quite disappointing. We are told that "he constantly had recourse to the direct lessons of nature, saying that such teaching at second hand made the artist, not the child, but the grandchild of nature!" Again we read that "Leonardo was wholly in love with nature, and to know her

through science and to mirror her by art were
the aims and end of his life." Michael Angelo
is the next great name we come to. Woltmann
and Woermann say that "the mightiest artist
soul that has lived and worked throughout
Christian ages is Michael Angelo Buonarroti."
Now this is a literary dogma to which we are
totally opposed, and so we are to all the pedan-
tic criticism which follows, about "strong and
lofty subjectivity," "purified ideal," and what
not. Let Michael Angelo's work be compared
with the work of Phidias. Woltmann and
Woermann tell us "he studied man alone, and
for his own sake," the structure being to him
everything. This is what we always felt to
be the *fault* of Michael Angelo, *i. e.* that he
was rather an anatomist, and often a lover of
monstrosities, than an artist. The action of the
muscles in his figures may not go beyond the
verge of the possible when taken *separately*,
and as one would test them with an electric
current, but we do insist that when taken as a
harmonious whole, the spasmodic action of
some muscles as expressed by him would have
prevented the exaggerated actions of others by
antagonizing their effect. Michael Angelo's
work has always given us the feeling that he
had a model, on which with an electric current,
he tested the action of each muscle separately,
and then modeled each one separately whilst
the circuit was joined; in fact that his works
are amateur scientific studies and not works of art.
Woltmann and Woermann say first of all

he does go beyond the bounds of nature, and that therein lies his greatness, and then they flatly contradict themselves, and say an anatomist has informed them that he does not go beyond the bounds of nature, and they quote this as a merit. Our opinion is that he exaggerates nature. It may be bad taste, but I am not afraid to confess that I do detest the man and his works, and recent studies of his life prove him to have been a human monster.

Raphael * and Correggio are both as unsympathetic to us, though we are fully aware of the £70,000 reputation of the one, and the literary reputation of the other. Raphael does not appeal to us, with his sickly sentimentality, his undistinguished composition, and his lack of observation of nature. Many of the figures in his pictures, standing some feet behind the foremost, are taller and larger than those in front. We feel sure he had no independence of mind. He was a religious sentimentalist and time will give him his true place. But as a taxpayer we must enter a protest against the ineptitude of authorities who pay such heavy prices for pictures such as the Raphael referred to. There was a small picture of a head—the head of a doctor—by an unknown hand, hanging near the Raphael, which, as a work of art, we propose to submit, was infinitely its superior, but it was done by *an unknown hand.* (These pictures have since

* M. Charcot has recently shown that Raphael's demoniacs are all false and untrue.

been re-hung.) For that £70,000 what a splen-
did collection of good work by men (as Whistler)
of the present day could have been purchased.

To the same period belongs Andrea del
Sarto, a painter of great power. He had more
feeling for nature and art than most of the men
of his time, and his breadth of treatment and
truthfulness of coloring are admirable. Of
course he painted religious pictures, but from
the impressionistic point of view they are won-
derful. The student must study the portrait in
the National Gallery painted by him.

The next and last great master of this period
is Titian, another of the few entitled to the
name of genius. His portraits are his best
works. Michael Angelo is reported to have
said, "This man might have been as eminent
in design as he is true to nature and masterly
in counterfeiting the life, and then nothing could
be desired better or more perfect." Titian's
works show that he had much more love for
nature than Michael Angelo ever showed, and
we think it a pity for Michael Angelo's sake
that he did not take a leaf from Titian's book
instead of criticising his power of design. His
landscape backgrounds show a feeling for
nature far above anything painted up to that
time. After his day art in Italy fell into evil
ways, though some writers on painting talk
of Caravaggio, and of Canaletto, whose pic-
tures look like well-colored chromographs, be-
ing sharp as photographs ; that Canaletto used
a camera obscura is well known, for Count

Algarotti has told us as much. He includes
Ribera and other Tramontane masters in the
list of those who used the camera obscura.
Ribera, however, was a good painter. The
passages in some of his works are masterful, as
in the dead Christ at the National Gallery.

FROM THE RENASCENCE TO MODERN TIMES.

We shall now glance over the works of
the great artists thoughout Europe from
the time of the Renascence period down-
ward, and see how and what influence nature
had on them, and we shall inquire whether the
study of nature and art and adhesion to the sub-
jects of every-day life was not the secret of the
success of all who stand out as pre-eminent
during this period. The simplest method will
be to take separately the countries where art
has flourished.

Beginning with Spain, we find at the outset
from history that there was but little hope for art.
Religion enchained art, and that terrible stain on
ignorant Spain, the inquisition, gave rise to the
office of "Inspector of Sacred Pictures." This
office was no sinecure, for it controlled all the
artists' movements, even prescribing how much
of the Virgin's naked foot should be shown.
Comments are needless, for how could art
flourish under such circumstances? One name,
however, comes at last to break through all
rule, and in 1599, at Seville, was born Velas-
quez. Velasquez, though moving from his
youth up in the most refined society of his

native town, had the might of genius to see
that the falsely sentimental work of his pred-
ecessors was not the true stuff, and he, like all
great workers, made nature his watchword.
He is reputed to have said he "would rather be
the first of vulgar painters than the second of
refined ones," and though he began by painting
still life straight from nature, he finally became
in his portraits one of the most refined, truthful
and greatest of painters the world has ever
seen. Though greatly influenced by the relig-
ious tendencies of the time, we find him often
painting the life around him, and we have from
his brush water-carriers, and even drunkards;
but he finally reached his greatest heights and
the exercise of his full powers in portraiture.
All who have a chance, and all who have not
should try and find one, and go to the National
Gallery and study the remarkable head of
Philip of Spain. Rarely has portraiture attained
such a level as in this example, and what was
the oath this painter took? "Never to do any-
thing without nature before him." The next
name, worthy in some ways, but not to be com-
pared with Velasquez, is Murillo; and when
was he notable? Was it in his sickly sentimen-
tal religious pictures? No, certainly not. It
was in such pictures as the Spanish peasant
boys, such as can be seen in the Dulwich Gal-
lery. This gallery is open to the public, and
quite easy of access, and should not be neg-
lected. The last Spanish name of note is that
of Fortuny, a Catalonian, who is often mistaken

for a Frenchman, since he lived in Paris some
years ago. His best pictures were homely and
festal scenes, including modern Spaniards and
interiors, which he painted as he saw. He is
accounted one of the fathers of pen and ink
draughtsmanship by Mr. Pennell. For this
new departure, and on account of his work,
Fortuny deserves all praise. Since his death,
in 1874, but few Spanish painters of note have
come to the fore, L. Jimenetz, Maso, Meifren,
excepted. The pen and ink drawings, however,
of Madrozo, Rico and Vierge are very fine and
truthful. The bulk of art of that country, how-
ever, languishes in prettiness, false sentimen-
tality, and works done for popularity; the
ephemerides of art.

GERMANY.

Germany seems to have neglected the lessons
taught her by Durer and Holbein, and the
mystics seize her and carry her away from
nature and art. Since the days of Holbein no
really great man has arisen. Kaulbach, who
has been well described as "all literature," is
praised by some, but he does not seem to have
had even poetic ideas. Makart was meretricious
and small, and Heffner's pictures are like bad
photographs in color, just the class of photog-
raphy we have always been against. Had he
been a photographer, he would never have
risen above the topographical, as he has never
risen above the topographical in painting.
Kuehl, Leibe and Olde are good, but not so

good as many of their masters, the French. The pen and ink drawings of Menzel and Dietz, however, are remarkable.

AUSTRO-HUNGARY.

Much has been made of Munkacsy, but his " Christ Before Pilate," and others prove him to my mind to be quite second-rate. Far better are Margitay, Schlomka, and, above all, O. de Thosen. But I find no originality in the works of Austro-Hungarian artists, merely an application of French methods to native themes. But what is good is impressionistic.

FLEMISH ART.

Rubens and Van Dyck we mention only to show we have not overlooked them. The work of both shows more regard for " getting on " and the " ancients " than for art ; it is lacking in feeling and beauty. Van Dyck, even in his portraits, is often wood itself. Teniers the younger as an artist is a long way ahead of either of these men, and in some ways he goes very far. Van Ostade is often good also. His portrait of a man lighting his pipe, a small picture to be seen at the Dulwich Gallery, is a masterpiece of painting, and as fine as anything of the kind done up to this period. This little gem is the work of a lover of nature and an artist. It is quite a small canvas, about 10 x 6, with no " story," nothing but a man lighting his pipe; yet it is perfect, and far surpasses all the sentimentalities of Raphael, or the *tours de force*

of Rubens. The student must see this picture without fail.

MODERN BELGIAN ART.

Of recent Belgian birth Bourrer knows how to paint the sea, whilst E. Claus, Collart, F. Courtens, J. Den Duyts, Musin, H. Vanderhecht, J. Verhas and I. Verstraete are all good landscape painters. Verstraete's "Un Soir d'été," "Lever de Lune à la Bruyère" and "Matinée d'Avril" being very fine and poetic. Vanderhest is very true, Musin coarse, Den Duyts true, Courtens broad and true, Collart lustrous, and Claus true and refined. Mlle. D'Anethan paints figures well, Mlle. Meurier paints still life admirably; A. Struys paints well, but above all J. Khnopff excels in drawing and painting, and giving truth of expression; his portraits and Verstraete's landscapes strike us as the finest modern Belgian work, whilst L. Stevens and E. Wavters strike us as poor and conventional, and long ago passed by. The modern Belgian sculpture is bad.

ENGLISH ART.

The English painters of note begin with Hogarth, though the bad work of Lely and Kneller is cited as English, because executed in England, yet neither of these two men were English, and no lover of art would be proud of them if they were. Hogarth, then, was the father of English painting, and he began on good healthy lines, for he chose his subjects

from his own time; and though he affected to
point a moral in his pictures, still there is the
grip of insight into essentials in his work which
mark it. The reader will probably have seen
his work at the National Gallery; if not, he
should do so at once.

We pass over Wilson, for in his work is not
apparent any love of nature or decoration, but
only a feeling for classicism. The next name
is that of Joshua Reynolds He was a manner-
ist, and, though successful in his own time, is
very mortal. Close on his knightly heels came
one of the true immortals, Thomas Gains-
borough, one of the most charming portrait
painters the world has ever seen. His land-
scapes, though better than any up to his time,
are not good, and his reputation rests chiefly on
his power in portraiture, in which he excelled.
Charm breathes from his canvas; he has seized
the very essence of his sitters' being and por-
trayed them full of life and beauty. See his
portrait of Mrs. Tickell and Mrs. Sheridan in
the Dulwich Gallery; you will never forget the
charm and the beauty of the ladies, wherever
you go afterwards. Study well these two, and
then go and gaze on a portrait by Reynolds,
and we doubt not you will have learnt some-
thing of the gulf that separated the two
painters. Leaving "the Kauffman" and Fuseli
to those who can admire them, we pass on to
poor George Morland, a genius in his own
branch of art. This man studied and painted
from life, and his pictures bear testimony that

he did so, and notwithstanding the drawbacks
caused by his unfortunate temperament, his
name lives and grows more respected every day.

We now come to a deservedly well-known
name—that of Thomas Bewick, the engraver
on wood. Here we have a man working in a
humble way, humble that is as compared with
painting or sculpture, yet loving and studying
nature in detail, daring now and then to add
some quiet fancy of his own. As a technician
he is famous; but his birds are not true to
nature; nor are they beautiful.

Wood-cutting has degenerated. Men of little
training and no artistic feeling took it up, and
slowly but surely the art decayed until it
became purely mechanical, and so it has re-
mained in England. Now it bids fair to be
superseded by photo-mechanical processes, as it
will undoubtedly be entirely superseded directly
a really delicate process of reproduction is dis-
covered for printing with the type. In the
United States, however, wood-engraving took a
fresh start, and brought photography to its aid,
and our opinion is that the effect obtained in
photographs printed on albumenized paper be-
came the effect which the wood-cutters aimed
for, and the result is a print of wonderful
detail and beauty; but for our taste it is too
polished and neat, the effect of overlaying is far
too visible, and though surpassing anything of
the kind done in England, it is, as a work of
art, altogether eclipsed by Bewick's work, the
reason being that every line in his blocks is

full of meaning. But the hydra head of commercialism showed itself, and wood-engravers with little or no feeling for or knowledge of art set to work turning out blocks like machines. Photography will keep these artisans from falling utterly away from nature, yet such work is harmful and of no artistic good to us, though it may please the public. Had there been no constant returns to nature (as there must always be, in some measure, when a photograph is copied) decay would be sharp and speedy, but photography bolsters up the dying art. Lately several wood-blocks have been produced cut from photographs wherein all the beauty of the photographs has been utterly lost by the engraver, and the results are bastard slips of trade ; but we shall have more to say on this subject later on. One thing at any rate photography can claim: that is, so long as it can be practised, art can never slip back to the crude work done in some eras of its decadence. Photography has helped many of those feeble wood-cutters immensely, and the *épicier*-critic calls these works " precious." It is extraordinary how men will deceive themselves.*

Now we come to a branch of art which is essentially English, namely, painting in water-colors. It is not meant by this that water-color is a new medium, or that the English water-colorists were the first to use the medium,

* Vide Mr. W. J. Linton's book on wood-engravers. That a wood-engraver should choose process-work to reproduce famous plates speaks volumes.

for the tempera paintings were but water-colors, and Albert Durer and others used it considerably ; but what is implied is that the English were the first to adopt it largely and develop it, though it was reserved for the modern Dutchmen and Frenchmen to show its fuller capabilities. The painter in water-color has not, of course, the same control over his medium as he has in using oils. But to see really beautiful water-colors the reader must not look for them in English galleries. No Englishman ever came so near to nature—to the subtleties of nature—in water-color as do the modern Dutch and French painters. The reader would do well to go to Goupil's exhibitions of modern Dutch and French painters, which are held from time to time, and keep a look-out for water-colors, and he should carefully study them at the Paris *Salon.* Of the bulk of English water-colors of to-day there is not one word of praise to be said, and the student in art matters will do well to avoid all exhibitions of this work until he has a greater insight into nature ; and then let him go to the various water-color exhibitions, and if he does not receive a mental shock we shall be greatly surprised. There is but little in them except pounds, shillings and pence. The best of them are nauseous imitations of Turner. These remarks do not, of course, apply to such work as is done by a few modern painters, such as Mr. Whistler, but these paint in oils first and water-color afterwards. The first Englishman worth considering in this branch of art is Girtin,

who was sincere as far as he could be, and had he not died at such an early age (under thirty) the probability is that Turner would have been eclipsed by him. Of Turner we shall speak later on. The name of David Cox rises above the men of his time ; but, after all, his is not the name of an immortal. He aimed well, however, for he tried to paint the life and landscape of his time. Much has been written about De Wint; but if we go to the basement of the National Gallery and study De Wint, and then go to Norfolk and study the landscape there, we shall find Mr. De Wint is sadly to seek. One thing, however, may be said in his praise. He studied out of doors. His peasants are not the fearful travesties of Hill, Barrett, and Collins. Lewis, and Cotman, and Vincent have, however, done some better things than De Wint.

Returning to oil painting, we must pass over the long list of names, including Presidents of the Royal Academy, whose names are now all but, if not quite, forgotten, for their peasantry of the Opera Bouffe, their landscapes after Claude never did interest any but the painters themselves and an uneducated public.

Then we come to Turner, that competitor in painting. This work has had an artificial afflatus through the writings of a "splendidly false" critic, and, curiously enough, the critic, like the artist, has had insight enough to see that the landscape artist should be an interpreter of the life and landscape of his own time; but, curiously

enough, the critic, like the artist, does not know
pictorial nature. The critic has taken Turner
as nature unalloyed, and hence the whole of
that gigantic work of his is built on sand. The
critic never had much, if any, weight with
the best artists. Even Turner himself was
amused with the reasonings of his eulogistic
logic! and gave it out as much as a man
can give out about his eulogist, that all the
tall talk about his pictures was rubbish. To
say of his earlier pictures that he painted in
rivalry or imitation, if you like, of Wilson,
Poussin, and Claude, is to say they are bad, as
they undoubtedly are. This spirit of rivalry
never seems to have deserted Turner, for in his
will he left directions bequeathing one of his
pictures to the Academy, on condition it should
be hung side by side with a Claude. The spirit
of this is, of course, patent. He thinks he has
beaten Claude, and that is enough. No great
genius would have descended to that. Art was
to him an unending competition, and the result
was that though he reveled in the life and
landscape of his own times, yet the small spirit
of competition was his ruin. His later pictures
are, of course, the eccentricities of senility, and
the garish colorings seen by a diseased eye, as
has been lately shown, and are as unlike nature
as one could expect such work to be. But let
us take his "Frosty Morning" at the National
Gallery. Look well at it, and what do you
find? Falsity everywhere, and most of the
subtlety and poetry of a frosty morning com-

pletely missed. The truest picture by Turner
that we know is a little aquarelle at South
Kensington—"A View on the Thames." Here,
then, when we get Turner true to the truth
which he felt in himself, and not competing
(that we know of), what do we find? We find
him immensely behind Corot in the poetic
expression of nature, as is well possible for so
reputedly great a man. The Liber Studiorum
should also be carefully studied, noting the
falsities; trees drawn by rule, figures not drawn
at all, the total disregard of the phenomena of
nature and of decoration, sometimes even the
evidence of several suns in one picture. There
is no truth of tone; no atmosphere; the values
are all wrong; all the charm and subtlety of
nature completely missed. Go to Corot or
Maris after this, and what a difference! Here
are no meretricious adornments, but more
nature and less mannerism. Turner is not the
man to study, and if you cannot "understand
him" well and good. Many artists cannot and
do not wish to, and many French painters of
great ability jeer at his very name.

All should study Constable's works at the
National Gallery and South Kensington; and his
life by Leslie is well worth reading, as showing
how much of a nature-lover he was in *theory*.
The best example of his work that we know is
a little river scene, with some willows, which
we saw at South Kensington Museum. You
feel, however, that there is no atmosphere in
most of his pictures; this is partly due to their

being out of tone. He had not the knowledge of nature and feeling for decoration that characterized Corot, and was not always faithful to his creed; hence his failings. It is true that we have read in his life such passages as these : " In such an age as this, painting should be *understood*, not looked on with blind wonder, nor considered only as poetic inspiration, but as a pursuit—*legitimate, scientific,* and *mechanical.".* . " The old rubbish of art, the musty commonplace, wretched pictures which gentlemen collect, hang up, and display to their friends, may be compared to Shakespeare's ' Beggarly Account of Empty Boxes.' Nature is anything but this, either in poetry, painting, or in the fields." . . . " Observe that thy best director, thy perfect guide is nature Copy from her. In her paths is thy triumphal arch. She above all other teachers." . . . "Is it not folly, said Mr. Northcote to me in the Exhibition, as we were standing before ———'s picture, for a man to paint, what he can never see ? Is it not sufficiently difficult to paint what he does see ? This delightful lesson leads me to ask, what is painting but an imitative art—an art that is to *realize*, not to *feign.* Then some dream that every man who will not submit to long toil in the imitation of nature, flies up, becomes a phantom, and produces dreams of nonsense and abortions. He thinks to save himself under a fine imagination, which is generally, and always in young men, the scapegoat of folly and idleness." . . . " There has never been a lay painter, nor can there be.

The art requires a long apprenticeship, being *mechanical,* as well as intellectual." . . . " My pictures will never be popular," he said, " for they have no *handling.* But I see no *handling* in nature." . . . Blake once, on looking through Canstable's sketch-books, said of a drawing of fir-trees, "Why, this is not drawing, but *inspiration !* " and Constable replied, " I never knew it before ; I meant it for drawing." . . . " If the mannerists had never existed, painting would have been easily understood." . . . " I hope to show that ours is a regularly taught profession; that it is *scientific,* as well as poetic ; that imagination alone never did, and never can, produce works that are to stand a comparison with *realities."* . . . "The deterioration of art has everywhere proceeded from similar causes, the imitation of preceding styles, with little reference to nature." . . . " It appears to me that pictures have been overvalued, held up by a blind admiration as ideal things, and almost as standards by which nature is to be judged, rather than the reverse." . . . "The young painter, who, regardless of present popularity, would leave a name behind him, must become the patient pupil of nature, nevertheless." Constable was not always true to himself, he certainly has little feeling for decoration. Merely imitating unselected nature never makes an artist.

Crome, who was, in our opinion, a better painter than Constable, was like him, an impressionist, and true to his faith. There is an

amusing scene in his life, which we will quote.
"A brother of the art met Crome in a remote
spot of healthy verdure, with a troop of young
persons. Not knowing the particular object of
the assembly, he ventured to address the Nor-
wich painter thus : ' Why, I thought I had left
you in the city engaged in your school.' ' I am
in my school,' replied Crome, 'and teaching my
scholars from the only true examples. Do you
think,' pointing to a lovely distance, 'either
you or I can do better than that ? ' "

* Crome has expressed his view of art in the
following remarks, which we read in his life :
" The man who would place an animal where
the animal would not place itself, would do the
same with a tree, a bank, a human figure—with
any object, in fact, which might occur in nature;
and therefore such a man may be a good color-
ist or a good draughtsman, but he is no artist."
At the National Gallery is to be seen a very
good specimen of his work, and one well worth
studying. Vincent, another East Anglian, did
some fine work, quite equal to that of Van der
Velde.

We now pass over the names of Callcott,
Nasmyth, Müller, and Maclise, persons who
have been called "great colorists," whatever
that may mean. A great colorist should be
a subtle and delicate colorist, and Müller is
almost chromographic in originality.

Creswell, Linnell, and Cooke, are names that

* I have since writing this seen a Crome that has all the feeling and
quality of a fine Corot. This was a picture of a row of poplars.

stand out at this period, and the best of them is
Cooke; his painting of "Lobster Pots," at South
Kensington, being fresh and pretty; but none
are poets; they have but little insight into
nature, though Linnell at times shows the true
feeling. Of considerable power were Wilkie,
Stansfield, Mulready, Leslie, Landseer and Ma-
son, but most of them have been over-praised.
They are all false in sentiment, and all lack
insight into the poetry of nature. In technique
Wilkie and Landseer are sometimes strong,
and they will always appeal to a certain class of
people. Mason's work is a fine example of the
folly of introducing the so-called "imaginative"
into landscape. Take his "Harvest Moon:"
when and where did ever men exist with such
limbs? The whole picture smacks of the model
and of the "stage idealism;" there is no nature
there, but a laughable parody of it. The next
name in English art is that of * Frederick Wal-
ker, who had a considerable grip of and insight
into nature. But in his work the traditions of
the idyllic peasants of the golden age linger,
and we find his ploughman merrily running
along with a plough as though it were a toy
cart; and what a ploughman! he never saw a
field in his life. His coloring and decorative
sense are sadly to seek, yet notwithstanding
this his name will always be a landmark in
English art. The reader will be able to study
one of his works in the National Gallery, and a

* His book illustrations have been so ruined by wood-cutters that
as Mr. J. Pennel says, they are valueless.

poor thing too! The date of Walker's death brings us down to the actual present. Regarding living English painters we will remain discreetly silent. It must be remembered that English art is young, beginning as it practically does in the eighteenth century, for the miniature-painters cannot count for much, and we must therefore not expect too much. Great men, especially great artists, are rare as Koh-i-noors. England can boast of a few, such as Gainsborough, Raeburn and Crome.

AMERICAN ART.

Of American art there is but little to say. No name stands out worthy of record till J. M. Whistler appears, and he, though an American by birth, can hardly be called an American painter, for the life and landscape of his own country he neglects, as also does Sargent, a strong painter, French by education. Whistler's name rises far above any artist living in England; his portrait of his mother and those of Carlyle and Sarasate are works good for all time. But his most original note has been struck in his delicate and subtile landscapes, chefs-d'œuvre worthy to be ranked with the best. Mr. Whistler's influence, too, has been great and good. As a pioneer he led the revolt against ignorant criticism by his attack on *Ruskin. His life in England has been a long battle for art, and though many do not approve of all his methods, and still less of his brilliant but illogical " Ten

* " The gentle art of making enemies."

O'Clock," his work and influence have been for good.

Another great step in advance, introduced by Mr. Whistler, has been the reform in hanging pictures; though he has not been allowed to carry out his plans thoroughly, yet he has managed his exhibitions much more artistically than any others in the country. In landscape his night scene at Valparaiso is marvelous, and we doubt whether paint ever more successfully expressed so difficult a subject. But even as Homer nods, so does, at times, Mr. Whistler. and sometimes "impressions" in oil, watercolor, and etching appear with his name, an honor of which they are unworthy. Yet so long as art lives will Mr. Whistler live in his Carlyle, his portrait of his mother, The Balcony, Lady Campbell, and some smaller works. Mr. Sargent's Carnations and Lilies must be fresh in our readers' minds. We will only say of it that we never saw the actual physical facts of nature so truthfully and subtly rendered. It is indeed a picture whose title to admiration will be lasting, and if the reader has not already seen it, or, having seen it, has listened to atrabilious critics, and passed it over as being "ugly," let him go to South Kensington and view it again, for the nation is its fortunate possessor. Let him look well at it, and consider what it is. It represents a garden at the time of day when the sunlight is fading but has not quite gone—crepuscule, in fact, and with the dying light of day is represented the artificial

light of Chinese lanterns. This is indeed a masterpiece, as is the masterly portrait of Ellen Terry as Lady Macbeth. Besides these two masters J. Stewart, George Hitchcock, W. T. Daumont, J. Melchus, A. Harrison, and L. R. Wiles are all good painters, whilst * Abbey, Parsons, and J. Pennell are good pen-and-ink draughtsmen ; and Kingsley, Cole, French, Johnson, Davis and others are very good wood engravers. The two last arts owe their revival entirely to photography, and photography is used by many of these " detractors," but the idea of original wood-cutting is a dream of the night. Photography is used and the cutting necessarily done in-doors, even if in a traveling caravan, and where does " out-of-door " lighting come in? These " original " wood-cutters if they really love nature as they profess had far better turn photographers, and so express genuinely the subtleties of nature which their art can never do even when they make use of our practice.

Here, then, we must leave England and America, only remarking that things look bad for the education of the American public when the best Americans stay away from there, and when rich sausage-makers buy Herbert's works with which to educate themselves, and when catalogue compilers take over boat-loads of English water-colors, with which still further to lead them wrong. America wants no such education as can be given by Herbert's senili-

* Has since become a good painter as well.

ties or English water-colors. She wants a band
of able young men, who, having learned their
technique in the best schools in the world,
namely, those of Paris, shall return to America
and paint the scenes and sentiments of their
own country, and therein only lies the hope for
American art.

Dutch Art.

The first mighty names of the modern period
are Franc Hals and Rembrandt Van Ryn.
Holland, by her bravery, had thrown óff the
Spanish yoke, and with it the crushing yoke of
Catholicism, and stood free to follow her own
bent. As a result of this freedom a body of
artists arose who did more for modern art than
any body of painters in the world. Franc Hals's
work is well known, his portraits are among
the best Dutch paintings ever executed. He
was a *bon-viveur*, and his work is full of the senti-
ment of his life and times. His famous " Ban-
quet," however, we do not think well painted.
Rembrandt, though a giant and fit for the com-
pany of the immortals Van Eyck, Velasquez,
etc., was not perfect, for sometimes the power
of tradition lurks in his work, and he forces his
portraits by warm colors in the background,
an artifice which was not at all necessary, and
which Mr. Whistler has done without. There
are a number of his works in the National Gal-
lery, and a good one in the Dulwich Gallery,
where is also a great Velasquez, so that the
reader should not fail to go there. Rembrandt's
best work was inspired by the simple life

around him; portraits and interiors satisfied him. It is a significant fact that the greatest painters have been content to paint the life of their own times and not to draw upon their imagination. The learned painter, it cannot be too often repeated, is he who is learned in all the resources of his art.

But to return to Rembrandt. Perhaps his mastery, his grip of nature, show forth as much in his etchings as in his paintings. He, like all great etchers, and there are few enough, used etching only within its legitimate limits, that is, as a method of expression by line, in a simple, direct and brief manner. An etching by a master may be looked upon in the same light as an epigram,* sonnet or ode by a poet. Many of Rembrandt's etchings can be seen in the British Museum, and should be thoroughly well studied; after which study, pick up some of the unmeaning work of Seymour Haden, or any other modern etcher, except perhaps Mr. Whistler and Rajon,† and you will, without doubt, distinguish the difference. Most modern works are good examples of how *not* to etch. Line after line is put in without any meaning at all; there is no evidence of study in the work and the subjects are trivial and commonplace. One of the greatest evils commercialism has done to art is to ruin modern etching, by having pictures of the old masters copied slavishly by the etcher, and elabo-

* Epigram here being used in the old Greek sense.
† Now dead.

rated and worked up, so that one wearies of them. Such work can scarcely be said to rise to the dignity of fine art at all, and Rembrandt, we think, would rise in horror from his grave, if he could see his paintings reproduced by etchers. *Any* reproduction of a picture is unsatisfactory and does not become fine art at all, but is only useful to furnish reflections of the mind whose work it is intended to represent, and for our part we think a good impersonal photo-etching does this better, because more faithfully, than any other process. It is difficult to imagine the mind that can set itself to work for months, even years, at an engraving or etching from another man's work when the world is so full of pathos and poetry, and subjects abound on all sides.

Rembrandt etched, and Mr. Whistler etches from Nature direct, not impertinently—there is no other word for it—tampering with other men's work.* But the public will buy these reproductions, and an artificial value is thus given to them, and the dealers will of course encourage whatever pays. One etching by Rembrandt himself is worth all these reproductions of pictures by engraving, etching, mezzo-tint, or photo-etching, because it is an original work of art. Not long ago a letter appeared in one of the literary "weeklies," complaining of the stamping of photogravures by the Print-sellers' Association. The obvious answer to this print-sellers' letter is, of course, that with the works of living painters, the style

* Thanks to Mr. Hamerton's foolish writings.

of reproduction rests with the painter, and if the artist is satisfied with photo-etching, what has any one else to say—painters are the best judges of these things. Very few painters we know would entrust the reproduction of their pictures to etchers or engravers, or would countenance the *publication of another man's view of their work*. We have seen photographs of Whistler's paintings, but never engravings of them. With bad paintings, on the other hand, the engraving of them has often made the painter's name as well as the engraver's. We could cite an example of a living * painter who owes his reputation chiefly to the engravings of his works, and poor things they are even when embellished by the process. At the time this discussion was raging amongst the philistines, it was gravely asserted that "engravings always rose in price," and this was given as a reason for buying them. Have the engravings of Mr. Landseer's pictures risen in price! Ask the poor subscribers to the first copies. Will the engravings of Doré's works rise in price? *Quien sabe?* If the reader is under any such erroneous idea, let him attend a few sales of engravings in London, and he will see proofs of etchings and engravings knocked down for a few shillings.

Leaving with regret the great Rembrandt (we pass over several smaller but often quoted names), the most influential name we come to is Van Ostade, another impressionist of great

* J. E. Millais, since died.

power, of whom we have already spoken. Next
we come to De Hooghe. This is the man who first
really gripped thoroughly and expressed truly on
canvas the mystery and poetry of the open air.
There are two specimens (courtyards) of this
painter's work at the National Gallery. They
are an education in themselves, and are well
worth long and careful study ; indeed, there
are few pictures more worthy of study. There
they hang, fresh as nature and beautiful as
paint can express, good, valuable for all time
—why ? Because the painter has known how
to give the sentiment of *plein air.* There
they hang, true and lovely, pictures of Dutch
life in the seventeenth century. No history
can come up to them in historic value, none
can be so true. A contemporary of De Hooghe
was Jan Van Neer, of Delft. The few pictures
that have descended to us of this painter prove
him to be as great an artist as De Hooghe
himself. His " The Soldier and the Laughing
Maiden" is the best known and has many of
the qualities of a Rembrandt.

Cuyp we will pass over with few words. His
hot coloring smacks of the imagination rather
than of nature. Paul Potter and Ruysdael also
are men with unduly great reputations; they
are both false in sentiment, and they handled
nature with impertinence. Any careful ob-
server can see that Ruysdael played with the
lighting of landscapes as did Turner, but he has
a sense of decoration.

Hobbema at times verged near unto greatness,

as for instance in the painting of a road with
trees, in the National Gallery, which our readers
will do well to study. In sea painting, Van der
Velde the younger is wonderful in his love of
nature. Good specimens of his work can be
seen in the National Gallery.

Coming down to our own times, the elder
Israels stands out as a distinguished artist. We
have only been able to see a few of his pictures,
but those show us the master. In carefully
studying the modern schools of art at the great
Paris exhibition, I felt at first that the modern
Dutch were original, and so they are to a limited
extent, but they fall far behind the Scandina-
vians in their originality. The Dutch have, how-
ever, only followed good conventions. Artz's
work is good, but a little 'painty.' One of the
best landscapes I have seen is J. J. Van de
Sarle's. Bastert is good, as is B. J. Blommers,
though his work is a trifle 'painty.' J. Gabriel
had a fine, open landscape, "Une Tourbière en
Oberysel." The younger Israel's "Paysans à
Table" is good. S. J. Cati's work is impres-
sionistic and full of a distingué air, and very
true to nature, though rather *chic*.

J. Maris is well known for good work, whilst
a picture of some windmills, by S. M. Maris,
is one of the very best landscapes I ever saw.
W. Martens is a good portraitist, and Mauve has
left some good landscapes. Mesdag's sea pieces
are good, though rather tight and painty. Roe-
lofs, too, is a good painter of Dutch landscape.

Good water-colormen are Weissenburgh,

Mesdag, Bosboom, Poggenbeck, J. Israels, Artz, and the elder Israels, and Mauve in his " Coppice Before a Fallen Tree."

Good etchers are found in Veth and Zilcken.

RUSSIA AND THE SCLAVE STATES.

Of the arts of these countries there is but little to be said. The art, what there is of it, is not national, but is really French in its origin and sentiment. Thus Edelfelt's work, though some of it was painted in Finland, is the work of a *French* impressionist, and not a first rate one either. The late Miss Bachkirtzeff's work is but poor French impressionistic work, whilst of other Russian painters, A. Harlamoff, Praniskuikoff, Lehman, Trembacz, are the only Russian painters whose work may be considered " national;" but they can claim no originality, though they are good painters. But any one could see that in these artists, and in those of Roumania, *e.g.*, Grigoresco, that whatever was good was impressionistic.

SCANDANAVIAN ART.

But it is in the neighbourhood of Russia—in Scandanavia—that we found the most original note struck in painting outside of France. There was, perhaps, just a suspicion of French influence in the work, but proof was given that an original and powerful art was developing.

Beginning with Norway. Mlle. Backer's " Intérieur d'Eggedal " is good. J. Grimelund's " Port D'Anvers " is bold and true, F. Kolstoe's

" Pécheur Norvegien " is a strong work with a style of its own. C. Krohg's work is good. E. Peterssen and O. Sincling are good impressionists. C. Skredsvig is a good landscapist and his work has fine quality. Wenzel's "Festin de Première Communion" beats S. Forbes' "Wedding" all to pieces. Werenskold's work, too, is first-rate. The Swedish painters are, perhaps, better than the Norwegians. Berch is a fine portrait and landscape painter. Birger is strong in his " Retour de la Chasse," whilst Ekström's landscapes are capital. Haborg is good. Heyerdahl's " L'Ouvrier Mourant" is very fine, though weak in parts in drawing. N. Kreuger is a first-rate impressionist. Carl Larsson, too, sent two beautiful pictures—in an arbor and outside. Thegerström, Wahlberg and Zorn all sent really good work, and as for Salmson's work, there is no Englishman can approach him. Our so-called impressionists, should study Salsmson, Larsson, Kreuger, Thorel, Zorn, Osterlind, Kröjer, and others.

In Denmark Archer, Johansen, Therkilsden, and, above all, P. S. Kroyer. There are but few men anywhere who can approach Kroyer; his " On the Sea-Shore " and " Departure of the Herring Fleet" being most original impressions. His merry " Hip, hip, hip, Hurra, hurra, hurra," is masterly.

To wind up, we are assured that, next to France, Scandanavia towers a head and shoulders above any other country in the world in art to-day, for there only, out of

France, do we find any original, any living, any great art.

FRANCE.

And now, lastly, we come to France—France where art has in modern times reached its highest level. France has in modern times always been the leader of civilization in Europe, and even now she is in the van of modern progress, our intellectual mother. We may have a finer literature to show, in Germany science may be more profound, but in all that is greater than literature or science, that is in solving the problem of throwing off the yoke of religious and political despotism, France has become the leader. Practical, energetic, and thrifty, the French with all their faults, still remain in many ways the first nation of the world. France and the French have more of the Ancient Greek's *esprit* than any other nation has or ever has had. In all the humanizing influences that distinguish brute man from civilized man, the French are to the fore, but in histrionic, glyptic and pictorial art, she is unapproachable, and still reigns Queen of the Arts, in those branches.

Passing over Nicolas Poussin, Le Brun and other lesser names, whose works are not those of masters, we arrive at Claude Lorraine; but the first name that really stands forth as great in French art is that of Watteau. Watteau, however, cannot be ranked among the Immortals, for though his technique was marvellous, and

his power of drawing unsurpassed, he like all
his contemporaneous artists is a little artificial,
for they lived in the artificial times of Louis XIV.

There is a picture in the National Gallery
which well explains what we mean. Then
name after name is handed down to us, but in
vain do we look for a master among them.
Boucher and Greuze still have admirers, but
they are not great painters. Delacroix strove
to rise from the artificial influence of the time,
but he was not strong enough to become a
master. It was reserved for Ingres to make a
real advance. He, though imbued to some ex-
tent with the old spirit of classicism, was a deep
lover of nature, and the story of the struggle
for the mastery between those two opposing
tendencies is the story of his art and life.
Though he rises above all previous painters of
his country, he cannot be ranked with the
masters. With Ary Scheffer there was a retro-
gression which in its turn was counteracted by
Delaroche. It was Delaroche who afterwards
rashly said every artist would one day have to
use photography.. Still, in vain do we look for
a genius, and until Constable's pictures, ex-
hibited in 1824 in Paris, aroused the French as
to the real aims of art, no really great master
appears. But when practical France saw, she
immediately took up with impressionism. Then
we have first Decamps, who took up the newly
revived ideas, but failed, and Rousseau made
the real departure—the poetry and mystery of
nature roused in him an ardent sympathy, and

all honor to him for struggling on at Barbizon, in the face of the neglect and contumacy of the *Salon.* But Rousseau, hero though he was, never rose to be a mighty painter, and his works fall far behind those of the best painters of to-day, but as a pioneer his name will always be remembered, and though he failed, he at least took Nature as his watchword. After Rousseau came Corot, a master good for all time. His early works show signs of the classical spirit, from which he had not yet shaken himself free; thus we sometimes see in his early works, peasants strangely habited and reminding one of the seventeenth century or ancient Greece, which is of course ridiculous ; but his later work is true and great. Full of breadth and feeling for the subtleties and poetry of nature. he has never been surpassed. Examples of his work in England can sometimes be seen in the French Gallery, the Hanover Gallery and at Goupil's, but it must be remembered that great as Corot is, there is much of his earlier good work that is bad. Another painter is Daubigny, a contemporary of Corot's, and though not such a subtile observer as Corot, still he is a painter whose work has had great influence; but it has been surpassed by younger men. Daubigny seems to us to have emulated "sharp" photography. Troyon was another who like Corot loved and studied and painted from nature, but he lacked the insight into nature that Corot had, and his work is not as fine as that of his contemporary.

At length, however, we arrive at an Immortal name, that of Jean François Millet. This great man must not be confounded with two Jean François Millets, who lived years before, and who were not artists at all, though painters. Everything about J. F. Millet the Great, is worthy of study. Let the student seize every chance of studying his works, chances which will, alas! be rare enough, as many of his best pictures are in America and most of the others in France. His pastels and water-colors are not very good, but his etchings which (reproduced) can be seen in the British Museum, are valuable for strength and power. Here is a directness of expression rarely surpassed. Before leaving him we will quote a few passages from his letters which show his attitude toward Nature :

"I therefore conclude that the beautiful is the suitable. . . . Understand that I do not speak of absolute beauty, for I do not know what it is, and it seems to me only a tremendous joke. I think people who think and talk about it do so because they have no eyes for natural objects ; they are stultified by 'finished' art, and think nature not rich enough to furnish all needs. Good people, they poetize instead of being poets. Characterize! that is the object.

"When Poussin sent to M. de Chantelon his picture of the 'Manna,' he did not say, 'Look, what fine *pate!* Isn't it swell? Isn't it tip-top?' or any of this kind of thing which so many painters seem to consider of such value,

though I cannot see why they should. He says:
' If you remember the first letter which I wrote
to you about the movement of the figures which
I promised you to put in, and if you look at the
whole picture I think you will easily under-
stand which are those who languish, which are
filled with admiration, those who pity, those
who act from charity, from great necessity,
from desire the wish to satiate themselves, and
others—for the first seven figures on the left hand
will tell you all that is written above, and all
the rest is of the same kind!'

"Very few painters are sufficiently careful
as to the effect of a picture seen at a distance
great enough to see all at once, and as a whole.
Even if a picture comes together as it should,
you hear people say, ' Yes, but when you come
near it is not finished!' Then of another,
which does not look like anything at the dis-
tance from which it should be seen, ' But look
at it near by; see how it is finished!' Nothing
counts except the fundamental. If a tailor
tries on a coat, he stands off at a distance enough
to see the fit. If he likes the general look, it is
time enough then to examine the details; but if
he should be satisfied with making fine button-
holes and other accessories, even if they were
chefs-d'œuvre, on a badly cut coat, he will none
the less have made a bad job. Is not this true
of a piece of architecture, or of anything else?
It is the manner of conception of a work which
should strike us first, and nothing ought to go
outside of that. It is an atmosphere beyond

which nothing can exist. There should be a *milieu* of one kind or another, but that which is adopted should rule.

"As confirmation to the proposition that details are only the complement of the fundamental construction, Poussin says, ' Being fluted (pilasters) and rich in themselves, we should be careful not to spoil their beauty by the confusion of ornament, for such accessories and incidental subordinate parts are not adapted to works whose principal features are already beautiful, unless with great prudence and judgment, in order that this may give grace and elegance, for ornaments were only invented to modify a certain severity which constitutes pure architecture.'

"We should accustom ourselves to receive from nature all our impressions, whatever they may be, and whatever temperament we may have. We should be saturated and impregnated with her, and think what she wishes to make us think. Truly, she is rich enough to supply us all. And whence should we draw, if not from the fountain-head? Why for ever urge, as a supreme aim to be reached, that which the great minds have already discovered in her, because they have wooed her with constancy and labour, as Palissy says? But, nevertheless, they have no right to dictate for mankind one example for ever. By that means the productions of one man would become the type and the aim of all the productions of the future.

"Men of genius are gifted with a sort of

divining-rod; some discover in nature this, others that, according to their kind of scent. Their productions assure you that he who finds is formed to find; but it is funny to see how, when the treasure is unearthed, people come for ages to scratch at that one hole. The point is to know where to find truffles. A dog who has not scent will be but a poor hunter if he can only run at sight of another who scents the game, and who, of course, must always be the first. And if we only hunt through imitativeness, we cannot run with much spirit, for it is impossible to be enthusiastic about nothing. Finally, men of genius have the mission to show, out of the riches of nature, only that which they are permitted to take away, and to show them to those who would not have suspected their presence, nor ever found them, as they have not the necessary faculties. They serve as translators and interpreters to those who cannot understand her language. They can say, like Palissy, 'You see these things in my cabinet.' They, too, may say, 'If you give yourself up to nature, as we have done, she will let you take away of these treasures according to your powers. You only need intelligence and good will.'

"It must be an enormous vanity or an enormous folly that makes certain men believe that they can rectify the pretended lack of taste or the errors of Nature. On what authority do they lean? With them who do not love her, and who do not trust her, she does not let herself be

understood, and retires into her shell. She
must be constrained and reserved with them.
And, of course, they say, ' The grapes are green.
Since we cannot reach them, let us speak ill of
them.' We might here apply the words of the
prophet, ' God resisteth the proud, and giveth
grace to the humble.'

" Nature gives herself to those who take the
trouble to court her, but she wishes to be loved
exclusively. We love certain works only be-
cause they proceed from her. Every other
work is pedantic and empty.

" We can start from any point and arrive at
the sublime, and all is proper to be expressed,
provided our aim is high enough. Then what
you love with the greatest passion and power
becomes a beauty of your own, which imposes
itself upon others. Let each bring his own.
An impression demands expression, and espe-
cially requires that which is capable of showing
it most clearly and strongly.

" The whole arsenal of nature has ever been
at the command of strong men, and their genius
has made them take, not the things which are
conventionally called the most beautiful, but
those which suited best their places. In its own
time and place, has not everything its part to
play? Who shall dare to say that a potato is
inferior to a pomegranate ?

" Decadence set in when people began to
believe that art, which she (Nature) had made,
was the supreme end; when such and such an
artist was taken as a model and aim without

remembering that he had his eyes fixed on infinity.

" They still spoke of Nature, but meant thereby only the life-model which they used, but from whom they got nothing but conventionalities. If, for instance, they had to paint a figure out of doors, they still copied, for the purpose, a model lighted by a studio light, without appearing to dream that it had no relation to the luminous diffusion of light out of doors—a proof that they were not moved by a very deep emotion, which would have prevented artists from being satisfied with so little. For, as the spiritual can only be expressed by the observation of objects in their truest aspect, this physical untruth annihilated all others. There is no isolated truth.

" The moment that a man could do something masterly in painting, it was called good. If he had great anatomical knowledge, he made that pre-eminent, and was greatly praised for it, without thinking that these fine acquirements ought to serve, as indeed all others should, to express the thoughts of the mind. Then, instead of thoughts, he would have a programme. A subject would be sought which would give him a chance to exhibit certain things which came easiest to his hand. Finally, instead of making one's knowledge the humble servant of one's thought, on the contrary, the thought was suffocated under the display of a noisy cleverness. Each eyed his neighbor, and was full of enthusiasm for a manner."

Bastien-Lepage, the hero of the forgotten "tinted photo" or value movement, is not even always strong in drawing, and his sentiment is often false, untrue, and brutal, and not nearly so fine as Courbet's sentiment; yet Courbet preceded him; he was but a follower, where Courbet was a leader.

Of the older living painters. Jules Breton and Lhermitte stand out as strong men ; but Breton has long ago been passed, and Lhermitte is not the man he was, but some of Lhermitte's work will live always. There is a remarkably fine Lhermitte in the Luxembourg, which every one should try and see. Of other living painters much might be written, for they, in our opinion, represent the acme of modern painting. We strongly recommend all readers of this book, after they have studied the pictures and sculptures here referred to, and have some insight into nature, to make without fail a yearly pilgrimage to the French *Salon*, where they will see fine painting, though of course there is much bad work in the *Salon*, as at other exhibitions.

The marvellous pastel work, aquarelles, and charcoal drawings will all show them how immeasurably behind France, England is in all the pictorial arts. Englishmen do not know what drawing is—therein lies the cause of their failure. This very year (1888) we went to the Academy the day after seeing the *Salon*, and what a fall was there !

Since writing these notes on the great French painters of this period we have seen nearly every Corot, Le Page, Millet, Daubigny, Troyons, Courbet, Manet, Monet, and the works of other epoch-makers. To begin with, we think little of Daubigny, as we have remarked above. Courbet, though he seems never to have had justice done him, is masterly in his " Stone-Breakers," one of the greatest works I ever saw: the works of Le Page, next to which it hung, appeared small and insignificant in comparison. Courbet's " Drunkards," too, is good. The more I see of Le Page the less I like him, though his portrait of " My Grandfather" is excellent, but his " Joan D'Arc," " Potato Gatherers," etc., are very poor and have no sense of focus, no atmosphere, and they are both false in sentiment. It is a cockney's view of the country. " Les Foins" and others are positively bad. Millet was a poet— though he seemed to me to feel color as a house-decorator would—but for all that he had a subtle feeling for the poetry of the fields, as in the " Hoer," but in the " Angelus " he shows weakness, and the " Sower" is exaggerated. " The Hoer," though, is perfect. Corot is too subtle to describe, he is the poet of landscape painting. Some early Corots, though, are as sharp and bad as photographs, and recall Canaletti's work. Jules Breton has been overated, his work is uneven and " painty." Cazin is fine in atmospheric effects, but there is withal an artificiality of coloring that spoils him for a

master. Diaz is much mixed up with "classical" ideals. Ingres appears second-rate. In Manet I find the old spirit struggling with the new, some of his work being absurdly bad, but again in other works, such as " Le Port de Boulogne," he is masterly. I saw one Meissonnier I liked, a portrait, broader than anything of his I had hitherto seen—but, withal, Meissonnier will not set the Seine a-fire a hundred years hence. Rousseau put new wine into old bottles.

Of the work of some modern Frenchmen the student should study the paintings of A. Aublet (good), Baillet (good in composition), P. A. Besnard (good in rendering light), J. F. Bouchor (good focus), Benj. Constant and Bougereau (for learning what to avoid), Carolus Duran (though rather painty), Carrière (for drawing and atmospheric effects, very fine in some ways, but too much positive spherical aberration in his lenses), Cazin (for atmosphere), Dagnan-Bouveret (for figures), P. E. Damoye (for good landscape work), A. L. Demont (poetic landscape without atmosphere, compare with Cazin's work) E. A. Duez (for good impressionistic work), E. Feyen (for good focus), H. Gerirex (to see that he is not a good painter), T. A. Girardot (true out-door effect), J. Japy (good landscapist), L. Joubert (good landscapist), C. Leandre (good landscapist), P. Mathey (good portraits), Meissonnier (to compare petty work with work like Corot's), Pelouse (for coarse landscapes), A. Perret (good painter), E. Pele-

teau (a good landscapist) J. F. Raffaelli, Moret,
Michel, and others (to see good landscapes on
the border of being ruined by " idealizing : "
compare with Corot), Renouf (to see good,
honest painting), A. Roll (to see the work
of a strong impressionist, and how well he can
render *light*), P. Voyse (to see a forcible land-
scapist), Protais (to see soldiers well painted).

This brings us to the end, so we will leave
painting with France in the van, and Scandan-
avia following closely, with Holland and Bel-
gium pressing close behind it, and America and
England floundering in the rear of these, for
we are no believers in the tall talk of the great-
ness of the immediate future of English paint-
ing.

SCULPTURE.

With sculpture the same old story greets us
that we meet with in the history of painting.
After the masterpieces of Greece come the
puerile conventionalities of the Early Christians.
But as we have hitherto done so shall we con-
tinue—that is, we shall discuss the masters
only, and the first we come to is Nicola Pisano.
Though his work shows that he was still imbued
with the spirit of classicism, yet he struggled
to throw off the paralyzing conventionality of
servile imitation, and tried hard to get back to
nature, and some of his sculptures in Pisa are
wonderful for expression. He was the pioneer
where followed the great Donatello. Pisano's
son worked in the same direction as his father,
and has left some wonderful architectural monu-

ments and sculptures, but his fame rests chiefly
on his architectural works, with which we are
not here concerned. Andrea and Nino Pisano
made great strides toward truth and natural-
ness, and so paved the way for the great man
to come. They were immediately followed by
Ghiberti, who spent many years of his life in
working at the well-known mighty doors of the
baptistery at Florence. These great gates,
however, show no subtlety of the sculptor's
art. Tonality there is none ; the whole is
rather a kind of emblematic picture-writing
than sculpture, but Ghiberti says he spent his
time in "studying nature and investigating her
methods of work," so that even though he did
not succeed, nature was his watchword. But
all these sink into insignificance before the
mighty name of Donatello. Like all true and
great artists, Donatello appreciated the limits
of his art, and followed his principles with
sincerity. Whilst we are now writing, the
wonderful low relief of St. Cecilia, which is on
view at Burlington House, is fresh in our mind.
There is the work in dark marble, looking as
fresh, beautiful, life-like, and artistic, as it did
the day it left the artist's hand.

What simplicity, what truth of impression,
what decorative power, and what subtle tonality
is there seen ! Those who remember this mas-
terpiece may have noticed the way in which the
outline of the neck is raised, and how untrue it
looked close to; but at a distance the impression
was perfect, and the suggestion of shadow most

beautifully rendered. That the modelling of
the mouth is feeble is obvious, but where is per-
fection? Casts of this work can be had for a
mere trifle from Bruciani, Covent Garden, and
we strongly recommend those who have not
seen the original to get one, for a suggestion of
such work is better than a gallery of trash.
There is another fine specimen of Donatello's
work in low relief at South Kensington, but
in that there is the mark of the allegorical,
and it just misses the distinguished and simple
character of the St. Cecilia. We do not care
for his Judith and Holofernes, though it is
one of the most noted of his works, and owes
its renown more to its historical association than
to its artistic qualities. It was natural that such
a great man should have many followers, but,
like most imitators of genius, they copied his
bad points and none of his good ones, for these
they could not attain to, not being geniuses
themselves. The wonderful medals of Vittore
Pisano or Pisanello must not be forgotten,
as they are well worthy of study. The student
can get casts of most of these for a trifling sum,
and we strongly recommend him to buy a few
casts of Pisanello's medals.

The work of the Della Robbia family is so
well known that we must touch upon it,
although for most of it we care little or nothing,
the medium, a glazed terracotta, being un-
attractive. Lucca, the greatest of the family
worked, however, at first in marble. Here and
there in his work one meets with a beautiful

face, and often with fine expressions, but the
whole lacks simplicity and fineness. He was
more a " decorative " artist than a sculptor.

Of Michael Angelo we have spoken. Ben-
venuto Cellini, a name well known, was a mas-
ter in gold-working, but hardly a sculptor.
Many lesser names follow, but no immortal is
again seen in Italy; for though Canova made a
name of some sort, he was no master. After
Michael Angelo came imitation and decline.
Neglect of nature, together with patronage,
killed the spark of art, and so thoroughly killed
it that even writers on art who had no art-
training were listened to upon technical mat-
ters, as Winckelmann and Lessing, but their
works only produced an artificial afflatus, as
Canova and Thorwaldsen proved, for both were
small men, false in sentiment, and with little or
no insight into nature. We say this advisedly,
after seeing much of Canova's work and nearly
all that of Thorwaldsen. There is little big-
ness in their works, but in addition to a classi-
cal sentiment a puerile imitativeness which is
still in vogue in Italy to-day in such work as a
Pears delights in, " You Dirty Boy," and other
trivialities. England, Spain, Holland, and
America seem, up to the present, not to have
produced a single great sculptor. At present
France leads the way, and has some strong men
in Jouffrey, Aubé, Falguière, Rodin and Carles ;
but there, too, the tendency seems to be towards
a fumbling imitation and petty *motif.* There is

much talk of French sculpture being in advance of French painting. We do not believe it.

And now we must end the chapter with the final advice to the student to study all good examples of the great artists whose work we have noted, and to leave all others alone. By and by the student will find that he is in a position to compare the good with the bad, then will it be time enough for him to look at the second-rate work, much of which contains fine passages here and there, and special merits of its own; but these cannot be appreciated until the student has considerable knowledge, and that is only to be obtained by a serious study of nature and of the work of the best masters here cited.

Finally, we think we have shown that the study of the beautiful in nature has been the watchword of all the best artists, and that, after all, there are but few artists in any age. Many painters and modelers and sculptors there be, but artists are few indeed. Men such as the sculptors of the Egyptian lions, the sculptors of the Assyrian lion-hunts, Pheidias, Van Eyck, Durer, Holbein, Titian, Velasquez, Donatello, Rembrandt, De Hooghe, Moroni, Gainsborough, Millet, Corot, Courbet, Whistler and M. Maris.

CHAPTER III.

Phenomena of Sight, and Art Principles Deduced Therefrom.

It will be well now to inquire on scientific grounds what normal human eyes really do see; for our argument is, that a living being does not see things as does the photographer's lens. That the living impression will vary with individuals, there is no doubt, for the artist will see subtleties never dreamed of by the commonplace or uneducated person, and his aim will, of course, be to portray those subtleties in his picture, and hence one source of individuality in a work, another being in the way in which it is done, and a third the inherent difference between artists. Our task now shall be to examine into the physical, physiological and psychological properties of sight, and to arrive at a conclusion, in so far as science allows us, as to how normal eyes do see things. The student will do well to read the Chapter on Sight in Dr. Michael Foster's "Text Book of Physiology," as well as the matter on the eye in Ganot's Physics, before going any further in this chapter, for we do not wish to go over ground which has been occupied previously, our aim being to give a review from the artistic

standpoint of the physical, physiological, and psychological properties of eyesight. We will, then, proceed to consider how well we see external nature, that is, within what limits, for we never see her exactly as she is, as we shall show.

To begin with, then, the retinal nerves are strictly reserved to respond to the vibrations of ether—called light. If the student has ever had a blow on his eye, he has probably *seen* "stars," because every stimulus to this pair of nerves makes us *see* things, and not feel them. Now each sense has certain limits between which it can detect subtle vibrations, but beyond which all is blank. The more refined the organization of the person, the greater will be the number of vibrations he can distinguish. Thus 399,000,000,000 vibrations in a second produce in us the sensation of light; above this the vibrations appear as spectral colors until the number 831,000,000,000,000 is reached; to an increase in the number of vibrations above that number the average optic nerve does not respond. Now the eye is an optical apparatus fixed between the brain and the ether, not that we may perceive light, for we could do that without the eye but that we may distinguish objects. The glyptic and pictorial arts are based on the senation of sight as music is founded on the sense of hearing. In the pictorial arts, then, we must clearly distinguish between the physical, physiological, and psychological properties of sight.

A. Light.

I. Physical characters of the eye as an optical instrument.

If a ray of light passes through a small hole into a darkened room (pin-hole camera), an image is formed of the object or objects without. The condition of a good definition of the image is that "all the rays from each point on the object must be carried to its own point on the image." If this hole be enlarged, this condition is impossible, and the light spreads over certain areas called diffusion areas or diffusion circles. In other words, widely divergent rays and contiguous rays become mixed. To admit more light a lens is used in the eye, and by the photographer, for although it is possible (by pin-hole camera) to take pictures without a lens, the light so admitted is necessarily so limited that the exposure needed is too long, apart from other objections I have elsewhere pointed out. The lens, however, helps us by admitting more light, and at the same time giving better definition, but it also introduces many disadvantages and renders things as we do *not* see them. Now a *theoretically* perfect physical image has been described by physicists as being both bright and sharp in definition, but the theoretically perfect image does not exist; for, apart from other considerations, the lens which we use to get microscopic sharpness amongst other things, cuts off light, and the sharper the image is rendered by stops, the less relief do we get.

Thus we see the lens introduces defects into the image which are not seen by the eyes.

In the human and photographic lenses the chief theoretical faults are:—

Dispersion. All refraction or bending of light by a lens is accompanied by dispersion. This error is corrected in opticians' lenses to a great extent. In the human eye, however, this theoretical fault is present, as can be proved by looking at a lighted lamp through a *violet* glass when a red flame will be seen surrounded by a bluish violet halo. The effect then of dispersion on the theoretically perfect image is a slight blurring of the sharpness of outline, since the size and position of the optical images thrown by the differently bent rays is not the same.

A lens having a spherical surface bends the rays so that they do not all come to a focus at the same point. What is the effect of this on our theoretically perfect image? Again it is slight blurring of the sharpness of outline. It is said the spherical aberration in a perfectly corrected optician's lens *is less than that in the lens of the human eye.* From this it is highly probable that the chromatic aberration is less in the perfectly corrected lens than in the eye for both these aberrations work together. This must be remembered in connection with our later remarks. In the lower animals, spherical aberration is nearly absent. Their vision therefore is more periscopic, and therefore more like that of an optician's lens.

This defect can be avoided in the optician's

lens, but it exists in, and is a serious fault of, the human eye. It is, however, found in many opticians' lenses, and is one cause of false tonality.

Helmholtz considers the amount of spherical aberration unimportant as compared with astigmatism. Astigmatism is the result of imperfect centering of the cornea and lens. This defect is found in most human eyes.

Astigmatism prevents the eye seeing vertical and horizontal lines at the same distance perfectly clearly at once. The defect in centering also causes irregular radiation, so that, as Helmholtz says, "The images of an illuminated point as the human eye brings them to focus, are inaccurate." What is the effect of those defects on the "perfect image"? Dimness of *outline* and detail in the *textures* of objects seen.

The optician's lens is made of pure glass, the media of the human eye are not clear, but slightly turbid, so that Helmholtz says, "The obscurity of dark objects when seen near very bright ones depends essentially on this defect. The effect of this entoptic turbidity is to cause irradiation which has the same subjective effect on objects as aërial turbidity has on objective things. This defect is most apparent in the blue and violet rays of the solar spectrum; for then comes in the phenomenon of fluorescence to increase it." By fluorescence is meant the property which certain minutely divided substances possess of becoming faintly luminous, so long as they receive violet and blue light. The bot-

tles filled with solution containing quinine which look blue in the chemists' windows, owe their color to this fact, as also does the blueness of "London" milk. These defects, combined with entoptic impurities which are constantly floating about in the humours, all help to detract from the brightness and sharpness of the "perfect image."

The "blind spot" is that portion of the retinal field with no cones or rods, and therefore insensitive to light. This causes a gap in the field of vision. "This blind spot is so large that it might prevent our seeing eleven full moons if placed side by side, or a man's face at a distance of only six or seven feet," says Helmholtz. In addition to this, there are lesser gaps in the retinal field, due to the cutting off of light by the shadows thrown by the blood vessels. Any one who has examined the retinal field with an ophthalmoscope knows what this means.

In addition to this the *macula lutea* is less sensitive to weak light than other parts of the retina. The effect of all these imperfections is to blur and dull the perfect image. The serious defects due to the blind spot are not noticed, according to Helmholtz, because "we are continually moving the eye, and also that the imperfections *almost always affect those parts of the field to which we are not at the moment directing our attention.*" The italics are ours. Here, then, is another great difference between the eye and the optician's lens.

The focus of the eye in a passive state is

adjusted to the most distant objects. It focuses
for nearer objects by contracting the ciliary
muscle which pulls tight the zonule of Zinn and
so curves the crystalline lens. It can focus thus
up to within six inches of itself, but the changes
of focus are almost imperceptible to the eye
beyond twenty feet. Now a *theoretically* per-
fect eye might form perfect images of objects
at infinite distances when there were no inter-
vening objects. But as has already been shown,
the eye is theoretically imperfect, and its images
are not therefore perfect, and it could not form
theoretically perfect images, even if the atmos-
phere were pure ether and nothing else, for
there are other facts in nature which prevent
this; thus we cannot see a sharp image of the
sun with the naked eye on account of its dazzling
brightness.

The *fovea centralis* or central spot is a most im-
portant factor in the study of sight and art. For
though the field of vision of the two eyes is more
than 180 deg. laterally, and 120 deg. vertically,
yet the field of distinct vision is but a fraction
of this field, as we can all prove for ourselves
Now the field of distinct vision depends on the
central spots for the reason that the central spot
differs anatomically from the rest of the retina
by the absence of certain layers which we need
not specify here. The absence of these layers
exposes the retinal bacillary layer to the direct
action of light. Helmholtz says "all other
parts of the retinal image beyond that which
falls on the central spot are imperfectly seen,"

so that the image which we receive by the eye is like a picture minutely and elaborately finished in the centre, but only roughly sketched in at the borders. But although at each instant we only see a very small part of the field of vision accurately, *we see this in combination with what surrounds it, and enough of this outer and larger part of the field, to notice any striking object, and particularly any change that takes place in it.*" If the objects are small, they cannot be discerned with the rest of the retina, thus, to see a lark in the sky, Helmholtz says it must be focused on the central spot. Finally he says, " To *look* at anything means to place the eye in such a position that the image of the object falls on the small region of perfectly clear vision. This we may call *direct* vision, applying the term *indirect* to that exercised with the lateral parts of retina, indeed with all except the central spot." Again, he says, " Whatever we want to see we look at and see it accurately; what we do not look at, we do not as a rule care for at the moment, and so do not notice how imperfectly we see it." Taking the distance between the two central spots at 3 inches it follows from perspective that we must have an object six inches distant to see it, this, then, suggests the limits of the angle of view we may include from one point of sight. Now all this is most important in connection with art, as we shall show later; we must beg the student therefore to hold it fast.

It will be seen from all this that a perfect

periscopic image is never seen by the eyes of
man, though in some of the lower animals the
matter may be different. It is evident, too, for
many reasons, that the photographic lens and
the eyes do not show the same picture.

B. INTENSITY.

A quotation from Helmholtz will best illus-
trate this point. He says, " If the artist is to
imitate exactly the impression which the object
produces on our eye he ought to be able to dis-
pose of brightness and darkness equal to that
which nature offers. But of this there can be no
idea. Let me give a case in point. Let there
be in a picture-gallery a desert scene, in which
a procession of Bedouins, shrouded in white, and
of dark negroes, marches under the burning
sunshine; close to it a bluish moonlight scene,
where the moon is reflected in the water, and
groups of trees, and human forms, are seen to
be faintly indicated in the darkness. You know
from experience that both pictures, if they are
well done, can produce with surprising vividness
the representation of their objects; and yet in
both pictures the brightest parts are produced
with the same white lead, which is but slightly
altered by admixtures; while the darkest parts
are produced with black. Both being hung on
the same wall, share the same light, and the
brightest as well as the darkest parts of the two
scarcely differ as concerns the degree of their
brightness.

How is it, however, with the actual degrees of

brightness represented. The relation between the lightness of the sun's light, and that of the moon, was measured by Wollaston, who compared their intensities with that of the light of candles of the same material. He thus found that the luminosity of the sun is 800,000 times that of the brightest light of a full moon.

An opaque body, which is lighted from any source whatever, can, even in the most favorable case, only emit as much light as falls upon it. Yet, from Lambert's observations, even the whitest bodies only reflect about two-fifths of the incident light. The sun's rays, which proceed, parallel from the sun, whose diameter is 85,000 miles, when they reach us, are distributed uniformly over a sphere of 195 millions of miles in diameter. Its density and illuminating power is here only one forty-thousandth of that with which it left the sun's surface; and Lambert's number leads to the conclusion that even the brightest white surface on which the sun's rays fall vertically, has only the one hundred-thousandth part of the brightness of the sun's disk. The moon, however, is a gray body, whose mean brightness is only about one-fifth that of the purest white.

And when the moon irradiates a body of the purest white on the earth, its brightness is only the hundred-thousandth part of the brightness of the moon itself; hence the sun's disk is 80,000 million times brighter than a white which is irradiated by the full moon.

Now, pictures which hang in a room are not

lighted by the direct light of the sun, but by
that which is reflected from the sky and clouds.
I do not know of any direct measurements of
the ordinary brightness of the light in a picture
gallery; but estimates may be made from known
data. With strong upper light, and bright light
from the clouds, the purest white on a picture
has probably 1-20th of the brightness of white
directly lighted by the sun; it will generally be
only 1-40th, or even less. Captain Abney's ex-
periment put this at a lower figure, but this in
no way affects the argument.

Hence the painter of the desert, even if he
gives up the representation of the sun's disk,
which is always very imperfect, will have to
represent the glaringly lighted garments of his
Bedouins with a white which, in the most favor-
able case, shows only the 1-20th part of the
brightness which corresponds to actual fact. If
he could bring it, with its lighting unchanged,
into the desert near the white there, it would
seem like a dark grey. I found, in fact, by an
experiment, that lamp-black, lighted by the sun,
is not less than half as bright as shaded white in
the brighter part of a room.

On the picture of the moon the same white
which has been used for depicting the Bedou-
ins' garments must be used for representing
the moon's disk, and its reflection in the water;
although the real moon has only one-fifth of
this brightness, and its reflection in water
still less. Hence white garments in moonlight,
or marble surfaces, even when the artist gives

them a gray shade, will always be ten to twenty times as bright in his picture as they are in reality.

On the other hand, the darkest black which the artist could apply would be scarcely sufficient to represent the real illumination of a white object on which the moon shone. For even the deadest black coatings of lamp-black and black velvet, when powerfully lighted, appear gray, as we often enough know to our cost, when we wish to shut off superfluous light. I investigated a coating of lamp-black, and found its brightness to be about one-hundredth that of white paper. The brightest colors of a painter are only about one hundred times as bright as his darkest shade.

The statements I have made may appear exaggerated. But they depend upon measurements, and you can control them by well-known observations. According to Wollaston, the light of the full moon is equal to that of a candle burning at a distance of twelve feet. Now, assume that you suddenly go from a room in daylight to a vault perfectly dark, with the exception of the light of a single candle. You would at first think you were in absolute darkness, and at most you would only recognize the candle itself. In any case, you would not recognise the slightest trace of any objects at a distance of thirteen feet from the candle. These, however, are the objects whose illumination is the same as that which the moonlight gives. You would only become accustomed to

the darkness after some time, and you would
then find your way about without difficulty.

If now, you return to the daylight, which be-
fore was perfectly comfortable, it will appear
so dazzling that you will, perhaps, have to close
your eyes, and only be able to gaze round with
a painful glare. You see thus that we are con-
cerned here not with minute, but with colossal,
differences. How now is it possible that, under
such circumstances, we can imagine there is
any similarity between the picture and reality ?

Our discussion of what we did not see at first,
but could afterwards see in the vault, points to
the most important element in the solution; it
is the varying extent to which our senses are
deadened by light; a process to which we can
attach the same name, fatigue, as that for the
corresponding one in the muscle. Any activity
of our nervous system diminishes its power for
the time being. The muscle is tired by work,
the brain is tired by thinking, and by mental
operations; the eye is tired by light, and the
more so the more powerful the light. Fatigue
makes it dull and insensitive to new impres-
sions, so that it appreciates strong ones only
moderately, and weak ones not at all.

But now you see how different is the aim of
the artist when these circumstances are taken
into account. The eye of the traveler in the
desert, who is looking at the caravan, has been
dulled to the last degree by the dazzling sun-
shine; while that of the wanderer by moonlight
has been raised to the extreme of sensitiveness.

The condition of one who is looking at a picture differs from both the above cases, by possessing a certain mean degree of sensitiveness. Accordingly, the painter must endeavor to produce by his colors, on the moderately sensitive eye of the spectator, the same impression as that which the desert, on the one hand, produces on the deadened, and the moonlight, on the other hand, creates on the untired eye of its observer. Hence, along with the actual luminous phenomena of the outer world, the different physiological conditions of the eye play a most important part in the work of the artist. What he has to give is not a mere transcript of the object, but a translation of his impression into another scale of sensitiveness, which belongs to a different degree of impressibility of the observing eye, in which the organ speaks a very different dialect in responding to the impressions of the outer world.

In order to understand to what conclusions this leads, I must first explain the law which Fechner discovered for the scale of sensitiveness of the eye, which is a particular case of the more general *psycho-physical law* of the relations of the various sensuous impressions to the irritations which produce them. This law may be expressed as follows: *Within very wide limits of brightness, differences in the strength of light are equally distinct, or appear equal in sensation, if they form an equal fraction of the total quantity of light compared.*

Thus, for instance, differences in intensity of

one-hundredth of the total amount can be recog-
nized without great trouble, with very different
strengths of light, without exhibiting material
differences in the certainty and facility of the
estimate, whether the brightest daylight, or the
light of a good candle be used."

Herein, then, are contained the limits with
which we can render true, and the physiological
reasons why we can render a fairly true impres-
sion of a scene in nature by painting, but a far
less true one by photography.

The only constant factor, then, is the *ratio of
luminous intensities*,— that is, the picture must
be as true as possible in relative tones or values.
Obviously a picture of bright sunlight should
look brighter in a moderately lighted room than
the surrounding room, that is, its first impres-
sion on the observer should be as if he were
looking at a landscape beyond the walls, through
the frame.

From these remarks it will be seen how utterly
impossible it is to render *truly* a bright sunlight
scene, for if the values be true, starting from
the top of the scale, the highest light, when you
get to the middle tints, they are too black
already, and the picture is out of tone and false.
Obviously the right way is to start from the
lower end of the scale, the *darks*, and get them
as true as possible, and let the lights take care
of themselves; but more of this anon.

D. Color.

As photographers, the matter of color exer-

cises us but indirectly, still the subject should be understood, on account of its bearing on painting. "Color perception," says Le Conte, "is a single perception, and irresolvable with any other. It must, therefore, have its basis in retinal structure," it is, in fact, an internal sensation, and has no objective or external existence.

Helmholtz divides the vibrations of ether known as light into three degrees. He says the longest and shortest rays do not essentially differ in any other physical property, except that we distinguish them from the intermediate waves. Thus the ear can receive at once many waves of sound or notes, and they remain distinct, but notes of color do not keep distinct in the same way, " so that the eye is capable of recognizing few differences in quality of light," says Helmholtz, and can only perceive the elementary sensation of color by artificial preparation. He also says, the only bond between the objective and subjective phenomena of color may be stated as a law thus, " Similar light produces under like conditions a like sensation of color. Light, which under like conditions, excites unlike sensations of color is dissimilar; " what we want in art, then, is the *appearance* of the phenomena. The illumination of the sun's rays cannot be weakened without at the same time weakening their heating and chemical action; this is a point to be remembered in exposure.

Color is, of course, excited by the length of the waves and their frequency, red being the longest and slowest, and they diminish in length and in-

crease in frequency in the order of the spectrum
through orange, yellow, green, blue, indigo, to
the shortest waves, which produce the effect of
violet, the whole combined forming white. Now
Hering has shown that there are only four
primary color sensations, though he at one time
included black and white, thus making six. The
four are red, yellow, green, and blue, which are
reduced by him to two complementary colors,
red and green, and yellow and blue. In our
present state of knowledge the Young-Helm-
holtz theory of three primary color sensations
for red, green, and blue seems preferable as a
working hypothesis, though it seems incompati-
ble with anatomical and physiological facts.

All objective differences between color, may
be reduced to differences of hue, difference of
purity, and difference of brightness. These are
the three color constants.

By tone, or hue, we mean in fact difference of
color as in the spectral colors. Purity is greatest
in the pure colors of the spectrum, and becomes
less in proportion as they are mixed with white
light. A pure or full color has no admixture of
white. All compound colors are less full than
the simple hues of the spectrum.

Brightness or luminosity is strength of light,
or amount of illumination. It is measured by
the total amount of light reflected to the eye.
A pure and bright color is full or saturated.

In nature black and white must be included
among the primary colors when *quality* is spoken
of, as light acts on black and white.

All differences of hue, therefore, are the re-
sult of combinations in different proportions of
the four primary colors.

Among the defects of the eye in seeing color,
Helmholtz says, "All are red blind at the inner-
most portion of the field of vision, all red colors
appear darker when viewed indirectly."

The furthest limit of visible field is a narrow
zone, in which all distribution of color ceases,
and there only remain differences of brightness.
Probably those nervous fibres which convey im-
pressions of green light are alone present in this
part of the retina. The yellow spot makes all
blue light appear somewhat darker in the centre
of the field.

All these inequalities are known and more or
less rectified by constant movement.* As the
eye becomes fatigued by bright light, so that it
cannot at first answer to delicate stimulus, so it
can become partially fatigued for certain colors.

Fatigue weakens the apparent illumination of
the entire field of vision, hence the propriety of
giving the impression as we first see it. Another
reason for doing this being that as the eye neces-
sarily focuses the various parts to paint these, it
gradually sees more and more detail in these
parts, and so the painter is always in danger of
losing breadth. We have not this danger to
contend with as we do our pictures at one stroke,
but we can realize the fault of overloading
with detail by careless focusing.

* Vide, pp. 101.

The color of illumination of a picture, too, varies greatly by effect of local color.

What is constant in the color of an object is not the brightness and color of the light which it reflects, *but the relation between the intensity of the different colored constituents of this light on the one hand, and that of the corresponding constituents of the light which illuminates it on the other.* For example, white paper in full moonlight is darker than black satin in daylight, or a dark object with the sun shining on it reflects light of exactly the same color, and perhaps the same brightness, as a white object in shadow. Grey in shadow looks like white.

Brightness of local color diminishes with the illumination or as the fatigue of the retina is increased. In sunshine, local colors of moderate brightness approach the brightest, whereas in moonlight they approach the darkest. Pictures to be seen in daylight do not admit of difference of brightness between sun and moon. As colors increase in brightness, red and yellow become apparently stronger than blue. Painters make yellow tints predominate when representing landscape in full sunshine, while moonlight scenes are blued. Helmholtz says: "Differences of color which are actually before our eyes are more easily apprehended than those which we only keep in memory, and contrast between objects which are close to one another in the field of vision are more easily recognized than when they are at a distance. All this contributes to the effect. Indeed, there are

a number of subordinate circumstances affect-
ing the result which it would be very interest-
ing to follow out in detail, for they throw
great light upon the way in which we judge
of local color; but we must not pursue the
inquiry further here. I will only remark that
all these effects of contrast are not less inter-
esting for the scientific painter than for the
physiologist, since he must often exaggerate the
natural phenomenon of contrast in order to pro-
duce the impression of greater varieties of light
and greater fulness of color than can be actually
produced by artificial pigments."

Again, when turbidity is composed of fine
particles its appearance is blue, as the mists
seen in autumn hanging round coverts, but it is
whiter than the aerial blue because of the color
of the covert behind. When this turbidity is
absent the colors are brighter, hence the fierce
blue on bright sunshiny days with easterly
winds. This matter of turbidity must not be
forgotten in portrait work; it is this which helps
to give relief, hence the absurdity of all pho-
tographers' devices, the object of which is to
minimize this turbidity. In addition to these is
the ever-changing effect of atmosphere on color,
that subtle medium with which the enchantress
Nature produces ever-changing effects. In
short the rule of aerial perspective is that atmos-
phere tends to make all distant dark objects
blue-gray, whilst it either warms distant bright
objects or leaves them unaltered.

Another point which must not be forgotten is

that with bright illumination bright objects be-
come more like the brightest, and with feeble
illumination dark objects become more like the
darkest. This is a very important matter, for it
means that in bright sunshine the lightest greys
are lost in white, whilst in dull weather the
darkest greys are lost in black, hence the falsity
of having deep blacks in brightly-lighted land-
scapes, and as has been shown, these are untrue,
and the result of ignorance and of faulty man-
ipulation. As Helmholtz has it, " The difference
of brightness and not absolute brightness ; and
that the differences in them in this latter respect
can be shown without preceptible incongruity if
only their graduations are imitated with expres-
sion."

E. Binocular Vision—Psychological Data.

Single Image.

The remarks already made would apply
equally well to man if he were a one-eyed animal,
but we find there are other considerations to
take into account since man is two-eyed. Now
the phenomena of binocular vision cannot be
treated of with such accuracy as the physical and
physiological facts already discussed. It is ob-
vious there is a common binocular field of view
for the two eyes. Now Dr. Le Conte shows us
that we see all objects double, except under cer-
tain conditions. When we look directly at any-
thing, then we see it clearly, but all things nearer
to us than the object looked at and beyond it, are

seen double, or blurred and indistinct. This is the case in life, as can be proved, unless we contract diplopia from drink or drugs.

There are, besides, two adjustments, the focal and the axial, the one an adjustment for distant vision, the other for single vision, and connected with these is the adjustment of the pupil, which contracts and expands, not only to light, but also to distance and nearness of the object. Therefore, three adjustments take place when we look at anything. Thus we see our perfect image can only exist in one place at once, that all between the eye and object and beyond the object is indistinct, and that the further off the object is the more luminous does it appear. Two objects, too, may be seen as one. We will now proceed to discuss in detail how the eyes affect our perception of objects.

PERSPECTIVE.*

Some years ago Mr. Goodall (a painter) and I made some experiments with the object of comparing a monocular perspective drawing with the drawing of a properly corrected photographic lens. We found that under similar conditions they were alike, as was, of course, *a priori*, probable. Since that I published a short paper with an experiment, which threw grave doubts upon the truth of perspective drawing

* When we use the term perspective drawing, we mean a mathe matical drawing of various objects in the field of vision (*i e.*, angular measurements), as received on a glass plate (ordinary perspective drawing) or upon the screen of a camera, for, under like conditions, they are, as is well known, identical.

when compared with what the eyes really see.

We now offer a series of propositions, experiments, proofs and deductions, which we venture to think are of fundamental importance to all artists, as well as to physiologists and psychologists.

Our experiments and deductions will show that for scientific reasons the accepted rules of monocular perspective are likely to mislead the artist, and prove the fallacy of photographic and all mechanical methods of measurement for artists who wish to draw things as they appear.

Proposition A.—The eye does not constitute a symmetrical lens, the† top and bottom portions being different. That portion of the eye which perceives distance and distant objects (*i.e.*, those above the ground), sees the objects on a larger scale than the portion of the eye which views the foreground or nearer objects, therefore our impression of nature is not what we get with a mathematically correct perspective drawing, or the drawing of an aplanatic photographic lens. That is, a perspective drawing surprises us by making the foreground objects look larger in proportion to the distance. Also we see a larger arc with the lower half of the eye than with the upper.

Proof 1.—That we do not see the same amount with both halves of the eye (upper and lower) is proved by the observer lying on his back and

† We have ignored for the sake of simplicity the optical law of inversion of the image on the retina ; when that is considered, the terms "upper" and "lower" must be merely interchanged.

looking straight up at the sky, when he will find that the field of vision of the upper half is much more limited than the space seen by the lower half of the eye. This holds for either one eye alone or for both when used together.

The proof is completed when we stand with our back to the landscape, bend down and look between our legs. Here the fields are inverted, and consequently the distance appears small and far off, and gives much more the appearance of a sharp photographic rendering of the scene. This peculiar effect has long been well known, and it has puzzled a good many observers, but hitherto no valid scientific explanation has been offered.

Proposition B.—We think this may be the result of the naturally selective action of the retinal nerves. It has been to our advantage in the struggle for life to see all the objects near to us and close around clearly, and to compass as wide a field as possible. It has also been to our advantage in the struggle for life for certain parts of nerves to try and draw distant objects nearer and to enlarge them, so that special functions may have developed purely by natural selection.

Deduction 1.—That mathematical perspective drawing gives quite a false impression of what we see when using *either one of our eyes or both*.

That such is actually the case we will now endeavor to prove, at the same time still further supporting our contention that the upper and

lower portions of the eye see objects in different perspectives.

Proof 1.—Let the observer select a church tower or tall chimney for experiment. If the sides are parallel the object will *appear* to his eye wider at the top than at the bottom when he stands facing it at the distance of the tower itself and looks steadily at its center. These experiments are best made in the diffused light of evening. The experimenter must not move his eyes up and down the tower from top to bottom, and so *measure or correct* his impressions, but he must look steadily at the center of the tower and take his pure sensuous impressions. As most towers and chimneys do taper considerably the result the observer gets when close to them is that they *look parallel* or nearly so. This fact was, no doubt, felt by the architects of the Parthenon, and it has never been known why they built the columns leaning inwards, a little out of the perpendicular. That they were built out of plumb has been proved by measurement, that they *look* parallel is well known, and the reason of this we venture to find in our proposition.

Proof 2.—A very simple proof is to look about the middle of a doorway or door—it will be felt that the door or doorway is wider at the top than the bottom. The same holds with books in a book-case.

Proof 3.—Cut two slips of paper.

(*a*) 8 inches long by 2 inches wide.

(*b*) 8 inches long by 2 inches by $1\frac{7}{8}$ inches wide, so that it tapers $\frac{1}{8}$ of an inch.

If the parallel slip (*a*) be held upright 8 inches from the eye (its own length) and looked at straight in the center—the center of the paper being opposite to the eye—the paper will appear slightly wider at the top than at the bottom, the same proviso of not correcting the pure impression by measurement (looking up and down it) holding, as we pointed out in the case of the church tower.

If the observer now takes the tapering slip (*b*) and holds it narrow end upwards, looking at it in the same way, it will *appear* parallel ; if he hold it wide end upwards, it will appear much wider at the top than at the bottom.

This holds equally true if the experiments are made either with one eye or both—showing that binocular vision has no effect on the impressions.

Proof 4.—Another interesting experiment is to place a penny upright on a table and a halfpenny 18 inches behind it and a little to the right or left of the penny. The eye must look *over* the penny at the halfpenny, so that the penny is a foreground object and the halfpenny a distant object. If the observer now looks steadily at the halfpenny, at the same time seeing the penny, he will find the impression is that the halfpenny looks nearly as large as the penny.

Proposition A and Proofs deal mainly with what we would describe as *Vertical vision*—that is, with the variations in the appearances of objects when placed one over the other, as in a

vertical column, or with objects at a distance as compared with objects in the foreground.

But within the radius where binocular vision acts (calculated by Mr. T. R. Dallmeyer to be 60 yards), new and important variations occur. These properties we shall consider under the term of horizontal vision.

Proposition.—Within the limits where binocular vision is effective (say normal vision, 8 inches to 60 yards) objects *appear smaller when they are compared with objects beyond the binocular limit*—that is, they appear smaller as compared with drawings as given by monocular or mathematical perspective.

An experiment to practically bring the effect of the binocular vision variations entering into the matter may be made as follows:

Take the tapering slip of paper aforesaid (*b*) and place it between the two eyes, the wide end resting upon the bridge of the nose, the slip being inclined at an angle of 30° with the horizon. The result is that the paper vanishes *towards* the eyes—diametrically an opposite result to what perspective would lead us to expect. This phenomenon still holds if the paper be gradually moved away from the eyes and held at arm's length, but in the same plane.

Proof.—Place a book at a distance of 6 feet from the eyes. Then proceed to measure the width of the book with a pencil (one eye being closed), as a draughtsman draws objects by monocular perspective, and then opens the other eye and measure the width of the book with

both eyes, the binocular measurement will be found to be smaller than the monocular measurement. If the height of the book be measured in the same way, there will be no difference in the result obtained with one or both eyes.

But more convincing is Proof 2. Wafer a square sheet of white paper (say 8 inches square) on the wall or on a window, 6 feet from the observer, and look at it. The impression given will be that it is larger vertically than it is horizontally. This explains the old trick of marking off the height of a tall hat against a wall, as a rule everybody places the mark too high—the reason is now explained.

Still another proof. Stand a halfpenny and penny on the table, as directed in the previous experiment. Now place the eyes on the same level as the plane of the table and observe. The result will be exactly the reverse to that previously obtained. That is, when looking directly at the halfpenny, at the same time looking (indirectly) at the penny, the penny will appear the larger, and *vice versa* when looking directly at the penny and indirectly at the half-penny, the halfpenny will appear nearly as large as the penny.

Another everyday proof. Let a person sit in one end of a long punt with parallel sides, and look at the other end—it will look to him to be wider than where he is, and yet its sides will by perspective laws vanish quickly away from him.

These proofs show the effect of binocular

vision, which is to increase the appearance of height and to narrow the appearance of breadth, consequently it makes objects appear taller than a perspective drawing would do.

Deduction.—The reason we get a different impression of relative sizes of objects by normal vision from that given by mathematical perspective drawings and photographs, is that the combination of these properties of Vertical and Horizontal visions gives quite a different result to that of perspective drawings.

Final.—Having shown how we see forms, it only remains to say that a mathematical perspective drawing or the drawing of an aplanatic photographic lens does not give forms as we see them. They are altogether false to the visual impression of the proportions of things and therefore give a wrong idea of the original scene. On the other hand, a perspective drawing or correct photograph gives the *actual facts* scientifically, *i.e.*, the pillars of the temple as leaning, the paper in experiment as *square*. All such drawings are, therefore, purely scientific diagrams, and artists, who wish to render what they see, must not rely upon them.

Aerial perspective is the perspective due to the scattering of light by ærial turbidity, for the atmosphere contains floating particles of matter; as the object recedes the curtain of turbidity becomes thicker and distant dark objects grow dimmer and bluer. This turbidity I believe makes the objects *appear* closer together, just as two dots joined by a line *appear*

nearer together. If this be so, there is another reason why in nature objects appear differently to the eye than they would in a photograph, and why sharp, clear, bright scenes in photographs often appear so scattered. Also it is evident if every plane be *sharply focused* dull and bright objects in the middle distance and distance will be brighter or duller than they appear to the eye, which is another reason why some object should be thrown a little out of focus in a landscape photograph.

Thus artistic vision depends upon vivid visual impressions, and it is the artist's duty, as M. Helmholtz says, "to find out the more predominant elements and relations of the visual impressions that determine our conception of what is seen." We will briefly analyze them.

LIGHT.

That must be given truthfully first of all. We must be true in tone in our practice before all things. We have spoken of these things elsewhere.

FORM.

Since on a plane surface we can only get a faithful perspective view which is stationary, so long as the point of sight (eye) is stationary, it follows an artist can really only get one picture from one point of sight, and directly he alters that point of sight he has a new picture. This causes painters much trouble, but it causes us none, if we work within the legitimate con-

ventional limits of perspective and use our lenses
correctly. But it will be said by moving our two
eyes we estimate distance and the size of objects,
and our eyes give us two pictures appearing as
one. True, and herein again is another radical
difference between the eye and the lens. We
feel the displacement of objects as we approach
a picture (less on approaching a *large picture*),
and this accounts for the effect of violent per-
spective, for in small pictures the want of the
second representation for the other eye is too
marked. Hence, perspective drawings, seen
from a point of sight that does not really occur,
appear true. Therefore, owing to this imperfect
action of binocular vision, there is always an
incongruity between the picture and reality, so
the painter gives depth by subordinate means—
i.e., by the relative focal sharpness of planes, by
the direct intelligibility of the work so that it
works quickly on the spectator by the true per-
spective rendering of different objects and their
varying sizes, and by truth of tone and modeling,
by the focusing of light, and the mutual reflec-
tions of surfaces on each other, and ærial per-
spective and coloring. Of these conditions (some
accidental) the true rendering of tone, focus, and
ærial perspective, are the most important. And
so the painter makes the unity of a picture more
favorable than any photographer ever can and
gives a much truer impression of a landscape
than a camera can.

Contrast.

Another great mental aid to the desired effect is contrast. Brightness appears changed by the proximity of the mass of another tone, so that the original appears darker by approximating a light shade and *vice versa*. Successive contrasts are obtained, as Helmholtz says, by the previously fatigued retina passing over them. Another reason then why the planes should not all be rendered of equal sharpness for then there is a loss of contrast and, therefore, of solidity, and the fatigued retina wants a subdued and delicate distance to dwell upon, and it responds more quickly to that stimulus after looking at the principal object. By careful, artistic focus, this contrast is emphasized. In short the *subjective phenomena must be represented in the picture*, and no photographer can do that. For example, the eye irradiates light owing to the turbidity found in its media, and irradiation sheds its halo uniformly over far and distant objects, the photographic lens does this to a far more limited extent. But we must use our lens and chemicals to render this irradiation. It has been said that if we run our eyes over a landscape, we instantaneously focus the various planes; this is not so if they are any distance from us and any distance apart, for then there is a distinct and appreciable time taken to effect this alteration and physiology clearly explains why this is so. To do this, too, implies taking a new point of sight for every plane; that the eye can do, for it really consists of a *series* of

lenses; but the photographer has but *one* lens, and if he wants new points of sight or new pictures, in fact, he has to use his lens afresh. We cannot get beyond our limitations, and even painters are limited here by conventional 'laws'; they may only take one point of sight for one picture, because they, too, are working on a plane surface. As Professor Helmholtz says, complete *apprehension* of external objects by the sense of sight is only possible when we direct our attention to *one part after another* of the field of vision, in the manner I have described—that is, new points of sight must be taken each time, which would necessitate a series of pictures and several lenses for us, a compromise for the painter. All art is limited, but pictorial art being a translation on to a plane surface of subjective sensation is limited by the very organs we see with and partially the conventional laws of perspective that have grown out of them—that is, if we pretend to paint anything as it is seen.

On these data and within these limits, then, must we work, and here we append a few general principles deduced from these data, which must guide us in our work.

Art Principles Deducted from the Data Cited.

We have shown why the human eyes do not see nature exactly as she is, but see instead a number of signs which represent nature, signs which the eyes grow accustomed to, and which from habit we call nature herself. We shall

now discuss the relation of pictorial art to nature, and shall show the fallacy of calling the most scientifically perfect images obtained with photographic lenses artistically true. They do not give a true impression of the scene, as we have shown, and shall again show, but what is artistically more true is really what we have all along advocated ; that is, that the photographer must so use his technique as to render, *as far as possible*, a true impression of the scene. The great heresy* of "sharpness" has lived so long in photographic circles because, firstly, photography has been practiced by scientists, and, secondly, by unphilosophical scientists, for all through the lens has been considered purely from the physical point of view, the far more important physiological and psychological standpoints being entirely ignored, so that but one-third of the truth has been hitherto stated.

To begin with, it must be remembered that a picture is a representation on a plane surface of limited area of certain physical facts in the world, arouud us, for abstract ideas cannot be expressed by painting. In all the works in the world the painter, if he has tried to express the unseen or the supernatural, has expressed the unnatural. If he paint a dragon, you find it is a distorted picture of some animal already existing ; if he paint a deity, it is but a kind of man after all. No brain can conjure up and set down on paper a monster such as has never existed, or in which there are no parts homolo-

* This heresy I claim that this book hushed for ever. 1897.

gous with some parts of a living or fossil creature. We defy any man to draw a devil, for example, that is totally unlike anything in existence. All so-called imaginative works fall then within the category of the real, for they are in certain parts real because they are all based on realities, even though they may be utterly false to the appearance of reality. By this we mean that an ideal dragon may be based on existing animals; his form may be a mixture of a cobra, saurian, and a mammal, as is often the case ; so far it may be real, but then the way in which it is painted must be false, for the natural effect of light and atmosphere on the dragon may and probably will be ignored, for there is no such animal to study from. The modern pre-Raphaelites are good examples of painters who painted in this way; they painted details, they imitated the local colors and textures of objects, but for all that their pictures are as false in impression as false can be, for they neglected those subtleties of light and color and atmosphere which pervade all nature, and which are as important than form. Children and savages make this same error ; they imitate the local color, not the true color as modified by light, adjacent color, and atmosphere. But what the most advanced thinkers of art in all ages have sought for is the rendering of the true impression of nature.

Proceed we now to discuss the component parts of this impression.

When we open our eyes in the morning the

first thing we see is light, the result of those all-pervading vibrations of ether. The effects of light on all the objects of nature and on sight have been dealt with in the beginning of this chapter, it only remains, therefore, to deduce our limits from these facts. In the first place, from what has been said in that section, it is evident we cannot compete with painting, *e.g.*, we are unable to pitch our pictures in so high a key as the painter does, and how limited is his scale has been shown, but by the aid of pigments he can go higher than we. It has been shown, too, that it is impossible to have the values correct *throughout* a picture, for that would make the picture too black and untrue in many parts. This fact shows how wrong are those photographers who maintain that every photograph should have a patch of pure white and a patch of pure black, and that all the lighting should be nicely graduated between these two extremes. This idea arose, no doubt, from comparing photography with other incomplete methods of translation, such as line engraving, or from following the old ideas of correct *values* throughout the scale : an impossibility.

The real point is that *the darks of the picture shall be in true relation*, and the high lights must take care of themselves. By this means a truer tone is obtained throughout. Now, to have these tones in true relation, it is of course implied that the local colors must be truly rendered, yellow must not come out black, or blue

as white, therefore it is evident that for highly
colored objects color-corrected plates are neces-
sary. But such plates are useless when the
quantity of silver in the film is little, for the
subtleties of delicate tonality are lost, which are
not compensated for by gain in local color, and
this is a point the makers of orthochromatic
plates must take into consideration. But in
rendering the pale and evanescent colors of a
landscape we are of the opinion that truer
values are to be got on an ordinary plate than
on orthochromatic plates, excepting only very
highly colored objects as yellow flowers. It will
be seen now why photographs of brightly colored
objects on uncorrected plates (even when the
greatest care and knowledge in using them is
exercised), are not, as a rule, perfectly successful,
and why the ordinary silver printing-paper is
undesirable,for it exaggerates the darkness of the
shadows,a fatal error. False tonality destroys the
sense of atmosphere; in fact, for the true render-
ing of atmosphere,a photograph must be relative-
ly true in tone; in other words, the relative tones,
in shadow and half shadow, must be true. If a
picture is of a bright, sunlit subject, brilliancy
is of course a necessary quality, and by brilliancy
is *not* meant that "sparkle" which so delights
amateurs. Of course, the start of tone is natur-
ally made from less deep shadows, when the
picture is brightly lighted, for the black reflects
light, and all the shadows are filled with reflected
light. It will be seen, therefore, that it is of
paramount importance that the shadows shall

not be too black, that in them shall be light, as
there always is in nature—more, of course, in
bright pictures, less in low-toned pictures—that
therefore the rule of "detail in the shadows" is
in a way a good rough-and-ready photographic
rule. Yet photographers often stop down their
lens and cut off the best modeling light, as well
as valuable aberrations, at the same time sharp-
ening the shadows and darkening them, and
throwing the picture out of tone. It cannot be
too strongly insisted upon that "strength" in a
photograph is not to be judged by its so-called
"pluck" or "sparkle," but by its subtlety of
tone, its relative values in shadow and middle
shadow, and its true textures and modeling.
Photographers have been advised by the mis-
taken to spot out the "dotty high lights" of an
ill-chosen or badly-rendered subject to give it
"breadth." Such a proceeding, of course, only
increases the falsity of the picture, for the high
lights, as we have shown, are never high enough
in any picture, and if a man is so unwise as to
take a picture with "spotty lights," he is only
making matters worse by lowering the high
lights, which are already not high enough. This
does not, of course, apply to the case where a
single spot of objectionable white fixes the eye
and destroys harmony, but to the general habit
of lowering the high lights in a "spotty" photo-
graph. Spotty pictures, in art as well as in
nature, are abominations to a trained eye, and
it is for that very reason that such subjects are
more common among photographers who are

untrained in art matters than in the works of
even third-rate painters. The effect of the
brightest sunlight in nature, for reasons ex-
plained, is to lessen contrast and give the
subject breadth, and the effect of a sharply-
focused, stopped-down photograph is to abnor-
mally *increase* contrast in the unseparated planes
and flatten the modeling, and thus falsify the
tonality. As the tendency of "atmosphere"
is to grey all the colors in nature more or less,
and of a mist to render all things grey, it
follows that "atmosphere" in all cases helps to
give breadth by lessening contrast. As shown
in the previous chapter, this ærial "turbidity,"
by which is meant atmosphere, takes off from
the sharpness of outline and detail of the image,
and the farther off the object is, the thicker
being the intervening layer of atmosphere, the
greater is the turbidity *cæteris paribus,* therefore,
from this fact alone, objects in different planes
are not and should not be represented equally
sharp and well-defined. This is most important
to seize—as the* prevalent idea among photog-
raphers seems to be that all the objects in all
the planes *should be sharp at once,* an idea which
no artist could or ever did entertain, and which
nature at once proves untenable. The atmo-
sphere in the main rules the general appearance
of things, for if this turbidity be little, objects
look close together, and under certain conditions
are poor in quality.

* This and much other matter now no longer obtains, as many
photographers have adopted and practice the original teachings of this
book.

In addition to tone and atmosphere, he must consider "drawing;" but by choosing a suitable lens, and using it correctly, our drawing is done as well as it can be done by an instrument, so that we need not regard this matter of form. A minor aid to rendering depth is the illumination of the object, a lateral illumination giving the greatest idea of relief, but the photographer should be guided by no so-called "schemes of lighting," because, for more important reasons, it may be advisable to choose a subject lighted directly by the sun, or silhouetted against the sun. All depends on what is desired to be expressed. For example, a photographer may wish to express the sentiment and poetry of a sunset behind a row of trees. Is he to consider the minor matter that there will be little relief, and it is not a good "scheme of lighting"? No, certainly not, otherwise he must forego the subject. Nature ignores all such laws. The only law is that the lighting must give a relatively true illusion of the subject expressed, and that a landscape must not be lighted by two or more suns. In portrait work, even, it must be remembered that the aerial lighting must stand out against the background, for in all rooms there is a certain amount of turbidity between us and distant objects.

The reason we prefer pictures which are not too bright lies in the fact that the eye cannot look long at very bright paintings without tiring. As a physical fact, too, the most delicate modeling and tonality is to be obtained in a

medium light. From what has been previously said, it will now be understood that a picture should not be quite sharply focused in any part, for then it becomes false; it should be made just so sharp as will best give the *appearance* of nature from one point of sight, *and no sharper*, for it must be remembered that the eye does not see things as sharply as the photographic lens, for the eye has faults due to dispersion, spherical aberration, astigmatism, ærial turbidity, blind spot, irradiation, etc., and beyond twenty feet it does not adjust perfectly for the different planes. All these slight imperfections make the eye's visions theoretically more imperfect than that of the optician's lens, even when objects in one plane only are sharply focused, therefore, except in very rare cases, which will be touched upon elsewhere, the chief point of interest should be slightly—very slightly—out of focus, while all things, out of the plane of the principal object, it is perfectly obvious, from what has been said, should also be slightly out of focus, not to the extent of producing *destruction of structure* or fuzziness, but sufficiently to keep them back and in place. For, as we have been told, " to look at anything means to place the eye in such a position that the image of the object falls on the small region of perfectly clear visions, and whatever we want to see, we look at, and see it accurately; what we do not look at, we do not, as a rule, care for at the moment, and so do not notice how im-

perfectly we see it." Though this does not in all cases hold as a hard and fast rule, such usually is the case, as has been shown, for when we fix our sight on the principal object or *motif* of a picture, binocular vision represents clearly by direct vision only the parts of the picture delineated on the points of sight. The rule in focusing, therefore, should be, focus for the principal object of the picture, but all else must not be sharp; and even that principal object must not be as perfectly sharp as the optical lens will make it. It will be said, but in nature the eye wanders up and down the landscape, and so gathers up the impressions, and all the landscape in turn appears sharp.* But a picture is not "all the landscape," it should be seen at a certain distance, twice the breadth of the picture being the rule, and the observer, to look at it thoughtfully, *if it be a picture*, will settle on a principal object, and dwell upon it, and when he tires of this, he will want to gather up *suggestions* of the rest of the picture. If it be a common-place photograph taken with a wide-angle lens, say, of a stretch of scenery of equal value, as are most photographic landscapes, of course the eye will have nothing to settle thoughtfully upon, and will wander about, and finally go away dissatisfied. But such a photograph is unsatisfactory. Hence, it is obvious that panoramic effects are not suitable for art, and the angle of view included in a picture should never be large. It might be argued

* This objection has been fully answered elsewhere.

from this, that Pseudo-Impressionists who paint
the horse's head and top of a hansom cab
omitted all suggestions are correct, since the
eye can only see clearly a very small portion of
the field of view at once. We assert, no, for if
we look in a casual way at a hansom cab in the
streets, we see only *directly* the head of the
horse and the top of the cab, yet, indirectly,
that is, in the retinal circle around the *fovea
centralis* we have far more suggestion and feel-
ing of horse's legs than the eccentricities of the
Pseudo-Impressionist school give us, for in that
part of the retinal field indirect vision aids us.
The field of indirect vision must be *suggested*
in a picture, but subordinated. But we shall
go into this matter later on, here we only wish
to establish our principles on a scientific basis.
Afterwards, in treating of pictorial questions, we
shall simply give our advice, presuming the
student has already studied the scientific data
on which that advice is based. All good art
has its scientific basis. Sir Thomas Lawrence
said, " Painting is a science, and should be pur-
sued as an inquiry into the laws of nature.
Why, then, may not landscape painting be con-
sidered as a branch of natural philosophy, of
which pictures are but experiments?"

Some writers who have never taken the trouble
to understand even these points, have held that
we admitted fuzziness in photography. Such
persons are laboring under a great misconcep-
tion ; we have nothing whatever to do with any
" fuzzy school." Fuzziness, to us, means *destruc-*

tion of structure. We do advocate broad sug-
gestions of organic structure, and artistic focus
of relative planes, which is a very different
thing from destruction, although, there may
at times be occasions in which patches of
"fuzziness" will help the picture, yet these are
are rare indeed, and it would be very difficult
for anyone to show us many patches in our
published plates. We have, then, nothing to do
with "fuzziness," unless by the term is meant
that broad and ample generalization of detail,
so necessary to pictorial work. We would remind
these writers that it is always fairer to read an
author's writings than to read the irrespon-
sible constructions put upon them by prejudiced
and half-educated persons.

CHAPTER IV.

NATURALISTIC PHOTOGRAPHY AND ART.*

BEFORE proceeding further, it will be well to give an epitome of the past matter, we shall do this in the following chapter.

When I first took up photography I was told by the whole photographic world (including optical experts); told by all, without exception, that if the photographic observer closed one eye and placed the other eye at the focal distance of the lens used in taking the photograph under observation, he would see the picture "true to nature."

I felt all along that such was *not* the case, and maintained the "sharp" or any other photograph when viewed under such conditions was not true to nature—to nature as the *two eyes* see it, and hence arose a long and inky warfare.

It was in this as in many other disputes— we were both right and we were both wrong.

The opticians were right from the mathematical standpoint, and I was right from the physiological and psychological standpoints, and so it was evident there were two truths to nature— the perspective or mathematical truth and the

* A paper read before the Photographic Society of Great Britain, March, 1893, revised.

psychological or visual truth. After many prac-
tical experiments I found the closest truth to
nature IN PHOTOGRAPHY (*from the psychological
point of view*) was to be obtained by throwing
the background of the picture out of focus to
an extent which did not produce *destruction* of
structure—that was my limit; the principal
object of the picture being either sharp or just
out of the "sharp." This convention I termed
the naturalistic method of focusing, and pointed
out that it had no connection with a general
soft sharpness such as that produced by Mrs.
Cameron's badly-corrected "Jamin lens," or by
pin-holes, or by throwing the *whole* of the picture
out of focus—practices all inferior from the
naturalistic standpoint, in my opinion, to my
focusing method—which is a deliberate and
conscious act to be modified according to cir-
cumstances, and no haphazard "dodge" like the
"soft sharpness" or "bastard naturalism," as my
friend Mr. Balfour called the more mechanical
"soft sharp" method.

This naturalistic method of focusing I prac-
tised and advocated and found later on by
further research that it was justified by physi-
ology. All this led to a great storm in a tea-
cup, and disputes arose as to how we did
see with two eyes and what was really *truth
to Nature* from the visual standpoint. In
the course of this argument I was pleased
to find a broad-minded optician taking an
interest in these matters. I refer to my
friend Mr. Dallmeyer, whose acquaintance I

did not make till after the publication of my
book.

This argument—though warm at times—did
good, and set many thinking, and at last I was
lucky enough to drop upon the key to the solu-
tion, which key I published in April, 1890, in
a number of *Photography*. It was a short paper
entitled, "A Note on Naturalistic Focusing."
My friend, Mr. Goodall, who was formerly
interested in the practice of photography, was
told by me of this little research, and imme-
diately he took it up enthusiastically and sug-
gested some new proofs and experiments, and
together we made first experiments and pub-
lished the results in a pamphlet entitled, "Per-
spective Drawing and Vision," * a pamphlet
that created another storm in the tea-cup, but a
pamphlet whose propositions, I venture to say,
still remain unshaken, though the Royal Astron-
omer at Sydney was invited to a public argu-
ment in the *Photographic News*—a challenge
still open to him or any other person of physio-
logical or psychological training: and here I
may say Dr. Griffiths and Mr. Sutcliffe were
the only two photographers who were, at the
time, acute enough to see and acknowledge in
public the full force of the pamphlet.

From this pamphlet it was again self-evident
to me that there is no *absolute* truth to Nature
from the visual standpoint, for as each man's
sight is different, the only absolute truth to
Nature for each man is his own view of her

* Reprinted in the chapter on " Sight. '

(though certain broad features remain true to all). On the other hand, from the mathematical standpoint or perspective drawing standpoint, there is an absolute standard, such as the sharp photograph taken with rectilinear and otherwise duly corrected lenses.

Now I will quote you a paragraph from a text-book on Psychology, published only last year (1892), a passage which shows how this view is now so far accepted that it has entered psychological text-books for students. The quotation is :

" Almost all the VISIBLE shapes of things are what we call perspective *distortions*. Square table-tops constantly present two acute and two obtuse angles, circles drawn on our wall-papers show like ellipses, etc., and the transitions fron one to another of these altering forms are in finite and continual."

That is the, position. Whence it is again evident that NO photograph gives things as we *see them* with our two eyes, though some photographs give results NEARER to what we see than others, and those are the naturalistic photographs.

The next question I put to myself was : How true must the photograph be so that it may be considered naturalistic? And this gave me much trouble, but at last I think I can offer the solution, which is,—It must be true in fundamentals to the point of *illusion*. Thus, a man's boots must not be twice as big as his head, and so on with everything.

So what I advocate is truth to the point
of illusion (for I am not considering to-night
scientific photographs but pictorial photo-
graphs). And I may now say the methods
of practice I advised in *Naturalistic Photography*
I still advise, and the bulk of artists I held up for
admiration in that work I still hold up as the
best exemplars of their various crafts, but I do
not consider photography an *art* but regard it
as a mechanical (I say "*mechanical*" advisedly)
process, whose results are sometimes more
beautiful than art, but are never art, just as
Nature is often more beautiful than art—just
as the beautiful white water-lily surpasses
the painted lily—yet is the real lily not art
but Nature. So the photograph is not art,
but a mechanically recorded reflection of Nature.
To state this matter more clearly I have adopted
a genealogical form of presentation.

NATURE.

(The fountain-head of sensuous impressions, but not
of concepts or *ideas*.)

PHOTOGRAPHY.

(A cross between *Nature* and a *machine*.)

Realism.	*Naturalism.*
(The sharp photograph —wherein sentiment, illusion, and decoration	(The more or less cor-rect reflection of Nature, wherein truth of senti-

are disregarded ; mere-
ly a register of bald
facts mathematically
true.)

ment, illusion of truth (so
far as possible), and deco-
ration are of first import-
ance.

From which it is self-evident that I believe
there is no true realism nor naturalism in the
arts proper but only in *photography :* for TRUE
realism and naturalism are *impersonal*—the re-
sults of a mechanical process which photog-
raphy logically is, because under the same
physical conditions the same *results* will always
follow. Place the camera under certain physi-
cal conditions and the same results will always
follow, which is *not* the case with art, which is
personal; indeed, the personal element in real
art is paramount and all-pervading. Thus, art
is a cross between *Man* and Nature, or—

ART
(Cross between Man and Nature—no machine intervening)

Impressionism.

(Which is a purely direct
personal vision of Nature
as thus an impressionist
may paint *sharply* or may
paint colors wrongly from
defect of vision : as does
Manet.)

Idealism.

(Cases in which the im-
agination is used; that is,
the combining of several
ideals into one harmoni-
ous whole. The idealist
may transcend *known*
Nature and so the vase
is produced.

In brief, what I submit is that all *artists*
(who do not use photography, and such are

bastards) are either impressionists or idealists,
and that logically they *cannot* be either realists
or naturalists, for they can never be truly *im-
personal*. M. Zola *calls* himself a " naturalist,"
but he is not, as has been pointed out : were
I to classify him it would be as a morbid
impressionist. On the other hand, M. Viaud,
a far more sensitive artist, has been called
a " naturalist ; " he has publicly denied it, calling
himself an " idealist," which he is not—he is
an impressionist ; morbid, too, in his way. On
the other hand, Theocritus I should call a
sane impressionist, and Milton an idealist,—or
to put it into paint, Mr. Whistler is a sane
impressionist and Rossetti an idealist.

And there can be insane impressionists and
idealists, as lunacy students know, as well as
mattoid impressionists, as was the late Richard
Jefferies in literature, and, say, Ruskin in art.

But still there is a link binding Nature, Art,
and Photography together—a touch of kinship
—and that is *decoration*. The artist admires
Nature when she " sings in harmony," *i.e.*, is
decorative; he admires the photograph when it
" sings in harmony," *i.e.*, is *decorative*, and he
admires works of art when they " sing in har-
mony," *i.e.*, are *decorative*.

Thus, photographs must be *decorative* to
appeal to artists, but that does not make them
art any more than Nature is art when she is
decorative. In a word, art is the personal ex-
pression of a personal vision of Nature or ideal.
A decorative photograph is a mechanical reflec-

tion of Nature *when* she "sings in tune," the good photographer requiring to know when Nature does "sing in tune." In a word, he must have true perception of the beautiful to succeed, after that he is merely the starter of a machine. If you will allow me to digress for a moment let me here make a reservation. It is that it matters not, for *merely* decorative purposes, what lens be used or how it be used, what exposure be given or how it be given, what developer be used or how it be used, what printing method be adopted or how it be handled, *provided* always the result be *decorative*, for no photograph can be said to have any "art qualities" (this does not allow it can be art) without being first of all decorative—a harmonious whole. That is the first quality which differentiates the few photographs from the thousand. But there are higher qualities, degrees of interest and distinction, as it were, and to possess these it must be illusively true, and fine in its *natural* sentiment, as well as decorative ; in a word "naturalistic." And even Mr. Whistler (a far greater artist than philosopher) gives himself away upon this very point in what I years ago called his brilliant but illogical "Ten o'clock," though such an acute critic as Mr. Henley has called this lecture the greatest art writing of the century, which I submit it is not. In this "Ten o'clock" Mr. Whistler advocates throughout his work art for art's sake (*i. e.*, pure decoration) as the be-all and end-all of art. But I

submit that he gives his case away when he
writes :—

As did her high-priest Rembrandt, when he saw
NOBLE DIGNITY *in the Jew's quarter of Amster-
dam."*

Or—

"To the day when she dipped the Spaniard's
brush in light and air, and made his people . . .
STAND UPON THEIR LEGS, that all nobility and
sweetness, *and tenderness and magnificence
should be theirs by right."*

"Noble dignity," "tenderness," &c., have
nothing necessarily to do with decoration, but
they are the ALL-ESSENTIAL qualities for fine-
ness of sentiment in the pictures cited.

It was on this very point that our greatest
poet, Mr. Swinburne, fell foul of Mr. Whistler
and got worsted. I venture to think, had Mr.
Swinburne merely quoted these and similar pas-
sages his position would have been invulnera-
ble, but he must argue. Indeed, truth of
sentiment and fineness of sentiment are dis-
tinctly advocated as virtues in these passages
and as I have always claimed them to be, and
so what becomes of *l'art pour l'art* theory and
the contention that "subject" has nothing to do
with it. I have always maintained "subject" is
as necessary as decoration for the perfect work,
and I still maintain it; but "subject" is often
confounded with "story-telling."

What is wanted in naturalism is a decorative
illusion of Nature, a decoration embodying some
fine and true *natural* sentiment, the decoration

without the sentiment (not sentimentality) is a mere sensuous patch-work of color, the sentiment without the decoration is mere "literature in the flat," and the truthful illusion without either sentiment or decoration is a mere statement of fact, which explains why Mr. Whistler's masterly "Carlyle" must always be of more *interest* than, say, a "still-life" picture by the same hand.

This may be a fitting place to insert a warning against an error born of misunderstanding. It has been said many times that by-and-by photographers will do works of art when they get "soul" into their photographs. The photograph that is fine in sentiment and decoration and true to illusion can never be *improved upon* any more than can the statue of the Venus of Melos. A perfect work is good for all time, as Mr. Whistler has said. Means are now at the command of photographers to produce the perfect black and white photographic work, though in future increased *facili-ties* for producing such work may be found by inventors.

And now we will return to the main subject, which I shall lay before you in a series of *propositions only*, for psychology has not yet become a science in *the true sense ;* psychological work is merely in the working hypothesis stage, though by no means at the worked out hypothesis end.

PROPOSITION I.

That the material universe may be regarded

by us as eternal (though varying in aspects) and the fountain-head of all our *sensuous* impressions.

PROPOSITION II.

That accepting the doctrine of evolution the mind has evolved from the merest crude sensations of the amœba to the complex and subtle sensations of the master artists of to-day.

PROPOSITION III.

That in the course of this evolution there arose the sensation and perception of the beautiful,* and this emotion was followed by acts intended for ornamentation of their persons or homes.

PROPOSITION IV.

That from this germ developed the sense of the beautiful until in civilized man this appreciation of the beautiful may be divided into three steps :—

1. That of sensation.
2. That of perception (intellectual).
3. That of emotion.

That these three be three distinct processes, yet are they one—indissoluble.

PROPOSITION V.

That the appreciation of the beautiful is thus *subjective*, an ideal existing in the minds of men in varying degrees of development; and that though Nature (by which the objective world

* According to Darwin this is first noticeable in birds.

is meant) has probably produced at various times exquisite harmonies, it took man to recognize these as beautiful, and so it has been said the artist is the master of Nature.

Proposition VI.

That as the NERVOUS system developed, these appreciations became more delicate and subtle, and so a man with a naturally delicate sense of vision gradually purges himself of the coarser emotions, and his perceptions are more purely cerebral acts. A master artist regards first of all by mere *acquaintance* the decorative harmony of a picture or natural scene, *then* by previously acquired knowledge he *knows* why it is lovely, fit, true in sentiment, and *distingué*, and that knowledge gives way to the emotion of joy, which is expressed physically by his smiling face.

That the *reverse* is the process with the Philistine ; the crude and tawdry appeals first to his emotion, hence the popularity of the sentimental subject, of the anecdote, of "literature in the flat."

Proposition VII.

That we have physiological proof that men's sensitiveness vary in degrees of fineness, thus a *virtuoso* in flour knows samples grown in different countries by their feel—a *virtuoso* in wine knows a glass of port taken from near the bottom from one taken from the top of a bottle ; and the blind Laura Bridgeman knew purely *by*

touch the clothes of all the inmates of a work-
house. From which it is self evident that in
all persons the boundary of their appreciation
is hard drawn; in some cases therefore fatally
limited by their very organization. A man
whose vision is not delicate can *never see* the
delicacies of line, color, and tone patent to a
more delicate nervous organization. Such a
limited person is forever doomed to be outside
the pale of the pictorial art world, as the man
with no ear for music is for ever doomed to be
an " outsider " in the musical world.

Proposition VIII.

That as the sense of beauty is a human ideal,
this ideal will vary with individuals and *in* the
individual from day to day, nay, from hour to
hour. Indeed so complex are the brain pro-
cesses, and so dependent upon each other, that
an artist may begin a picture with one ideal and
finish it with quite a different ideal. Indeed,
it is one of the great difficulties of the artist
to keep steadily to his original ideal through-
out the work. A glass of wine, a santonine
powder, may completely change his ideal or
power of execution. From which it is plain
how delicate a thing is a work of art, how
thoroughly *personal* is every touch in a work
worthy the name of art—what a perfect index
of its creator's mind.

Proposition IX.

That the ideal existing in any given brain at

any moment is complex, the result of the man's whole previous life up to date; wherefore, this ideal is no mere reflection of Nature, but a result of imagination, or the selection from various ideals or parts of ideals; and thus man may go beyond Nature and conceive things that do not exist in the world—such as the vase, the phonograph.

That fine art is the artistic expression of this ideal by a *personal* method, and that no man is an *artist* who has the ideal and can see the beautiful if he have not the power of execution as well. Art is therefore achievement. By their *results* alone are artists to be judged; as thus a very inferior *technician* may be a very delicate seer of the beautiful, but the world only give him credit for his picture—*his result*—and if that be poor, if his hand cannot express his ideal, he does not rank highly nor often does he get credit as a seer. "Art is therefore with the man," as Mr. Whistler has said.

Proposition X.

That Nature sometimes sings in tune, or succeeds in producing glorious and exquisite harmonies, harmonies fully appreciated by the seers of the beautiful, for many more may appreciate than can depict; hence the rarity of real artists. Whence also a layman may be a far keener seer than most painters; but seer *and* masterly executant is Genius itself.

Again, that the harmonies of Nature are altogether different from the harmonies of art—

are dependent on different phenomena, and that
Nature and art are different worlds. That
Nature sometimes sings in tune Mr. Whistler
himself has allowed, but I submit that it is
absolutely impossible to reproduce that har-
mony on a plane surface; it is a thing by itself,
a thing apart; though a number of unphilo-
sophical painters *think* they do reproduce
Nature—but they do not. Here is a very sim-
ple proof suggested to me by my friend Mr.
Havard Thomas, a sculptor. Let the observer
look at a distant landscape behind some reed-
stalks in the foreground. The reed-stalks in
Nature, under certain conditions do not blot out
any of the background, *we see round them*, and
see the *whole* landscape beyond. In art the
reed-stalks would always *blot out* part of the
background. I think our sense of the third
dimension of space or " distance " arose first
through this peculiarity of vision. For further
and deeper proofs of the utter impossibility of
reproducing Nature as we see her I must refer
you to Prof. Helmholtz's *Scientific Lectures*, to
Mr. Rood's *Chromatics*, and to our *Perspective
Drawing and Vision*. A careful study of these
publications aided by a few experiments made
for himself will convince the veriest neophyte
that it is *impossible* to reproduce Nature or make
a " mere transcript."

PROPOSITION XI.

That in photography we are confronted with
a new phenomenon, in that we find some of the

results of a *machine* give true pleasure to master artists, which has never hitherto been the case with machine-made works.

PROPOSITION XII.

That photography is not art, because a machine comes between the man's ideal and Nature, and the result is *machine-made ;* the trapping of a sunbeam. Say the photographer, like the painter, goes to Nature with certain ideals —we will for illustration's sake assume that two men have exactly similar ideals of the beautiful (which is of course impossible). They go together to Nature, and find a beautiful natural harmony in a lovely stretch of purple sands by the sounding sea. The photographer at once sets up his machine, focuses and exposes; but in these very processes *his* ideal has *gone*. What results *may* be beautiful, but it is no more the representation of his ideal, the vision he first saw. It is something else, for the machine imposes certain conditions which were never in the photographer's mind at all. How often has the most experienced of us been disappointed with the photograph of what was fine in Nature—fine to our eyes that is, and sometimes *vice versa ?*

The painter, on the other hand, begins, and if he be an expert each touch helps to his desired or ideal end; this wavelet is delicately put in, that breaker strongly and broadly, and so on; everything is done unto one end, and all is certain from the first—whereas the photographer

has boxed a maimed and contracted reflection of what he saw. True, it may be a beautiful reflection, but after all it is *Nature's drawing*, and not the man's. Still, such machine-drawn pictures may in certain cases satisfy, or rather harmonize, with the photographer's ideal of beauty, or indeed with the master painter's, as does a beautiful natural landscape; and yet again the beautiful photograph is not *art* any more than the natural scene of which it is a reflection.

PROPOSITION XIII.

That though the machine draws the photograph, yet in the production of a photograph there are a few (very few) very limited *incalculable* elements, as there are in organ grinding and engine driving.

These are—

(1) Selection of view.
(2) " lens.
(3) " focus.
(4) " time of exposure (under, correct, or over), developer, and development curve.
(5) " printing method.

These limited incalculable elements give a man a very limited opportunity of blending his materials to his ideal, and though by taking advantage of these *with knowledge* he may surpass other photographers in decorative work, still they are too limited for him to express to any degree of certainty or fullness *his ideal*,

and since the drawing is mechanical, these few very limited incalculable elements cannot enable a man to express his ideal in anything like the same degree as does a personal art. Indeed photography is not nearly so *personal* an art as sailing or rifle shooting, both of which have very little of the mechanical about them and much of the personal.

In photography man puts the machine under certain physical conditions, and the machine will always (under these same conditions) bring about the same result, therefore the process is logically mechanical. On the other hand, a personal art is one in which the results would differ again and again under the same physical conditions, for the *mind* would work differently on each so-called "replica" of the original—*no artist could paint two pictures exactly alike.* A photographer might take fifty views of a subject exactly similar, from which it is self-evident that photographs are not works of art in the sense accepted by artists, though photography may be an art or craft in the old sense of the word art, as surgery is an art; but such a use of the word "art" as applied to photography would not satisfy the *dilettante*, for the word so used would include *every* photographer as an artist, which is not what the ambitious mean at all.

PROPOSITION XIV.

That therefore it would be wiser for all photographers to drop the use of the words "art"

and "artist" in connection with photography
(photography is a science or hopes to be some
day)—and classify exhibition works as—

(1) Pictorial (when the *intention* is merely
and purely to produce a beautiful
thing).

(2) Scientific (accurate mathematical re-
flections).

By using the terms "pictorial photographs"
and "scientific photographs" we should, I think,
allay all opposition from artists—not to say
painters, and critics (who are right in refusing
to call photographs works of art), and should
be at the same time working in a less preten-
tious way and in a legitimate pursuit, humble
as compared with painting, 'tis true, though the
best results surpass all but the masterpieces of
art in beauty. And I would suggest that this
Society sets the example at their forthcoming
Exhibition, and describes the works submitted
into two classes, scientific and "pictorial"; for
works should be classed according to their
intention.

PROPOSITION XV.

The pictorial photographs are worth doing
(if well done) because they give us certain
beautiful qualities art cannot give, hence their
raison d'être. That the producers of such may
prove themselves as keen seers (not artists) of
the beautiful as the master artists themselves,
They may have art-knowledge too, yet if they
be no creators by personal method I submit

they are not "artists." But then this does not mean, on the other hand, that mediocre draughtsmen whose vision is vulgar or obtuse are to patronize seeing photographers, for such mediocrities are not "artists," and indeed, seeing photographers have far more claim to the title, as the masters would allow.

Proposition XVI.

That though photographs are sometimes more beautiful than art, they never equal Nature when she sings in tune. Indeed, I submit that when Nature "sings in harmony" she is more beautiful than photography or art : unrivaled in her delicacy, fineness, and distinction.

Proposition XVII.

That "idealism" and "impressionism," if used in connection with photography, are mere contradictions of terms, and used by slovens in thought—or worse.

Let us conspire *not* to be called by any false or vain names such as "artists," but to produce beautiful pictorial work, each of us in his own way. Let us in friendly and unselfish spirit band together for the furtherance of this end, and let the too eager or ambitious (I will not say vain) neophyte remember that the proof of his delicacy of vision is in a measure what he shows us *of his own*, and that as there are few Laura Bridgemans with perfect touch, so there are few seers of the most delicate beau-

ties, because few organisms have delicate vision.
Let the neophyte remember that physiology
proves that most are for ever fatally limited to
remain *without*, and no disgrace either, if such
have but the honesty and pluck to own it; the
disgrace is pretentiousness and imposture: in
pretending to see.

Amongst these blind have been the vast body
of persons who have ridiculed Mr. Whistler,
indeed nearly the whole press has ridiculed
him; and yet to-day his pictures hang in the
most honorable position in Paris, the city at
present the Queen of the Arts, and so it will
always be, for I for one believe that truth is
great, and will in the end prevail over obtuse-
ness and dishonesty.

As for these propositions, I do not intend to
fight over them, for they are *propositions*, and
therefore no fighting matter, but provisional
until psychology shall either prove or disprove
them.

END OF BOOK I.

TECHNIQUE AND PRACTICE.

BOOK II.

TECHNIQUE AND PRACTICE.

BOOK II.

TECHNIQUE AND PRACTICE.

"Artists are supposed to pass their lives in earnest endeavor to express through the medium of paint or pencil, thoughts, feelings, or impressions which they cannot help expressing, and which cannot possibly be expressed by any other means. They make use of material means in order to arrive at this end. They tell their story—the story of a day, an impression of a character, a recollection of a moment, or whatever, more or less clearly or well, as they are more or less capable of doing. They expose their work to the public, not for the sake of praise, bnt with a feeling and a hope that some human being may see in it the feeling that has passed through their own mind in their poor and necessarily crippled statement. The endeavor is honest and earnest, if almost always with a result weakened by over-conscientiousness or endeavor to be understood. . . . Your work is exhibited not with the intention of injuring any of the human race. It is a dumb, noiseless, silent story, told, as best it may be, by the author to those whom it may concern. And it does tell its story, not to *everybody*, but to *somebody*."

WILLIAM HUNT.

CHAPTER I.

THE CAMERA AND TRIPOD.

THE camera as used to-day is a modified form of the camera obscura adapted to the special end of taking photographs. It is essentially nothing but a light-tight box, to one side of which a lens can be adjusted, and to opposite side of which the slide containing the sensitive plate can be applied and exposed, so that it receives no light, save that passing through the lens. There are many patterns and many minor differences in the construction of these boxes, some few of real value, but the majority are of no advantage. In all apparatus the student should choose the simplest and strongest, for in pictorial work lightness *per se* is no object, nay, it may be harmful, as leading to over-production. In fact nothing should stand in the way of getting the best results, and though many of the cameras on the market are light and fitted with numerous devices which are said to simplify operations and help the worker, yet such is not really the case, and these thousand-and-one aids to work are apt to become deranged, and finally to embarrass the photographer at some critical moment.

In choosing a camera, then, for landscape

work, choose a square one, with a reversing frame, a double swing-back, and good leather bellows, these being better than flat sides, as the light is not reflected from the sides of the box onto the plate, the bellows thus act as diaphragms. Let the flange of the lens be fitted, to a square front which can be easily removed and replaced, and let there be a rising front, but do not have a movable front, for the lens should always be at right-angles to the focal plane. It is advisable to have the camera brass-bound for the sake of its preservation, and if for use in tropical climates the bellows should be made of Russian leather, as the oil of birch with which the leather is cured is most distasteful to insects. In ordering a camera there are a few points which experience has led us to consider essential to comfort. One is that the part of the base-board of the camera which rests on the tripod head should be strengthened or made of much stouter material than is usually used. Another is that the thumb-screw should be of much larger diameter than is usually the case, and this should be borne in mind, even in the making of the smaller cameras, for on a windy day when the camera has a heavy lens on one end and a loaded double dark slide on the other, the vibration is often ruinous to the picture during exposure, while sudden gusts of wind may even crack the wood round the screw hole. It seems to us a thumb-screw at least half an inch in diameter should be used, unless the camera be made to fit into the

tripod head, a method often adopted of recent years, and of course the best way of all. On more than one occasion we have nearly lost the camera altogether in the water when trying to screw it to the tripod when working from a boat on a tide-way, but by having a part of the base-board made to fit into a wooden tripod head, this at times most difficult operation is rendered easy and certain.

The camera should always extend and close by means of a tail-screw, those opening by means of a rack and pinion are much more liable to get out of order. Of course this remark is not applicable to the smallest-sized cameras. A round spirit-level sunk into the tail-piece of the camera is useful. In ordering a camera the two vital points to be considered are the size, including the length of the bellows. The size of plate you intend working with determines the size of the camera. We have worked with all sized cameras, from quarter-plate up to one taking twenty-four by twenty-two inch plates, and it is only after long experience and much consideration that we venture to offer an opinion on the size to be chosen. For ordinary work, then, we recommend the half-plate size as the minimum, and the ten by eight inch size as the maximum. Perhaps a whole-plate camera ($8\frac{1}{2}$ x $6\frac{1}{2}$ inches) is on the whole as useful as any. The strength required to do a day's work with a twelve by ten inch camera is beyond any but a strong man. It is assumed, of course, that the pictures of the sizes

cited are for albums, portfolios, or book illus-
trations. It must be remembered, however,
that the size of a picture has nothing to do with
its pictorial value, a pictorial quarter-plate
picture is worth a hundred commonplace pic-
tures forty by thirty inches in size. For pro-
ducing large pictures for the wall, however, we
consider the camera should be between fifteen
by twelve inches and twenty-four by twenty-
two inches; we cannot imagine anything larger
than twenty-four by twenty-two inches for out-
door work, and our memory goes back to a
marsh road in Norfolk, where we and two
peasants had all we could do to carry a twenty-
four by twenty-two inch camera when set up
from one marsh to another.

The student will of course remember that his
camera must be square in order to have a re-
versing frame fitted, but that makes no differ-
ence to the size of dark slides. Having then
fixed on the size of his camera, a question re-
quiring the greatest thought, he must next tell
the maker the length of bellows he requires,
which is usually measured from front to back
when the camera is racked out to its full
length. As we recommend the use of long-
focus lenses, as will be seen in the chapter on
lenses, and as no definite law can be laid down
for this length, it is advisable to order a camera
four or five inches longer than the focal length
of the lens which is advertised to cover the
next larger size plate to that which your dark
slide holds.

And now for a caution against a fallacy current in photographic circles, which is that one size of plate is more suitable for pictorial purposes than another. The size of the plate has nothing whatever to do with success or beauty. Every composition will demand its own particular size and shape, and say you work with a ten by eight inch camera, you will find you will often take a nine by four inch or a ten by three inch plate or a dozen other sizes and cut off all the rest. All fanciful rules for fixing on the size of a plate for pictorial reasons cannot be too strongly condemned. Such things must be left to the individuality of each worker, and every picture-gallery in Europe gives the lie to all rules for a choice of size. The photographer must, of course, suit his plate to his subject, not his subject to his plate.

For studio, or indoor work, the camera may of course be heavier for obvious reasons, and a different form of support is necessary, the one usually adopted being very convenient for lowering or raising the lens so that the best point of sight is obtained according to the position of the model. It seems to us, however, that these studio cameras and stands are made a great deal too heavy and cumbersome. For this kind of work a very necessary part of the apparatus is a hood of some dark material fixed on to the front of the camera and extending above and beyond the lens, in order to obviate the effect of the numerous reflections always present in a glass studio. Out of doors this

is only necessary when the sun is shining into
the lens; otherwise it is never needed, for we
have tried it, and have proved that its use has in
no way improved either the truth or the quality
of the negative. In cases where the sun shines
into the lens a hat, a piece of cardboard, a
folded newspaper, or anything of the kind, will
answer the purpose equally well.

The tripod head should be preferably of tough
wood covered with felt. A metal tripod head
is apt to endanger the woodwork of the camera,
even when covered with leather. The legs
should be simple and firm, the best we know of
being made of two pieces of ash or oak hinged
at the bottom, the points shod with iron, and
the legs being stiffened when in position by a
bar of iron which is secured by a hinge. Every
one should have two pairs of legs at least; one
pair, so that when the camera is set up the lens
may be on a level with the eye of a man of aver-
age height, and one pair shorter, so that the lens
is only three feet from the ground. In addition
to these we always have handy three tough
poles eight feet long and about the diameter
of a broomstick; these are shod with iron heels,
and have notches cut at the unshod ends.
These are most useful to lash to the long legs
when using them in water-ways. It is as well
to have six double-backs, for by filling them all
at one operation the student empties a box of
plates, and so avoids a chance of mixing ex-
posed and unexposed plates. The most con-
venient method of carrying the plates in all

cases up to and including the ten by eight size, is to have a bag made which will take the camera, three double-backs and the focusing cloth, and a separate bag for the other three double-backs which can be left behind or taken out at pleasure.

A very useful piece of apparatus is a clamp which can be screwed on anywhere, but especially to a boat's gunwale, the taffrail of a steamer, a fence, and many other places whence good pictures can often be secured. Such a clamp can be purchased at most of the dealers' shops.

Having decided on these matters, we will suppose the novice is now provided with camera and tripod. Now for a few details about starting. In setting up the camera on its tripod, one leg should be placed either between the photographer's legs or exactly opposite to him, he will then find he can command the camera easily and alter its postion with a touch. If, on the contrary, the legs are put up by chance, he will soon find his lens playing all sorts of gymnastic tricks, one moment looking fixedly up at the stars, the next studying with the deepest interest the ground at its foot.

The manipulation of the rising front is a power needing considerable study, for, by moving it, you can regulate the amount of foreground you wish to include in your picture. The limit of rise of the front is determined by the manufacturer, and the limit beyond which the student must not go is determined by the covering power of the lens he is using, for he

will remember that every lens only covers a
certain circle, the area of the circle depending
on the construction of the lens. The usual
method of describing the covering power of a
lens is to give the measurements of the greatest
parallelogram that can be inscribed within this
circle. It will be easily seen that if the lens we
use only just covers the plate, that when the
front is raised above a certain point, the lower
corners will have no image exposed on them,
and the higher the lens is carried, the more of
the lower part of the picture will be cut off.
As the image is upside down, the blank corners
will appear in the sky of the negative. It is
then obvious that if the covering capacity of
the lens is greater than needed for the plate
used, the rising front may be used to a much
greater extent than if you only use a lens cov-
ing the plate you are exposing. It must always
be remembered that if the optical axis of the
lens be raised above the center of the plate the
illumination may be unequal.

The effect of the horizontal and vertical
swing-back is identical, as is obvious if the cam-
era be placed on its side, for the horizontal
swing becomes vertical, and *vice versâ*. If the
camera be set up plumb, the effect of using the
vertical swing-back to its extreme limits (which
are determined by the mechanical construction
of the camera) is to lengthen objects in the
direction of their obliquity and to sharpen the
focus of some of them, whilst objects in other
parts are blurred and dwarfed. What does this

mean from an art point of view? It means that as a rule it throws the whole picture out of drawing, the relative positions of the planes are altered, the relative definition in the planes is altered and with it the relative values, and therefore, as a rule, the picture is artistically injured. This rule-of-thumb use of the swing-back arose, no doubt, from the practice of those whose aim was the production of "sharp" pictures, for with the swing-backs they invariably use small diaphragms to obtain sharpness all over. For architectural work the swing-backs should never be used and the camera should *never* be tilted. The swing-backs can, however, be used, with the greatest caution, in pictorial work, and their value can scarcely be overrated, but it requires great knowledge to use them appropriately. The subtle changes in the drawing and composition of a picture which can be obtained by an intelligent use of the two swing-backs, make them, to those who know how to use them, most valuable tools. But if the beginner will take our advice, he will keep his ground-glass plumb, and his horizontal swing-back square, and never venture to alter either until he has thoroughly mastered his *technique*, and has some insight into the principles of art. The use of these swing-backs seems so easy, as of course it is, when "sharpness" is all the desideratum. By their means, the appearance of the whole scene can often be more truly rendered, and things can be subdued and kept back in the most wonderful manner :

and since we wish to get a true appearance of
the scene we are interested in, not a realistic
wealth of detail, it can be easily understood
how invaluable are the swing-backs when used
cautiously. Muybridge's galloping horses are
in all of their movements scientifically (realis-
tically) true, but many of these are never seen by
the eye, so quick are they, and they are, conse-
quently, not true to illusion. On the other hand,
the student, if 'he goes to the British Museum,
can see in the Parthenon Frieze that the
sculptors in some cases carved the legs of the
farthest of three horses in higher relief than
those of the nearer horses, but if he goes off a
few paces and *views the carving in its entirety,*
he will see the true appearance is gained ; the
nearest legs look the farthest off, and so the work
is true in illusion, though not true in absolute
fact. And though the use of the swing-back
makes the drawing scientifically a little false,
yet if the proper lenses be used, the falsity is so
very slight as to be hardly noticeable. Indeed,
it may give a truer impression.

By perforating a thin metal plate with a mi-
nute hole, large enough only to admit a pin's
point, and fitting it to the front of the camera
in place of the lens, an image will be thrown
on the focusing screen, as the piece of ground
glass at the opposite end of the camera is called.
If the image be received on to a sensitized plate,
it will be impressed on the plate, and can be
developed in the ordinary way. But such a
" pinhole " photograph is absolutely ruined by

lack of tone, and since the exposures required
to produce pictures without lenses vary roughly
from one to thirty minutes, this method cannot
be seriously considered here, for, as we shall
show, within certain limits, the quicker the
exposure the better ; nevertheless, the drawing
of pictures taken in such way would obviously
be scientifically more correct, but the lens gives
the operator greater power of modifying the
planes of the view and producing truer tone
and no differential focus can be got with a
pinhole, for everything is sharp. Indeed, we
have never seen anything done with a pinhole
that could not be better or as well done by a
lens, and the best things we have seen could
never have been done by a " pinhole." Mr.
Spiers was the first to produce pictorial " pin-
holes " and some uncultured persons out-
Heroded Herod and called "pinholes" printed on
rough papers (after Col. Noverre's example)
"impressionistic photographs"—and themselves
" impressionists," to such depths of folly will
blatant and pushing coxcombery go.

The student must be careful to see that the
inside of the camera is a dead black, and that it
keeps so. At times the camera may leak or get
out of register, that is, the plate does not ex-
actly take the place of the ground glass, in
which case he should at once send his camera
to the maker. Should the student wish at any
time to test the register of his camera, he has
only to pin up a printed card and focus it as
sharply as possible, using his lens at full aper-

ture, using a magnifying glass, if one be at hand. Then load the dark-slide with a plate of ground-glass, and after sliding it into position, open the slide (if a double-back) when the image will be seen on the ground-glass plate, and its sharpness can be noted. The other side of the dark-slide is then tested in the same way. If perfectly sharp, the camera is in register.

A good form of small camera to be carried in the hand is still a great desideratum for studies. Exquisite studies of figures, birds, and all sorts of animal life could be made with such a contrivance, studies admirably suitable for tailpieces or illustrations to go in with the text. That there are dozens of patterns of hand cameras commonly called "detective cameras," we are well aware, and we have tried some of the best, but we have found none satisfactory for our purposes, and can therefore recommend none. We may here remark that the name "detective camera" is, in our opinion, undesirable; photographers ought not to have it even suggested to them that they are doing spying work with their cameras, whereas the term "hand-cameras" meets every requirement. Of course the smaller cameras advertised to be worn on the person are merely toys. The camera we should like to see introduced would be a very light collapsible camera, which could be easily carried in the pocket when not in use. It should be able to take pictures not larger than four and a half by three and a half inches, and should be fitted with the Eastman spools,

so that any number of exposures could be made. The lens should be a quick acting long focus rectilinear lens, fitted with a good shutter. There should be a light view meter attached to the top. There is no necessity for a ground-glass screen, for on the tail-board could be registered various distances, at which the film is in focus ; and since for pictorial purposes most of the studies would be of objects near at hand, this arrangement would be effectual, The larger cameras can at times be used as hand cameras. We have repeatedly used a 12 x 10 camera as hand camera, but for the particular work required a small, light, quickly prepared instrument is required.

The handiest view meter I have used is a square frame fitted to the front of the camera with another frame behind with an eye piece, both centered so that the front frame includes the same position as the ground-glass screen.

When in the country the operator may break his focusing screen. If such an accident happen, he can use as a substitute one or other of the following screens : Expose an ordinary dry plate to the light for a second and develop it in the ordinary way until it shows a uniform grayness, then fix and dry. Another way is to cover a glass plate with a thin layer of starch or olive oil, or a piece of oiled paper or a wet cambric handkerchief stretched across the frame will answer.

CHAPTER II.

LENSES.

IF the reader should know nothing of light and optics, we recommend him to get Ganot's Physics, and thoroughly master Book VII., on "Light." This may seem a little formidable, but our reader will find that with a very simple knowledge of mathematics he can easily understand all the fundamental sections, and it is our opinion that light and chemistry should be studied directly from systematic text-books that treat of those subjects. In the Appendix we shall refer to some additional books which we consider advisable for the student to read, but for the present we strongly recommend him to thoroughly master the parts of Ganot that we have cited, and to avoid all other desultory reading until he has done so.

Far too much time has been given, and far too much importance has been hitherto attached to the subject of optics in connection with photography. Much time and expense would have been saved had the pioneers of photography had good art educations as well as the elementary knowledge of optics and chemistry which many of them possessed, for without art training the practice of photography came to be looked upon purely as a science, and the

ideal work of the photographer was to produce an unnatural, inartistic and often unscientific picture. It is, indeed, a satire on photography, and a blot which can never be entirely removed, that at the very time the so-called scientific photographers were worrying opticians to death, and vying with each other in producing the greatest untruths, they were all the while shouting in the market-place that their object was to produce "truth to nature" works. At length, when the most doubly patented distorting lenses were made to meet their demands, they, with imperturbable self-confidence, presented a sharp, visually untrue photograph, insisting upon its truth. "A truer picture," said they, "than drawing"; "truer than the eye sees," some said. In short, their picture was absolutely perfect. When a lens giving a brilliant picture, with all the detail and shadows sharp, and the planes all equally sharp, was at last produced, the scientists were *in excelsis*. But, alas! they often proved themselves as unscientific as they were inartistic! Had they but taken up their simplest form of lens and used it as magnifying-glass, they would have seen immediately that all was not right, and instead of clamoring for the pictoral falsities of "shortness of focus," "wide angle views," and the other hydraheads of vulgarity, they might have set to and made the lens which was required. It was but a simple thing that was required.

We shall endeavor to render this rather com-

plex subject sufficiently clear, so that the student may know what he is doing when he uses his lenses. Difficult as it is to put this matter simply and clearly, we shall approach the subject with that object.

To begin with, a lens is not absolutely necessary to take a photograph with. Such pictures may be taken with what is called a "pin-hole" or diffraction camera. We will not stop to say how they can be made, because we consider them undesirable for pictorial purposes. The light simply passes through a minute hole perforated in a metal plate and placed over the place where the lens usually goes.

The very phenomena of diffraction, which have given the name to the pin-hole camera, are against its use. Capt. Abney has laid down that to obtain the best possible definition, for a focal length of 16 inches the diameter of the pin-hole should be .032 of an inch; for a focal length of 100 inches .08 of an inch; but it must be remembered that the pin-hole picture is always in focus, has great depth of focus and an angle depending on the focal length used (or distance from a plate of given dimensions) and is slow to work with.

Now it will be asked if our pin-hole can take these pictures, why use a lens ? The answer is, that some very fair pictures have been taken without a lens, but since our wish as producers of pictures is to give as true an appearance of nature as we see it as possible, we must make use of lenses, because a pin-hole is not suffi-

ciently flexible to meet our needs. For example, the exposure must necessarily be long—from 1 to 30 minutes. We cannot, therefore, take quickly-moving objects; perhaps we want good modeling and sharpness; we cannot get it, for by using the smallest possible pin-hole admissible we get flatness,* and modeling is always ruined. Then if we want brilliancy we *must* use a big orifice, but if we want sharpness with it we shall not get it, for a large hole gives us diffusion circles and consequent fuzziness.

"Well," you say, "I don't mind that." To which I reply, "That is possible, but then we must have command of the amount of diffusion circles, so as to get our differential focusing.

To help us in these matters lenses of all kinds have been made for a variety of purposes and objects, and we shall go into these as clearly as we can, showing the student what to avoid. Lenses, though free from diffraction, except with exceedingly small stops, must necessarily introduce evil as well as good qualities; they are essentially a compromise. We shall discuss what a naturalistic photographer must avoid.

The chief points to grasp clearly are the following: Our lenses are convergent systems forming real images; a divergent lens gives no real image. A lens for optical purposes may be regarded as an infinite number of prisms united together.

* For a given distance of plate from pinhole there is one *best* aperture to ascribe to the pin-hole : a larger or smaller orifice giving worse definition through excessive diffraction.

It is well known that a prism will refract or bend a beam of light out of its direct course before entering the refracting medium of which the prism is composed. The effect of such a refraction is not only to alter the course of the ray but also to split the components of white light into a chromatic beam, known as the spectrum; the most refrangible rays being violet and ultra violet, which have a powerful influence upon the ordinary photographic plate, the least refrangible being the red, this end of the spectrum, to be accurate, the yellow rays, having most effect upon our organs of sight and little effect upon the silver salts contained in an ordinary photographic plate. We shall have occasion to say something more about chromatic aberrations a little later on.

In Figure I we see parallel rays of light $P_1 P_2 P_3 P_4$ falling upon the lens. P_1, at the point

Fig: I

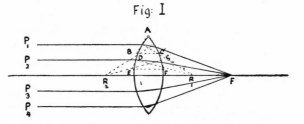

where it enters the lens, is refracted or bent as though passing through an exceedingly minute prism (exaggerated in the drawing) A B C, similarly the ray P_2 is refracted by another prism in close contact D E F G. F is the point

termed the focus of the lens to which all rays passing through the lens meet, provided the lens be aplanatic or without aberration, the points R_1 and R_2 are the centers of curvature of the surfaces of the lens. It will be seen that the surfaces of the prisms depicted are tangents to the radii from R_1 at the points of incidence of the rays P_1 P_2.

Figure II shows the effect of a parallel beam passing into a refractive medium, such as glass

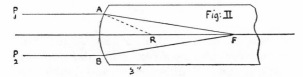

from which it does not emerge, the focus being formed at F, within the medium. The lenses, however, with which we deal in photographic practice pass from air into the refracting medium, glass, and emerge into air again before arriving at the focus. Our lenses then are constituted of a refracting medium or refracting media, which are bounded with spherical curves as illustrated simply in Figure III. The

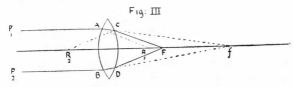

surface A B is struck from the center of curvature R and would form an image at f (as in

Fig. II) if continuing in the same medium ; the ray P_1 A after being bent in the direction, A f meets another bounding surface C D, the two surfaces A B and C D forming the lens, and is here refracted at C to the focus F.

All lenses are composed of glasses of one of

Fig. IV

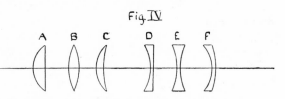

the shapes A, B, C, D, E, or F. A and D are respectively plano-convex and plano-concave lenses, B and E double convex and double concave respectfully, C and F convergent and divergent menisci.

Achromatic combinations or lenses constructed to combine visual intensity with the highest chemical intensity are combinations of lenses, one of the forms A, B, or C which are convergent, combined with one of the forms D, E, or F which are divergent, the combinations may be double, triple, or even a still larger number of lenses may be combined together. As a rule, and with the older glasses one general law obtained, viz., that the higher the refractive index of any kind of glass the greater was its dispersive power, that is to say, that if a prism was constructed of the same shape of any two kinds of glass, and a beam of light passed through such prisms, the beam would

be bent or refracted more, and also the spreading of the spectrum would also be greater with the prism composed of the denser glass. The properties which obtain in some of the Jena glasses do not follow this regular order, for, in the cases to which we are referring, one glass may have a higher refractive index than another, and yet have at the same time less dispersive power ; the contrary also holds in some cases, in that one glass may have a higher dispersive power than another and yet have a lower refractive index. The result of these improvements in glass manufacture has materially assisted opticians to overcome the difficulties formerly presented to them in the cure of astigmatism. Larger apertures are now possible than was formerly the case, consistent with a flat field and freedom from astigmatism.

The next matter upon which we must say a word is a property that all lenses possess. There is for every lens or lens system one point in the single lens or combination through which all rays of light will pass without deviation, this point is called the optical center. In the two lenses shown in Figure V, the method of deter-

Fig. V

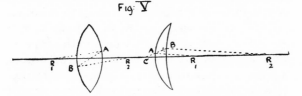

mining the position of the optical center is

shown. Parallel radii, R_1 A, R_2 B, are drawn
from the centers of curvature R_1 R_2, meeting
the surfaces of the lens at A and B. These are
joined and in every form of lens the point
where the line A B crosses the axis or is pro-
jected to meet the axis in C, is the optical
center of the combination. From the Figure it
will be seen that in a double convex lens this
lies within the material of the lens, but in the
convex meniscus it lies slightly beyond the
deeper curve and outside the material.

In all lenses, except the telephotographic
combination to which we shall refer later on, the
optical center may be said to be contained within
the lens mount. We do not wish in this chapter
to enter into what might be puzzling technical-
ities to the ordinary reader, so that we shall not
enter here further into the question of the
nodal or Gauss points and planes in optical com-
binations. There are in reality two nodal points
in every lens or lens system, these two points
are separated very slightly in some combin-
ations, and very widely in others. This is
particularly the case in a telephotographic
combination, and has an astounding difference
in the back focus, but still maintaining the
same equivalent focus according to whether
the lens is screwed into the mount one way or
the other, that is to say, whether the front or
back combination is presented to the object.
But, as we have already stated, ordinary pos-
itive systems have the optical center or the
nodal point from which the focus is measured,

self-contained. We do not propose to enter more fully into this interesting subject.

We may now proceed to the all-important "Law of Conjugate Foci," which is simple enough. The main principle to bear in mind in approaching this subject is the fact that image and object are always interchangeable. In Figure VI we see parallel rays from a very distant object passing through the lens and coming to focus at the point F 1 ; if we were to place a bright object in the position F_1, the rays would emerge from the lens again as a parallel beam. It is seldom in ordinary photographic practice that all the points in the subject are so far distant that they may be considered parallel, and hence it is that we must give the law of conjugate foci careful consideration. In looking at Figure VI it will be self-

Fig: VI

evident that if the parallel beam of light passed from left to right through the lens instead of from right to left, the image would be formed at F_2, the distance C F_1 or C F_2 being the measure of the equivalent focus, a factor which is known to the user of a photographic lens, as it is or should be accurately given by the optician. The law of conjugate foci is simply this, that

at whatever multiple of the equivalent focus the object is situated from the measure of the equivalent focus toward the object, the image will be displaced the reciprocal of the number of times of that number of times beyond the focus for parallel rays. In the figure we have shewn the object O situated at a distance of twice the equivalent focus, viz., O F_2 beyond F_2; it then follows that the distance F_1 I is one-half the focus beyond F_1. If the object was situated one hundred times the focus beyond F_2 the camera back would have to be extended one hundredth of the focus beyond the position at which it would be in accurate focus for parallel rays. The nearer the object approaches the lens the greater, therefore, is the displacement of the camera back from the position in which it is in focus for parallel rays. If the object O is made to approach the lens until the distance S F_2 is the exact measure of the equivalent focus, the displacement from F_1 must also be again the exact measure of the equivalent focus, and an object placed at S_2 will be reproduced of exactly the same size at S_1, these points are known as the "symmetric points." In the ordinary tables given for copying or enlarging, the common rule for copying the same size is to place both object and focusing screen at double the equivalent focus of the lens on either side of it, in other words, occupying the position of the "symmetric points." A generalization to be derived from the study is that if we are engaged upon photographing moving

objects, if they are receding, we follow them with the focusing screen by wheeling in ; on the other hand, if they are coming towards us, wheel out the camera and so again follow the movement of the object in order to obtain it in good focus.

Suppose the light from a star falls on a bi-convex lens ; these rays are assumed to be par-allel. They emerge and meet at the principal focus as explained. Conversely, a candle placed at F would make the rays divergent (outgoing) parallel rays, so practically the star and the can-dle are theoretically interchangeable. These are conjugate foci, but in practice the rays from a luminous body are no longer parallel. If the radiating point taken is nearer than infinity (the star), but still situated on its axis, the rays emitted by the luminous body are no longer parallel ; they diverge and fall divergently on the lens and their focus is formed so much the farther beyond the lens the nearer the point approaches it. At a point from the lens equal to twice its principal focal length, the image is formed at an equal distance behind the lens, and the nearer the radiating point gets, the further back the image is formed, and when the point approaches to the lens to the distance of the principal length, the rays emerge parallel to each other and no longer form an image.

External luminous objects may be considered to be made up of an infinity of luminous points, each of which sends a pencil of rays to our eyes, or to our focusing screens. It is thus clear

why the image is upside down on the ground
glass, for the light must travel in straight lines.
From what has been said already, it will be seen
that the sharpness of the image depends upon
the relation of the size of a pin-hole to its dis-
tance from the plate, and that the larger the pin-
hole beyond a certain limit, the less sharp the
picture, but the brighter it is, the smaller,
within certain limits, the hole, the sharper the
picture but the fainter it is. Now the quick-
ness or rapidity of the pin-hole or lens depends
on the ratio of the working aperture to the
equivalent focus. That is, supposing the hole
or lens to be two inches in diameter, and the
distance of the focusing screen eight inches
from the aperture, the camera would be said to
be working at 8 divided by 2 = four or $f/4$.

For convenience this is written as either $\frac{1}{4}$ or
$f/4$ or spoken of as 1 to 4. To compare the rela-
tive rapidity of different lenses or ratio inten-
sity as it is called, the denominators are simply
squared, when the results will give the ratio of
rapidity. Thus compare ratio intensities of two
lenses working at $f/10$ and $f/20$ respectively.

Their relative rapidities are as 100: 400 or as
1: 4. That is the lens working at $f/10$ is four
times as quick as the lens working at $f/20$.

This holds with all lenses of whatsoever kind.
But it must be remembered that working
aperture is not necessarily the diameter of the
lens-tube, but of the area through which the rays
pass, thus fixed stops or introduced diaphragms
necessarily diminish the working aperture, but

when comparing two lenses in this way full aperture is understood, that is there are no diaphragms introduced. The student will now understand on what the quickness of the lens depends and why the introduction of smaller diaphragms increases the length of exposure, $f/8$ is a quick lens, $f/6$ very quick, and $f/3$ the quickest ordinarily made.

Now the next point is *what size will the image be on our ground-glass.*

Now it is evident that the size of the image depends upon the focal length of the lens and the distance of the object from the lens. We must remember here that there is one focal plane in a camera where the image is seen sharpest, by wheeling out or wheeling in the camera this sharpness is blurred. Now if a man is focused sharply and he moves *away*, we must follow him by wheeling in to get him sharp, and he gets smaller; and conversely, if he approaches we wheel out to get him on the focal plane and he gets bigger. Now providing we know any two of the factors, *i.e.*, focal length of lens, distance of object from lens, and size of image, the third can easily be found.

Let F be the principal focal length of the lens, D the distance of the object, F_1 the focal length at which the object is sharp. Then

$$\frac{1}{F} = \frac{1}{F_1} + \frac{1}{D}.$$

e.g. Take a lens of 20 inches equivalent focus and suppose the foreground or nearest object

we require to be sharp to be between 60 and 70 feet, say 800 inches; we have

$$\frac{1}{20} = \frac{1}{F_1} + \frac{1}{800},$$

39 F_1 = 800 or F_1 = 20·51.

So that the camera must be wheeled out half an inch beyond the position for parallel rays in order that the object be sharp; and the size of the image will be $\frac{1}{40}$th of that of the object, actually as 20.51 to 800.

Referring to our figure illustrating conjugate foci, we may state, for all practical needs, the object being distant 40 times the focus, the image will be $\frac{1}{40}$ of the focus beyond the focus for parallel rays, $\frac{20}{40}$ or half an inch.

If we wish, therefore, to get an image of a certain size, with a certain lens, we can determine how far off to place that object to get our desired size. Mr. Sécrétan, however, has worked out a series of most useful tables which are published.

Now for the time I wish my readers to regard all photographic lenses ever made as being exactly like one another, except in the matter of focal lengths and angles of view included, and when we regard the *size of images* and amount of view taken in, all lenses may be considered on these points as only quantitatively different. Now it is perfectly obvious that the narrower the angle of view included in the picture the longer the focal length. Therefore the question arises, within what angle must we work. Perspective has

clearly shown that we get better and more
pleasing views of objècts if we draw them
from a point distant twice the distance of the
greatest diameter. Now if we get off to that
distance we shall find it advisable to use what
are called long-focus lenses, and these neces-
sarily include a small angle of view.

Perspective and experience show that the best
working rule for choosing the focal length of the
lens is to select one twice the base length of a
picture as nearly as can be though a focal length
of the diagonal of the picture is safe. It will thus
be evident that if you use a wide-angle lens a
part of the picture will be in true perspec-
tive; and if you take a picture with a lens of
20 inches focal length, and one with a lens of
12 inch focal length, there will be a part of
the picture in this which can be enlarged so as
to give exactly the same picture as the 20 inch
focal length picture. Now the great advantage
to the novice to be derived from the use of lenses
of long focus is that he cannot so ignorantly em-
ploy them as he can the wide-angle lenses. Then
it will be asked, "what is the use of these wide-
angle lenses?" These lenses were made for
people (not artists) who wished to embrace the
whole of nature in their photographs, and they
were *made to include* large angles of view, not
to be correctly employed for using portions of
the picture only. When a view is taken with a
wide-angle lens close up, as is usual, the result-
ing photograph is artistically false, and these
lenses give false drawing thus, for we must look

at the complete result, and not cut out that por-
tion of the picture which is in good perspective.
The near objects are relatively out of propor-
tion; the eye cannot take in a wide angle of
view such as these without straining itself terri-
bly, which is not *looking* at a thing. We shall
be told that if we place the eye at the distance
of the focal length that the perspective will be
true. It will be true for the small portion we
can see, but not for the parts that we have to
strain our sight to include.*

Let anyone take a large building with a short
focus lens and then place his eye at the distance
of the focus, he will see, not the building, but a
few *sharp* windows, with modeling and tone
such as he never saw in nature. Putting the
eye at the distance of the focal length is the
best point of sight when the picture has been
taken in true perspective. This may be said to
hold of all pictures.

It will be seen from what I have said, that
the wide angle lenses can give true perspective
for certain portions of their picture if correctly
used, but that is no gain, and their use in
ignorant hands is so dangerous and their other
bad qualities so truthful, that I have no hesi-
tation in condemning them for artistic work.
The focal length of the lens then should be as
a working rule, twice the length of the base of

* We may state that the drawing given by the lens is the same as
with a pin-hole similarly disposed to the plate, the drawing being in
theoretical mathematical perspective, and may convince some who
would "strain at a gnat," that they see the whole picture as they
would view the object.

the picture, that will meet the case. A lens should never include more than 40 deg.

Apart from what may be called false perspective lenses (which they are if *used* for the purpose for which they are made), for it cannot too often be repeated that they are never made for the purpose of using them so they would be pictorially long focus lenses, *i. e.*, when portions of the picture are correct in perspective; there are certain *single* lenses that distort objects. Now the shorter the focus of a lens (the diameter remaining the same), the greater is the distortion. By using a diaphragm this distortion varies, for if the diaphragm be brought right up close to the optical center of the lens, its center only is free, there is no distortion, but if it be moved away from the lens, distortion follows within certain limits, for if moved towards the lens we get barrel-shaped distortion or a bulging of the sides of a square. By moving the diaphragm behind the lens towards the ground-glass we should get pin-cushion distortion or the opposite kind of bulging. This distortion is overcome say in a rapid rectilinear lens by uniting two objectives and placing the diaphragm in the middle; in short the lenses neutralize each other.

Now all single lenses have this distortion more or less; it is not perfectly corrected, it cannot be, so that is another point against them. Of course, if a large aperture single lens be employed and the picture only taken with the central or more parallel rays, this distortion is

almost inappreciable, but as we have said it is there, and the more of the lens is used the more distortion must you get. We have hitherto supposed all lenses to be theoretically alike for simplicity's sake, and every lens to possess the same qualities.

From this short study we have arrived at the fact that for naturalistic photography narrow angles, long focal lengths and rectilinear lenses must be used.

But there are many other qualities possessed by different lenses that we must discuss and weigh in the balance, and altogether try and find out what are the best all round lenses, so that we may give as true a visual impression of nature as possible.

This leads us to consider peculiarities in lenses called aberrations. If we return to the pin-hole camera we remember that as we increase the size of the aperture beyond a certain size the image becomes blurred. Now as our single lens gets bigger the marginal and central rays do not come to a focus on the focal plane at one and the same time. This is called spherical aberration because it results from the *sphericity* of the lens.

The other aberrations which we shall discuss as we proceed are chromatic aberration, curvature of the field, distortion, astigmatism, and lens reflection.

Now a lens with spherical aberration gives a halo to the image, the halo constitutes lateral spherical aberration.

To illustrate:

Figure VII illustrates the passage of marginal and central rays through an uncorrected

Fig VII

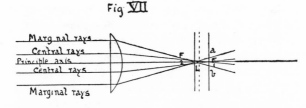

lens, the marginal rays come to a focus at $f/2$, considerably nearer the lens than the focus of the central rays which takes place at $f/1$, the distance between $f/1$ and $f/2$ is what is termed the longitudinal aberration, the transverse aberration is shown at A B. This occurs as an outstanding halo round the best focus possible, viz., at $f/1$. Between $f/1$ and $f/2$ there is a portion L, known as the least circle of aberration, and is the smallest section it is possible to make —the cone of rays convergent from the lens. The measure of a spherical aberration is greater or less according to the curves assigned to a glass lens constructed to produce a given focus. Practically an infinite number of curves may be ascribed to give the same focus, all differ-in the amount of longitudinal and transverse spherical aberration. Using glass of refractive index 1.5 the "crossed" lens in which the curvatures of the radii are as 1 to 6 will have the least aberration and a deep meniscus the most. Referring to the lens as shown in Fig.

VII the aberration given by this is nearly four
times greater than if the parallel rays were re-
ceived upon the convex surface, or in other
words, if the lens had been reversed.

The student would do well to examine this
aberration practically by focusing a lamp flame
with the full aperture of an uncorrected lens,
it is most visible with lenses of short foci, rela-
tively to their diameter. If we utilize only the
central rays, and this is readily done by using a
diaphragm, we shall be able to nearly destroy
the outstanding aberration when the aperture
is reduced to about $f/15$.

Spherical aberration is destroyed completely
by combining a negative lens with the con-
vergent lens. Such a lens is termed aplanatic.
In lens making, however, it is necessary not
only to cure the spherical aberration but the
chromatic aberration also, the latter must
always be considered of primary importance in
a well corrected lens. The form given to a
lens will be determined by the purpose for
which it is intended, such as, proper correction,
of flatness of field, equality of illumination,
freedom from marginal astigmatism, etc., so
that it frequently happens that spherical aber-
ration cannot be completely cured, sometimes
the effects of correction are to leave outstand-
ing possible spherical aberration, when a lens
is said to be under-corrected. Occasionally neg-
ative spherical aberration is found outstanding
when the lens is said to be over-corrected ; in
this latter case the marginal rays have a longer

focus than the central rays. We should mention here that this positive spherical aberration is occasionally purposely left outstanding in lenses to give a *softness* to the picture. Single lenses are invariable supplied with a fixed stop ranging between $f/10$ to $f/16$, and at their apertures the aberration is eliminated, if larger apertures are worked with, then the spherical aberration will assert itself. There is another defect noticeable in single lenses, whether corrected or not for spherical aberration.

If we examine a point of light off the axis of the lens it will be found that the central point or areol (if spherical aberration exists) lengthens as the point departs from the principal axis, forming what is technically termed a *coma*, this of course is inadmissible and has to be cured by the aid of the diaphragm, in an uncorrected single lens it requires a stop of about $f/30$, but if a " compound single " combination from $f/10$ to $f/16$.

If two lenses are compared, the one having twice the diameter of the other, their radii of curvatures being equal, the one with the double diameter will have four times as great longitudinal aberration, and eight times as great a circle of lateral aberration; again, if two lenses with the same aperture, of which the focal lengths are as one to two, that which has as its focal length, two, has half the longitudinal and one quarter the lateral aberration of the other.

Now, in certain lenses this aberration is completely destroyed by adding a divergent lens

which form together a convergent lens, free
from spherical aberration. Such lenses are
called " aplanatic " lenses, but in lens making it is
most important to correct chromatic aberration,
and though the same correction for spherical
aberration is applied for chromatic, it so hap-
pens that having to be perfectly corrected, the
spherical aberration is not always perfectly got
rid of, and if any remains, and if it corrects
spherical aberration too much, the system is said
to possess negative spherical aberration. If it
leaves too much spherical aberration, the system
is said to have positive spherical aberration.

The spherical aberration in the case of a sin-
gle combination, constructed to give a flat field
cannot be completely destroyed; it becomes
negligible with diaphragm apertures varying
from F. 10 to F. 16. This positive spherical
aberration is some times purposely left out-
standing in lenses to give a softness to the
picture.

We refer above to the aberration when present
in a narrow angle lens, where the rays are par-
allel to the axis of the lens, but when these rays
strike the lens obliquely as in wide angle
lenses, the longitudinal aberration alters its
position, and the areola lengthens as the point
departs from the principal axis, and going
through different forms lengthens until termin-
ating in a point at their upper end, which is
given the name " coma." This form also affects
an aplanatic system, for the rays of light fall
obliquely to its axis.

Now, this aberration has been considered a vital necessity in pictorial photography, and has been brought into great prominence of late, because unscrupulous opponents of naturalistic photography, not being able to controvert the first principles of Naturalistic Photography, tried to raise issue on subordinate points, and they naturally fixed on the one they knew would be most distasteful to photographers, namely, Diffusion versus Sharpness.

This diffusion has been advocated by one or two artistic photographers only. Sir W. J. Newton advocated it by throwing everything a little out of focus, which gives a superficially similar appearance as introducing positive spherical aberration into the lenses, as was afterwards done by Claudet and Dallmeyer, and Mrs. Cameron advocated it by precept, in her classical portraits.

This effect can be got by using a pinhole camera, but in this instrument the diffusion is equally spread over all the different planes, and there is no power of emphasizing one plane more than another and the latitude of the use of diffusion is limited, and, owing to the smallness of the aperture, things come out flat and lack modeling. The length in time in exposure, too, is against it.

Mr. Davison has made some interesting experiments in this direction, but we are certain that the pinhole camera is of no practical use; whatever can be done with it, can be better done by employing a lens with positive spherical

aberration which has every advantage, artistically considered, but it is undesirable. With Dallmeyer's original portrait lens, the quality can be introduced at will, by unscrewing the back combination; in our opinion, not a *desideratum.*

The only way, in using an aplanatic lens is to throw the principal object slightly out of focus, and by the judicious use of diaphragms, to arrange the picture so that the distant planes are out of focus. Sometimes it is not necessary to throw the principal object out of the sharpest focus. This is my principle.

But, it will be asked, to what extent may this power be used?

The answer is : so as not to carry it to the extent of destroying structure, as I have before laid down. What this means the student can see practically by focusing a white numeral on a black ground with the lens uncorrected for this aberration. He will find that in one position he cannot recognize the numeral, but as he stops down it takes form though the halo is still round it and though its detail is absent.

Since I enunciated my views on Naturalistic Photography, I have fully discussed this point elsewhere.

Lenses with no spherical aberration are aplanatic. The "rapid rectilinear" type, originally so named by Dallmeyer; properly corrected portrait lenses,—the long focus landscape lens, with the diaphragms *in situ,*—the lenses of Zeiss and Goerz,—are all aplanatic.

As all the lenses we shall use will be aplanatic we need not go farther into this matter.

CHROMATIC ABERRATION.

The next important aberration is that of chromatic aberration. If a beam of white light falls on an ordinary uncorrected lens, the prism breaks up the light and the rays are brought to different foci. The violet being more refrangible, has its focus at v, whilst the red has its focus at r ; the other rays focusing between these points.

Around each of these points can be seen halos which take off from the sharpness of the image. Now if one wants to take a photograph of this beam, and if we look at the point r on the screen we will find it appears clearest to us,

Fig: VIII.

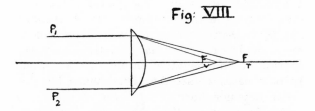

but if we put our focal plane there we shall only get a confused picture, because the violet rays are the active ones. But by wheeling in the camera up to v the image will grow sharper and sharper.

The plane v is the one to place the plate in. The brightest rays (of least refrangibility) look

brighter and clearer to us, but they have but little actinic power. The one is the " visual " focus—the other the " chemical " focus. These two foci must coincide or else the objective is said to have a chemical focus.

This aberration is corrected as we have said above, by using another lens of different dispersive power, for a lens cannot correct the chromatic without the spherical aberration, though it may do the reverse.

It is comparatively easy to correct this aberration for parallel rays, but for oblique rays this is very difficult, and is most apparent in wide angle single lenses, where it is not marginally perfectly corrected. This is one cause of the falsity of tone, which I was the first to notice in lenses.

The coma of such a lens is prismatic, as I have actually seen. The picture is, therefore, sharper in the middle. This aberration, like the spherical, may be over or under corrected, and we may then have positive chromatic aberration and negative chromatic aberration. In both cases we see the visual sharp, but the chemical is not sharp.

If a lens has positive chromatic aberration, objects nearer than that focused for come out best defined, but if the lens has negative chromatic aberration, objects farther off than that focused for appear best defined upon the photographic plate.

Mr. Dallmeyer has made me a lens with positive chromatic aberration—the aberration

purposely introduced to experiment with. In using such a lens, if we focus for an object everything between us and the object will be sharper than the object focused for, and all others beyond will fall away. It is, however, useless for artistic purposes, although more than one person said the problem has to be solved by such a lens.

CURVATURE OF FIELD.

To obtain perfect definition over the whole of the plate, with nearly all lenses the screen should have a slightly concave spherical form, corresponding to the curvature of the field of the image. Received upon a plane plate the image is sharpest in the middle and blurred around the edges—a fact often attributed to spherical aberration alone.

Together with this must be considered depth of focus. Monckhoven defines depth of focus as the property of lenses of giving a clear image— in planes of which the distance is unequal—it follows, therefore, that the screens may be moved slightly out of focus plane without the image appearing less sharp. This can be proved experimentally with a camera.

Their depth of focus varies with the aperture of the lens used, and this alone, for theoretically there is no such thing as depth of focus with an aplanatic lens.

Figure IX illustrates the manner of judging the distance through which the focusing screen

may be moved, still giving a sufficiently well defined image to be termed sharp. The limit permissable is one-hundredth of an inch, but this may be occasionally exceeded, and fre-

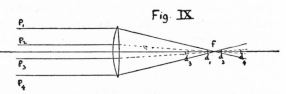

Fig. IX.

quently is by some photographers, due care being exercised that the extreme planes within which foreground and distance are included do not necessitate in their conjugate foci circles of indistinctness sufficiently large to destroy structure. In the figure it will be seen that the rays, P_1, P_4, cross the axis at the focus, F, at a considerably greater angle than do the more central rays, P_2, P_3. If we allow a circle of confusion as large as shown at d_1, d_2, the camera screen can only be moved between the planes of d_1, d_2, without giving too large an amount of out of focus effect. If on the other hand we insert a diaphragm and limit the passage of the rays to those passing between P_2, and P_3, it will be observed that the camera back may be moved within the very much greater distance, d_3, d_4, and still have no worse definition than recited in the former case.

We learn another lesson from this figure. One frequently hears the remark that with such and such a lens all objects beyond a certain distance are in focus. A plane passing

through F, is the focus, as we have seen, for parallel rays, and the screen is never moved nearer to the lens than this position. Now it is evident from this figure·that an object whose conjugate image would be formed at d_2, is the nearest to the lens when used at full aperture, that can be permitted; on the other hand, if the lens were stopped down as at P_2, P_3, objects considerably nearer would also be in focus, the nearest of all having its conjugate image at d_4. It will thus be seen that " depth of focus" varies as the aperture of the lens, lenses of high intensity having less depth of focus than slower lenses, and again less of it is obtained when focusing upon nearer objects. The stop must not be too small or diffraction will assert itself, and it is safe never to employ a stop smaller than $F/30$, certainly nothing smaller than $F/60$.

The effect of the diaphragm employed to give greater depth of focus also influences the curvature of the field of a lens, and by limiting the size of the marginal pencils produces the effect of greater flatness of field. As stated before, the employment of the new Jena glasses has enabled us to obtain lenses giving greater flatness of field than was formerly the case. Such lenses are invaluable for copying flat surfaces, such as maps and plans, but the slight curvature inherent in our best aplanatic lenses is seldom a drawback. It simply means this; that if the object photographed be flat the image will be slightly curved by the lens, but if the subject be arranged in a curve radially

from the lens as is frequently more or less the case, the image will be perfectly received upon the plane of the plate.

CURVATURE AND ASTIGMATISM.

In any lens with spherical aberration there is a position of a stop which gives a symmetrical excentrical pencil. Take a few examples of a single thin lens, the object being distant, in which case we always have positive spherical aberration.

Fig. X is a meniscus with convex side to incident beam. The radius of first surface being two and two-ninths inches and second surface four inches, the focus is ten inches, and the stop should be behind the lens at a distance

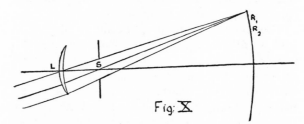

Fig. X

of one and nine-elevenths inches; the field is then free from astigmatism, the radius of curvature of field in primary and secondary planes being fifteen inches.

Fig. XI is a curved lens, the radius of first surface is five and five-ninths inches and second surface fifty inches; the focus, as before, is ten inches, and stop is here at vertex. Then

radius of curvature of field in primary plane is two and eight elevenths inches and secondary plane six inches, both being strongly curved, and principal plane most so.

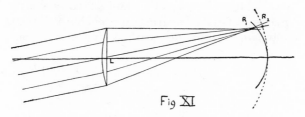

Fig XI

Fig. XII is case of plano-convex with plane side to incident light. Radius of second surface is five inches for ten inch equivalent focus

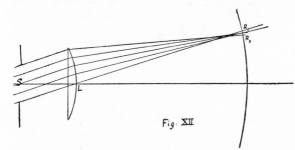

Fig. XII

lens. The stop is now in front of lens at distance of three and one-third inches, and here again there is no astigmatism, the radius of curvature in primary and secondary planes being both fifteen inches.

Fig. XIII is case of meniscus lens, but with concave side to incident light. Radius of first surface one and one-ninth inches and of second

ten-elevenths inch; distance of stop two-thirds
inch in front of lens.

Then radius of curvature of primary image
is one hundred and fifty inches and of second-
ary image twenty-one and three-sevenths
inches. This is nearest approach to flatness
that can be obtained with a single thin lens,

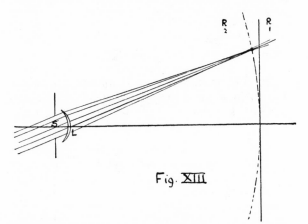

Fig. XIII.

and here there is astigmatism, the primary
curvature being less than secondary. R is the
radius of primary curvature, *i. e.*, the curvature
of field given by rays lying in the plane of the
drawing; R_2 radius of second curvature given
by rays lying in plane perpendicular to plane of
drawing; L is lens; S the stop.

When I began to study lenses in relation to
pictorial photography I was impressed by the
much truer expression given by some lenses
than by others. I first called attention to this

and found that coma and astigmatism were causes, as also unequal illumination.

Mr. Dallmeyer has taken the matter up since I first mentioned it in " Naturalistic Photography," and in a valuable paper " On reflected images, optical combinations, and their effect on the brilliancy of the final image," he throws more light on the subject. I shall quote from his paper, and although he does not apply it to the resulting tonality of the picture, he has unconsciously given us a great deal of help.

A flare spot is due to a real and uncorrected image of the diaphragm on the plate by internal reflection in the back of the lens upon the plate, and he says, as is well known, " an alteration in the position of the diaphragm cures it." Mr. Dallmeyer's deductions are :

1. The fewer the number of reflecting surfaces, *cæteris paribus*, the greater the brilliancy.

2. The smaller the diameter of a lens, *cæteris paribus*, the greater the brilliancy. Therefore, uncorrected surfaces and larger apertures, lower the tone of the image. This is easily seen by focusing an object with various lenses.

Next, as Mr. Dallmeyer points out, we must consider the light reflected by the lens and the diffused light in the coma and the reflection from the plate. As I said, I noticed practically long ago that the resulting image was different in tonality.

It has been shown, too, that a percentage of light is lost by reflection from the front of the lens. The scientific man will no doubt try

to measure all these things, but practical questions of tone are not to be so treated. The only method is for the experienced tonist to judge of the result by looking at nature and then at his camera picture.

As shown before, by throwing part of the picture out of focus, I got truer perspective and tone ; so by using large apertures I add here we get truer tonality. The small stops, besides killing modeling, injure tone, for different planes are rendered with equal brightness, which is fatal.

Mr. Dallmeyer is mistaken that I assume the mistiness due to true reflection gives atmosphere; that is a misconception. By using larger stops we get truer tones, and so get atmosphere, and by using certain lenses we do not get that unusual brilliancy which is as fatal as universal sharpness, but we get truer tone and so help to get atmosphere.

I have often been asked which lens gives the truest visual impression on the ground glass, and my experience is that the back combination of the rapid rectilinear gives the truest tonality when used at open aperture.

The long focus landscape lens, too, gives true tonality ; the wide angle landscape, false tonality when used at open aperture. It may be possible by analysis to find out here and there how various factors which affect the appearance of the image, may be controlled and modified. Though this will be a gain to science, I doubt if it will be much gain to art, for we can by

judiciously using a good aplanatic lens obtain fairly true tonality on our ground glass screens.

One of the effects of my throwing the principal object slightly out of focus, on some occasions, is to obtain a truer tonality. Spherical aberration of course affects the tone of the resulting image. It lowers it throughout and indiscriminately, and is, therefore, inartistic.

I doubt not but some curious studies could be made in the use of lenses uncorrected for spherical aberration. As has been said, we condemn all lenses with outstanding positive spherical aberration. What we want is an aplanatic lens, in a word, one corrected for all aberrations. These lenses are the triumph of optical science and are of various kinds.

Mr. Lake Price long ago said that the area of aperture of the lens was the very helm by which it was governed. This is so, given an aplanatic rectilinear lens.

Now, in choosing our lens we have to keep in mind the work for which it is intended.

There are times when we wish to use a quick lens, others when a big image of a distant object is important. Then we require long focus lenses. I think no one should use a lens including more than 40 degrees, and the* focal length we think should be at least as long as the diagonal of the plate used, preferably twice the length of the base of the plate. In a

*Of course this does not apply to lenses of peculiar construction like the telephoto lens.

specially constructed lens like the telephoto this does not of course apply.

The student will find it advisable to have a quick-acting rectilinear portrait combination like the Dallmeyer D. lens. A rapid rectilinear giving wide angle, and longer focal length, and a set of long focus landscape lenses. I have four of these for use with my camera.

The wide angle landscape and wide angle rectilinear lens I consider undesirable, for if they are not to be used as wide angles, of what good are they? Though it is true that if you enlarge a portion of the picture it will be the same as that taken by a wide angle, still, the lens is more cumbersome than a long focus including the same angle.

For example: Used on a 10-inch base a long focus landscape for 6½ x 8½ plate has a focal length of 12 inches, and includes an angle of 45 degrees, precisely the same angle and focal length as a 12 x 10 wide angle landscape gets in on the same plate.

Personally, I prefer a battery of lenses varying in focal length from 12 to 35 inches, and including angles varying from 23½ degrees to 45 degrees, the base line of my plate being 10 inches.

The Telephotographic or Large Image Lens.

This lens is constructed for photographing near objects of large size or distant objects of relatively large dimensions with comparatively

short camera extensions. In all lenses that we have hitherto dealt with, the optical center of the combination has been contained within the lens mount. In the telephotographic lens now under consideration, the entire system is positive in nature, forming a real image; its constituents are ordinarily a positive lens of which the focus is considerably longer than that of the negative component. It is evident that if the components were placed in close proximity the focus of the system would be negative and

hence no real image would be formed. By proper adjustment, however, of the separation between the two elements, a real image can be formed at any camera extension chosen. The shorter the extension the greater is the amount of subject (always a narrow angle) included upon the plate, and the greater the extension the less the amount included upon the same plate.

The greater the camera extension the longer is the corresponding equivalent focus.

This lens therefore has a great selective

power, and is invaluable in composing pictures
from its selective capability.

This lens differs in optical construction from
ordinary positive systems, in that the optical
center, or to be more precise, the nodal point
from which the equivalent focus is measured
lies outside and beyond the front combination.
The result of this is that the novice is astounded
at the large size of image that can be obtained
at a comparative short extension of camera.

In 1887 I asked Mr. Dallmeyer if such a lens
could not be made, and he replied—no! Next
in the autumn of '96, I again requested him
to assist me in the construction of an
instrument for the dual purpose of obtaining
large images of small objects in natural history
observations, as well as for photographing dis-
tances with truer rendering as regards per-
spective, and in a manner that should obviate the
depressed and dwarfed rendering given by all
ordinary photographic methods, and suggested
that the ordinary telescope could be converted
aud arranged for such a purpose. This Mr.
Dallmeyer very shortly accomplished, relying
(as he has pointed out in a paper delivered
before the Society of Arts) upon well known
principles in the science of optics and as the
history of the subject has shown he was the
first to do so in a serious manner for photo-
graphic purposes, and improvement after im-
provement has followed the first design. Need-
less to say many others seeing the commercial
value of such a construction followed in the

wake, but we wish to place on record the true history of the origin of this valuable adjunct to the apparatus of the photographic world.

The original construction was of very great power or magnification, but Mr. Dallmeyer has subsequently introduced instruments of more moderate power. The high power systems include an angle of 12 to 15 degrees, and the later more moderate power from 18 to 20 degrees.

Before giving shortly details of the method

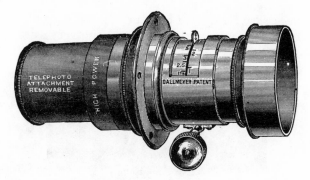

of calculating the focus and intensity ratios of the telephotographic system, we must call photographers' attention to two very important factors in the employment of this instrument.

In the first place as we have already stated the optical center of the combination being outside and beyond the front combination, it will be evident that the slightest tremor in the camera itself will appear very much exaggerated in the resulting image as against using an ordinary camera, in which the optical center is contained

within the lens itself for in the telephoto-
graphic lens we have practically to consider
any slight movement in the camera itself as a
movement of the short end of a lever, the
indistinctness of the image being reckoned by
the vibration or movement of the long arm of
the lever (in our case the optical center situated
outside the camera).

The other point to be taken into consideration
is one that can only be arrived at by practical
experience, and that is the very short exposures
necessary for distant objects. In ordinary pho-
tography, we usually find without very care-

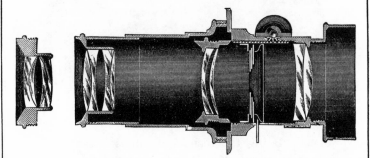

ful development that the distance is "burnt
out" if a full foreground development is re-
quired. No definite rule for reduction and
exposure for distant objects can be set down
but if the exposure is calculated according to
intensity ratios, we shall be safe in stating that
a reduction of one half to a third of that calcu-
lated in the ordinary manner may be given.

The simplest means for determining the cor-

responding foci and intensity ratios of a tele-
photographic system is by means of the ratio
between the foci of the positive and negative
elements. This ratio can always be determined,
for example, if a six inch lens is combined with
a three inch negative, the ratio is 2 to 1; if the
six inch positive is combined with a two inch
negative, the ratio is 3 to 1, and so on. If
the distance between the diaphragm of the lens
and the screen be measured and multiplied by
the ratio as above stated, the result will be the
equivalent focus of the system, and the intensity
is simply this equivalent focus, divided by the
clear aperture of the diaphragm employed.
This rule is quite sufficiently accurate for all
ordinary purposes, but we will add a further
and exact mathematical rule, dependent upon
the linear magnification of the image given by
the positive lens alone.

Magnification—Divide distance from negative
or posterior lens (after the image has been
focused sharply) to focusing screen by the focus
of the negative lens, and add one to the result.

Corresponding focus—Focus of positive lens
multiplied by the magnification.

Intensity ratio—Intensity of positive divided
by the magnification.

Delicate optical instruments, like lenses, must,
it is needless to say, be carefully protected.

A good lens should be free from scratches,
striations, dull patches due to imperfect polish-
ing, and veins; but air bubbles do not affect its
value, for it must be remembered that the shape

of the hole through which the light passes does not affect the image, save only by cutting off some of the light. Thus, if a wafer be stuck to the center of the lens, the image will be found unimpaired. Dust and dirt, however, though they do not seriously impair the definition of the image, yet cut off much light, as will occur to any one when he thinks of the difference between the light of a room, when the windows are dirty, and when they are perfectly clean. Lenses should not be left in bright sunlight, for this causes a change that slows them, the dark also injures them in certain cases, for, as all microscopists know well, darkness causes a change in Canada balsam, with which lenses are cemented together.

Mr. Dallmeyer insists that lenses should be kept dry and free from sudden changes of temperature, otherwise they may tarnish or sweat, as it is called. Any one who has been troubled with this sweating will never forget it. Our experience is that the best way to keep lenses is in small leather, velvet-lined cases. We generally keep with them a piece of soft chamois leather, or an old silk handkerchief. No compound of any kind should be used to clean lenses ; if anything appears to be going wrong with them, they should at once be sent to the maker.

A valuable little tool is a view-meter. The handiest and compactest we have seen is that supplied in telescopic form.

CHAPTER III.

DARK ROOM AND APPARATUS.

THERE is no need to despair if there be no dark room, no place to build one, no means to pay for one. Some of our most successful plates were developed in a scullery, and others in the bedroom of a house-boat. In fact, the sooner the student learns to develop anywhere, the better.

If a dark room be necessary, you cannot do better than build one as suggested by Captain Abney, in his "Treatise on Photography," modifying it to suit your taste and means. One thing, however, you should be careful about, and that is the ventilation, and money should not be spared on that department. The dark room can be scientifically ventilated by any good sanitary engineer. We have already, elsewhere, gone into the subject of ventilation of dark rooms, warning photographers of the pernicious effects of defective ventilation.* The best sinks are made of earthenware, as supplied by Doulton. The lamp should be large, and give a good light. Ruby glass is, to some, injurious to the eyesight, and has been known to

* "Ventilation of the Dark Room" and "Ammonia Poisoning" in the "Year Book of Photography and Photographic News Almanac" for 1886-87, and on "Pharyngitis and Photography" in the "Year Book of British Journal of Photography" for 1887.

produce nausea and vomiting, in which cases
cathedral green and yellow glass should be
added. The photographer will require at least
eight dishes, and at the very start he should
make it a rule never to use a dish save for one
purpose. We consider the best dishes for all
purposes are made of granatine or ebonite.
They should be bought in a nest, the smallest
size taking the largest plate used by the oper-
ator, and the other seven increasing in size, so
that one fits into the other. This makes them
more convenient for carriage. The dishes should
be distinguished by painting on their bottoms.
One will be wanted for developing, one for the
alum bath, one for the changing bath, one for the
hyposulphite bath, one for an intensifying bath,
leaving others over for odd jobs.

When it is remembered that hyposulphite of
soda is so "searching" that it has been known
to penetrate through the ordinary so-called
"porcelain" dishes and crystallize on the out-
side, one may judge how important it is to keep
a separate dish for each operation.

A light wooden board with a handle is most
convenient for putting over the developing dish,
in the earlier stages of developing, especially
when using orthochromatic plates, but the
student must be careful to keep it on a shelf by
itself. Another requisite is a broad brush of fine
sable hair, say three inches broad, this had bet-
ter be kept perfectly dry and clean in a box of
its own.

The chemical solutions should be kept in

bottles with glass stoppers, each bottle should have an enamelled label, so that it can be readily seen in the dark room and cannot be destroyed by acids. A zinc washing trough which holds two dozen plates must be procured. A simple wooden drainage rack is also neces- sary. We have tried several travelling lamps, and there are several good ones now on the market, of these we prefer the candle illumi- nated. Two measuring-glasses at least must be procured. It is as well to have one minim glass to hold sixty minims, and a large measure to take the full quantity of developer required for one plate. A pair of ordinary scales with weights (apothecaries'), costing a few shillings, will complete the list of apparatus required. A few simple printing frames will be wanted, one of which should be a size larger than the plate used. A square slab of glass, the size of the plate, and another a few inches larger each way, will be found the best for trimming prints upon. A razor or very sharp knife will be found the best tool for this purpose.

Our student should get all these things of good quality, and set his face against the syrens who whisper in his ear that he ought to get this and ought to have that ; he does not want anything more than we have told him, a greater number of things will only embarrass him. We are perfectly well aware that the most elaborate fittings have been put up by photographers, and we are equally aware that these have as yet not led to the production of a single picture.

CHAPTER IV.

THE STUDIO.

For portraiture a studio is a necessity for obtaining the best results. We shall very briefly discuss the question of studios, for we hold that, provided a studio be large enough and light enough, there is not much else to consider. We have been in several studios, and worked for a considerable time in them, one of which we, having hired, had all to ourselves, so that our remarks are based on the experience of studios photographic as well as on those of painters and sculptors.

The best light is undoubtedly a top light and a side light, the side light reaching to within a few feet of the ground. It is a common fallacy among some portrait photographers that the side light should reach to the ground, so that the boots may be lighted. Such an idea evidently arises from a misconception of the thing required ; the boots are to be subdued as much as possible, it is the model's portrait we want, not that of his boots. The studio in this country should, if possible, face north or northeast, the roof slooping at a inclination of half a right angle. There should be no tall buildings standing near it, as exterior shadows and reflections interfere with the purity of lighting.

We do not intend to give specifications for the building of a studio, for this has been already admirably done; this proviso only being made, that the studio be made long enough to use long-focus lenses so that we shall get better results. The glazing should not extend from one end of the studio to the other; an unglazed space should be left at each end. By curtains the length of glazing can always be shortened. A gray distemper is perhaps the most suitable color for the walls.

Successful portraits can be taken in ordinary sitting-rooms, but we do not think the best results can be obtained in this way, although fine pictures of the man and his surroundings can be obtained, but not the best portrait pictures, on account of the inferior and comparatively ill lighting, although there are, no doubt, rooms in private houses as good as any studio, but such cases are exceptionable.

Regarding business arrangements and conveniences, we have nothing to do with them.

FURNITURE.

The old, and even modern, portrait painters are answerable for many of the faults to this day committed by photographers, because they take portrait painters as models. Lawrence was especially guilty in the use of conventional backgrounds and accessories. Of photographic furniture, as generally understood, there should be *none*. The studio should be furnished

simply, and with taste, as an ordinary sitting-room. There should be no shams of any kind, and the furniture should be chosen with a regard to unobtrusiveness and grace, rather than massive beauty. All heavy curtains, draperies, hot-house plants, and such incongruous lumber, should be avoided. It should be remembered that what is wanted is a portrait—the face, or figure, or both—and all accessories should be subdued. It is very little use to lay down rules for these things, all must depend on the individual taste of the photographer.

But, above all, avoid shams and cheap ornamental objects, such as cheap bronzes, china pots, and Birmingham *bric-a-brac*. The chairs should be upholstered with some good plain colored cloth, with no pattern, and the floor carpeted with matting, or a simply colored carpet without pattern. Let simplicity and harmony predominate. The room in fact should be a harmony in some cool color, and the furniture should not be *felt* when in the room.

Head-rests must be entirely tabooed. We have taken many portraits some with very long exposures and no head-rest was necessary. In nine cases out of ten it simply ruins the portrait from an artistic point of view.

Reflectors, on light stands, should be ready for use ; but it is obviously erroneous to use large and unwieldy reflectors. The reflector is really only necessary for the head and

shoulders ; for our object is to subdue all other parts as much as possible.

All artificial backgrounds should be banished, together with such stupid lumber as banisters, pedestals, and stiles : they are all inartistic in the extreme. It is a false idea to represent people in positions they are never found in—such as a girl in evening dress against a seascape, and all the other hideous conventionalities of vulgar imagination. The background—which is a matter of vital importance—should be arranged to suit the sitter, that is, a harmony of color should be aimed at. Light fabrics without patterns, skins, or pieces of tapestry, will serve every purpose and give more desirable results. The portraitist should keep a selection of pieces of fabric of light hues, and a light skeleton screen can be kept ready, to which to tack them as required, suiting the color to the dress of the sitter. Gradated backgrounds are a mistake, the tonality is much better shown by having a background of one tint, and so arrang- ing the light that the modelling and tonality shall be decorative.

Breadth and simplicity are the foundations of all good work. The background should never be placed close behind the sitter, as is customary ; but its distance from the sitter should be studied with the lighting. As a rule, it is better to place the background three or four feet from the back of the sitter. What is required is that the head shall melt softly into the background, and yet retains its modelling.

The camera should work with a shutter—the Cadett pneumatic shutter for portraiture being as good as any we know—and the pneumatic apparatus should have a very long india-rubber tube attached, for reasons to be explained later on.

Means may be arranged for taking pictures by artificial light, if necessary, though personally we do not care for them. The tonality, though true to the light, has a false, artificial appearance by day. There are many methods of making artificially lighted pictures; the best, in our opinion, are those taken by the electric light. Others are done by gas, and by magnesium flashes—a method quite recently revived as something new, and for certain groups, most useful. The best of those we have seen gave results that appeared to us somewhat artificial.

You must remember that in a studio you are taking a person *in a room*, and that is the impression you must try to get in your picture *It is a false idea and an inartistic one to endeavor to represent outdoor effects in a studio.* Studio lighting and outdoor lighting are radically different, and in a studio you have only to try and give an *indoor effect.* This has been the principle of all great artists. None but an amateur could fail to notice the falsity of lighting as seen in outdoor subjects taken in the studio. On the other hand, in a studio you may get any effect of lighting you can for indoor subjects, for all such effects are to seen in a room by a careful observer. Adam Salomon took many of his

portraits in front of a red-glass window. This is quite legitimate, as is also the arrangement of fabrics for the background, and the dictating what colored dress the sitter shall wear. Let our student work in harmonies of color as much as possible, and let him never take outdoor effects in a studio. Make the room as much like a comfortable sitting-room as possible, and hide all the tools of the craft.

CHAPTER V.

FOCUSING

HAVING now seen the principles by which we must be governed, and the apparatus required, we will briefly apply them.

By focusing we understand, bringing the ground-glass into the plane which coincides with the sharpest projection of the image called the focal plane ; the position of this plane varying of course with the focal length of the lens and the distance of the object from the lens. Presuming, then, that the camera is in register, and set squarely before the object to be photographed, as can be determined by the spirit-level, let the student proceed to focus his picture as sharply as he can *without any* "stop." He must be careful that the swing-backs are parallel to the front planes of the camera.

Now the great habit to cultivate is to think in values and masses, that is, you must, in your mind, by constant practice, analyze nature into masses and values, and if you constantly practise this at the beginning, you will find that it becomes a habit, and automatically, as you look at a scene or a person, you will see on the ground-glass of your mind the object translated into black and white masses, and you will

notice their relative values. This habit is absolutely necessary for good work, for it is by this analysis that you will learn to know what is suitable for pictorial art, and what is not ; for if the masses and values in a picture are not correctly expressed, nothing will ever put the picture right. Our own experience has been that where this analysis has left an impression of a few strong masses, the picture has always been stronger when finished than otherwise. Now our student, having sharply focussed his picture with open lens, must take his head from beneath the focusing cloth, and look steadily at his picture ; fixing his eye on the principal object in the picture, he should go through this mental analysis, and at the same time note carefully how much detail he can see, both in the field of direct and indirect vision; and his object should be to render as truly as possible the impression thus obtained. He should then look on the focusing screen, and putting in his largest diaphragm, and using his swing-backs, and altering the focusing as may be necessary, see how truly he can get this impression, always remembering that the larger the diaphragm he uses the better, for he will remember that after a certain aperture many useful aberrations are cut off. For this reason he should always begin with an open aperture, and work down to the smaller size diaphragm as needed. By working in this way, he will soon see what command he has over his translation, all by the judicious use of his focusing

screen, swing-backs, and diaphragm combined. In focusing he must remember one thing— never to focus so that it can be detected in the picture where the sharper focusing ends and the less sharp focusing begins—as can be brought about by diaphragms. The sharpness should be gradated gently. He must also remember that the ground-glass picture is false and deceptive in its brightness, even in a perfectly aplanatic lens, due to obvious physical facts. This is a point of great importance, which must not be forgotten. The ground-glass picture, though greatly admired by the Tramontane masters, and approved by Canaletto and Ribera, as Count Algarotti assures us in one of his raptures on the camera obscura, is not so natural and beautiful as it may appear from the toy point of view—it is not what the artist wants, any more than he wants the pictures of an ordinary camera obscura, for if these pictures were satisfying in an artistic sense, every one could, by erecting a camera obscura, have the satisfaction of his desire, and there would soon be an end to the pictorial arts, for no one who loved this picture so dearly would want a camera to take photographs with, but only one to look through. The deceptive luminosity of the ground-glass picture must not be allowed to influence our normal mental analysis of the natural scene. As we said before, therefore, the principal object in the picture must be fairly sharp, *just as sharp as the eyes see it, and*

no sharper ; but everything else, and all other planes of the picture, must be subdued, so that the resulting print shall give an impression to the eye as nearly identical as possible to the impression given by the natural scene. But, at the same time, it must be distinctly understood that so-called "fuzziness" must not be carried to the length of *destroying the structure* of any object, otherwise it becomes noticeable, and by attracting the eye detracts from the general harmony, and is then just as harmful as excessive sharpness would be. Experience has shown, that it is nearly always necessary to throw the principal object slightly (often only just perceptibly) out of focus, to obtain a natural appearance, except when there is much moisture in the air, as on a heavy mist-laden gray day, when we have found that the principal object (out of doors) may be focused *quite sharply*, and yet appear natural, for the mist scattering the light softens the contours of all objects. In the cases of lenses with positive spherical aberration this holds too, but they are more suitable for portraiture, though at times they will do for figure subjects, but as a rule the conjugates in landscape are too widely apart to give them any advantage. Nothing in nature has a hard outline, but everything is seen against something else, and its outlines fade gently into that something else, often so subtilely that you cannot quite distinguish where one ends and the other begins. In this mingled decision and indecision, this lost and found, lies all the

charm and mystery of nature. This is what
the artist seeks, and what the photographer, as
a rule, strenuously avoids.

As this loss of outline increases with the
grayness produced by atmosphere, it follows
that it is greater on gray days and in the dis-
tance ; and less on bright, sunshiny days. For
this reason, therefore, the student, must be very
careful on bright days about his focusing, for
on such days there is often no mist to assist
him, but still he must keep the *planes separate*
and attain good modelling, or he has no picture.
Let us image an example : A decaying wooden
landing-stage stands beneath some weeping
willows at the edge of a lake. From the land-
ing-stage a path leads through a garden to a
thatched cottage one hundred yards distant ;
behind the cottage is an avenue of tall poplars.
On the landing-stage stands a beautiful sun-
bronzed village girl in a plain print dress ; she
is leaning against the willow and is looking
dreamily at the water. We row by on the lake,
and are struck by the picture, but above all by
the dazzling native beauty of the peasant girl ;
our eyes are fixed on the ruddy face and we
can look at nothing else. If we are cool enough
to analyze the picture, what is it we see directly
and sharply ? The girl's beautiful head, and
nothing else, and we can only see that from
one point of sight. We are conscious of the
willow-tree, conscious of the light dress and the
decaying timbers of the landing stage, conscious
of the cottage, away in the middle distance,

and conscious of the poplars telling blue and
misty over the cottage roof ; conscious, too, are
we of the water lapping round the landing-
stage ;—we feel all these, but we see clearly and
definitely only the charming face, unless we
move our head. Thus it is always in nature,
and thus it should be in a picture. Let us,
however, still keep to our scene, and imagine
now that the whole shifts, as does scenery on a
stage ; gradually the girl's dress and the bark
and leaves of the willow grow sharp, the cottage
moves up and is quite sharp, so that the girl's
form looks cut out upon it, the poplars in the
distance are sharp, and the water closes up and
the ripples on its surface and the lilies are all
sharp. And where is the picture ? Gone !
The girl is there, but she is a mere patch in all
the sharp details; all relief, contract and model-
ling are lost. Our eyes keep roving from the
bark to the willow leaves and on from the cot-
tage thatch to the ripple on the water, *there is
no rest*, all the picture has been jammed into one
plane, and all the interest equally divided.
Now this is exactly what happens when a deep
focusing lens with small diaphragms is used,
the operator (for no artist would do this) tries
to make everything sharp from corner to cor-
ner. Let the student choose a subject such as
we have suggested, and put what we have
imagined into practice, and he will see the
result; he must, for scientific reasons, lose model-
ling and so flatten his picture, to say nothing of
other causes. Yet this "sharp" ideal is the

childish view taken of nature by the uneducated
in art matters, and they call their productions
true, whereas, they are just about as artistically
false as can be. For this reason, too, it must be
remembered that the foreground is not always
to be rendered sharply. If our principal object
is in the middle distance, let us say, for example,
some cottages on the border of a lake; our
foreground, consisting we will suppose of
aquatic plants, must be kept down, and pur-
posely made unimportant. This is done chiefly
by the focusing and stopping.

Among the few satisfactory portraits we have
seen, that fatal sharpness has been avoided.
The well-known miniature painter, Sir W. J.
Newton, one of the first vice-presidents of the
Photographic Society of Great Britain, distinctly
advised that all portraits should be thrown a
" little out of focus." The falsity of focusing a
head sharply is shown by the fact that by doing
so freckles and pimples, which are not noticed
by the eye, stand out most obtrusively, indeed
a case is on record, where an eruption of small-
pox was detected in its earliest stage by the
lens, while nothing at all could be detected by
the eye, though this was but partly due to
the lens, and part was owing to chemical rea-
sons. This false focusing has brought in its
train another huge falsity—retouching—of
which we shall speak more fully hereafter.

Sharp focusing, too, by making objects tell
relatively too strongly, throws them out of tone,
and so ruins the picture. When sharpness is

obtained by stopping down, the diaphragm cuts off light and injures normal brilliancy, flattens the modelling, cuts off the useful aberrations, exaggerates shadows, and so throws the picture out of tone. Of course, if the object in view is to produce a diagram for scientific purposes such, for instance, as photographs of flowers for a work on botany, or of fish for a work on ichthyology, or of butterflies for a work on entomology, the most brilliant illumination possible should be aimed at, and the focusing should be microscopically sharp, for such works are required to show the *structure* as well as the form, but even in these the modelling must not be flattened. But, above all, the drawing should be correct, and this is approximately obtainable only by the correct use of lenses, which, as we have pointed out, has not always been the case. If, on the other hand, the operator wishes to produce *pictures* of flowers, butterflies, fruit, fish, &c., the same rules hold good as for any other *picture*. As an example of the treatment of flowers, the student will do well to study Mr. Fantin's paintings of flowers.

We have seldom seen flowers, fruit, or still life decoratively rendered by photography, though we have seen many scientific records to all appearances perfect, but in which the drawing was often a little false. We have seen it stated by the inexperienced who have produced diagrams of microscopic and other objects, that they were untouched (and rightly so), and that, *therefore,* these diagrams were

artistic and true to nature. Of course, from
what has been already said, it is obvious they
were not necessarily true to nature (though,
perhaps, none the less useful for that), and the
statement that they were "artistic" arises of
course from a total misconception as to what
that word means.

Here, then, we must quit this subject, and we
hope that we have impressed upon the student
the fundamental necessity for exercising much
thought, and judgment, and care, in focusing,
stopping down, and using the swing backs, for
these three all work together, and are quite as
important as the questions of exposure and
development. If the student has mastered all
that has gone before, and thoroughly under-
stands his text, he will not stumble over focus-
ing.

Of course there is no absolute state of "sharp-
est focus," but when we use the word "sharp"
we mean the sharpest focus obtainable by any
existing photographic lens when used in the
ordinary way.

CHAPTER VI.

Exposure.

A plate can be exposed in three ways, that is,
by removing the cap and replacing it, when the
exposure is made; by folding the camera cloth
and placing it over the lens (the cap having
been removed), before the shutter of the dark-
side is drawn, and then quickly withdrawing
and replacing the cloth and sliding back the
shutter; and thirdly by using a mechanical aid,
called a shutter.

The first method needs no comment save that
the cap should be withdrawn in an upward
direction. The second method has been of in-
valuable service to us, and is much practised by
Scotch photographers. By this means very rapid
exposures can be made, and yet detail obtained
in dark foreground masses. The third method
is so well known that hundreds of mechanical
contrivances, called "instantaneous shutters,"
have been invented. We have always done all
the work we could by quick exposures, and
here we may at once say that for pictorial pur-
poses "quick exposures" are absolutely neces-
sary where possible. We do not say "instanta-
neous exposures," because it is high time that
this unmeaning word should be relegated to the
limbo of photographic archaics. Is it not ob-

viously illogical to call exposures of $\frac{1}{200}$ of a second, and of one second, both instantaneous? —yet such at present is the custom. "Instantaneous" means nothing at all, for a quicker exposure can be obtained by the second method we have described than with some shutters. It is in fact difficult to classify exposures, for obviously the classification must be based, *cæteris paribus*, on the time the plate is exposed, and this, especially in quick exposures, is not to be measured save by special apparatus, which of course is of no use for every-day work. We offer as a suggestion the following rough working classification for describing exposures. We would define as

QUICK EXPOSURES,

Uncapping and capping lens *as quickly as possible*. Snatching velvet cloth away and replacing it *as quickly as possible*. All shutter exposures which *cannot be timed* by the ordinary second-hand of a watch ; a note being added in the case of shutter exposures, giving make of shutter, and stating whether it was set to quickest, medium, or slow pace.

TIME EXPOSURES.

All other exposures might be called *time exposures*, it being understood by this term, *that the exposure was long enough to be counted by the second-hand of an ordinary watch.* A note could always be added, giving the number of seconds the plate was exposed.

We are perfectly aware this method would give only approximately rough statements of the times of exposure, but that is all that is wanted for ordinary work, for after all, except in delicate scientific experiments, the times given to exposures must always be roughly true. On the other hand, in cases of delicate scientific work, it may be required to measure exactly the length of the exposure, and this is easily done with the proper apparatus, as applied by Mr. Marey and others. Our nomenclature is intended for the use of ordinary operators, so that they may describe fairly accurately the exposure given to a particular plate; and it is at any rate more accurate than any nomenclature now in use, for, as we have shown, by the camera cloth method a quicker exposure can be made than with many shutters working slowly. The fundamental distinction, it seems to us, for everyday work is, whether the time of exposure is measurable by the second-hand of an ordinary watch or not, and that is the point on which our nomenclature is based. Hence, when we use the term "quick exposures" in this work, we mean it as already defined. The shutters themselves should, we think, be called "quick exposure shutters," or simply "exposure shutters," instead of instantaneous shutters. We will say but few words on "shutters," as these mechanical aids to exposure are called.

Theoretically, the best shutter is that which allows the lens to work at full aperture for the longest time, and which causes no

vibration or alteration of the position of the apparatus during exposure. The mechanism should be simple and strong, and the whole small in bulk. We find Thornton & Pickard's shutter the handiest for out-door work. Another important matter is the correct position of the shutter, and this, theoretically again, is behind the lens, providing the aperture be large enough to prevent any of the rays of light admitted by the lens being cut off. But in practice, a shutter working in the diaphragm slot of the lens answers best, and theoretically the worst way of all is to work the shutter on the hood of the lens.

All portraits should be taken by shutter, and by quick exposure, if possible ; in fact, we feel sure a *first principle of all pictorial work in photography is quick exposure.* There is nothing to be said for time exposures, although we are fully aware how much has been written on their advantages, and the beneficial effects on the resulting negatives. We, however, have never seen these wonderful gains, and for quality we have seen very rapidly exposed plates result in negatives which will hold their own in quality against any, whilst in every other respect there is everything to lose in "slow" or time exposures. Quick plates in addition allow of a wider range of tone. There are cases, of course, when time exposures are admissible, and even necessary, as in certain gray-day landscapes, but when dealing with figures or portraits in good light, let the exposure be as quick

as possible, ere the freshness and naturalness of the model be lost.

From what has already been said, the student can understand that the exposure will vary with the attendant circumstances. When he considers that there are several factors to be considered in determining the length of exposure, such as the lens used, the diaphragm, the hour of day, the season of the year, the constantly varying conditions of light, the subject, and the plate used—he will see how apparently hopeless the subject is, but Hurter & Driffield's exposure meter * will prove invaluable.

Still, a few examples showing the protean aspects of nature, and the difficulties of dealing with it, will illustrate our meaning. Bouquet has calculated that the sun at an altitude of 50 deg. above the horizon is 1200 times brighter than at sunrise. If we, then, apply the ordinary chemical law, that the chemical action is proportionate to the illumination, noon would be the time to give the least exposure ; but such is not our experience, for the period of greatest intensity is often an hour or so before or after noon, because the angle of reflection is more favorable to us in England. Again, another factor to be considered is the presence of clouds ; white clouds needing less exposure, as they reflect light to a powerful extent. Again, in sunrise and sunset light we have to consider refraction, the warm colors predominating. Another point to consider is our altitude, for there is less

*To be bought at Messrs Marion & Co.'s, Soho Square, London.

atmosphere in high altitudes ; therefore, as any
Alpine traveler knows, the sun acts more pow-
erfully on the peaks than in the valleys. Dr.
Vogel tells us that the light of the blue sky is
chemically active and powerfully so. It will be
seen, then, from previous remarks, why winter
light is so feeble. Bunsen has worked out the
chemical power of light, and expressed it in
degrees thus :

	12 (noon).	1 p.m.	2 p.m.	3 p.m.	4 p.m.
June 1	38°	38°	38°	37°	35°
Dec. 21 ...	20°	18°	15°	9°	0°

	5 p.m.	6 p.m.	7 p.m.	8 p.m.
June 1	30°	24°	14°	6°
Dec. 21 ...	0°			

Thus at noon on June 21st the light is nearly
twice as powerful as on December 21st, and
when we couple with this fact the moisture gen-
erally found in the atmosphere at mid-winter,
we see how deceiving are appearances. Again,
it is acknowledged by many that the light in
autumn is one and a half times as great as it is
in spring ; but we cannot act on this knowledge
alone for outdoor work, for the conditions of
vegetation are quite different, for, as Tyndall
has shown, "in delicate spring foliage the blue
of the solar light is for the most part absorbed,
and a light mainly yellowish-green, but contain-
ing a considerable quantity of red, escapes from
the leaf to the eye: . . . as the year advances
the crimson gradually hardens to a coppery
red."

Another complication is the east wind. It
certainly sweeps away the moisture from the

air and dries everything up, giving all things a
black shade, and bringing them up closer to
view, at the same time dwarfing distant objects;
and while an east wind does all this by taking
away moisture from the atmosphere, the actinic
value of light is at the same time lowered. On
the other hand, after rain, the light acts quickly,
probably owing to the numerous reflections from
moist leaves, and from the fact that they do not
absorb so much light under these conditions.
That the warm colors require a longer exposure
than others is too well known to need dwelling
on. The presence of water in the foreground,
on the other hand, necessitates a shorter expos-
ure : even the amount of sky included in the
picture will affect the length of exposure. The
existing temperature, too, strongly affects the
negative.

It is perhaps necessary here to state that there
is no set key or scheme of lighting to work by.
Some persons have preached that no photograph
should be taken when there is no sun, or that
sunlight is the best time for taking a photograph;
such statements are as absurd as childish, one
might as well ordain that all music should be
played in one key. As beautiful pictures are to
be obtained on the gray dull days of November
as in sunny June. We remember once reading
a statement that all paintings were of sunshine
subjects. We quite forget by whom this extraor-
dinary statement was made, but at any rate the
writer must have been very ignorant of his
subject ; he could never have heard of half the

great pictures of the world ; but surely the name of Rembrandt might have occurred to him. A photograph must be true in sentiment, and as true as possible to the impression of the time of day, just as a picture must be. There are some subjects which in sunshine look beautiful, and which on gray days are worthless, and *vice versa*. Therefore, here again there is no rule, each subject must be judged by itself.

The rapidity of plates can be measured by an instrument called a sensitometer. Actinometers are valuable aids, and we recommend Hurter & Driffield's instrument.

But as in all good things, simplicity goes hand in hand with perfection. We have advocated quick exposures as absolutely essential to pictorial work, and it follows, therefore, that in making quick exposures there is less liability of going wrong ; so the two work hand in hand. He who exposes slowly misses the very essence of nature, and it is this very power of exposing so quickly that gives us a great advantage over the graphic arts. The painter has to resort to all sorts of devices to secure an effect, which perhaps only lasts for half an hour in the day. Not so with photographers, if we see and desire to perpetuate an effect, it is ours in the twinkling of an eye, and thus in a really first-rate photograph there will always be a convincing freshness and naturalism.

Here, then, we must leave the very vital question of exposure. It is, perhaps, the most important and the most difficult of all photo-

graphic acts. In the studio the matter is simpler than out of doors, because the light is not so much affected by ever varying meteorological conditions; in landscape work, on the other hand, exposure becomes a most difficult problem.

It is in exposures that intuition acts, as it does in all intellectual matters, and he who can seize on the right exposure at once by instinct is the photographer born.

CHAPTER VII.

Development.

BEFORE entering on the subject of development, it is necessary to tell the student that if he does not already understand the principles of chemistry, he should lose no time in doing so, and as aids to such understanding he cannot do better than get Roscoe's "Lessons in Elementary Chemistry,"* and Abney's "Photography with Emulsions," and master the chapters mentioned in the footnote, ignoring the rest for the time. Also let him buy Bloxham's "Laboratory Teaching." For a few shillings he can purchase apparatus enough to do qualitative analysis. This he will be able to do by following Mr. Bloxham's directions, omitting, perhaps, testing with the blow-pipe. If he has the time and means, he will do well to do some quantitative analysis, working, say with water, since it is of such immense importance to the photographer. He will find a knowledge of chemistry as interesting as use-

* Roscoe's Chemistry :
Lessons 1, 2, 3, 4, 5, 6, 7, 8, 9, 10, 11, 12, 13, 14, 15, 16, 17, 18, and potassium, sodium, and ammonium in lessons 19, 22, 23; chromium and uranium in lesson 25 ; mercury, silver, and platinum in lessons 26, 27, and 28.
Photography with Emulsions :
Caps. 1, 2, 3, 5, 6, 7, 8, 9, 22, 24, and 31.

ful, and the power of observation and accuracy acquired by the study will be invaluable in subsequent stages of his work. We refer the student to works on chemistry by specialists, because we think it is a mistake to swell the bulk of our book by an exposition of chemical principles. We caution the student, however, who intends to take up pictorial photography to have nothing to do with plate-making. That manufacture can only be done satisfactorily by experts constantly employed at it, and it is as reasonable to expect a painter to prepare his own colors, and make his own canvas, as to insist upon a photographer making his own plates.

Some people have tried to propagate the false idea that a picture taken on a plate of the exhibitor's own making has a special kind of merit, but obviously this is only true when the object is an "Emulsion process competition." In judging of the merits of a picture, no facts should be taken into consideration, save its pictorial qualities. Still the student should know the methods by which his plates are prepared, and that his chemistry will teach him, and when he has found plates which suit him, let him keep to them. We have worked with fourteen different kinds of plates, and have found most of them good, though each requires different treatment. One piece of advice is, however, necessary, always buy your plates direct from the makers, unless you can rely upon your dealer. Some plates

are, of course, much quicker than others, and
this point the beginner must carefully bear in
mind, making his exposures accordingly. He
must not forget, however, that there are brands
of plates which are "starved" of silver ; these
he should avoid, and it would be well if a
vigilance committee were appointed in every
society to test batches of plates occasionally,
and report on them in the photographic jour-
nals, thus showing up the fraudulent manu-
facturers. Assuming, then, that the student
has carefully studied the chemistry of develop-
ment and has fixed on a satisfactory brand of
plates, we will proceed to give him a few prac-
tical hints, but before we do so we must get rid
of an obstacle in his path, and that is the wet-
plate process.

If the student were to ask ten middle-aged
photographers whether they prefer a wet plate
or a dry plate negative, nine out of ten would
without doubt answer, "Oh, a wet-plate neg-
ative." If the student is curious and asks, why ?
he will get a vague answer, in which the words
"bloom" and "beauty" play conspicuous
parts, the adjectives reminding him of an ad-
vertisement for patent balms for the skin.
The fact is, not knowing the first principles of
art, photographers have raised for themselves
false gods, and they are still worshiping them.
Let us at once and most emphatically state
that wet plate negatives do not give so true an
impression of nature as a gelatino-bromide
plate. We have seen much of the best of Mrs.

Cameron's work, and she obtained from collodion and silver decidedly the best results ever obtained from wet plates, for she had artistic insight, yet even in her work the tonality is not so true, and the "quality" and freshness is not so fine as can be obtained from gelatino-bromide negatives. The work by this process is hard, and incapable of expressing texture correctly, while the general impression is more or less artificial. This is fortunate for us, for the slowness of the wet-plate process would seriously handicap it, even if the result were better than that of dry plates. The inadequacy of collodion plates is emphasized when we look at the work of the vulgar who used them, and whose ideal was sharpness and "bloom." Such work will be found most unnatural and undesirable. Surely many of the false ideas current amongst photographers arose from the evolution of the art. Daguerreotypes, the first photographs, were shiny, and most of the subsequent processes followed in their wake, until one clear-sighted photographer, Blanquart-Evrard, tried to combat the evil tendencies. Considering, then, the poor pictorial quality of collodion plates and their slowness in exposure, there is absolutely nothing to be said in their favor. It is decided, then, that our student will work with gelatino-bromide plates.

We will assume now that we have our "latent image" on the plate, correctly exposed. We must now bring it out or develop and fix it, and this is one of the easiest processes of photography;

provided the exposure has been correct. Let us remember that the light reflected from the different planes of objects before the camera, has acted on the molecules of haloid salts in our emulsion in different ratios, that is, the light reflected from white objects has eaten into the plate, not deeply, the depth of erosion varying as we descend the tonal scale until we reach the black, but as light acts on everything in nature we shall get a certain amount of etching or eating into the blacks even. Now it will be quite clear that different tones or planes will be bitten by the light (if we may so express) according as they reflect light. We shall thus develop first the plane of high lights and so on, then the middle planes, till we come to the delicate grays of the distance. In short, the action is analogous to the biting of an etched plate which has bitten-in tones, with this difference, that in the etched plate we bite the *blacks* first, as that is a positive, and in the photographic plate we bite the white first. But alas! in the photograph we cannot control the biting; it is mechanical.

We have now our dishes ready and we mix our developer according to directions given with the plates and to our exposure as before. We remember the action of our chemicals. After taking our plate from the carrier we brush it over to remove all dust particles and plunge it into the developer, taking care that the developer covers the plate at once or we shall surely get uneven patches. Then

rocking the plate gently we watch for the appearance of the high lights (the whitest parts) and an experienced eye will be able to judge by the way they come up if all is going well. If a turgid outline comes up and the development does not progress and cannot be coaxed with developer, the plate is under-exposed and useless. But if all goes well it will come up and develop gradually. Finally the student must remember that the negative must always *appear* a little denser than he wants it, for when the unaltered salts are washed out of the clearing solution, he will find the density *appears* less than he thought. When he has decided the negative is sufficiently treated he must wash it thoroughly at the tap and plunge it into the alum bath for a minute or two, then re-wash it and plunge it into the hyposulphite bath until it is clear, that is, no yellow-greenish patches appear on the plate as he holds it at an angle with the light. He should leave it some minutes after it appears clear to thoroughly get rid of the unaltered salts, then wash and replace in the alum, after which wash and transfer to the washing tank.

It is a pleasure to lock oneself in one's developing room with a batch of good plates to bring forth pictures from behind the gleam of the yellow-greenish film. It is perhaps the most pleasant of all photographic processes, and the feeling, when one holds a good thing before the developing lamp, must be experienced to be appreciated. It was once thought

that we could control the development of the
image to any extent, but Messrs. Hurter &
Driffield's chemical researches show that to be
impossible; in fact, they can develop a properly
exposed plate in the dark mechanically, and the
only control the operator has is over the
"development factor", *i.e.*, a numerical ex-
pression for the amount of development a
plate receives and is controlled by the length of
time occupied in development. That is the
gradations of a negative can be adapted to the
range of the printing paper. This factor is de-
termined graphically. In September, 1890, I
asked.Messrs.Hurter & Driffield to solve a simple
problem I sent them, concerning a white, black,
and gray house, and their reply I print, hoping
it will be of use to all students.

DENSITY AND OPACITY.

These terms have hitherto been used indis-
criminately to express the same property of the
negative, viz.: that of preventing the trans-
mission of light. There would have been no
necessity whatever, from the photographer's
point of view, for us to draw any distinction
between the two terms. On the other hand
there is no necessity to have two words to ex-
press the same thing, and the word " opacity"
seemed to us sufficient to express the *optical
property* of the negative.

The opacity of the negative depends of
course upon the amount of silver deposited
after development upon a given area. This

amount of silver is so small, in the case of small areas, that it would be impossible to weigh it. It has therefore to be determined by optical methods. The values obtained by these methods are not absolute, but relative only. They are proportional to the amount of silver per unit area, and just in the same sense in which the word "density" is used in physics, we too employ it to denote the relative amounts of silver. The word density therefore means, in this sense, the *density of the deposit*, i.e., the relative quantity of silver per unit area.

What we wanted to discover was the relation between the exposure and the opacity of the resulting image. This relation is, however, of a very complicated nature, while the relation between the exposure and the weight of silver is of a much simpler character. Again, the relation between the weight of silver and the opacity is of a similar simple nature. The weight of silver per unit area is thus the connecting link between the light which produced the image, and the opacity of that image ; and, in order to avoid the long circumlocution "relative amount of silver per unit area," we appropriated the word "density."

This distinction between "density" and "opacity" may appear to others frivolous and mistaken, but, as other publications we shall make on the connection between negative and positive will show, it is exceedingly useful. The number which we call "density" can, by a simple multiplication be converted into milli-

grams of silver per square centimeter area. We also use it in calculating the exposure necessary to produce a positive from a negative by direct contact.

We will now proceed to consider the problem of the landscape with its white, gray, and black houses situated in different planes, the black being furthest away.

We have no experiments which show the influence of the atmosphere in long distance views.

Apart from the effects of the atmosphere, the distance has a very small influence on the time of exposure.

Theoretically, the exposure to a white surface necessary to yield the same opacity in the negative as the sky would produce in one second would be

At a distance of 100 x focal length of lens 1.02 sec.
" 50 " 1.04 "
" 20 " 1.10 "
" 10 , 1.23 "
" 2 " 4.00 "

We assured ourselves by experiments that the distance has a very small influence on the time of exposure. We placed three large sheets of white cardboard at different distances from the lens, and photographed all three simultaneously. We measured the "density" of the images of the three sheets and found

Ft. in.			Density observed.	Density theoretical.
At 6.6 distance or	9.7 × focal length,		1.150	1.150
" 14 0 "	21.	"	1.205	1.165
" 21.6 "	32.	"	1.215	1,215

These results show that apart from the effect of the atmosphere, the distance has but a trifling influence on the exposure, and it is impossible to time exposures so accurately as to allow for these small differences. We shall therefore pay no further attention to the distance, but consider the three houses as situated in the same plane.

In order to represent these objects in their relatively correct tones, the first absolute essential is a thickly and evenly coated plate, and this we must assume we have. Before long we hope plate-makers will realize the importance of attention to these points. It is entirely a mistake to suppose that a plate is thickly enough coated because there is enough silver upon it to yield the maximum density required. Our investigations show that great contrasts can only be truly rendered on a well coated plate rich in silver compounds.

With the view to render the meaning of what follows clearer to you, we have prepared a diagram of which we send you a tracing.

Every plate has its own characteristic properties, which we represent graphically by means of a curve. This curve we call the characteristic of the plate, and it is roughly represented in the annexed sketch. The four curves here shown are all members of one system, and they are all of them characteristic of the same plate.

If, with various intensities of light, a series of exposures be made on a plate, and the images

be fully developed, each exposure will be represented by a deposit of a definite amount of silver (its density). If, now, we choose, as abscissæ, the exposures in such a manner that every successive equidistant point means double

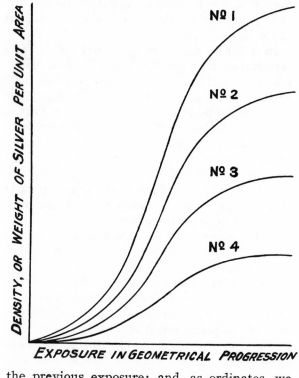

the previous exposure; and, as ordinates, we choose the densities, the curve, when plotted, has always the form shown in the sketch. The curve has three distinct branches, as discussed

in our paper, which correspond with under, correct, and over exposure. If we develop to the full limit, the curves may appear like No. 1, and if we develop to a less extent, it may appear like Nos. 2, 3, or 4, or any other lying in between these; but the various ordinates of the flatter curves are strictly proportional to the corresponding ordinates of the highest curve. Thus each plate may be represented by an entire system of curves.

Which of these curves will be reached in development depends on the composition of the developer, time of development and temperature.

We will suppose that our landscape with its three houses has been taken upon a plate sufficiently well coated to render them true in tone, and that we know the characteristic of the plate. We now proceed to discuss this landscape under the three heads, under, correct, and over exposure (Vide tracing).

I. UNDER EXPOSURE.

If the exposure given have been insufficient, the three equidistant lines B_1, G_1, W_1, may mark the light intensities reflected by the three houses, which, for the sake of argument, we will take as 5 for the black, 20 for the gray, and 80 for the white.

What we affirm is, that any alteration, either in time of development or constitution of developer, will simply decide upon which of the sys-

tems of curves the respective densities shall be, whether, for example, at *a*, *b*, and *c*, or at *d*, *e*, and *f*.

It would be possible, even in a case of under exposure, aided by an experienced eye, to so develop that something akin to a correct relationship between the two extreme densities might possibly result, but the density of the

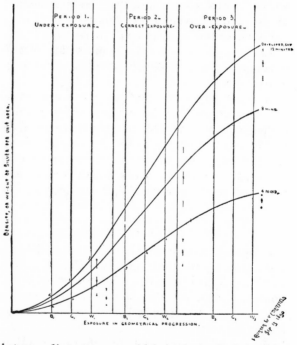

intermediate tone would be relatively false, the density representing the gray house too closely approaching that of the black house.

If the under exposures have been very decided, the ratios of the amounts of silver deposited would be as 1 : 4 : 16 (that is, as 5 : 20 : 80), however long the development might be continued. But when the amount of silver is in this ratio; that is, in the same ratio as the light reflected by the objects, the opacities of the images will produce prints false in tone, and this false relation being established by the peculiar form of the curve, the photographer has no power to alter it.

The opacity varies with the development, but it varies according to law. The photographer cannot cause the opacity of the white house to grow without that of the black house growing with it, in accordance with a fixed law, indicated by the system of curves.

II. CORRECT EXPOSURE.

If a longer (correct) exposure be given, the ratio of the silver deposited will be altogether different from that we have just considered. Instead of the silver being deposited in the ratio of the light intensities, it will be in the ratio of the logarithms of these intensities. With these particular intensities (5 : 20 : 80): this would mean that the difference between the amounts of silver representing the white and gray houses is the same as the difference between the amounts of silver representing the gray and black houses.

Different treatment in development would

result in different amounts of silver deposited, though their ratio would remain undisturbed ; but any increase of density in the white house would result in a corresponding increase of density in the black and gray houses, in such a manner as to bring the three points on the lines B_2, G_2, W_2 simultaneously from a lower to a higher curve, say from g, h and i to j, k and l. The photographer has the power to decide how far he will allow the density of the white house to proceed, but he cannot restrain the density of the black house while he allows the density of the white house to increase.

Among the infinity of curves which are intermediate between the axis of the abscissæ and the extreme curve, there is only one which would correspond to a negative from which a print true to nature could be obtained. It is the finding of this curve which is the difficulty in development. When this curve is reached, the *opacities* of the three gradations representing the three houses would be exactly as 5 : 20 : 80, the ratio of the light reflected by the houses.

If, however, development were stopped before this curve was reached, and if it happened that the plate were slightly fogged, the negative would convey to the eye the impression of over-exposure. Such a negative could be put right by intensification, and many experienced photographers would hence declare that they had corrected an over-exposed plate, whilst a measurement of the relative densities of the

three houses, would, at any stage of the development, have revealed the fact that it was a case of correct exposure after all, and that the real fault was under-development.

III. OVER-EXPOSURE.

In the case of unduly prolonged exposure the images of the three houses would fall in the upper part of the curve where intersected, say, by the lines B_3, G_3, W_3. The result of this would be that the tone of the gray house would too nearly approach that of the white house, whilst, in the case of under-exposure, it too nearly approached that of the black one. You might, by development, decide the density of one of the houses, but it would be out of your power to alter its relationship with respect to the other two.

Exposure decides within which of the three periods the three houses shall lie.

Development decides which curve of the system shall be reached.

The difficulty which we hope to be able to overcome is the decision of the right moment at which to stop development so that the resulting print will be true to nature. At present the experienced eye can alone decide the point.

The particular problem, in the solution of which we should highly esteem your kind assistance, is to decide when a print *is* true to nature. We have ourselves some doubt as to whether a picture has not to be somewhat exaggerated in

light and shade, in order to convey an adequate appearance of relief.

When stereoscopic pictures are viewed in the instrument, the effects of light and shade are often offensive, whilst, viewed without the stereoscope, this impression is not produced. What is your opinion upon this subject?

In order to assist you still further to understand our distinction between opacity and density, and the influence of development, we are

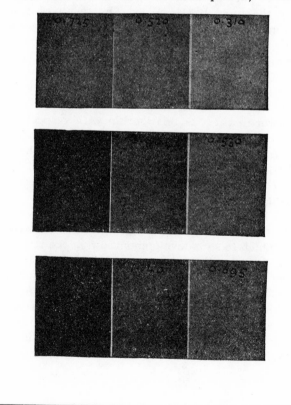

sending you an experimental plate. It is a "Cramer" plate, and it is a feature of these plates that they take a long time to develop, 12 minutes being generally insufficient. You must understand that the plate we send was exposed entire to a standard candle, the three strips being respectively exposed 1.25, 2.5 and 5 C.M.S. as indicated in sketch.

No. 1	1.25 C.M.S.	2.5 C.M.S.	5 C.M.S.
No. 2			
No. 3			

The plate was then cut into three portions which were developed respectively, 4, 8 and 12 minutes. The strips are marked with their densities which are

No. 1......0.310 1.0 .. 0.520 1.0 .. 0.725 1.0
No. 2......0.530 1.67 .. 0.905 1.70 .. 1.235 1.64
No. 3......0.695 2.33 .. 1.140 2.33 .. 1.625 2.33

The ratios existing between these densities are given in small figures, and are, you will see, practically the same in all three cases, thus affording another proof that the "ratio of densities is altogether unalterable.

The opacities corresponding to these densities are as follows:

No. 1.. ...2.04 3.31 5.30
No. 2......3.38 8.03 ... 17.18
No. 3......4.95 ... 13.80 42.17

We always use a developer recommended by Messrs. Hurter & Driffield: viz. their standard pyro-soda developer, i. e., a solution containing in 1000 parts, 8 parts of pyrogaliol (sufficient

to readily allow high densities to grow), 40
parts of soda, and the same amount cf sodium
sulphite.

After development the plate should be well
washed, and then placed in an alum bath.
Alum acts as a scavenger, and clears up all the
remains of the developer. Next the plate
should again *be well washed*, and put in the
hyposulphite bath. This bath should be con-
stantly renewed, for as soon as it becomes well
discolored it is inadvisable to continue its use.
It should not be made stronger than 1 to 5,
1 to 10 being the best proportion. Taking the
plate from· the fixing bath, you should wash it
very thoroughly, and re-plunge it into a fresh
alum bath, leaving it for a few minutes, then
again wash it and put it into a plate-washer,
the water of which should be frequently
changed. It can then be placed in a drying
rack, and left to dry gradually in a dry room,
where no dust is raised.

It is, in our opinion, always well to expose
two plates on each subject, but once having
seen a beautiful thing in nature, the enthusi-
astic student will determine to get it *perfectly*,
if it takes fifty plates and as many days to do
it in.

We strongly advise those desirous of doing
pictorial work to begin by studying tone on
selected subjects especially fit for the study
of tone; for example, a figure in a white dress
against a white background, another in a black
dress against a black background, and then a

white dress against a black background, and a black dress against a white background; some white flowers against a sheet of white paper; yacht-sails against the sky; faces against the sky; black velvet in bright sunshine, and on a gray day; yellow flowers (with orthochromatic plates) on a white background. In short, the student should think of all the possible harmonies and discords that can be found indoors and out of doors, and he should, before taking a plate, make a mental translation of the subject into black and white, and put on paper roughly, with a piece of charcoal, what he expects to get, by drawing rough masses in tone of the subject. He should at first think nothing whatever of composition, or the more poetical qualities of a picture; but simply study tone, and by this he will learn thoroughly what he ought to aim at. Let him eschew all requests to take portraits, dogs, horses, parks, and what-nots : but let him always study tone.

When he has mastered tone, and with it exposure and development, he knows the most difficult part of his technique and practice, let him then proceed to picture-work. In this early stage let him take anything and everything that is a study of tone, and let him take it anyhow, no posing, no arrangement, and when he knows his *métier* thoroughly let him destroy all these early plates ruthlessly. We strongly advise him to give away no prints of early work, or he will most surely rue the day when

he did so. In our opinion a year is not too much in which to work in this way, both indoors and out of doors, in studios and out, with shutter and without, before there is any attempt to take a portrait or picture of any kind.

In working with gelatine plates various unavoidable accidents and faults will crop up, some of which can, however, be remedied. Such cases we will now go into.

Under-exposure gives chalky whites and sooty blacks, *ergo* no tonality, *ergo* worthless. No remedy, destroy at once.

Over-exposure gives thin negatives. What a thin negative is, is a matter of opinion, and must be settled by a comparison of the print with the impression of nature which it is wished to obtain. For many effects thin negatives are invaluable, and the student must not take the ordinary photographer's opinion as to his negatives; but only that of an artist, for, as has been shown, low-toned prints are unrecognized by the ordinary craftsman, his aim and object is never to produce such things, these he designates by all sorts of names, whereas they may be, by their tonality, infinitely truer than his "sparkling" falsehoods. In short, it all depends on what the student wishes to express. Some of the best work done has been produced from negatives made purposely thin, which have at the same time been true in tone, and full of breadth. The density of a negative can be increased by intensifying the negative; but it must not be forgotten that intensification

does not correct the relative *tonality* in a particular key. This is a matter of great importance which has been overlooked.* From this it will be seen that such a negative is worthless for artistic purposes, and had better be destroyed at once.

But there are cases in which the tonality is relatively true but the negative is pitched in too low a key, that is, it is too low in tone throughout. For such cases· intensification is invaluable, and Mr. Chapman Jones has introduced a valuable system of intensification which he read in a paper before the Photographic Society of Great Britain. The great advantage of Mr. Chapman Jones's system is that he has great control over degrees of intensification.

Get the following solutions:

A. A saturated solution of mercuric chloride, to which has been added strong hydrochloric acid (half a drachm of acid to a pint of solution).

B. One pint of a ten per cent. solution of *sodium sulphite* (but re-crystalized), acidified with sulphurous acid until the solution ceases to give a red color to a dilute solution of *phenolphthalein*. Litmus paper is useless as a test in this case.

C. A quarter of a pint of a saturated solution of ferrous oxalate.

D. One and a half pints of a saturated solution of a neutral potassium oxalate. This may just be

* Cf. Journal and Transactions of the Photographic Society of Great Britain, Vol. XIV., No. 4, pp. 40 et seq.

acidified with oxalic acid, but the acid slows its action. Now we have a negative which we just wish to give a last flip of density to throughout to scale. We pour a sufficiency of the mercuric chloride solution into a dish and place our negative in it until it becomes grayish white. Then take it out and wash it under running water for an hour at least. Then plunge it into the sodium sulphite solution where it will blacken and we have attained our desired result.

But suppose we want to carry the intensification a stage farther. We again treat it with the mercuric chloride solution, but this time we take one part by volume of the ferrous oxalate to six parts by volume of the neutral oxalate solution and mix them, adding 3–4 ounces of water. Now we plunge our negative into this new solution until it darkens again. It will now have about twice the opacity it got by the sulphite treatment, and so we can go on repeating the process up to five or six times. Mr. Jones puts it thus in his admirable "Introduction to the Science and Practice of Photography":

" 1. Mercuric chloride followed, after well washing with sodium sulphite gives the little additional brilliancy sometimes lacking in a carefully made and almost perfect negative.

2. Mercuric chloride on the original negative followed, after thorough washing, by ferrous oxalate, gives roughly as much increase of density as compared with No. 1, as No. 1 gives when compared with the original negative.

3. A repetition of the application of mercuric chloride and ferrous oxalate—that is, these reagents applied to the result of No. 2—give another step in the intensification.

(NOTE.—The result of this treatment is about equal to the action of mercuric chloride followed by ammonia upon the original negative.)

4. The result of No. 3 may be treated again with the mercuric chloride and ferrous oxalate, and so on as often as may be necessary.

5. The fourth and fifth consecutive application of mercuric chloride and ferrous oxalate will probably give a result about equal to that of the uranium intensifier acting upon the original negative.

6. If a still greater effect is desired the last intensifier may be used on the original negative. This intensifier, though, is not required for nature negatives."

The negative by this method is not stained, the shadows are not choked, the tonality of relative luminosities is not deranged, the operations are reliable, and the result permanent. I have found it a valuable method. Though formerly opposed to intensification, this scientific and reliable method of Mr. Jones has made me reconsider its advisability and in certain cases I recommend it, but prefer, if possible, to hit off the right tonality at once.

It must be remembered that the ferrous oxalate acts much more slowly than either ammonia or sulphite. If a dark looking stain is left on the negative the ferrous oxalate has not

been sufficiently washed away and a further washing will remedy it. Every operation should be thorough and the processes must not be hurried.

The student will find that for certain effects he may intentionally produce a slight fog over his plate, as has often been done with very good results; but if his plates are unintentionally fogged, they are ruined. Fog is due to light having had access to the plate, either during manufacture, during exposure, or during development. By developing an exposed plate it can be proved whether it was fogged during the manufacture, as in that case the plate turns black. If the fog is caused by a leaky camera the edges of the plate, which are generally clear glass, are not fogged, for they have been hidden behind the rebate of the dark slide. Light coming through the dark slide shows itself in lines or patches, and is not general. If all these sources have been eliminated, the dark room must be suspected. This is tested by putting a plate in the slide, drawing the shutter out half way, and exposing the plate for a few minutes to the developing light. If the exposed half fogs, then the dark room is to blame.

We have only met with red and green fog once, and that was in developing a uranium plate. This is green by reflected light, and red by transmitted light. It is generally deposited at the corners of the plate and round the edge.

Yellow and brown fog are rarely met with, and are yellow and brown by *reflected* light,

whereas stains are colored only by transmitted light. The student can easily distinguish between fogs and stains in this way. We have been very successful experimentally with Captain Abney's method of clearing off green fog. He recommends the following solution to be used after fixing :

Ŗ Ferric chloride................. 50 grains
 Potassium bromide............. 50 grains
 Water..... 4 ounces

The plate should be well washed after this treatment, and developed up with the ferrous oxalate developer.

But such plates are not always saved pictorially by the method, for the tonality may be thrown out, and the texture of substances is nearly always damaged.

Frilling is due to the expansion of the gelatine, and will rarely occur if the plate be put in the alum bath before fixing. The gelatine can be made to contract by soaking in methylated spirits of wine.

Blisters are of rare occurrence, and will dry out if the plate be carefully handled and washed in alum, as directed. They may be treated locally with methylated spirit, which causes the gelatine to contract.

The best reducer for dense negatives we know of is Dr. Eder's. He recommends the use of— A., one part chloride of iron to eight parts of water. B., two parts neutral oxalate of potash to eight parts of water. A well-known authority on photographic matters, Dr. H. W. Vogel,

says, "Both solutions keep a long time without deteriorating. Immediately before using, equal parts of A and B are mixed, forming a bright green solution, which keeps well for several days in the dark, but decomposes in the light. Of this mixture a little is added to a fresh and strong solution of 'hypo.' In difficult cases 1 part 'hypo' and $\frac{1}{4}$ to $\frac{1}{2}$ of iron solution are employed. The plate to be reduced is placed in this solution. The image weakens quickly and uniformly. The plate is taken out and washed just before the desired reduction is reached, because the action continues during the washing, gradually diminishing under the stream from the tap. This reducer acts on plates developed either with 'pyro' or 'oxalate,' and does not destroy the details in the shadows like cyanide. There is also less tendency to frill than with the cyanide bath."

Reducers, like intensifiers, should not be resorted to, unless in case of a very valuable negative, for it must never be forgotten that, though the printing density is reduced, the tonality is not corrected.

Yellow stains due to the developer, are easily removed by Edwards' Yellow clearing solution, which we have found most effectual—

Sulphate of iron	3 ounces
Alum	1 ounce
Citric acid	1 ounce
Water	1 pint

Transparent spots are due to dust in camera or slide, or to using the "hypo" bath too long. If

the spots have sharply defined edges, they are
due to air bubbles forming at the beginning
of development.

Halation is a bugbear we have had little ex-
perience of, though we have taken many in-
teriors. The only occasion on which we met
with it was once when the plate was over-ex-
posed on a stained glass window, containing
much blue in it. If a large stop be used, and
the exposure kept as short as possible, our ex-
perience is that no halation need occur. If,
however, the student fears it, and there is al-
ways a danger of it where any bright lights act
on the film, he should, with a squeegee and
some glycerine, apply. a piece of some dark
tissue to the back of the plate ; this is easily
stripped off before development. There is a
slight amount of halation in every plate, but it
is really nearly always inappreciable and is
after all true in illusion for the eye does not
see things sharply against the sky. Mr. San-
dall has introduced a valuable plate for interior
work and various " backing " solutions are now
in the market to prevent this result.

All plates should be kept in a dry place, and
whilst traveling it is as well to keep them in
tinfoil. The effect of damp is to produce
patches, which either do not develop at all or
develop unequally.

The removal of varnish is easily accomplished
by putting the plate into hot methylated
spirit, and rubbing the varnish off with cotton
wool.

It has been said that sea air affects gelatine plates ; this has not been our experience.

The backs of the negatives which are generally dirty, should be cleaned by scraping, and then rubbing up with a rag moistened in hot water, or preferably, methylated spirit. The negatives should be kept in a dry place, in grooved cardboard boxes. Wooden boxes should not be used for storing either plates or negatives.

Marblings are due to a dirty fixing bath ; or to an uneven action of the developer arising from not rocking the plate, or to adding the alkali to the developer in the dish and not thoroughly mixing them before putting in the plate. The clearing solution removes some of these.

Prolonged and patchy fixing is due to the alum bath being used before " fixing " in plates from which the developer has not been thoroughly washed. It can be remedied by washing and swilling the plate in water just rendered alkaline by ammonia, and then fixing as before. We once had a plate which took several hours to fix even after this treatment.

We have had limpet shell markings appear in a few negatives some months after development. We know of no remedy for the defect ; nor do we know the cause, but believe it to be due to hyposulphite of soda left in the film.

Deposit on film is sometimes met with after the imperfect washing out of hyposulphite of soda ; or sometimes whilst the negative is in

the fixing bath, if it has been in the alum bath previously and not thoroughly washed, sulphur is deposited. The remedy is obvious.

Colored metallic-looking patches appear at times near the edges of the plate, which may, or may not, be accompanied with fog. We have often observed these patches in plates which have been kept a long time. There is no remedy if they are unaccompanied by fog, but if fog is present, the ferric-chloride solution will generally remove them.

Scratches on the back of the negative show as dark lines in the film.

Rarely, we have met with small patches which seem to have refused to develop; they are generally circular. Captain Abney says they are due to the use of chrome alum in the emulsion. There does not appear to be any remedy for this accident.

In one batch of plates we were greatly troubled by dull spots and pits, one of the plates being covered with pits as thickly as if it had been peppered from a pepper-box. Captain Abney says they are due to the use of gelatine which contains grease. They rúined a whole series of fine negatives for us once. These complete the enumeration of the accidents likely to occur during development.

We shall now presume that the student has thoroughly dried his negatives, after having developed them. Before storing them, however, he must varnish them, to protect them from scratches, and especially from damp, for

gelatine, being very hygroscopic, easily absorbs moisture. At times, when warming an apparently perfectly dry negative over a flame, preparatory to varnishing it, a slight steam can be seen to arise, due to the evaporation of the moisture in the film. This moisture in the gelatine would of course in time lead to decomposition, and ruin the image ; for these reasons, then, all negatives should be varnished. Before "varnishing" each negative should be carefully brushed over with a camel's hair brush. Now it is obvious that many of the varnishes used are more or less non-actinic, as Dr. Carey Lea has proved ; he, therefore, recommends the following :—·

Bleached lac......10 drachms
Picked sandarac. 5 drachms
Alcohol12 ounces

Let the lac dissolve in the alcohol, then filter, first soaking the filter paper with alcohol. Pour slowly, and if necessary at the end add one ounce more of alcohol to enable the rest to pass. Next add the sandarac to the filtrate and refilter, using of course a fresh filter.

Warm the plate gently, and, holding it in the left-hand bottom corner between the thumb and finger, pour a pool of varnish on to the plate that will cover about one-third the area of the plate, then let it run to the right-hand top corner, then to the left-hand top corner, then to the thumb, and finally drain off at the right-hand bottom corner into a filter. Then place it on a drainage rack, till just set, when rewarm

by the fire, etherwise it does not set hard and smooth.

Since paper negatives and a roller slide were suggested by Fox Talbot, and made fit for use by Blanquart-Evrard, several ingenious persons have been trying to improve upon these early attempts. From time to time, during the last fifty years, various workers have announced old ideas as new discoveries, nor have these been confined to roller slides and paper negatives, but extended to many other photographic processes. That no one can claim any originality of discovery on this head since Talbot and Evrard is obvious ; only perfected methods can be claimed. There have been many of these introduced, but none worth discussing until that offered by the Messrs. Walker and Eastman. They have perfected Talbot's and Evrard's work, and though they have numerous imitators their work is *facile princeps*.

Now the student will naturally expect us to give an opinion on these paper negatives. For many photographic processes they are of course invaluable, but for pictorial work our opinion is that they are not equal to the ordinary method. These remarks apply equally to the various flexible films which have lately been introduced.

For hand cameras, we should think, film negatives would be very useful, and for small studies such as they produce, would do well.

There still remains, however, a very important point from the pictorial point of view, as regards tonality, for as the student who has read

his chemistry knows, the different parts of the spectrum act differently on the different haloids. The effect of this has been to destroy true tonality, thus a yellow flower comes out black if taken on ordinary plates. To remedy this dyes have been used which absorb the weakly acting rays, and thus has been made one of the greatest advances in photography, both scientifically and pictorically. This orthochromatic photography has engaged the attention of experts, and Abney, Vogel, Eder, Ives, and Edwards are hard at work upon it now, besides many amateur scientists. We have been for some time working in this direction for artistic purposes, having begun with Tailfer's plates before any others were introduced into the English market. For the photographing of pictures Messrs. Dixon and Grey conclusively proved the superiority of the process by their exhibits at the Exhibition of the Photographic Society of Great Britain, in 1886. But the matter is more complex and difficult when landscapes and portraits from life have to be considered. It is with the wonderful protean aspects of nature that we have to deal when working from nature, and we feel the question is not one to be entirely settled in the laboratory. Our method is always to work out of doors, noting, as far as possible, the conditions and judging the results by the prints, and though such experiments are far from conclusive, we can at present say that the orthochromatic plates are partially correct in the rendering of

tonality, but not perfect, the reds overrun the other colors and are too strongly rendered. In fact, the reds and greens are not truly rendered, and even if the correct values of the spectrum are rendered in a laboratory, it does not therefore follow that the relative tones of nature will be truly rendered for it must never be forgotten that spectral and pigmentary colors are different and that no pigmentary color is pure. We have then to make our orthochromatic plates so that they will give us true tonality as the eyes see it and none but an accomplished tonist can judge of this. This is the point which must be remedied. Undoubtedly orthochromatic photography alone will be used in the near future, but just at present it is not cut-and-dried enough for all practical purposes. And later research tends to confirm our first impressions as Captain Abney's recent paper showed. In fact, for many landscapes it is evident that ordinary plates give a truer rendering than do orthochromatic plates. The student, however, must use these plates for landscapes with bright colors as yellow flowers, etc. They are supplied by many dealers.

Thus it will be seen that in every operation the art-knowledge of the operator will tell. For example, let us suppose a camera set up with the lens fixed, before a beautiful landscape composed on the ground-glass screen by an artist, then let us imagine that two photographers proceed to take plates of the picture. After the very first operation of focusing,

stopping and adjusting the swing-backs ; a marked gulf will separate the two pictures ; the gulf widens as the exposure is made, and finally in the developed plates they are no longer the same thing. One may be a sharp, commonplace fact, untrue in illusion, the other may be full of illusion and poetry. Let a print be taken from each plate and presented to an artistically uneducated craftsman and to an artist, the craftsman will go into raptures over the sharp craftsman picture, the artist will do the same over the artistic picture, but the artist will not look for a moment at the craftsman's ideal, and this little matter any one can prove for himself. Let the student, then, strive to earn the artist's praise, and let him ignore the workman's, and value his opinion on these matters at the same price he would value his opinion upon any other subject where taste and refinement are called into question.

CHAPTER VIII.

RETOUCHING NEGATIVES.

RETOUCHING is the process by which a good, bad, or indifferent photograph is converted into a bad drawing or painting.

Theoretically, retouching may be considered admissible, that is *if the illusion can be made more true by it.* There are, perhaps, half a dozen painters in the world who could do this, but no one else. Nature is far too subtle to be meddled with in this manner. We have discused the question with many artists, and their verdict is the same as ours. It is the common plea of photographers that photography exaggerates the shadows, but we think it has been shown that if photography is properly practised no such exaggeration of shadows takes place and if it did, retouching would only add to the falsity in another way. This retouching and painting over a photograph by incapable hands, by whom it is always done, is much to be deprecated. The result is but a hybrid, and is intolerable to any artist. One fatal fact in all painted photographs, and one which for ever keeps them without the realm of art, is that the shadows, being photographic, are black and not filled with reflected color as in nature and as in

good oil painting. The same remark applies to mechanically-colored photographs. Such abominations, from an art point of view may, however, be useful in the trades, for pattern plates and such things. Consider for a moment the habit of working up in crayon, monochrome, water-color and oils. What does it mean? and how is it done? In some establishments the practice is for a clerk to note down certain of the sitter's characteristics, such as "hair light, eyes blue, necktie black"; these remarks are sent with a photograph, generally an enlargement, to the *artist !* He, in a conventional and crude manner makes necessarily a travesty of the portrait, and for these abominations the customer pays from 5*l.* to 20*l.* Consider the utter sham and childishness of the whole proceeding, and remember that a portrait painter of the greatest ability can only paint with the model *actually before him,* yet these workers-up, who are not artists at all, can paint from memoranda made by a clerk. It is astonishing to think there are people in the world foolish enough to pay for such trash. Even the very best oil painting done in such a way is but trash, and if the photographic base is so destroyed or covered over that none of it shows, it must then be judged on the grounds of monochrome drawing or painting as the case may be, and a sad thing it is when judged on these grounds. It may be said, "But painters paint posthumous portraits." Yes, they do, confiding public, but they paint them as sculptors model posthumous busts, but

they do not call them works of art. We know several artists who are compelled by necessity and the vanity of human nature to execute these posthumous portraits, and we know, too, how they value such work. But it must not be forgotten what a gulf separates able artists from the third-rate "workers up" for photographers. Moreover, honest artists never attempt posthumous portraits on the top of a photograph, but simply use the photograph as a guide for modelling, light and shade, etc., a quite legitimate use, both for painter and sculptor. The Royal Photographic Society of Great Britain is to be congratulated on the stand it has made in the matter by not hanging any of these abominations on their walls, and it is to be hoped they will stand firm and never admit hand-colored photographs of any kind until the great problem of photography in natural colors is solved.

We have amongst photographers to-day persons who pride themselves on their skill in taking out of a photograph double chins, wrinkles, freckles, and all the character of a face, and who call themselves, we believe, "high art photographers"; mere flatterers of mankind's weaknesses are they, not even honest craftsmen. And not only do they thus mutilate portraits, but with their Chinese white and Indian ink will they, with all the confidence of the uneducated, touch up a landscape or a face with no model before them. Of tonality of course they never heard, and Nature they never knew. It was

once our lot to judge the pictures at a Cambridge photographic exhibition, and we were not a little staggered by the audacity with which one noted "London firm" had touched up and worked upon an opal enlargement of Niagara Falls. The picture was very true and beautiful before those vandals had got hold of it, but great Cæsar! what a sight it was afterwards, with its impasto of Chinese white, and its shiny gum-polished, India-ink deepened shadows! In short, a more meretricious production it has seldom been our lot to inspect, and this thing was exhibited by a University undergraduate! If such is the taste of an educated man, what can one expect from the rest of the world! Let then, the student avoid all these meretricious productions as he would all vulgarities, such as eating peas with his knife. No first-rate artist will allow his prints to be retouched; he would never be able to bear the look of them afterwards. That the idea of retouching springs from a wrong theory is evident; the improper use of lenses gave false drawing, and people were inartistically and sharply photographed, so that wrinkles, warts, freckles and even the pores of the skin showed, and so on, and then arose the demand for a retoucher to correct all that, and one error led to another, although, without doubt, the false work of a retoucher is much truer than the false work of an uneducated operator. Certainly people do not see, at the distance a photograph is taken from, the wrinkles, spots, and other small blemishes,

and they are too uneducated to see the falseness
of tone and texture which retouching engenders.
Of all the photographers who talk glibly of art,
we warrant scarcely one is able to distinguish
between a bust carved by a stone-mason, one
carved by a mediocre sculptor, and one carved
by a master, in fact we have proved this,
and yet they talk, talk, write, and lecture on
art; while to an artist the difference between
each of those three busts is, as great as
the difference between a mountain, a hillock,
and a marsh. The public see the warts and
spots, and call them false, the greater falsity of
tone and retouching they cannot distinguish.
An etcher once remarked to us, " How is it
photographers seem to do everything to make
photographs anything but photographs?" And
such is the case ; the matchless beauty of a pure
and pictorial photograph does not satisfy their
vulgar minds, and yet such is the only kind of
photograph at which artists will look.

It is now fifty years since Daguerre publicly
announced Niépce's discoveries, and on the
scientific and industrial side, photography has
results to show nothing short of marvellous,
but what has it to show on the artistic side? Of
the thousands who have practised photography
since 1839, and who are now dead, how many
names stand out as having done work of any
artistic value? Only three. One who was at
the same time a sculptor, namely, Adam-
Salomon, but without first-rate artistic ability;
one a trained painter, but with very second rate

artistic ability, Rejlander; and one, an amateur
—Mrs. Cameron. Besides these three there is
no name among the numerous dead photog-
raphers worth a mention, and even now the
work of Rejlander and Adam-Salomon is
archaic. It serves but as landmarks in the his-
tory of our art. Mrs. Cameron's work alone will
survive, and only her portraits, her compositions
being childish. And have matters improved?
Well may it be asked by those who have the
good of photography at heart, whether it will
always be thus. We hope not; but if it is to be
otherwise, some radical change must be made,
and the blind no longer lead the blind. We
have said, then, that of all the thousands of
craftsmen who have practised photography and
are dead, three names only stand out as having
produced works to which we can apply the title
artistic. Now let us see what those three have
to say to the matter of retouching.*

Mr. Adam-Salomon, though he strengthened
certain parts of his negatives by artificial means,
which in the hands of an artist like himself,
was admissible, condemned retouching alto-
gether. He says, "Eschewing retouching with
brush or pencil on the film, risking the further
deterioration of the negative, I make light finish
the task it has, from want of time, or bad qual-
ity, insufficiently done, and in such a manner
that no hand can hope to rival its delicacy and
precision, and this is the only plan that a lover

* Since 1882 matters have slowly improved, but until quite recently
Rejlander and Salomon's imitators had too much influence. That is
broken now and there is hope (1890).

of his calling can justifiably pursue." So we
see that a highly-trained sculptor, like Adam-
Salomon, said that he *dared* not retouch, but
only sunned down violent contrasts at first, and
then printed in all the picture, so that it could
not be detected.

Rejlander, not being a painter of great ability,
but having a painter's training, tried all meth-
ods in certain directions; but he too came to
the conclusion that retouching was inadmissi-
ble, and he says: "I think the practice of re-
touching the negative a sad thing for photog-
raphy. It is impossible, for even very capable
artists, to rival or improve the delicate, almost
mysterious gradation of the photograph. Mag-
nify the photographic rendering of, say, the
human eye, with a strong lens, and it is found
to be almost starting in its marvellous truth.
Magnify the retouched image, and it will look
like coarse deformity. It ceases to be true. I
have sometimes seen a touched photograph
which looked very nice, but it possessed no
interest for me; I knew it could not be trusted.
I have been charged with sophisticating photo-
graphs because I combined and masked and
sunned prints. But there is a great distinction
between suppressing and adding; I never added.
I stopped out portions of the negatives which
I did not require to form my picture; I sunned
down that which was obtrusive, and where one
negative would not serve, I used two or more,
joining them with as much truth as I could.
But I never attempted to improve negatives.

I never believed that I could draw better or more truly than Nature. I consider a touched photograph spoiled for every purpose." This, then, was Rejlander's verdict, and though from this we gather he had not yet thrown off the fallacy of combination-printing, yet he subsequently abjured that also. Even when he did use combination-printing, he practised it in a manner never equalled by his imitators, for like all imitators they have copied the bad qualities and left all the brains behind.

Mrs. Cameron, the last and greatest of the three, had knowledge and feeling enough also to eschew retouching, none of her work is retouched. The more we see of Mrs. Cameron's work, and the work of Adam-Salomon and Rejlander, the more astonished we are at her untaught artistic ability, for her work towers above that of both Rejlander and Adam-Solomon, and were it not for her puerile figure-pieces and childish angels, etc., she would have taken a very high place indeed in our world for all time, but like all untrained persons she was very uneven and uncertain, and though in her portraits, she is really great, in her illustrations to the "Idylls of the King," etc., she is puerile and amateurish.

When, it comes, by the means of retouching, to straightening noses, removing double chins, eliminating squints, fattening cheeks, and smoothing skins, we descend to an abyss of charlatanism and jugglery, which we will not stop to discuss. That such things pay and

please vain and stupid people, no one denies, but so do contortionists please a certain public, so do jugglers and tight-rope dancers, and such like, but all that is merely grotesque.

There are various practices of doctoring the the negative by using paint and other mediums on the backs, or by grinding the backs of the negatives. These are, in our opinion, all unnecessary and harmful, the remarks on retouching apply equally well here. Such artifices may easily deceive and even please the uneducated, but the artist only sees them to despise and condemn them. The technique of photography is perfect, no such botchy aids are necessary, they take the place of the putty of the bad carpenter.

Of course, spotting does not come under the head of retouching. The spotter does not attempt to modify structure or tone, but merely to render an unavoidable and accidental "blemish" less patent. All spots should be filled with red paint mixed with a little gum and water but care must be exercised in this operation, to put on only just enough paint to fill the hole.

Our parting injunction, then to the photographer who would do good work, is, avoid retouching in all its forms; it destroys texture and tone, and therefore the truth of the picture.

CHAPTER IX.

PRINTING.

HAVING his negative, the next thing our
student will want to do is to print from it ; but
before doing so, it will be necessary to decide
upon the process he will use.

This is a question of great moment, and one
which will here be considered on purely pictorial
grounds. When first we began photography,
we printed in all sorts of ways ; but silver
printing, on account chiefly of its unpleasant
glaze, was soon discarded. Then we prepared
some ordinary drawing paper, and printed on
that, till one day we saw an album of views
printed in platinotype. Their beauty acted
like a charm, and straightway we took to
platinotype. Still we felt that for portraiture,
a red color gave a desirable warmth. So we
tried carbon, and practised it when necessary.
Even now, when we look back on those days,
we remember the intense pleasure carbon print-
ing gave us. In the year 1882, when we first
exhibited at Pall Mall, we sent four platinotype
prints, and two silver prints. At that exhibi-
tion there were only three other exhibits in
platinotype. Immediately after that exhibition
we determined to give up all methods of print-

ing except platinotype, and we have since
steadily by example and precept advocated that
process. When we were brought into contact
with artists, and learned something of art, we
knew the reason of what we had instinctively felt
to be true. And now, after much experience
and careful examination, in many cases in com-
pany with able artists, of all the printing papers
and processes to-day employed, we emphatically
assert that the platinotype process is still *facile
princeps.* We should maintain this, even if
platinotypes were no more permanent than sil-
ver prints, but here again, as in all good things,
simplicity of manipulation goes with excellency,
for there is no doubt that platinotypes are per-
manent, they will last in good condition as long
as the paper on which they are printed. This
fact alone would finally place the process at the
head of the list. Since the introduction of the
platinotype process various papers have been
introduced into the market, with unglazed sur-
faces, for which the quality of permanency has
been claimed. Several of these are old methods
re-dressed, as the gelatino-bromide and chloride
papers. But are these papers permanent ? At
any rate they do not give any truer tonality
than silver prints, and this is a fatal draw-back.
We have examined hundreds of prints on
gelatino-bromide and chloride paper, and they
all give false tonality as compared with platino-
type. The gelatino-bromide paper like all
silver prints, whether matt or glazed, is false in
tonality, the blacks are too black, and the whole

picture lowered in tone. Then, again, as to the
question of permanency, it is of course incon-
testable that silver prints fade, and as regards
the gelatino-bromide paper, experiment has not
proved it to be permanent. This is what a
chemist, Mr. A. Spiller, says in the Year Book
of Photography and Photographic News for
1888: Writing on " Bromide *versus* albumenized
paper," he says, " From the above consider-
ations it may fairly be conceded that *under the
same conditions* a bromide print will most likely
remain intact longer than an albumenized paper
print ; but more than this, I am afraid, with
the evidence at present at hand, we are not in a
position to state. In offering this, it must be
understood that only under equally favorable
circumstances is the bromide process likely to
yield results more permanent than that on
albumenized paper, for just as a gelatine plate or
silver print fades when the 'hypo' fixer has
been imperfectly removed, so again in the
bromide process, if insufficient washing after
fixing be resorted to, the resulting photograph
cannot be expected to last long."

Such was the opinion of every photographer
who had thought the matter out, but we give
Mr. Spiller's opinion since it is that of a
specialist in chemistry. In conjunction with a
landscape-painter we went carefully into this
question of the different printing processes, for
a book we were conjointly engaged upon was
to be illustrated by photographs from our
negatives. We soon determined, on artistic

grounds, that there was nothing that could compete with platinotype. Before deciding, however, we wrote, at the request of our publishers, to a leading producer of gelatino-bromide papers, asking him if he could guarantee the permanency of prints on this paper. When the answer came it was evasive and unaccompanied by any guarantee. These gelatino-bromide papers are to be met with under different names, and though for certain trade or industrial purposes they may be invaluable, for pictorial purposes they are inferior to platinotype. Carbon, though superior to silver printing, is still inferior to platinotype, for even when the glaze is got rid of, the method of the formation of the image, being sculpturesque, gives a falsity of appearance and an unnatural running together (like melted wax) of portions of the detail.

There is, then, in our opinion, for our student, but one process in which to print, and that is the platinotype process discovered by Mr. Willis. Every photographer who has the good and advancement of photography at heart, should feel indebted to Mr. Willis for placing within his power a process by which he is able to produce permanent and beautiful work. We have no hesitation in saying that the discovery and subsequent practice of this process has had an incalculable amount of influence in raising the standard of photography. No man of taste could rest content to practice photography so long as such inartistic printing

methods as the pre-platinotype processes were in vogue. If the photoetching process and the platinotype process were to become lost arts, we, for our part, should never take another photograph.

But here it is necessary to warn the student against the remarks of the platinotype company and many of their admirers, who maintain that for good prints "plucky" negatives are necessary; and then follows the old story about "fire," "snap," "sparkle," and Co. As we have already despatched that gang, we will spend no more time over them. For low-toned effects, and for gray-day landscapes, the platinotype process is unequaled, but the "fire," "snap," "sparkle" company think such effects bad, weak, muddy, and what not. Of course, the student will listen to nothing of this, but try for himself, and when he wants advice, let him ask it of good artists. We once showed a gray-day effect to a clerk at the Platinotype Company's Office, having previously had the opinion of some first-rate painters upon it; the clerk looked at it critically and said "Yes, very nice; but look at this," and he took us to a frame hanging in the same room and pointed to a commonplace view, taken with a small stop in bright sunlight—a view, we believe, of a church or something of that kind; there was *his* ideal of what a platinotype should be. The print in question was very fit for a house-agent's window. No! Platinotype printers do not seem to know what a good thing they have.

Their paper is as suitable and as beautiful for soft gray-day effects as for brilliant sunshiny effects, and it is to be hoped they will soon have their eyes opened to this fact, and cease to encourage the false notion that good—*ergo* plucky, sparkling, snappy—negatives are those required for the use of the paper. The process, however, is not perfect, the only perfect printing process being photo-etching, as we shall show presently; but of all the processes for printing from the negative it is the best; of all the typographic processes it is the best; and it is better than many of the copperplate processes.

The Ferro-Prussiate printing process, of course, does not concern us, blue prints are only for plans, not for pictures.

Our printing process, then, is to be platinotype and platinotype only, and as there is no use in swelling this work with facts already published, we advise every student to get full directions from the Platinotype Company, 29 Southampton Row, High Holborn, London, and to study them carefully.* It is advisable to arrange the printing so that you are not compelled to keep the paper any time; get it fresh when required, therefore, and only as much as you require for immediate use. Before putting it in the box, drive all the moisture out of the calcium-chloride by heating it

* Those who wish to study the chemistry of the subject should buy "Platinotype," by Capt. Pizzighelli and Baron A. Hübl, translalated by the late J. F. Iselin. M.A., and edited by Capt. W. de W. Abney, F.R.S. London: Harrison & Sons, 89 Pall Mall.

on a shovel, or old tray, over the fire, and dry the box thoroughly before the fire. Dry also all the printing frames thoroughly before a fire, also the rubbers, the use of which must not be neglected. Be sure you mix the baths and developer with pure *boiled distilled water only*, or else you will be liable to find a fine powder on the prints.

Be very careful not to place the prints in water between the washings. Above all, never use your dishes for any other purpose. Some photographers, living in the country, complain that they cannot get up heat to boil a large enough quantity of developer for 12 x 10 prints. We found an excellent heating apparatus in the tin spirit lamps with treble wicks, supplied by Allen of Marylebone Lane, with his portable Turkish baths. With two of these lamps we had no difficulty in heating a developer for 24 x 22 prints. The dish can be supported by blocks of wood at the four corners, and raised to the height required by other blocks, or a tripod. The prints when taken from the washing water should be dried on a clean sheet, and are finally improved by pressing with a warm iron. For spotting, India ink is the most suitable medium. This, it is said, is permanent, and any shade can be got, but good India ink, like many other articles of trade, is a rare thing.

There are different kinds of paper sold by the Platinotype Company for printing, and the printer will of course choose the texture of paper that suits his subject. Delicate land-

scapes and small portraits should be printed on the smooth papers, while for strong effects, large figure subjects, and large portraits full of character, the rough papers are more suitable. The charcoal gray tint of ordinary platinotypes is apt to become monotonous in book illustration, and it is as well to vary it occasionally by using the sepia tints; these are quite suitable for landscapes and certain figure subjects. Directions are given by the company for producing this color. A great desideratum is a red color for portraiture, and it is to be hoped that Mr. Willis will see his way to producing a paper on which prints in what is called "Bartolozzi red" can be obtained.* Red, though it does not give such true tonality, gives a truer impression of flesh and texture, just as sepia often gives a truer impression of certain kinds of landscape. But of course these tints must be used with judgment, and no one but a vandal would print a landscape in red, or in cyanotype. Having now disposed of the question of the printing process to be used, we must discuss some of the details incidental to printing.

Whoever introduced the practice of vignetting was no artist, and the "dodge" was evolved from a misconception of the aims of art, or for commercial purposes. Its origin is obvious, the idea was taken from one of the incomplete methods of artistic expression, such as chalk drawing. In such methods the artist

* Various workers have since introduced various methods of producing different colors and tints.

has a perfect right to leave the background un-
tinted, or only to shade round the head so as
to give it relief, but with a perfect technique
like photography, vignetting is useless. We
get by this method a softly, delicately lighted
head, against a sparkling background, the
two are incompatible, not only that, but the
photographer who vignettes is deliberately
throwing away a most effective aid to perfect
presentation, namely, the relief effected by the
reflected light from his background, and when
you add to this the conventional shape of the
vignetted head and shadows, the result is feeble
in the extreme. Here, then, is another false
god which has for years held sway. We ask the
student, did he ever see a vignette painted by
Da Vinci, Rembrandt, Holbein, Velasquez,
Gainsborough, or Frans Hals? Such men
knew too well the value of a background to
throw it away; they could not have painted a
vignetted head. Look at their chalk drawings,
and the case is very different; there they were
dealing with an incomplete method, and kept
rigidly within their bounds. In our early photo-
graphic days, we learned printing from an in-
dustrial photographer, who did an extensive
business in vignetted heads, and it was a source
of great amusement to us to watch the mechani-
cal application of the vignettes by the "head"
printer. This is of course another source of
the mechanical appearance of ordinary photo-
graphs; for by vignetting fifty different heads
a certain uniformity must result, as in a regiment

dressed in uniform, with of course the fatal re-
sult, the loss of all individuality, character, and
of course " art." The few photographic portraits
that we have seen worth studying were certainly
not vignetted. Mr. Hill and Mrs. Cameron
did not vignette, they knew better. That people
demand vignettes and pay for them is nothing
to us, let photographers sell them as they do
scraps and chromographs, and other fancy arti-
cles, if it please the childish and vulgar, but let
them not be called works of art, for on the con-
trary they are certain indices of bad taste. Vig-
netting might be admissible in certain *decora-
tive* cases in book illustration, as when a land-
scape decorates an initial letter, but in pictures,
never.

The simplest application of combination print-
ing is the printing of a cloud into a landscape
from a different negative. Though it is far pre-
ferable to obtain the clouds on the same negative,
and this is quite easy in landscape photog-
raphy, it is, if you use great judgment, admis-
sible to print in clouds from a separate nega-
tive, but this requires an intimate knowledge
of out-door effects, and the clouds must be
taken in a particular way. Printing in clouds
is admissible because, if well done, a truer ren-
dering of the scene may be rendered, and the
joining of sky and landscape is nearly always
gradual and undefined. But the ordinary way
of taking cloud negatives is much to be con-
demned. The practice is to point the camera
to the zenith if need be, to focus sharply, to use

the smallest stop, develop and select for final
use according to the lighting, indeed, not al-
ways being very particular on that point. But,
by elevating the camera a point of sight is
taken different from that employed in taking
the landscape ; by focusing sharply, often using
a wide-angle lens drawing falsely, the clouds are
rendered false in tone and false in drawing.
All this an artist detects in a moment, a work-
man, never. The first necessity, then, in taking
cloud negatives is that the point of sight shall
be *the same* as that chosen for the landscape ;
the second that the clouds shall be so focused
that their tonality shall remain true ; and
the third and most important point that
the cloud form shall be harmonious with
the landscape. The very simplest truths of
nature are daily ignored by photographers in
the works they exhibit. There are often three,
or even four suns in one landscape, or at least
the evidences of them ; mighty *cumuli* float
over lakes where there is no ripple, and yet
there is no reflection ; or, as we have seen, re-
flections of clouds have been printed in where
there are ripple marks ; or heavy *nimbi* lighted
from one direction are placed over *cirro-cumuli*
lighted from another direction ; or, again, a
setting sun sinks to rest over wave-broken
water that reflects glints of light from exactly
the opposite direction.

The best way, then, if a cloud negative is
wanted, is *to take it at the same time as the
landscape and from the same point of view*, get-

ting as much as possible the same view
as seen in nature. The exposure must of course
be by a shutter set fairly quickly. We think the
best way of printing in clouds so obtained, is to
take a piece of damp tissue paper the size of
the negative, gum it around the edges to the
back of the negative, then with some blacklead
and a stump blacken the sky out when the
paper is dry, carefully following the contours
of those objects which stand in relief against
the sky with a lead pencil. In this way you
can with marvellous accuracy stop out the sky,
and the work being on the back of the negative
and in plumbago, the contours still show the
mingled decision and indecision of nature. The
print is then taken, and afterwards the cloud
negative is arranged as desired, the sky-line
being covered with cotton-wool and the rest of
the exposed landscape by a black cloth. No
special printing frames are required for this
purpose, only one a size or two larger than the
negative you are printing from. Cloud print-
ing, as we have said, is the simplest form of
combination printing, and the only one admis-
sible when we are considering pictorial work.
Rejlander, however, in the early days of
photography, tried to make pictures by com-
bination printing. This process is really what
many of us practised in the nursery ; that is
cutting out figures and pasting them into white
spaces left for that purpose in a picture-book.
With all the care in the world, the very best
artist living could not do this satisfactorily.

Nature is so subtle that it is impossible to do this sort of patchwork and represent her. Even if the greater truths be registered, the lesser truths, still important, cannot be obtained, and the softness of outline is entirely lost. The relation of the figure to the landscape can never be truly represented in this manner, for all subtle modelling of the contours of the figure is lost, and the perspective drawing will be false. Such things are easy enough to do, and when we first began photography we did a few, but soon gave it up, convinced of its futility. Rejlander, though he tried it, soon saw the folly of such play, and he is the only artist we know of who used it Mrs. Cameron and Adam-Salomon never indulged in such things that we know of. Some writers have honored this method of printing by calling it the highest form of photographic work. Apollo help them ! The subject is hardly worth so many words, for though such " work " may produce sensational effects in photographic galleries, it is but the art of the opera bouffe.

In printing, variously-shaped masks are used. There is no objection to them, but in our opinion they do not in any way improve the subject, although they do not necessarily spoil it like vignetting.

Besides all these "dodges," there are machines for producing imitation enamel portraits in basso-relievo and cavo-relievo, but all such ideas are false in theory, and the results inartistic hybrids unworthy of any serious consideration.

Recently some French and English amateurs have revived the old "gum-bichromate" printing method, announcing it as a new discovery and dubbing it by the stupid and specious name "photo-aquatint," which should be applied to photo-etching if to anything photographic. The chief claim of these amateurs has been that the process allows of the exercise of "individuality." Of course this is merely verbal juggling—for what is photography is mechanical—in the drawing and rendering of forms for example,—what is due to jets of hot water is not photography nor limited to this process, for ordinary carbon printers have always modified their results by "hot-water" locally applied. We have examined what are given out to be the best examples of this work and find them all most false in tone and bad in texture, and in no way whatever comparable to a naturalistic platinotype, say. Every good quality of photography is lost in them except the mere outline of things, the weakest part of photography, and the method is most incomplete and inferior to the best ordinary carbon prints—for example. The process merely uses photography as a basis for after "hand-work" of a most fumbling or bungling description.

Here, then, we come to an end of the subject of printing, and in our opinion the student should consider himself fortunate indeed in having so beautiful a method as the platinotype process with which to work.

CHAPTER X.

ENLARGEMENTS.

The best enlargements made for the trade are made from very sharply-focused negatives. In fact, some of the best enlargers take up the original negative from which the enlargement is to be made, and examine it with a small magnifying-glass, and if any of the outlines are woolly they will not promise a good enlargement. This, then, shows that a small negative must be taken very sharply if it is to produce a good enlargement; that is, it must be taken purely from that point of view, all pictorial considerations being thrown aside. It is obvious, then, from what we have already said, that this is undesirable, for every negative should be suited to the subject. From what has been said already, it is evident such a negative will be untrue in illusion.

Enlarging, too, of course, increases all falseness in drawing; if the drawing in the different planes is wrong in the small negative, it will be still more apparent in the large negative or print.

But it will be argued, and justly, that sometimes an enlargement is more pictorial than the small picture from which it was pro-

duced. There are even cases where an enlarge-
ment can be truer in perspective than its orig-
inal, but tone, texture and modeling are gener-
ally still false. This is sometimes, but rarely, the
case; and when such is the case, it is the *result
of chance.* You would never be able to take a
negative in a particular way so that you know
for certain it will be improved by enlarging
so many diameters, and therein lies the in-
herent **defect** which unfits this process for
pictorial work.

The * actual process of enlarging is very
simple, either by artificial light or daylight;
but it is in our opinion a needless and undesir-
able proceeding.

We have made many experiments in this
direction, but we have never yet been able to
get an enlargement as fine in quality as the
direct photograph. Many of the little subtleties
which give quality to the work are either lost or
are only obtained accidentally. Not long ago
we saw a beautiful portrait—an enlargement,
the print from the small negative of which was
very poor, and no one was more surprised at the
improvement in the enlargement than the pho-
tographer himself, but he could never make
sure of doing the same thing again from
a different negative. Therefore, enlarge-
ment must always be a speculation, and
though, like all speculations, some may
succeed, yet are the majority haphazard, but
then in certain cases the results may be worth

* See Dr. Murchison's Optics. Book II.

keeping. A picture of fine quality, quarter-plate size, is worth a dozen enlargements 24 x 22.

It is only in certain very limited effects that the tonality will be true after enlargement, and that of course constitutes another fatal objection. The original negatives having been taken with a small stop, the modeling is flattened, and no enlargement will give true modeling or replace the lost modeling. All textures, too, are stretched, and generally have an unnatural appearance. Mathematically, of course, it is theoretically legitimate, but practically, as a rule, it is unsatisfactory. It will have been seen from the chapter on lenses that there are many points in the use of the lens, such as reflected images, which may further alter the enlargement as well as matters here cited.

CHAPTER XI.

For industrial and educational purposes trans-
parencies of all kinds are valuable, and we shall
touch upon them elsewhere. With lantern slides
our art student has nothing to do. A lantern
picture is an optical illusion, and lantern slides
are toys when they do not serve lecture pur-
poses. For lecture purposes they are of course
invaluable, but they have no place *per se*, as
pictorial works, neither have stereoscopic slides.
They all rank with the camera obscura, the
diorama, and the panorama.

We say all this because a beginner must be
cautioned against paying any serious attention
to these subjects if his aim be to become a
good pictorial photograph. Such work is
much too serious for her devotees to trifle
with any other subject, and besides the mak-
ing of lantern and stereoscopic slides is apt
to have a bad effect on the beginner. His at-
tention becomes centered on the production of
pretty things—neat, small, superficial prettiness
pervading most of the work of good lanternt
slide workers. Conventional compositions
and niggling prettiness are the lantern-slide
maker's beau-ideals. Of course these qualities

are very admirable for lantern slides, for without them they would have but little attraction; but they are quite distinct from, and very, very far removed from having any connection with the best photography.

We know many artists who photograph and value photography *per se*, but we have yet to meet that one who deigns to make lantern slides except for the purpose of making enlargements from which to draw. It has been said that the appearance of stereoscopic pictures is wonderfully true; this is not the case. There is a luster, false tonality, and apparent illusion, which to an artist makes them anything but true, for the aim of art is not complete illusion. In short, until photographers do away with much of the " play " of their craft, and look at it seriously, they cannot hope that highly trained artists will join in with them.

For scientific lectures of course lantern slides are invaluable, as we have already said, and for this purpose they should be untouched; but we cannot help smiling when we hear of producers of slides claiming for their work the title of " artistic " *because* they are untouched and true. Scientific truth is not necessarily art, as we have often pointed out, and as Muybridge's photographs prove.

Let our student, then, avoid these snares, unless he wishes to cultivate what Mr. Herkomer has aptly called " Handkerchief-box act."

CHAPTER XII.

PHOTO-MECHANICAL PROCESSES.

From our earliest photographic days we always felt that all "ordinary" printing methods, however good in themselves, would finally have to give way to photo-mechanical methods, as all processes are called by which the negative is permanently reproduced. All the photo-mechanical printing processes may be divided into two great classes :

A Processes in which the aim is to produce diagrams.

B. Processes in which the aim is to produce pictures.

For the first purpose any of the methods are useful; that is, typographic processes, where the block is set up with the type in the printing-press; the collotype process, where the prints are subsequently mounted on paper, or interleaved in a book; and the photo-etching process, where the plates are introduced between the leaves of a book.

It is obvious that when the aim is diagrammatic, brilliancy, sharpness, correct drawing, and the truthful rendering of texture are *the* requisites, as in the reproductions of negatives from nature to illustrate scientific works, books of travel, etc. In such cases these are the main

points to be considered; and when to these considerations is added the question of cost of production, it is evident nearly all the processes worth mentioning which are now in existence will serve one or other, or all such purposes. But when the question comes to be considered from a decorative point of view, the matter is totally different, for it is a *sine quâ non* in this case that all the fine quality of the original photograph be preserved the cost must not be considered. We shall then briefly discuss these processes. As we said in a former chapter, of ordinary printing out methods the platinotype process is alone worth considering for this purpose, but for book illustration a serious objection to its use is its monotony.* For although there are two colors, the charcoal gray and the sepia, the gamut of color is very limited; a serious matter this, for our experience leads us to believe that there is a particular color and tint especially suitable to each subject. Another objection to all ordinary printing papers is the want of relief in the gelatine film of an ordinary negative, a want which gives a certain flatness in the resulting print, when compared with a print from a copperplate where the cavo-relievo is deeper. Relief in the block undoubtedly has a great influence on all results, and in all the photo-mechanical processes "*depth*" is an essential, and the best processes are those in which the printing-plates are the deepest.

* This can now be more or less remedied as we have said.

Another fact which renders platinotype less valuable than photogravure is that there is always a certain amount of "sinking in" of the image, as there is with a painting on canvas; but a painting can be brought up by varnish, a platinotype cannot.

Let us, then, examine the various processes, and see which will serve our purpose.

For artistic reasons we are of the opinion that Collotypes, Woodburytypes, and all such methods, are undesirable; and this we say deliberately, after long study of the subject, for in supervising and choosing illustrations for the books which we have illustrated we carefully examined specimens of nearly all the photomechanical processes extant. We say this, although an impractical writer on the subject of photo-mechanical processes has given out the opinion that the ideal process is one in which the resulting print should be a facsimile of a "silver print;" but of course such a remark is artistically wrong, and is only true when speaking of scientific photographs.

For the benefit of the student, then, we say there are but two processes to be considered for artistic book illustration—a typographic block to be printed with the text, and an intaglio copperplate. The typographic block has the whites lowered like a woodblock; and as it is printed in the ordinary way, with the type, there is no extra trouble or cost in the printing. With a copperplate, on the other hand, the plate must be carefully inked and wiped, and each print

separately pulled by hand, the difference in
time taken by this process, and consequently
the cost, is therefore greatly increased.

After a careful examination of all the typo-
graphic processes we have no hesitation in say-
ing that there is *not one* satisfactory in the
market. When the original picture is not tra-
vestied and cheapened by mechanical-looking
crenellations and stipplings, it is marred by ob-
vious handwork and by falsity of tonal transla-
tion. Any photo-mechanical process, to be per-
fect, must, as we have all along maintained,
require no retouching of any kind. All the
typographic blocks, too, are too shallow; hence
in the rough working and pressure of the
printing-press all tonal subtleties are injured by
smudges, as the block becomes clogged with
ink and fluff from the paper. Many of these
blocks serve remarkably well for rough dia-
grammatic purposes, but for artistic purposes
there is not one we can recommend when the
object is to reproduce pictures taken from
nature. For some kinds of work they serve the
purpose. A first-rate photo-mechanical block to
print with the text in the ordinary printing
press, which is entirely the result of a chemical
process, is a great desideratum, and it is a prob-
lem which experimenters in this direction will
do well to study. Not only is it that there is no
typographic block adequate, but in addition,
when the present process is employed for dia-
grammatic purposes, or to satisfy the pictorial
standards of the untrained in art, they are ter-

ribly marred by crude retouchings and daub-
ings with Chinese white, until such travesties
of nature appear that are only to be equalled by
some of the "finishing artists" of the photo-
graphic studio. Yet, bad as these block pro-
cesses are, they are infinitely better than the
second-rate woodcuts made from photographs.
Day after day, books appear illustrated with
woodcuts and pen and ink drawings done from
photographs, in which the woodcutter or pen
and ink draughtsman has effectually ruined all
the beauty of the photograph. If the student,
then, should ever be in the position of having
to choose between the facsimile woodcuts of
English woodcutters and photo-mechanical
block-work, let him choose the latter as the
lesser evil; it is better than any except the
American school of facsimile woodcutters. And
here it may be well to note a dishonest practice
which is daily becoming more common with
writers of books of travel who buy photographs
abroad, and unscrupulously have their books
illustrated with them. We know of certain
such illustrations which are advertised as being
prints from wood-blocks and pen and ink draw-
ings done from *sketches by the author.* Quite
recently a book of travel appeared illustrated
with third-rate woodcuts purporting to be done
from sketches by the author, which were really
done from photographs purchased in the shops
abroad. We know of one case where this was
done in England, the photographs pirated being
English photographs. Should such a thing

ever happen to the student, he must, as a duty to the photographic world, prosecute without compunction, and exact the utmost penalty of the law. Such dishonesty is one of the most despicable forms of thieving.

But to return to our subject. As we have said, we felt from the first that photo-etching was the ultimate goal to be reached ; that was the final end and method of expression in monochrome photography. We argued the matter out with many painters, and they agreed with us, as did they agree that the process of reproduction must be the *result of chemical changes only*—that no retouching was admissible, or a hybrid would be the result, and a hybrid is detestable to all artists, although we have recently seen writers untrained in art matters advocating a photo-etched plate as a basis for etching or mezzotinting. Having decided, then, on these points, we determined to try the photo-etching processes of the various firms. On inquiring from the best English and French firms, we found that but very few, in most cases no landscapes from nature had been reproduced in this way, although a few portraits had been done. We carefully examined the specimens(nearly all specimens of picture work) of thirteen different firms ; in fact, all the firms practising photo-etching that we could hear of. From this examination it was evident that however good many of the processes were for picture work but few were adaptable to our needs. Having at last settled on the four apparently most

suitable processes, we began our studies. Neg-
atives were sent to each of these firms, of whom
only one had ever attempted reproducing a
landscape direct from a negative from nature.
The proofs came, and were in *every* case most
unsatisfactory; they had all been barbarously
retouched, all the tonality *had been* falsified,
faces against the sky were made lighter than
the sky, faces were roughly outlined with an
etching-needle, high lights were scraped away
needlessly, and shadows barbarously deepened
with the roulette. Our battles then began, and
we demanded plates free from retouching; the
voluminous correspondence we had on the sub-
ject would afford amusement. Various firms
protested—it couldn't be done; it was absurd;
was art the result of a chemical process? and
Heaven knows what! However, we persisted
with inflexibility, and though we had to accept
in some cases the least visible retouched plates,
we finally gained the day all round, in so far
that all the firms supplied us with plates with
no visible retouching. Thus was instituted a
a new departure, negatives from nature were
reproduced, through our battlings, with no
visible retouching; and although a few dia-
grammatic negatives had been reproduced here
and there before us, we were the first to start
the serious reproduction of negatives from
landscapes and figure subjects which could be
regarded as pictures *per se*, and not merely as
topographical views.

But now the coast is clear, and the student

can get his negatives done without visible
retouching by asking for it. From an examin-
ation of these results it was soon evident that
one firm, the Typographic Etching Company,*
produced plates immeasurably superior to those
of any other firm, and in addition, Mr. Colls,
formerly this firm's chief photo-etcher would
finally guarantee their production *without re-
touching*, though he too, at first, greatly re-
touched the plates.

For reproducing negatives taken from nature,
then, this process is *perfect*, and we cannot see
how any photo-engraving process will ever
surpass it. Mr. Colls is a careful worker and
perhaps therein lies the secret of his success.
It is perhaps invidious to select a firm for
special mention, but as the results of Mr. Colls
are in every way so superior when artistically
considered, we feel it our duty to record the
fact here for the benefit of the student. Quite
recently there has been much discussion on
the vital question of " Photogravures *v.* En-
gravings," and some of the English firms have
publicly announced that is it necessary to fin-
ish their work by hand, while others privately
maintained the same fact. Mr. Colls, on the
other hand, maintains that a plate, perfect
in quality, can be produced without the aid of
a touch by hand. Further on will be found a
communication on the process by the etcher,
Mr. Colls, who therein states that he can and
does produce his work without any retouching.

* Mr. Colls has since set up works of his own.

His process renders the light in the shadows better than any of the other processes, this being affected by the method of working, and, as a whole, the "quality" of his work is unapproachable.

And here we would caution the scribes of the press who have lately written so freely and so mistakenly on the subject of photogravure, that the best photogravures are *not* produced in France, but in England. Englishmen do not seem to know when they possess a "good thing."

We venture to say, without any diffidence, that for the reproduction of negatives from nature, the process as perfected by Mr. Colls is *facile princeps*, and to assert that for the reproduction of pictures, some of the English processes are equal to, if not superior to, the continental processes. This is also the opinion of several artists who have seen specimens of the work done in both countries. The process, as worked in America, does not give results equal to those obtained in England. For diagrammatic purposes, we consider nearly all of the English processes possess qualities of equal value.

Another new departure for which we had some battling was a *minor* point, but an *important* one. It was on the question of lettering. It had been the practice of many of the firms to engrave in plain lettering beneath the picture, the name of the firm, and the words "negative by——," and often in addition the word "copyright." This engraving, as it was

usually done, gave a "cheap" look to the pic-
ture. We felt that the picture was injured by
this procedure, so we insisted that our name
should be cut in the picture, in a quiet manner,
as an etcher would sign his name, and that no
ordinary engraving should appear on the plate.
In case, then, our student should at any time
have any of his works reproduced, we will give
him a few hints, for though the publisher does
the business part, the illustrator always has the
passing of the plates.

When sending his plates, then, to be bitten,
he should send a well-printed platinotype print
with them, a print having just the effect he
wishes for in the copper plate. If clouds are
to be introduced, the cloud negative should be
sent as well. He will in due time receive a
proof, which he must go carefully over, making
any notes on the margin as to re-biting, &c. If
it be retouched or utterly bad, it must be re-
jected. Of course, it is here evident that his
art knowledge will come in, for if ignorant of
art, how can he make remarks to the "biters"
who are sometimes artists? He must continue
asking for proofs until he receives a satisfactory
one, for no plate can be forced upon him if he
can prove it to be wrong. If he have real
grounds for objection, he will find the English
firms most generous, for they take a pride in
their work. They have, in some cases, made as
many as three plates from a subject for us, with
no extra charge, and this we could never get a
French firm to do. When he approves of the

plate, he signs the proof to that effect. Then
comes the great question of "color," that is the
colored ink to be used; for one of the great
advantages in photo-etching lies in the number
of colors and shades of colors which can be
used. Here, again, his artistic knowledge
comes in, and he will find the effects produced
by different colors are marvellous. Having,
then, suggested his color and tint, he will re-
ceive proofs printed in them, and he finally
decides upon the tint suitable for each plate,
and these are kept as standards on a file. The
matter of printing papers, too, offers great
variety and scope for artistic selection; but here
the student will find he has not a free hand, the
publisher often limiting his choice in that on
financial grounds. The student must see, how-
ever, that if India paper be used, an unsuitable
tint be not selected. For example, India paper
may be yellow or white, obviously then, if the
plate is to be printed in bartolozzi red, white
India must be used, and not the ordinary yellow-
tinted India. The student must be careful
when sending his platinotype print, to cut it
exactly to the limits he wants the picture on
copper. Copper-plates can be produced in this
way from prints in cases where the negative
has been broken. If the sky is not an import-
ant part of the picture, it is better to have it a
flat gray tint, or delicately gradated. The
student, of course, remembering certain physi-
cal truths, as for example, that still water is, as
a rule, lower in tone than the sky which it re-

flects, &c. The best test of relative value of
sky and water is to turn the *picture upside down*.
All these subtleties must be carefully con-
sidered, for a sky lower in tone than the still
water reflecting it, would, with rare exceptions,
be a fatal artistic error, and enough to condemn
the plate. The details which thus go to make
or mar a picture are countless.

This then, is our experience of the photo-
mechanical processes, and, as we make it a rule
never to write on anything we have not full
practical knowledge of, we have asked our
friend, Mr. Colls, to write us some particulars
of these processes. We have done this because
there are certain misleading books in the
market on the subject, written by men without
such special knowledge as can only be obtained
by a man who has worked at the process for
years and at nothing else, and who is, in addi-
tion, practically trained. Mr. Colls is both a
specialist and an artist in this work.

In our opinion enthusiasts who practice pho-
tography will also photo-etch their own plates,
which is greatly to be desired, but since these
processes are at present kept very secret, this
knowledge cannot now be acquired. Neverthe-
less, we feel that the day is not far distant when
every one who expresses himself by photo-
graphy will also bite his own plates and make
his own blocks, and the prints will be published
by print-dealers as etchings are now. This, in
our opinion, is the only method which can give
fullest satisfaction. A final important consid-

eration is the number of good prints which can be pulled from each plate. Colls' plates, being bitten deeper, will obviously stand more wear and tear than the others, and will produce a greater number of good impressions. Mr. Colls thinks that at least 3000* good impressions can be pulled from each plate, if the steel-facing will last. We append Mr. Colls' remarks:—

METHODS OF REPRODUCING NEGATIVES FROM NATURE FOR THE COPPER-PLATE PRESS.

" In giving a description of the various methods that are employed for reproducing photographs from nature for the copper-plate press, it is obvious that only those which are purely ' automatic ' need be mentioned, as it is impossible to give a true rendering of those beautiful forms and delicate gradations of tone, which we see in nature, by any but automatic means. For so ever-varying and sudden are her changes, that it is by photography alone we are able to secure these effects, and having obtained them, we require a process which will give us identical impressions, and one which will harmonize with printed matter when re quired for book illustration.

" This we have in the Intaglio plate, which gives the most perfect tonality, and possesses all the richness and quality of a mezzotint plate, with the same degree of permanency.

* In my opinion this is too high an estimate, for though some plates may give 3000 good prints others may not give 300 satisfactory prints.

" For convenience of description the different
methods of producing Intaglio plates may be
classed under two heads—'Grown' and 'Bitten.'
I will first mention the 'grown,' and will en-
deavor to point out the characteristics of the
different processes, so that a comparison may
be made between them, with the object of de-
termining the one best suited for the purpose.
In all the growing methods the basis of the
process consists in obtaining a gelatinous mould
of the subject ; the most usual and simple way
being to develop a carbon print from a reversed
negative on a polished copper-plate which has
been previously silvered, to prevent the copper
which is afterwards deposited upon it adhering ;
and to produce the grain which is necessary to
hold the printing ink. The mould when wet is
dusted over with powdered glass, sand, or the
like, previously treated with wax or stearine,
to assist its removal.

" When the mould is quite dry the gritty par-
ticles are removed by gentle rubbing, leaving
the gelatine in a grained state. Plumbago is
then rubbed well over the picture to render the
mould conductive, and it is placed in the
electrotyping battery and a stout cast taken.
There is some little uncertainty attending the
entire removal of the gritty particles, and great
danger that in making the mould sufficiently
conductive in the heavy portions, the fine work
is destroyed by getting blocked with the plum-
bago. The former objection has been over-
come by substituting powdered resins, which

can be readily dissolved away without injury
to the mould, and the latter by the introduction
of a tissue containing granular plumbago,
which while producing the necessary grain for
holding ink, is one of the best conductors of
electricity, so that no after-treatment is re-
quired.

" Similar to this is a process by which the
grain is obtained by the action of light on a
chemical substance, which crystalizes under the
action of light, the crystals becoming larger the
longer they are acted on by it. A deposit of
copper is then made on the crystalline surface
and a plate obtained.

" By these methods very satisfactory results
may be obtained for certain classes of work
where the range of tone is not great, they are
more particularly suited for reproducing the
works of early engravers, old cuts, etchings,
pencil and crayon drawings, and similar work
upon rough or grained surfaces. In fact, when
printed upon old paper, as is sometimes done
in particular cases, so closely do they resemble
the originals, that the most expert judge would
have great difficulty in detecting the reproduc-
tion from the original ; but for reproducing
nature work, where the scale ranges from the
highest lights to the deepest shadows, these
methods are not suitable without much hand-
work, which is ruinous to the faithful rendering
of the subject, and the introduction of the
roulette which is used to give the necessary
depth does not improve the appearance, as the

depth obtained by it is heavy, and lacking that
transparency which is so desirable in all classes
of work from nature. The great drawback to
these methods is that the grain produced is
upon the surface of the plate, standing up in
innumerable little prickles, and the only way
of working up a plate is with the roulette and
scraper (the nature of the grain being unsuited
for re-biting). These, added to the soft nature
of grown copper, as compared to rolled or ham-
mered copper, which is used in the biting
methods, necessitates the greatest care in print-
ing, and usually require very strong and some-
times forcing inks to give the necessary
strength, and although a plate be steel-faced it
will not hold out for a large number of im-
pressions.

"There are other ways of producing a grain
upon a gelatinous mould by re-sensitizing and,
when dry, dusting over the picture brocade
powder, either coarse or fine, as the suject may
require ; the mould being previously treated
with vaseline, or a similar substance, to allow
of the powder adhering, and exposing to day-
light for a short time. The powder is then re-
moved, and it is ready for the battery, after
being blackleaded. As all the growing methods
resemble each other so closely, I will not men-
tion any others, but will proceed with a short
description of the biting processes.

"A polished copper-plate, preferably a ham-
mered one, is thoroughly cleaned, to remove
all traces of grease, and is dusted over with

powdered asphalt or resin, and the plate heated until the powder becomes partially melted. A carbon print from a reversed transparency is next developed upon the grained plate and allowed to dry. The unprotected margin is then painted round with asphalt, or other resist-varnish, and a wall of bordering wax placed round the work. It is then ready for biting, which is done with perchloride of iron, the bare portions being first attacked ; water is then added, and the biting proceeds to the next tone, and so on, adding water when required, until the solution has penetrated the thickest portions of the film. The greatest care must be exercised during this operation, and a careful watch kept lest the action remain too long on any part. The biting should proceed in a gradual manner, so that the values are not exaggerated. The plate is then rinsed in water, the bordering wax removed, and the pigment cleaned off with a little potash ley.

" The biting of a plate resembles very closely the development of a dry-plate positive, as the action may be seen throughout the operation as each successive tone is reached. There are many variations to the above method, and each worker has his particular way of producing the grain, making the mould, biting, etc., but they are all based on the one just described. As the introduction of the biting methods as commercially worked is of more recent date than the grown, less is known of it, and those who work it most successfully keep it secret, and were it

known there is little likelihood of its being
satisfactorily worked by any but those experi-
enced in copper-plate work, as long and careful
study is necessary to master those minute de-
tails which are so important to ensure good
results. For so delicate are the operations, that
the changes of weather, temperature, etc., play
an important part, and must be attended to.

"One of the great advantages a bitten plate
has over a grown is that the scale is greater than
by any other method, and the nature of the
grain admirably lends itself to re-biting should
any parts require deepening. That is, re-enter-
ing the original work by covering the grained
surface with a protective coating, which resists
the action of the acid etching fluid, and deep-
ening those parts that may require it, stopping
out with resist-varnish any portion where deep-
ening is not wanted. This at once does away
with the roulette, and the plate still maintains
its original character. Re-biting is seldom re-
quired on a plate from nature, *for with care a
plate can be made which needs no after-work
whatever, and when bevelled and steel-faced is
ready for the press, notwithstanding the asser-
tion that has been made to the contrary, which
recognizes the process only as a basis for skilled
afterwork.** It is needless to say that in all
mechanical processes the very best negative
is required to work from, for although a

* I have, since writing this article, learned the process from Mr.
Colls, and can add my testimony to his, that plates can be reproduced
of the finest quality that do not require a single touch with a tool of
any kind.

great deal may be done in the biting to counter-
act any defects in the negative, yet, if the
negative is wanting in any particular, the
after-result is sure to suffer. And here I wish
to say that by the very best 'negative' I do
not mean the ordinary photographer's beau-
ideal, but a negative which gives as true as
possible an impression of the object photo-
graphed, and is full of the 'quality' and sub-
tlety of nature.

"The grain obtained on a plate which is
bitten, differs materially from one that is grown,
inasmuch as in the former it is below the sur-
face, and in the latter upon it, as previously
described; consequently its wearing capabili-
ties are far greater.

" Another biting method which possesses the
merit of ingenuity rather than utility, is of con-
verting an ordinary bromide of silver positive
into chloride of silver, by the action of per-
chloride of iron and chromic acid. The film
when damp is brought into close contact with
the face of a polished copper-place. Chloride
of silver now rests upon the copper-plate, more
of it in the vigorous or dark portions, and less
of it in the lighter, and by a galvano-chemical
process the chloride of silver decomposes, form-
ing metallic silver and soluble chloride of cop-
per, and producing depths corresponding to the
amount of chloride of silver present. The energy
of the action may be increased by moistening
the film with a weak solution of chloride of
zinc, and a battery current seems necessary

to produce good results. As can be seen, the
process is a very delicate one, admitting of
little if any latitude in working, and, unlike the
first-mentioned biting process, will not permit
of any work being put on the positive as is
usually done in the first method for certain
work where the darks are very hard and pro-
nounced, and a great saving of after-labor
avoided.

" It is advisable to say that the work done on
the positive and plate to which I refer is done
in connection with facsimile work, and not with
' nature work,' for in the reproduction of engrav-
ings the deep blacks of the engravings have to
be reproduced, and since in nature there is no
black of this kind we do not have to accentuate
parts of the plates to produce it."

Since writing the above it has been dis-
covered that the English can produce better
photo-etchings than foreigners, and yet years
after I stated the fact, this tardy acknowledg-
ment was made. And the Society of Arts en-
couraged English work, but instead of get-
ting the man who had done more toward im-
proving photo-etching than anybody to read the
paper on "Photogravure," an amateur novice
was asked to read the paper and a still greater
amateur put in the chair.

CHAPTER XIII.

MOUNTING AND FRAMING.

Having our print, the next question is how shall it be mounted and framed. There can, of course, be no laws for this, but we feel justified in making a few remarks on this head.

The best mountant we know of is a weak solution of fine French glue. It acts better than any other mountant we have used, and we have tried several of the formulæ made with starch, arrowroot, and other compounds. Fine French glue holds firmly and there is no cockling after mounting. After mounting, the prints are improved by being passed through a press, but this is by no means necessary. We shall now make a few remarks upon framing. In the first place it is our opinion that all cut mo unts are inartistic. Mr. Whistler, not long since, made some remarks on this head, which are well worthy of attention. His objections to cut mounts were that the different tints of the picture, the gold border, and the cut mount, weakened the edges of the picture and detracted from its directness and strength, and this is no doubt true. For this reason we do not think platinotypes look well mounted on India paper, the edges are decidedly weakened, and as for mount-

ing silver prints on India the result is most in-
harmonious. In our opinion then the print
should be mounted upon white paper, preferably
Whatman's rough drawing-paper, and for all
pictures less than whole plate size, we should
recommend a margin from three to four
inches. A suitable moulding for these would
be a beveled moulding enameled white. In all
cases where the mount shows, it must be re-
membered that the color should harmonize with
the print. We saw some photographic prints of
Whistler's "Sarasate" mounted on plain black
cabinet mounts, and they looked charming. As
in that case, the picture came out nearly all
black, the whole made a harmony in black.
When the prints are mounted on cards as in the
case of cartes and cabinets, there should be
absolutely nothing on the face of the card.
The hideousness of the photographer's name in
shining gold letters is far too common. Noth-
ing could look better for these small pictures
than plain black mounts, with no word or letter,
or colored line, or any other "embellishment."
If the photographer is such a tradesman at heart
that he must air his medals, let him put all that
part of him on the back of the card. The
method of stamping each photograph with the
photographer's name is not less to be depre-
cated. For the industrial photographer some
simple but artistic lettering should be chosen,
and it should be printed small in one corner, in
Indian ink, which harmonizes with the gray of
platinotypes. Any good die-cutter could sup-

ply an artistic stamp, and the charge, even if a little greater than usual, could not be very great. Or the photographer might cut out his name artistically in the gelatine film, but we recommend the former plan. The mounts for cartes and cabinets should have a margin of at least half an inch all round, as this adds considerably to the effect.

For platinotypes ranging from 15 by 12 and upwards, we prefer to frame them up closely, showing no mount. The frame we like best for large black and white work is a pattern we took from a painting by De Hooghe. These frames are made of mahogany, 2½ inches wide, and beveled inwards, and have a rather broad slip of English gilt between the frame and·the picture. The mahogany is stained black or some other color and polished. Pictures of 15 by 12 and upwards should also be framed close up, and for the larger sizes we prefer black frames and simple mouldings with but little carving. Cambridge frames are simple, but do not look distinguished. Each picture should have a separate frame, and we trust that exhibition committees will one day see their way to enforcing this rule, which, besides ensuring a better effect, would prevent much bad work being hung. Sometimes six prints are hung for the sake of one or two, because they are all in one frame. We could scarcely believe, had we not seen it, the fact that some exhibitors have chronicled on a part of their frame the medals taken elsewhere by the picture. Such a proceeding, besides being

vain and ill-bred, is apt to influence credulous judges. One would think it quite needless to say that this form of advertisement is not ornamental, nor does it enhance the virtue, qualities, or beauty of the picture. All artificial methods of mounting and framing are to be avoided. One of these is mounting on glass. All albums used for mounting prints should have plain pages, tinted in harmony with the charcoal gray of the platinotype. All the vulgar decorations of ships, flowers, etc., which disfigure the photographic albums of to-day should be rigidly excluded. The bad taste of the manufacturers of these things is only another proof of the bluntness of the æsthetic feelings of producers and buyers alike.

CHAPTER XIV.

COPYRIGHT.

The hazy notions existing among many photographers as to how to secure the copyright of their photographs, and other details, has led us to make a few remarks on the subject. In the first place the student is cautioned to secure the copyright of every photograph worth keeping, for we presume he will only keep pictures. This should be done at once; it is our practice to send the first rough print at once to the copyright office.

The photographer must write to the Registrar, Stationers' Hall, Doctors' Commons, E. C., for forms for copyrighting photographs. These cost one penny each, and a money order must be enclosed for the amount, stamps not being accepted. He will then receive the form as given on the next page.

The student must carefully note the footnote on the schedule, and be most particular in all cases when he sells his copyright in any plates to have a written agreement drawn up and signed *before* he fills in the copyright schedules. After this proceeding he can fill up the schedule as directed, and it is, of course, only on these occasions that he will be required to fill in columns two and three of the schedule.

The student should carefully study the matter of copyrighting, for he will find both publishers and photographers are, as a rule, ill-informed on those parts of the copyright law to which we now refer.

He fills in then all but columns 2 and 3, as in the dummy, and returns the form with a shilling, a copy of the photograph to be registered, and one penny for postage, when he will receive a receipt. Each photograph must be separately copyrighted. This 1s. 1d. protects the photograph for 42 years, or for the author's lifetime and seven years after death. The author (being a British subject, or resident within the dominions of the Crown) is entitled to the copyright of every photograph made in the British dominions or elsewhere. We shall extract a few pertinent remarks from an excellent article on copyright, which appeared in the " Year's Art of 1887."

The "author" of a photograph seems to be the person who actually groups the sitters, and "is the effective cause of the picture." An agreement is made with operators to obviate this reading of the law. "A photograph taken from an engraving is 'an original photograph' within the section." Thus a photographer cannot copy the photograph of an engraving in which there exists copyright.

The copyright given by the act is "the sole and exclusive right of copying, engraving, reproducing, and multiplying the photograph and the negative thereof, by any means or of any

(COPY OF)

Memorandum for Registration under Copyright (Works of Art) Act.

TO THE REGISTERING OFFICER APPOINTED BY THE STATIONERS' COMPANY.

I, *John Silver*, of o, *Regent's Street, London*, do hereby certify, That I am entitled to the Copyright in the undermentioned Work; and I hereby require a Memorandum of such Copyright [*or*, the Assignment of such Copyright] to be entered in the Register of Proprietors of Copyright in Paintings, Drawings, and Photographs, kept at Stationers' Hall, according to the particulars underwritten.

(Every particular given must be clearly written.)

Description of Work.	Date of Agreement or Assignment.	Names of Parties to Agreement or Assignment.	Name and Place of Abode of Proprietor of Copyright.	Name and Place of Abode of Author of Work.
Photograph entitled "Spring."			*John Silver, o, Regent Street, London.*	*John Silver, o, Regent Street, London.*

Dated this 28*th* day of *June*, 1888.

(Signed) *John Silver.*

N.B.—Office Hours from Ten to Four; Saturdays, Ten to Two.

N.B.—In all cases where a Painting, Drawing, or Negative of a Photograph is transferred for the first time by the owner to any other person, the Copyright will cease to exist, unless *at or before the time of such transfer* an agreement in writing be signed by the transferee reserving the Copyright to the owner, or by the owner transferring the Copyright to the transferee, as may be the intention of the parties; and the date of such agreement and names of parties must be inserted above, or registration will be no protection.

size. The fact that there is copyright in a representation of a scene or object does not prevent other people from making an independent representation of such scene or object, but a photograph of groups so arranged as to exactly resemble a picture would be an infringement of the copyright of the picture, for if in the result that which is copied be an imitation of the picture, then it is immaterial whether it be arrived at directly or by intermediate steps." Photographers should pay great heed to this clause. For if a photograph or photogravure be so arranged or grouped as to resemble another already copyrighted, the law has been infringed. This is a most wholesome fact, for the veriest fool can go and arrange a picture after an artist has once shown him how to do it, for as in all art the originality is to select a beautiful scene in nature, there lies the difficulty.

The photograph is not protected until it has been registered, and if the picture is pirated *before* registration there is no remedy except in special cases.

Photographers should then register the first print they take from their negatives. Making lantern-slides from copyrighted photographs or photo-etchings is of course an infringement of the law, and should be severely dealt with.

"If a picture or photograph is painted or taken on commission, as the copyright (unless reserved) is in the hands of the purchaser, the painter or photographer may not paint or produce a replica."

Penalties. " For each offense the offender forfeits to the proprietor of the copyright, for the time being, a sum not exceeding 10*l.* When several copies are sold together, the sale of each copy constitutes a separate offense." It will be seen that a photographer could be ruined if a sale of say 1000 copies could be proved, and serve him right, too.

All pirated repetitions, copies and imitations, and all negatives of photographs made for the purpose of obtaining such copies, are to be forfeited to the proprietor of the copyright.

" The proprietor may also bring an action for damages against persons making or importing for sale unlawful copies, although the importation is without guilty knowledge."

Issuing spurious pictures.—If a photograph be falsely signed, it is an infringement, as it is to make any alteration in the work and then publish it as original.

It is commonly believed that, unless the word copyright be on the photograph, it is not secured. This is an error—as long as the photograph is copyrighted that is all that is required.

" Pecuniary penalties can be recovered by bringing an action against the offending party, or by summary proceedings before any two justices having jurisdiction where the offender resides."

In ending this subject, we would impress upon the photographer, that it is his solemn duty to exact the utmost rigor of the law, should he ever have his work pirated.

CHAPTER XV.

EXHIBITIONS.

Exhibiting a work of art is publishing it, and the student will, when he obtains suitable works, very naturally begin to think about exhibiting them. The subject of photographic exhibitions is one upon which we have written many times in the photographic press. Photographic exhibitions are in a most unsatisfactory condition all over the world.

At present, a society, or a corporation, or a private firm, for ends of their own, advertise an exhibition, often on purely financial grounds; they hope it will pay them, sometimes it does pay and sometimes it does not. The method of organizing these exhibitions is to get a list of patrons, generally a few of the "classes," a few photographers who are known, but whose fame more often than not is based on nothing solid, and is ephemeral, and finally perhaps the names of a few second-rate artists may be used to conjure with. Numbers of medals are advertised and all works have to be sent *carriage* nearly *paid*. The judges are then chosen, and in most cases they are utterly incompetent. *No one can judge a work of art unless he be an artist.* The combined assurance and ignorance of those

who accept what should be considered a serious
office, is laughable and lamentable. Is our
exhibiting student then going to submit his
work to men untrained in art ? If he does, he
will find it either unhung, skied, or passed over
in the awards, to make room for the pretty
nothings and false renderings of the craftsman's
ideal. The whole judging business is such a
blatant farce that the method of awards at pho-
tographic exhibitions is a stock joke among
artists. We have repeatedly been to exhibi-
tions with artists, and on nearly every occasion
their opinion was that many of the most worthy
pictures were passed over. Such a state of
things is appalling, and when with that is
coupled the notorious unfairness with which
certain exhibitions are directed, as recent dis-
closures have proved, it is indeed lamentable.
The tendancy of many exhibitions as at present
conducted is to *aegrade* photography ; that
is our deliberate opinion, after having for
several years watched the system of making
and having served on several juries of awards.
A fatal error very common among photogra-
phers is to suppose that, because a man is an
eminent scientist or a great authority on lenses,
he is therefore a fit and proper person to judge
pictures. The truth is he is one of the most
unfit, for he is prejudiced, and his scientific
training has a bad influence on his judgment.

In our opinion all medals should be done
away with, all distinctions between " amateur "
and " professional " removed; all pictures should

be hung on the line, the hanging committee
should be selected from these photographers
who have proved themselves *by their works* to
know most about art ; and all pictures should
be exhibited in separate frames. If medals
must be awarded in order to attract exhibitors,
let the awards be made by artists and photo-
graphers of recognized position only. You have
only to look at the majority of medals awarded,
to know what to expect; there is, with one or
two exceptions, not the feeblest suggestion of
art in them, they belong to the class of medals
awarded to patent ice-cream machines, best
refined arrow-root, and dogbiscuits. If medals
are awarded, each one should be a work of art,
the original having been modeled by a good
sculptor. The student, as a rule then, should
pay no regard whatever to the awards made at
exhibitions by photographers, the only real test
of value is when the awards are made by trained
artists, but it is rarely that even one artist or ex-
pert pictorial photographer serves on a jury of
awards.

If our student must exhibit, we advise him
to mark his work " Not for Competition."
Gambling for medals has lately assumed alarm-
ing proportions, as the recent comments in the
Photographic News prove. It is enough to dis-
gust all artists, who will of course keep aloof
from photographic circles, as they already do,
so long as things continue as they are. Can
the folly of human nature go further than
when we hear of Mr. Guncotton, noted for his

studies in collodion, or Mr. Chromatic, noted
for his patent lens, or Mr. Gelatine noted for
his emulsion process, assembling in solemn
conclave to award medals for pictures, to judge
which, needs years of careful and special study
and wide artistic experience. The student,
serious on these matters, has only to note how
different are the awards when artists give the
prizes. Many of our best workers, we know,
will not exhibit, so long as the craftsman's ideal
is set up as the standard, and the judges are
not artists. In the early days of photography,
when Sir Charles Eastlake, formerly President
of the Royal Academy, was also President of
the Royal Photographic Society, and when Sir
W. J. Newton, the eminent miniature painter
was one of the Vice-Presidents, there seemed
some chance for photography, and all might
have gone well, had not these artists, as we are
informed, been harried and worried by the
ignorant wranglings of their brother " photo-
graphic artist " (?) judges.

Those who were thus responsible for the
resignation of those artists, deserve to be
pilloried to the end of time in photographic
literature, and such, we are sure, is the feeling
of all who earnestly wish for the good and
advancement of photography.

This is a painful subject, but we conceive it
to be our solemn duty to warn the student
who is anxious to follow pictorial photography
against all these traps. Let him set out with
the determination to work for the approval of

artists, and let him dispise the approval or dis-
approval of all ignorant of art. As John Con-
stable said long ago, " the self-taught artist
has a very ignorant master ! "

We hope the reforms regarding exhibitions
which we have for years advocated, and more
fully set forth in a photographic journal, in an
article entitled "An Ideal Exhibition," may
*some day be adopted, but we cannot be very
sanguine. However, until some such reforms
are adopted, photography must struggle on in
darkness, and the blind will continue to lead
the blind ; and all we can do is to caution
others, and ourselves avoid the guidance of the
blind, unless we too wish to be led into the
ditch.

* Similar views have been adopted, first at the Vienna "Salon,"
and later in London.

CHAPTER XVI.

CONCLUSION.

WE have then finished Book II., and we presume that the student has now mastered his technique and practice, but the end is not yet. The student may thoroughly understand the scientific side of photography, he may have mastered completely the use of his tools and he may be able to produce pictures on his plates such as he desires, but the end is not yet, for now he has to learn the practice and principles of art, he has to prove whether he can do " a good thing," for such is only given to a few. All can learn to draw, to paint, to photograph, to etch, but they may remain draughtsmen, painters, photographers, etchers all their lives, and never show original power. The history of art shows indeed how few becomes artists at all, and as for those who become great artists, they are as scarce as great poets. The student then must study art in some form or other, as well as his own technique and practice, which he could learn alone if he followed our instructions. Art, however, cannot so be learned, and the student should, if possible, attend some art classes. There are numerous art schools throughout the kingdom, and our student can-

not do better than enter one of them and go
through a course of drawing. Though no very
profound knowledge is to be obtained at such
schools, what is taught is better than nothing
at all, and after all the student cannot expect
to get the best advice on the matter, that is
given to but the very few and fortunate.

In the·next book we shall give what advice
we can, but at the same time our student must
study practically some branch of art ; unless,
indeed, he wishes to become one of the mighty
band of art-ignorant craftsmen, or unless he is
so fortunate to be cast amongst highly talented
artists, to whom he can easily apply for advice.
For having learned his technique and practice
he has but learned how to speak, he can only
show his calibre by what he has to say and
how he says it, just as all the world can write
yet only the highly trained can write artistically.

In a very few months the student will see, if
he is fitted by nature to become an original pho-
tographer, and if he is not, our advice is give it
up, or take up one of the scientific special
branches, and if he is incapable of doing good
work there, he must content himself to play at
photography, as too many photographers do
now, but in our opinion photography is not
worth playing at, there are so many more satis-
fying games when play is the end and aim.

End of Book II.

PICTORIAL ART.

BOOK III.

PICTORIAL ART.

BOOK III.

PICTORIAL ART.

" He does not sufficiently understand that things are of value only according to their fundamental qualities, and he still believes that the care with which a thing is done, even if it is aimless, ought to be taken into account. In fact it would be a good thing to make him understand that things exist only to the extent of the stuff they contain."

J. François-Millet.

CHAPTER I.

EDUCATED SIGHT.

WE are all born mentally blind, but almost immediately we detect light, as can some of the lowest animals, then we *learn* to distinguish the colors and forms of objects as we grow older, and there the majority of us stop, and yet we all think we can see equally well. That we cannot is a truism, for after being able to distinguish colors and forms, but very few persons go on to educate their sight more perfectly. Some of us may learn to distinguish certain kinds of material, the different aspects of these materials under different conditions, and so they learn trades and are excellent judges of tea, coffee, hosiery, and paper. Still higher come the scientific men who pay more attention to the education of the sight. They learn to distinguish the microscopic beings, the life-histories of the lower forms of animal life, the histology of flowers, the structure of the trees, the aspects of the skies, the physical and chemical phenomena of the elements, the movements of the planets, so that in all their walks nature is full of interest to them ; they find wisdom in a pond, they revel in a marsh, or they travel to a far country for the sake of rare birds' eggs, or spend days and nights in their laboratories

to solve new chemical problems, or organize expeditions to study unusual phenomena of the heavenly bodies ; they see and love all these things. The man uneducated in science finds no interest in a drop of muddy water, he finds nothing wonderful in the vegetation of the country side, he passes unheeded the rarest birds, and the rainbow and storm cloud and the blazing comet, all alike to him, have no interest ; he is blind to them, or if he sees them at all, it is as through a glass, darkly.

All this the world allows, and allows that no one save those who by hard work have trained themselves can see these things. But mark the stupidity of mankind ; he allows he is blind to the pleasures of science and will remain so, unless he studies the subject, but when it comes to art matters, like a weathercock, he shifts round and thinks he can understand all that without any training at all, yet he is born as blind and incapable of understanding art as he is of understanding science until he has trained himself to understand.

The artist, like the scientific man, begins by studying closely his subject—nature as a whole—he studies her in all her aspects, he seeks for harmonies and arrangements in color and form, for beautiful lines of composition, and only after long and close observation do the scales drop from his eyes and he sees a beautiful pose, even in a child digging up potatoes, or a man throwing a hammer or running a race, or he sees subtle beauties of color in a reed-bed, or

poetry and pathos in an old peasant stooping
under a load of sticks, and this is far more diffi-
cult to see than it is to learn to see the scientific
truths, and that is why there are so few real
artists and poets and so many more scientific
men. Art, alas, cannot be learned like science,
hard work will not necessarily make an artist.
Most photographers are art-blind, but they are
like the color-blind old lady who did not know
it, and of course the only hope for them is to be
convinced of their blindness, then perhaps they
may do something towards getting rid of the
defect.

The student should now clearly understand
why it is so necessary that this faculty of artis-
tic sight should be cultivated and trained, for
since it is our fundamental principle that all
suggestions for pictures should come from
nature, we must first see the picture in nature
and be struck by its beauty so that we cannot
rest until we have secured it on our plate ; we
must therefore learn to see it in nature. If we
see a beautiful pose, or a beautiful effect in
nature, we should at least make a note of it if
we cannot secure it. A slight sketch made at
the time will do. Therefore, amateur reader,
if you have not trained yourself by study to see
these things in nature, blame no one but your-
self, but remember you are blind, blind, blind ;
but there is a remedy, and no surgical operation
is required either.

Study ! You must ever be on the look-out for
beauties, that is the necessary mental attitude,

otherwise they will never be seen. You must look for a thing if you wish to find it, and it is only by showing us your finds that you will prove you have artistic insight; *we shall not believe a word you say about art until we see it in your work*. If you do not study, or if you are incapable, you will remain blind in spite of your looking, and there will be weeping and gnashing of teeth when you show to the world commonplaces which you think are gems, for the world will soon tell you they are commonplace. We once knew a person who was color-blind, who resented the suggestion as a personal insult, until one evening her eyesight was tested, when her color-blindness was proved.

Let the student then be assured that he is blind, he cannot *see* art and nature until he has studied them long and closely. He may be arrogant enough to think he knows all about her without study. If that is so, as he grows older let him refer back to his earlier works, and if he has progressed meanwhile, let him recall how perfect he thought those early works at the time he did them, and then let him lash himself for his folly. A really good work will always bear looking back at, and will hold its own however old the artist gets. There is no royal road to this appreciation of the beauties of art and nature, none but incessant and loving study, and though the cockney, or sage of the university, who dwells in towns and learns his art and his nature in the National Gallery and British Museum, may lecture on nature and

art, let the student avoid him and his example. Lectures on art at any time are but Dead Sea fruit.

The student then must educate his eyesight in order to see the beauties of nature and art, and to do this he must study hard, for the true artist wishes to see these beauties and to record them, that is all, nothing more. The seers who see deeply, they are the poets ! In science the original discoverers are the seers, and since but few can aspire to become seers, nevertheless let the rest be content to go on studying, for all of us can see these things with an educated and intelligent eye, and seeing, understand, and that reward is worth the pains.

CHAPTER II.

COMPOSITION.

No chapter of this book has given us so much thought as this chapter on composition.

We could easily, as most writers have done, have given a digest of Mr. Burnet's laws of composition with variations and additions, but we have no faith in any "laws of composition." A law, to be logical, must hold good in all cases ; now the so-called "laws of composition," are often broken deliberately by great artists, and yet the result is perfect. This is easily explained, for these so-called laws are mere arbitrary rules, deduced by one man from the works of many artists and writers ; and they are no more laws in the true sense than are the laws of Phrenology or Astrology.

The great question then, which presented itself to us, was this : Will the study of these so-called rules do good or harm to the student ? Will a knowledge of them lead him to the production of conventional work, or will it in any way help him in his future work? We had many earnest discussions on this point with artists, and they seemed equally uncertain in the matter, though one condemned all such laws as absurd and unnecessary. We most cer-

tainly feel inclined to agree with that one dis-
sentient, but in trying to place ourselves in the
position of the photographic student, with ab-
solutely no knowledge of art, we have come to
the conclusion that, perhaps, the student had
better study Mr. Burnet's "Treatise on Paint-
ing." A cheap edition of this book is published
by Dr. E. Wilson, of 289 Fourth Avenue, New
York,* and every student should get a copy of
it. It can be thoroughly mastered in a week
or two, so that not much time will be lost. The
numerous plates will at any rate be of some
use to the student.

Now, from these remarks, it must not be as-
sumed that we are no believer in " composition."
Composition is really selection, and is one of
the most—if not the most—vital matters in all
art, certainly the most vital in the art of photog-
raphy. But the writer maintains there are no
laws for selection. Each picture requires a
special composition, and every artist treats each
picture originally ; his method of treatment,
however, often becomes a "law" for lesser
lights.

It has been assumed by opponents to
"Naturalism" that naturalistic photographers
ignore composition, and portray nature "any-
how," just as she happens to present herself
to them. Nothing could be further from the
truth. None is more careful in selection and
arrangement than the naturalistic photographer,
at the same time none is less conventional.

* To be had also of Messrs. P. Lund & Co., of Bradford.

Nature is not always suitable for pictorial
purposes, though she is often enough suitable,
and it is when she is propitious that the
worker depicts her ; hence the great principle
of naturalism, that all suggestions should
come from nature. The object of art training
is to show these propitious moods, and to
enable the photographer to portray them. We
prefer, then, the word " selection " to composi-
tion. The matter really stands thus, a good
naturalistic photographer selects a composition
in nature which he sees to be very fine.

By composition, as used in this paragraph, is
meant the harmonious and fitting combination
of the various component parts of the picture
which shall best express the subject.

Our best method will be to follow Mr. Bur-
net's division of his subject, and offer a running
commentary on the essentials of his work from
a photographer's standpoint, giving our ideas
on the subject when they differ from those of
the author of " A Treatise on Painting."

" A TREATISE ON PAINTING," BY J. BURNET, F.R.S.

Education of the Eye.—Measurement and Form.

Omitting to comment on Mr. Burnet's re-
marks, we put the matter thus, that it is highly
desirable for all photographers to learn draw-
ing, and to learn it intelligently. Nothing
could be more lamentable than the way in
which drawing is taught in the majority of
our schools ; it is worse than useless. The

student should go to some good art school
for a few months, and learn drawing, for in
that way are learned the analysis and construc-
tion of objects, and, above all, the eye is trained
to careful observation, which will be invaluable
in the study of tone and selection.

PERSPECTIVE.

This section the student should read over
carefully, understanding *thoroughly* the " point
of sight " and the causes of violent perspective.
For in photography, though his lens may com-
paratively be true in drawing, he can as easily
obtain violent perspective as the draughtsman,
by placing the lens too close to his model.
Fore-shortening, too, should be thoroughly
understood. This section should then be com-
pared with our views as perspective is previ-
ously given. Aërial perspective has been
simply treated by us in this work, and the
various remarks of Burnet on this subject must
be taken *cum grano salis.*

CHIARO-OSCURO.

This term means light and shade. Now the
term " chiaro-oscuro " is very misleading, for it
is used by different artists to mean different
things. The whole of photography depends on
the proper management of light and shade, for
our drawing is done for us ; but we prefer to
use the more modern terms " tone " and "con-
trast " to express what we mean by light and

shade ; that term we have already fully ex-
plained. Chiaro-oscuro, as we understand it, is
the *arbitrary* placing of masses of light against
masses of shade to produce certain desired ef-
fects ; it is, therefore, conventional, and akin to
the *law* which required all trees to be painted
fiddle-brown. It is needless to say the only
way such a conventional chiaro-oscuro can be
obtained in photography is by arranging the
objects in nature, or by retouching, and both
are against our principles. The student, then,
must, as we have said, master "tone," that is
his chiaro-oscuro, his light and shade, and he
must always remember to look for " breadth "
in his treatment. Breadth is found in all good
work, and it depends in photography not en-
tirely upon light and shade, but upon the
focussing as well, as we have already
indicated. Why are spotty-lighted, sharply-
focused, brightly-developed negatives so
" noisy " and garish and inartistic ? It is that
they lack "breadth." It must not be thought
from this that no sunny pictures have breadth ;
on the contrary, if the masses are large, and the
planes well rendered, and the tonality true,
there can be as much breadth in a sunny picture
as in a gray-day effect. It has been said that
" breadth " is a device of the painters, but this
is mere nonsense. Let the student look well at
a simple stretch of grass-land bordering a still
lake, on a damp, misty evening, and then he
will see breadth. Let him focus that scene as
sharply as he likes, including a portion of sky

as well, and develop and print from it, and he
will find breadth, and he will probably have a
clear understanding as to the meaning of the
word.

Mr. Burnet divides chiaro-oscuro into five
parts, viz. light, half-light, middle tint, half-
dark, dark. This arbitrary division is hyper-
critical. For working purposes, light, half-tone
or middle tint, and dark, are quite sufficient ;
other subdivisions are far too subtle and
numerous to be considered theoretically, and,
practically, truth of tone is only to be learned
by long experience and study, and we believe
all the directions given by Mr. Burnet for pro-
ducing relief, harmony, and breadth, to be arti-
ficial and useless. An examination of his
plates shows clearly how futile are his deduc-
tions, and how untrue in light and shade, viz.
tone, they all are.

COMPOSITION.

Mr. Burnet opens with the statement that
" geometric forms in composition are found to
give order and regularity to an assemblage of
figures." This is the first principle on which is
built his structure of geometrical composition.
We will omit the dicta of literary men on pic-
torial art which Mr. Burnet is so fond of quot-
ing, but which we consider too worthless to do
more with than mention. Let us then apply
ourselves to the study of his thesis.

His first remarks are upon angular compo-

sition, and as he finds that these lead him into conventional methods, he goes on to say that this conventionality can be rectified by balance. Even if we would follow this form of composition our means are limited, for, unlike the painter, we cannot alter and re-arrange. However, we have no wish to make "angular compositions," and consider them false in theory. Painters on the other hand, must settle these matters for themselves; we know how many settle them, that is by ignoring all such teachings as nonsense. Next we come to the "circular composition," which, we are told, is "applicable to the highest walks of art," wherever they may be. Soon after this we come upon the truest remark in the book. "Artists generally prefer the opinions of untutored children to the remarks of the most learned philosophers," and we fear most modern artists prefer the teachings of nature to those of that philosopher John Burnet, F.R.S. Finally, Mr. Burnet winds up with the words, " I must also caution the young artist against supposing that these modes of arrangements are given for his imitation. I merely wish him to be acquainted with the advantages any particular composition possesses, that in adopting any invention of his own, he may engraft upon it these or similar advantages."

Now this reads very oddly after talking of *rules* of composition, for what is the good of a rule if it is not to be followed? and it reads very illogically when compared with the quo-

tation from Reynolds (Brougham ?), which
goes to back up the excuse for advocating rules
as Burnet gives them—viz., "to those who im-
agine that such *rules* tend to fetter genius," etc.

In short, the whole work is illogical, un-
scientific, and inartistic, and has not a leg to
stand on. It is very specious to say that all
compositions are made according to geomet-
rical forms, for nothing can be easier than to
take arbitrary points in a picture and draw geo-
metrical figures joining them. The pyramid is
a favorite geometrical form of composition.
Now take any picture, and take any three points
you like, and join them, and you have a pyramid,
so does every composition contain a pyramid,
as does a donkey's ear. But enough of this.
The student is distinctly warned against pay-
ing any serious attention to these rules; it is,
however, as we have said, well that we should
know of them, and we suspect we will learn
something of design from merely looking care-
fully at the plates. Of tone he will learn noth-
ing.

With Mr. Burnet's remarks upon color we
are in no way concerned.

But the student will say, how, then, can com-
position be learned? Our answer to this is that
composition, that is selection, cannot be learned
save by experience and practical work—there
is no royal road to it, no shilling guide. This
subtle and vital power must be acquired if we
are to do any good work, for we are dumb until
we do acquire it. We can no more adequately

express ourselves in photography without having mastered composition, than a child can express himself in prose until he has learnt the art of writing. It is for this reason that we must learn art practically, for no written "rules or laws" can be given, Each picture is a problem in itself, and the art-master can help the student to solve the problems as they arise, in that way only can composition be taught. The proof of this is that young painters who have been through the schools are very weak in composition, it is only by repeated failures that they acquire the necessary knowledge. Let the student trace the development of any painter's work, and he will find that his early works are always poor in composition and feeble in *motif*. It has been well said that art can be learned though it cannot be taught save by practice.

CHAPTER III.

OUT-DOOR AND IN-DOOR WORK.

It is presumed the student has thoroughly mastered and applied all that has preceded this chapter, especially the matter of tone, otherwise it is no use attempting to make pictures, which means attempting composition.

Presuming then the student is master of the subject as already treated, we will now proceed to offer some suggestions on picture-making, but be it distinctly understood they are only suggestions.

We shall divide the subject into two sections, beginning with out-door work.

OUT-DOOR PORTRAITURE.

Very fine portraits and groups can be taken out of doors. In taking such pictures, it is admissible to dictate the dress of the model, and to arrange tea-parties, sporting, athletic, and other groups. But if the student intends to make them pictorial, he must be very particular with his *types*, and see above all things that the sentiment is true. For example, it is a fine parody on nature to photograph a gaunt and self-conscious girl in æsthetic clothing, for dress it cannot be called, with a tennis-bat in her

hand. For a tennis picture, fine girls, physically
well-formed, should be chosen.

Next the student should choose a simple
background, which with the dress and flesh
tints form a harmony or fine study in tone.
The model's dress should be very simple and
well-fitting, such dresses as were worn by Bot-
ticelli's women (dresses quite unlike the modern
æsthetic gowns), being very becoming for
women, while flannel shirts or simple white
trousers will look well on the men. All
monstrosities and exaggerations of fashion
should be avoided, such as flowers, chate-
laines, wasp-waists, high heels, and dress
improvers. The best material for dresses
for pictures is a coarse, limp, self-colored
muslin (butter-cloth is excellent for the
purpose). All jewelry should be eschewed,
the only decoration of this kind that photo-
graphs simply and well is perhaps a string of
pearls, which looks charming.

The work must be true in sentiment, and
the student must choose an appropriate treat-
ment of the subject. The portrait being out of
doors, we must be made *to feel* that fact ; thus,
a girl resting from tennis, a girl in a riding-
habit, or better still on horseback, would be
very appropriate. The background must be
carefully selected to be in keeping with the
figure, and to help to tell the story fully and
emphatically, and yet it must be kept subdued.

Groups are very difficult to treat artistically,
and our never-failing rule is to limit as much

as possible the number of people in the group.

Having now chosen his model and arranged other matters, the student must remember to let his model stand or sit, as he or she likes, and all suggestions for the pose should come from the model ; this is a fundamental principle of naturalism. A great friend of ours, a well-known sculptor, assures us he would not dare to pose a model according to any preconceived idea, but he watches the model pose in different ways, and when he sees a striking and beautiful attitude he seizes on that and makes a rapid sketch of it. This is the only true way for the photographer to work, he must have the camera ready, focused and arranged, and when he sees his model in an *unconscious* and beautiful pose, he must snap the shutter. It is thus very evident how important is art-knowledge and insight for all good photographic work, and it is thus evident how a man who is sympathetic and of a refined temperament will show his taste in his work.

With commercial groups of bands, foot-ball teams, etc., the student has nothing to do, and let him never be induced to photograph anything which he does not think will make a picture. He must have patience also, when waiting for nature's suggestions; we have waited a whole morning, rubber ball in hand, for a suitable grouping of colts, but we finally got one of the best things we ever produced. If our photographer be a smoker, let him light his pipe

and take it easy, talking meanwhile to the model ; as length his chance will come, but it may only come once, and then he must not hesitate or the picture may be lost in a moment. It is preferable that all out-door portraits should be taken on a gray day, or in the shade if the sun be shining.

There is a wide field open to wealthy photographers for producing really good pictures of their friends at country houses. But the student must remember that to produce a perfect picture takes a long time and can only be achieved by long and patient practice, coupled with artistic ability. The hurried representations of shooting, boating, and family groups, which are so often produced by industrial photographers, are artistically beneath contempt. They are mere statements of facts, and as much akin to art as the directions in a cookery-book are akin to literature. Photography up to a certain point, and in a haphazard way, is so easily learned now-a-days that there is absolutely no merit in producing such work. Such photographs are only the confessions of untrained and commonplace minds.

LANDSCAPE.

The student who would become a landscape photographer must go to the country and live there for long periods ; for in no other way can he get any insight into the mystery of nature. All nature near towns is tinged with artificiality, it

may not be very patent but the close observer detects it. Among fisher-folk this may be seen in the sealskin cap, in the rustic it shows itself in the hard billycock hat, in landscape pure it may be seen in some artificial forms of the river-banks, or in artificial undergrowths ; the mark of the beast, the stamp of vulgarity, that hydra-headed monster which always appears wherever a few men are gathered together, is sure to be found somewhere. For this reason then the would - be landscape - photographer should pack up his things and go to some locality with which he is in sympathy, just as a painter does. Here let him be cautioned against taking part in any of those " outings," organized by well-meaning but mistaken people. It is laughable indeed to read of the doings of these gatherings ; their appointment of a leader (often blind); of the driving in brakes, always a strong feature of these meetings ; of the eatings, an even stronger feature ; and finally of the bag, 32 " Ilford's," 42 " Wrattens'," 52 " Paget's," etc.

Apply the same sort of thing to painting, and would it not indeed be ridiculous? Would it not lower painting in the eyes of the world if say thirty academicians with a leader for the day, assembled at Victoria Station with pastels and boards, or with paint-tubes and small canvases, and went by train to some village and there proceeded to pastel or paint what the leader suggested ; then would follow the dinner (the best part, no doubt), and next day how

edified would be the world to read in the daily
papers of the most successful outing, the result
of which was the covering of 32 "Rowney," 29
"Winsor and Newton," and 40 "Newman"
canvasses! All these "playings" bring photog-
raphy down to the level of cycling and canoe-
ing, and yet many photographers wonder that
artists will have no official connection with
photography. We know well that it is for these
and similar reasons that serious artists will not
allow their names to be officially connected with
photography, and we here earnestly appeal to
all who really have the advancement of photog-
raphy at heart to do all in their power to bring
such trivial "play" to an end. Having then
decided to go to the country, let the student
think well with which kind of landscape he is
most in sympathy; but let him always remem-
ber this fact that all landscape is not suitable
for pictorial purposes ; he must therefore learn
to distinguish between the suitable and the un-
suitable. Landscapes there are full of charm,
pleasant places for a picnic or encampment,
but when you come to put them into a picture,
they become tame and commonplace.

Again let the student avoid imitation. If he
knows that a photographer has been successful
in one place, do not let him, like a feeble imitator,
be led thither also, for the chances are, if his pre-
decessor were a strong man, that he will produce
commonplaces where the other produced mas-
terpieces, and thereby confess his inferiority.
It is far better to be original in a smaller way

than another, than to be even a first-rate imita-
tor of another, however great.

For this reason the present method adopted
by inartistic writers of publishing "Photogra-
phic Haunts" is strongly to be deprecated; such
guides can but lead to conventional and imi-
tative, therefore contemptible work. The fact
of the matter is, nature is full of pictures, and
they are to be found in what appears to the un-
initiated the most unlikely places. Let the hon-
est student then choose some district with which
he is in sympathy, and let him go there quietly
and spend a few months, or even weeks if he
cannot spare months, and let him day and night
study the effects of nature, and try at any rate
to produce *one picture* of his own, one picture
which shall show an honest attempt to probe
the mysteries of nature and art, one picture
which shall show the author has something to
say and knows how to say it, as perhaps no
other living person could say it; that is some-
thing to have accomplished. Remember that
your photograph is a rough index of your
mind; it is a sort of confession of faith on paper.

We will now offer a few remarks on the com-
ponent parts of a picture.

THE "LINES."

As we have said there can be no rules for the
arrangement of lines, yet they are all-important
and essential to the expression of harmony and
directness. The student must cultivate the

habit of quickly analyzing the lines of a picture, and coming to a decision whether they are harmonious and pictorially suitable. For example, he must not have the lines of different objects cutting each other and forming unpleasant angles, for if he does this the eye of the observer will never get away from the geometrical figure, however good the other part of the picture may be. He should look for repeated line, and his lines should run into the picture thus all uncomfortableness is avoided. There is no necessity for balance or the equal arrangement of masses on either side of the picture, for this, though it may produce pretty pictures, will never produce strong, ones. Every line must help to tell the story and strengthen the picture, otherwise it weakens it.

AËRIAL PERSPECTIVE.

It is of vital importance that this be well rendered, the method for expressing it having already been shown.

The student must remember that he must give the true value to the separate planes of the picture, or it is worthless for reasons already stated. The state of the weather, has, as we have indicated, a wonderful modifying effect on this perspective, and must be carefully studied.

TONE.

Of vital importance is the relatively true rendering of tone as already indicated. This is

such a subtle subject that no directions can be
given for it, and the student can only master
the subject by long and ardent study of nature.
He can test his knowledge by his power of
criticizing pictures away from nature, for their
truth or falsity of tone. The key in which the
picture is pitched should always be in keeping
with the subject rendered.

COMPOSITION.

The objects must be arranged so that the
thing expressed is told clearly and directly, in
short, the student should try to express his sub-
ject as it has never been expressed before. All
things not connected with the subject should
be removed, and all but the chief thing to be
expressed should be carefully subdued. The
interest must not be divided, but all must go to
help the expression of the *motif* of the picture.
Thus a white patch the size of a threepenny
piece may ruin a twelve by ten inch plate,
as many a hat, a basket, and many a small
article has done ; just as a false foot may ruin an
otherwise fine stanza. Be most careful how
you introduce a detail, it may either make or
mar your picture.

The sentiment and detail must always be ap-
propriate or the result is a travesty. Thus
haymakers do not wear new-fashioned buttoned
boots, nor do rustics wear sun-bonnets and
aprons all clean and fashionably cut. But this
is only a superficial matter, the artist must carry

appropriateness much deeper than in mere cos-
tume; for example, a flock of sheep on a pas-
ture may be made quite false in sentiment, if
they are driven in a way that suggests a march
to the slaughter-house, and they very easily
huddle together in a manner that suggests that
final procession. The student will now see how
subtle all these matters are and how little yet how
much divides the masterpiece from mediocrity.
Some photographers think naturalism consists
only in taking things as they are, and they will
exclaim, if you criticize their work, "Oh ! it was
just like that any way." True, oh ingenuous
one, but it was just some other way as well, and
perhaps that other way might have given a work
of value whereas this way has given a bald and
uninteresting fact. Selection or composition is
a most subtle matter, and one very difficult to
learn, but let the student persevere, and if he
have the ability he will find that the scales will
fall from his eyes as he goes on.

<center>ILLUSION.</center>

The illusion must be true throughout, and if
all the preceding components are true the
illusion will be true.

Our student may now have carried out all
these things and yet there may be no picture,
his mind may be commonplace. He may have
wasted a good technique on a commonplace
subject, such as a yacht going at full sail, an ex-
press train, some very ordinary dogs or horses, or

some very extraordinary men or women. We are then brought to a very important matter, the subject.

SUBJECT OF THE PICTURE.

The subject must have pictorial qualities, it must be typical, and must give æsthetic pleasure. The student must look for elegance and a *distingué* air in his subject. You will find that the best pictures will be of those subjects which hit you hardest in nature, those which strike you so much so that you feel an irresistible desire to secure them.

You must then train your feelings, for, as John Constable said, "the art of feeling nature is a thing almost as much to be cultivated as the art of reading the Egyptian hieroglyphics." You must then, when you have felt your subject, be resolute and only take in what is necessary to express your subject; this is the text of the artist. Everything must be harmonious and comfortable, but that alone will not suffice any more than will the subject alone. Everything must be in keeping in the picture. The artist must be in sympathy with his subject, "*entrer dans la même peau,*" as the French say. He must have no preconceived notion of how he is going to do a subject, but take all his suggestions from nature and humbly follow them, and lovingly portray them. Pure imitation of nature (even if it were possible) won't do, the artist must add his intellect, hence his work is

an interpretation. To photograph a "flying express" so that it looks as if standing still is imitation, to render it with the suggestion of motion by its smoke and steam is an interpretation. The great question which the student should ask himself is: My aim, what is it? If that be serious and honest, and not feeble and vainglorious, he is all right. Remember that the aim of art is to give æsthetic pleasure, and that artists are the best judges of this matter, and you will find that so good is their training that they often elevate the meanest things they touch.

The highest expression is that of poetry, and therefore the best works of art all contain poetry. What poetry is and how it is to be got is not to be discussed in our present state of knowledge, suffice it to say that the poet is born and not made, though the poet's speech may be improved by training.

Thus it will be seen how difficult a matter it is to produce a *picture*, even when we have thoroughly mastered our technique and practice, for, to recapitulate, in a picture the arrangement of lines must be appropriate, the aërial perspective must be truly and subtily yet broadly rendered, the tonality must be relatively true, the composition must be perfect, the impression true, the subject distinguished, and if the picture is to be a masterpice, the *motif* must be poetically rendered, for there is a poetry of photography as there is of painting and literature.

Never rest satisfied then until these arrange-

ments are all fulfilled, and destroy all works in which they are not to be found.

That it will be possible for comparatively few to succeed is evident, but the prize is worth striving for, for even if we do not all attain to the production of perfect works, we shall have gained a knowledge of art and an insight into nature, that will be a never-failing source of pleasure to us in our daily walks.

FIGURE AND LANDSCAPE.

By far the most difficult branch of photography is that in which figures occur in landscapes. All previous remarks apply to this branch of the art, only here it is more necessary than ever that every detail be perfect. This is a branch which we have perhaps studied and developed more than any other, excepting pure landscape, and yet even now we feel but a beginner in it. One thing we must never forget, that is the *type;* you must choose your models most carefully, and they must without fail be picturesque and typical. The student should feel that there never was such a fisherman, or such a ploughman, or such a poacher, or such an old man, or such a beautiful girl, as he is picturing. It a great mistake for photographers to attempt rural subjects unless they have lived in country for a long time and are thoroughly imbued with the sentiment of country life. The truth of this axiom is proved by the falseness of sentiment seen in most country

pictures done by good painters even. The
student who lives in town will find good figure-
subjects in the town, and if he has no sympathy
with such life, he should try such subjects as
shooting parties, coursing meets, riding sub-
jects, and beautiful women. It is fallacious to
try and cultivate an unsympathic field and is
sure to end in mediocrity or failure.

STUDIO PORTRAITURE.

The easiest branch of photography is por-
traiture in the studio, for all conditions, includ-
ing even the dress of the model, are in the
photographer's hands. The lighting is also
perfectly under control.

The principles of lighting a face are briefly
these : A top light gives the best and subtlest
modelling, and gives more relief than any
other lighting. But the aim of pictorial art is
not to give relief to illusion, therefore the top
light effect is modified by a side light and by
reflectors. The principle of using a reflector is
this : Light falling at right angles on a plane
surface gives the highest light, then as we turn
the reflector through a circle we get all grada-
tions up to full dark, when the reflector is
turned right round. This principle must be
remembered in lighting the planes of the face.
The portraitist must work as does the sculptor,
in planes and tone, that is, he must quickly
make an analysis of the face and observe the
most suitable treatment of the subject, and then

he must focus so as to bring the planes out well, and they must be broad in treatment and relatively true in tone.

These are the only principles which can be given for lighting, their application can be learned by study, first on a plaster cast and afterwards on the living model.

The great thing to obtain is the character or expression of the model, everything must be sacrificed for this in portraiture, and enough of the figure must be taken in to thoroughly express the character. Thus the head alone may do in some cases, it others it will be necessary to include the hands, in others the whole body. It is needless to repeat that all portraits should be taken by quick exposures. The best way is for the student to have a very long elastic tube to his shutter, then he can walk about and talk to the model, and when he sees a good natural pose, he can expose, and his picture will probably be good. The present way of posing, using head-rests, etc., is feeble and archaic, and nearly certain to result in failure.

Another important hint is to place the lens on the same level as the eye of the model, neither higher nor lower, especially if large heads are taken. When the picture is to be full length or three-quarter length, the head should still receive the principal attention, and all else be subdued.

We have already treated of arrangements of backgrounds and dresses in harmonies, and of the absolute necessity for using only suitable

accessories. In addition all other principles of composition, harmony, breadth, as already described, must be remembered.

CHAPTER IV.

HINTS ON ART.

As practical hints for working cannot be woven into a continuous text, we will give them separately.

Never compete for prizes for "set subjects," for work of this kind leads to working from preconceived ideas, and therefore to conventionality, false sentiment, and vulgarity.

Remember that the original state of the minds of uneducated men is vulgar, you now know why vulgar and commonplace works please the majority. Therefore, educate your mind, and fight the hydra-headed monster —vulgarity. Seize on any aspect of nature that pleases you and try and interpret it, and ignore—as nature ignores—all childish rules, such as that the lens should work only when the sun shines or when no wind blows.

Æolus is the breath of life of landscape.

The chief merit of most photographs is their diagrammatic accuracy, as it is their chief vice.

Avoid the counsels of pseudo-scientific photographers in art matters, as they have avoided the study of art.

If you decide on taking a picture, let nothing stop you, even should you have to stand by your tripod for a day.

35

Do not climb a mast, or sit on the weather-cock of a steeple, to photograph a landscape; remember no one will follow you up there to get your point of sight.

Do not talk of Rembrandt pictures, there was but one Rembrandt. Light your pictures as best you can and call them your own.

Do not call yourself an "artist-photographer" and make "artist-painters" and "artist-sculptors" laugh; call yourself a photographer and wait for artists to call you brother.

Remember why nearly all portrait photographs are so unlike the people they represent —because the portrait lens as often used gives false drawing of the planes and false tonality, and then comes along the retoucher to put on the first part of the uniform, and he is followed by the vignetter and burnisher who complete the disguise.

The amount of a landscape to be included in a picture is far more difficult to determine than the amount of oxidizer or alkali to be used in the developer.

Pay no heed to the average photographer's remarks upon "flat" and "weak" negatives. Probably he is flat, weak, stale, and unprofitable; your negative may be first-rate, and probably is if he does not approve of it.

Do not allow bad wood-cutters and second-rate process-mongers to produce libels of your work. Be broad and simple.

Work hard, and have faith in nature's teachings.

Remember there is one moment in the year when each particular landscape looks at its best, try and secure it at that moment.

Do not put off doing a coveted picture until another year, for next year the scene will look very different. You will never be able twice to get exactly the same thing.

Vulgarity astonishes, produces a sensation; refinement attracts by delicacy and charm and must be sought out. Vulgarity obtrudes itself, refinement is unobtrusive and requires the introduction of education.

Art is not legerdemain: much "instantaneous" work is but jugglery.

Though many painters and sculptors talk glibly of "going in for photography," you will find that very few of them can ever make a picture by photography; they lack the science, technical knowledge, and above all, the practice. Most people think they can play tennis, shoot, write novels, and photograph as well as any other person—until they try.

Be true to yourself and individuality will show itself in your work.

Do not be caught by the sensational in nature, as a coarse red-faced sunset, a garrulous waterfall, or a fifteen thousand foot mountain.

Avoid prettiness—the word looks much like pettiness—and there is but little difference between them.

No one should take up photography who is not content to work hard and study so that he can take pictures for his own eye only. The

artist works to record the beauties of nature, the bagman works to please the public, or for filthy lucre, or for metal medals.

At the University of Cambridge, in our student days, it was considered "bad form" to give a testimonial to a tradesman for publication. This is still "bad form;" let the student, therefore, never let his name appear in the advertisement columns of photographic papers beneath a puff of some maker's plates or some printing papers. "Good wine needs no bush."

The value of a picture is not proportionate to the trouble and expense it costs to obtain it, but to the poetry that it contains.

Good art only appeals to the highly cultivated at the first glance, but it gradually grows on the uncultivated or the half cultivated; with bad art the case is otherwise.

Give the *life* of the model in a portrait, not his bearing towards you during a *mauvais quart d'heure*.

Do not call reflections—shadows; learn to distinguish between the two.

Always be on the look-out for a graceful movement when you are conversing with a person, thus you will learn. Keep rigidly within the limits of your medium, do not strive for the impossible, and so miss the possible.

Never judge of the merits of a painting or piece of sculpture from reproductions.

Every good work has "quality."

Do not mistake sentimentality for sentiment, and sentiment for poetry.

Spontaneity is the life of a picture.

Continual failure is a road to success—if you have the strength to go on.

The color of a landscape viewed in the direction of the sun is almost unseen ; therefore turn your back on the sun if you wish to see nature's coloring, and you do !

Do not emulate the producers of photographic Christmas cards and "artistic" (?) opals ; they are all worthy of the bagman.

Do not mistake sharpness for truth, and burnish for finish.

The charm of nature lies in her mystery and poetry, but no doubt she is never mysterious to a donkey.

It is not the apparatus that chooses the picture, but the *man* who wields it.

Say as much as you can, with as little material as you can.

Flatter no man, but spare not generous praise to really good work.

Lash the insincere and petty *homunculi* who are working for vanity.

Hold up to scorn every coxcomb who paints "artist-photographer" or "artist" on his door, or stamps it on his mounts.

Remember every photograph you publish goes out for better, for worse, to raise you up or pull you down; do not be in haste, therefore, to give yourself over to the enemy.

By the envy, lying, and slandering of the weak, the ignorant, and the vicious, shall you know you are succeeding, as well as by the

sympathy and praise of the just, the generous, and the masters.

When a critic has nothing to tell you save that your pictures are not sharp, be certain he is not very sharp and knows nothing at all about it.

Don't be led away to photograph *bourgeois* furnished interiors, they are not worth the silver on the plate for the pleasure they will give when done. The greater the work the simpler it looks and the easier it seems to do or to imitate, but it is not so.

Photographic pictures may have one merit which no other pictures can ever have, they can be relied upon as historical records.

Art is not to be found by touring to Egypt, China, or Peru; if you cannot find it at your own door, you will never find it.

People are educated to admire nature through pictures.

Science destroys or builds up, and seeks only for bald truth. Art seeks to give a truthful impression of some beautiful phenomenon or poetic fact, and destroys all that interferes with her purpose.

Topography is the registration of bald facts about a place; it is sometimes confounded with art.

The artistic faculty develops only with culture. A man may be a Newton and at the same time never get beyond the chromographic stage in art.

Without individuality there can be no individual art, but remember that the value of

the individuality depends on the man, for all the poetry is in nature, but different individuals see different amounts of it.

Had Constable listened to rules we might have had "fiddle-brown" trees in our pictures to-day.

Nature is full of surprises and subtleties, which give quality to a work, thus a truthful impression of her is never to be found in any but naturalistic works.

The undeveloped artistic faculty delights in glossy and showy objects and in brightly colored things. The appreciation of delicate tonality, in monochrome or color is the result of high development. The frugivorous ape loves bright color, and so does the young person of "culture" and the negress of the West Indies, but Corot delighted only in true and harmonious coloring.

Nature whispers all her great secrets to the sane in mind, just as she delights in giving her best physical prizes to the sane in body. Nature abhors busy insanity.

Do not be surprised if you find "stolen bits" of your photographs in the works of inferior etchers, aquarellists, and black and white draughtsmen ; it pays them to steal, while it does not hurt you, for they cannot steal your "quality."

Many photographers think they are photographing nature when they are only caricaturing her.

The sun when near the horizon gives longer shadows than when near the zenith.

The shallow public like "clearness," they like to see the veins in the grass-blade and the scales on the butterfly's wing, for does it not remind them of the powerful vision of their periscopic ancestors—the Saurians.

When the vulgar herd jape at photography, stand firm and ask them if their long-eared ancestors did not jape at water-color painting and at etching.

When charlatans talk of improving photographs for the illustrated press know that they merely take a photograph and daub it with unmeaning patches of paint to hide the work of the camera, and then they advertise their dishonest fumblings as "artistic works done by hand."

Ask of critics only "fair play." Much of the criticism of to-day consists in the suppression of the truth of the author and the advocacy of the falsity of the critic. Criticism is as yet in the metaphysical stage, but it will one day become rational and of some worth. Then, critics will not attempt the huge joke of "placing" people in order like a pedagogue, *e.g.*, Matthew Arnold between Gray and Wordsworth, as some wonderful person did not long ago in one of the reviews; but criticism will show us how works of art may serve to illustrate the life-history of different epochs. The huge farce of "placing" criticism will be one of the stock jokes of the twentieth century.

CHAPTER V.

By the term "decorative," we mean the ornamentation of anything constructed for some useful or special purpose as opposed to the ornamentation whose object is to please *per se.* Thus, though both sculpture and easel pictures are decorative in one sense, they are executed with no consideration or regard for other purposes than to please. As we have before shown, the humblest of the decorative arts may be raised to the dignity of a fine art if an artist takes the work in hand and succeeds, or the work may degenerate into mere crafts man's work. For decorative purposes, the various methods are modified and adapted to the important considerations of the use and fitness of the object or place decorated. Thus no good artist would paint a finished and studied landscape on a dado, he would paint the scene flat, and color it in appropriate harmony with surrounding objects, for that is the aim ; and a workman not an artist would, of course, pain-fully elaborate and finish it so that it would be neither a decorative work nor a painting in the ordinary sense. In all good decorative work the same old story of naturalism holds good ; all the best decorative work we have seen was

43

suggested by nature, and though, of course, it is beyond the scope of decorative art to " copy nature," as superficial folk say, yet all patterns and forms and harmonies should be suggested by nature. We have seen harmonies of seaweed and sand which would have made a beautiful color scheme for decorative work. The best decorative work has always been suggested by nature; geometrical patterns being taken from crystals, microscopic drawings of vegetable cells, etc.

However, we must omit a general discussion of this interesting subject, for we are here only concerned with its photographic side. We are not aware that this application of decorative art has ever received much attention; and when we mention transparencies and enamels, we have said all that has been done towards employing photography decoratively. By enamels, of course, is not understood those glossed and raised productions on paper, which by some extraordinary blunder have been erroneously called enamels.

Now the photographer, who studies and hopes to excel at decorative photography, must remember that he must work on the same general principles as he does in producing pictures, that is, he must pay attention, in a broad way, to the tone of the room, to effects of contrast, to harmonies, to the effect of artificial lights and of complementary colors, and above all to naturalism. Thus a delicate landscape must not be enameled on a tea-cup, for it is obviously

false in principle to place a picture on a curved surface. Again, a palmetto leaf must not be burned into the tiles of a fireplace, the two are incongruous and incompatible. Taste, and a regard for truth should govern all such work.

We will now briefly enumerate the uses to which photography might be put in decoration.

FOR PANELING AND FRIEZES.*

Much might be done in this direction by an appropriate choice of subject. For panels bits of landscape of strongly marked types, sea pieces, dead game, and plants might be admirably used. By landscapes of strongly marked type, we mean such things as a dead or leafless tree overhanging a pond, a pollarded willow in winter, and like subjects, where the elements are few, the composition simple, and where there are no subtle atmospheric effects. For this work the subject must be expressed with great terseness and directness, for the form is what is required, not subtlety of tone or mystery. A group of dead mallard or teal, or an arrangement of bulrushes and water-lilies, are all suitable and admirable subjects. Negatives for this class of work should be rather dense, and in some cases they may be as sharply focused as possible, it being remembered that for form (diagramatic form) decision is what is required. There are certain subjects, however,

* Mr. F. Hollyer has since then done some admirable work of this kind.

which will bear being only just suggested, such as bulrushes, reeds, etc., which are full of character in themselves. These objects should be photographed against flat-tinted backgrounds, the color chosen being ruled by the color of the furniture of the room. The best method of procedure would be to sensitize the panel and print directly on to it by the platinotype process, or perhaps by some of the carbon processes, red carbon being especially suitable for this work. The Platinotype Company give directions for sensitizing various surfaces, all of which can be obtained from their offices in Southampton Row, High Holborn.

For friezes, beautiful arrangements could be made of suitably draped figures of girls, of athletes, and of animals, the draped figures being in white, taken against a black background. These subjects printed in red carbon would look admirable if properly arranged. Enlargements could be used in these cases, as it does not matter if the original negatives are made microscopically sharp. Various subjects and methods of treatment will suggest themselves to the thoughtful and artistic student.

We cannot help thinking there is a field for the photographic decoration of tiles. For this purpose, as they are low down and seen close to, tone pictures might be used; but any quality of landscape would not be admissible for this work.

Mr. Henderson's method of enameling is fully given in the late Baden-Pritchard's

" Studios of Europe." These tiles would have to be cautiously used.

There is little or nothing to be done in the decoration of windows by photography. Of course, transparencies will immediately suggest themselves, but they, like modern glass painting, are false art. The first requisite of glass painting is that all the light possible shall pass through the pane, and that the colors shall be flat. Modern window-painters overstep the limits of the art, and try to render tone as well, the result being bad artistically and bad decoratively, as utility is affected. Glass transparencies and opals are, to our mind, worthless for decorative purposes, and should not be encouraged.

M. Lafon de Camarsac was the first to apply photography to porcelain work, in the year 1854. He worked with colors and produced some marvellous results, applying gold, silver, and various pigments in this way. His method was used for producing enamels for jewelry, but, of course, such things could be utilized in decorative work. But to produce pictures on tea-cups, saucers, brooches, etc., seems to us against all principles of art. We think that with great care and taste this class of work might be artistically utilized in decorative art, but none but an artist must attempt it. So we shall give Poitevin's method.

A positive on glass is obtained, and a glass plate is coated with gum sensitized with bichromate of potash. The positive is then

placed in contact with the prepared plate and
exposed to the light, the result being invisible
as in carbon printing. A very fine hair sieve is
now taken, and dry powdered charcoal is sifted
over the coated plate, and it will be found that
the charcoal adheres to the parts acted upon by
light. Thus is produced a delicate portrait in
as perfect tone as the original. This portrait
is temporarily secured by brushing it over with
collodion. The collodion film has now to be
separated by delicate knives, and it brings
away with it the charcoal picture. This film
is next placed on a white enameled plate,
which plates are bought ready prepared, and a
fixing paste (that used by ceramic painters
being employed) is spread with a brush over
the enamel. This paste combines with the
charcoal image. All is now ready for placing
in the enameling furnace, when vitrification
takes place, and all the organic bodies are
destroyed, the vitrified charcoal image alone
remaining. We think that with taste even
china services might be decorated by means of
photography. At any rate there is a wide field
for any one with taste and feeling.

Wall-papers and hangings. We do not know
whether or not photography has been applied
to the manufacture of either of these materials,
but there is wide scope for it. It must be re-
membered, however, that definite patterns are
obtrusive and undesirable. A rather monoton-
ous geometrical pattern is required, the sug-
gestion, however, coming from nature. Thus

a good pattern could be obtained from a transverse section of a rose-bud, or from various seed-cases, such as those of the convolvulus and rose. Histological specimens also, and desmids and diatoms, all suggest beautiful and varied forms of geometrical patterns. This has often occurred to us when examining the wonderfully varied and beautiful forms of the diatom family. It would, it seems to us, be very easy with multiplying backs to get large numbers of a form on one plate, and then to reproduce them by cheap photo-mechanical means, and though we have never yet heard of photographic wall-papers, yet there is no reason why they should not be manufactured, if made artistically.

For hangings these same patterns might be woven in or even printed directly upon the materials, by the platinotype process. The company who brought forward that process keep prepared nainsook, why not other materials? For small things, such as d'oilies an endless and pleasing variety might be introduced.

In short, photography can and should be made amenable to the principles of decorative art, and employed legitimately in thousands of ways ; but the student must never forget that he must rigidly and resolutely keep within the bounds of his medium, which bounds we have briefly indicated here. Common sense, taste, and study are his best safe-guards. In all attempts, however, let him go to nature for his suggestions ;

she, if he be humble and patient, will not be less lavish to him than to the painter. So we find ourselves at the end of this chapter, and our considerations on photography as applied to decorative art lead us to conclude that the form in which it is at present chiefly applied, *i.e.* transparencies, is false in principle, and therefore undesirable. We felt this long before we studied art at all, and although we made many opals and transparencies at one time, we soon gave them up as vanity and foolishness. Those, however, who with training and artistic feeling care to explore the undeveloped fields above indicated, will be sure to find many new treasures.

L'ENVOI.

PHOTOGRAPHY—NOT ART.

" In such an age as this, painting should be *under-stood*, not looked on with blind wonder, nor considered only as poetic inspiration, but as a pursuit, *legitimate*, *scientific*, and *mechanical*."

JOHN CONSTABLE.

PHOTOGRAPHY—NOT ART.

Let us, lest we be misunderstood, preface our article by acknowledging without stint the great and invaluable uses of *scientific* photography—that is, photography taken with the best corrected optical instruments that give mathematical reproductions of objects before them—reproductions scientifically true in *some* respects, but not in all; *e.g.,* false in color translation. No doubt science will remedy these defects, and then we shall have an invaluable *machine* by which *impersonal* drawings can be made. The uses of such drawings it were superfluous to consider; they are already widely known to many, and their increased usefulness can be trusted to gain ground without any advocacy. But it must never be forgotten that such mathematical plottings of persons and things are not true in the sense that they reproduce objects as we see them. I first called attention to the fact as regards form and perspective drawing, and subsequently, in conjunction with Mr. T. F. Goodall, published a paper on the subject. Our observations have, in many cases, been corroborated by one of the greatest living psychologists; and one or two of the results, we have since found, were previously discovered by another psychologist. In

addition, a well-known teacher, the author of a
work on simplified "perspective," has accepted
our pamphlet, and intends withdrawing his
work. Our investigations easily explain why
photographs so often do not resemble the
people they are meant to represent, why land-
scapes are nearly always so disappointing and
petty, and why architectural photographs are
useless to the seeing draughtsman, as Mr. J.
Pennell so ably pointed out.

I may briefly say that perspective drawings
(and such are correct photographs) are useful
purely as "measurements"—as surveys, in
fact for topography; when photography is inval-
uable. In the matter of textures photography
sometimes serves—sometimes other methods
are truer. But in most transient landscape
effects photographs are disappointing. Look at
the full moon just rising, and take a photograph
of it, then compare the proportion of the moon
to the rest of the landscape; the photograph will
give an absurdly "small" impression of the
scene.

This brings us to the subject of photography
and art. It has often been asked, "Is photog-
raphy an art?" We answer: "*No*," and with
Mr. Pennell agree that "it can never be an art."

It is amusing to watch the wrigglings of
various vain persons who would be known as
"artists," and yet are living on from day to day
practising some other trade or profession, per-
sons who—provided photography were an art,
and all that some say of it—could never be

classed as anything but "amateurs." They belong chiefly to a body of well-meaning persons well known to neural pathologists—a class that fills our galleries and libraries with rubbish done at their own expense. But there are some who really are puzzled to know why photography is not an art.

We will endeavor to enlighten them. Let us assume we are going to prove to the world photography is an art; that the most fastidious and critical judges of the period (artists of all schools), have assembled for us to demonstrate to them that photography is an art.

We begin then the "proof" (?).

First, we must select a subject, a real objective picture in the world before us. We select a landscape, say, that experience has taught us would make an artistic painting. We may in that act of selection prove we have artistic judgment. We will assume we have proved this fact. Next we arrange it on the screen, focus it as we like, place our diaphragm in the appropriate slit, and put on the cap—all ready to expose. No special photographic knowledge is required for all this—any artist amongst our judges could do the same thing—his purely *artistic knowledge* would tell him when the focus was right for his desired effect. *Up to the taking off the cap, then, nothing is required but artistic knowledge* (saving a trifle of mechanical knowledge learnt in a *few minutes* by any intelligent person). The person who really wishes to arrive at an impartial judgment must

hold *this fact closely*. All done so far has noth-
ing to do with photography, but with art; as
for example, any great painter might come and
do all this, and then any operator could take
the picture. Whatever artistic value it had,
would of course belong to the artist who
selected, arranged, and focused the view. For
" taking" the picture is a pure science, as for
ever proved by Messrs. Hurter & Driffield.

TAKING NEGATIVE.

Having selected a good view, artists next
have *to paint or etch, etc., it. The photog-
rapher does not make his picture*— A MACHINE
DOES IT ALL FOR HIM. Whatever subtlety ot
tones, of drawing, there are in the photograph,
these are the work of a machine. The operator
has no part in it, and he cannot control the
result at all, as the classical researches referred
to have proved beyond a doubt. The fact that
the photographer does not do the work is nearly
always overlooked; he gets to talk of *his works*
so much that he forgets that after all he has
only set the machine to work, and he has no more
done the work than the engineer who starts the
locomotive pulls the train. This must be
realized to justly estimate the credit attached
to the producer. Now since the machine does
the work, and since any intelligent person can
easily learn to manipulate the machine, nearly
all the credit of all so-called " artistic " photo-
graphs is in choice of view, arrangement on

screen and choice of focus. In these matters the photographer is absurdly limited in power as compared with hand-work, by the mechanical conditions of the camera. It is therefore very easy to imitate an original worker in photography—a practice, I regret to say, far too common; mediocrity is ever imitative. In addition, the limited powers of the machine tend to level all workers, and prevent genius from fully expressing itself as it can in all individual arts. Very little credit really attaches to *any photographer*, and such work can never reach any but a mediocre plane; it will never fully satisfy any genius, nor any first-rate intellect. But to proceed. We have now got the negative—*and by pure photography nothing more can be done.*

An *artist* now *might* improve the negative by retouching, local intensification, and reduction, etc.; but it must be remembered that everything done by these methods *is not photography at all,* but hand-work, and only art when done by an accomplished and trained artist; and I know of no artist capable of doing such work who would waste time upon negatives. Such work must be judged, and the credit put down to art, not photography. This work is done to-day for commercial ends, and fulfils a commercial need, but all that has nothing to do with art or photography.

Next comes the "printing" from the negative. An *artist* has the power of choosing the process, and paper that will best suit his subject.

That is purely a matter of art-knowledge if the object be artistic; but, if scientific, the paper will be chosen for scientific considerations. The choice here is very limited. After the paper is chosen, again comes the mechanical photographer and starts the engine, and *light does the printing*, he merely stopping the engine when the printing is done. In this respect the merest journeyman copper-plate printer is a greater artist than the photographer. If the photographer dodge in printing by masking, that is merely a crude form of art, and not photography.

Et voila ! He presents his print to the judges whom we imagined assembled. They discuss it, and the spokesman sums up as follows: "You selected the view: that was art (we allow you have an eye for the picturesque). You arranged it well; focused it well (we think): that was art. But you were so limited by the machine that your individuality could but barely assert itself in this respect. Then you started a machine, and *that machine drew* the picture for you; you merely fixed its work by chemicals, which is photography, not art. You selected some ready-prepared paper, and the *sun printed your picture*, and you fixed it again. That is photography, with an iota of art in the selection of the paper. We find you have not proved to us you are an artist, for *you* can execute nothing. You cannot even draw a cube fairly; and, moreover, we find your machine does not give us any idea of the magnificent scene you selected. One of us—an

accomplished landscape painter—has been drawing the scene in black and white (we omit to refer to your color impotency), and his *proportions* and tonality are altogether different from those of your photograph. His picture is altogether grander and bigger, yours being merely a *mechanical perspective drawing, false in many respects*. We find that, if you think photography to be art, you must decide who is the artist in the case of an automatic machine— the penny, the person who drops the penny in the slot, or the automatic machine."

Perhaps, convinced by this inexorable logic, you would say: "Yes, I yield to reason, for only fools live in a fool's paradise; but would I not be an artist if I were to reproduce my negatives on copper, photo etch them, and hand-print them myself?" . They, knowing the process, would answer, "No! The laying of the ground is a mechanical process. The biting, if scientifically conducted—and all other ways are mere bungling—is mechanical; and finally but chiefly you are doing a set task, viz., to REPRODUCE your photograph. You are not like the etcher *creating a new work*, but merely mechanically reproducing the work of a machine, Any hand-work put on the plate will, of course, not be photography, though it *may* be art."

Finally the spokesman says to you: "You have demonstrated to us most clearly that photography *is not art*, and never can be. If. however, you like the results (we do not include the invaluable scientific results), do them; you

can by them show in a VERY LIMITED way
whether you have anything of the artistic
temperament (we refer always to the unphoto-
graphic part of the work, as we have explained),
but do not hold yourself up to ridicule by call-
ing yourself an artist, unless you have been
trained as an artist and follow art as a *profes-
sion*; for remember that many of us here could
pay persons to do the merely photographic
work, and soon take the wind out of the sails
of all but the three or four of you whom we
allow are masters in the selection of pictures in
nature, and could these three or four paint what
they select as well as they photograph it we
allow they would be master-artists. To be an
artist you must have the power of SELECTION
AND EXECUTION. No matter what the medium
chosen, the lack of either is *fatal,* just as there
are many real poetic natures who cannot write
a stanza."

I may finish this little paper by a suggestion
as to why I think artists invariably consider,
and will continue to think, hand-work superior
to machine-work. Photographs often interest
them for a time, yet the interest is *never lasting ;*
people soon tire of them. I believe the reason
of this to be that mankind will always value the
personal element in a work ; they constantly
recur to the etching or painting because it has
been done by a man.

Photography then, when not scientific or
topographical, is a *pastime*, dangerous in many
respects, as apt to foster morbid vanity in the

degenerate, but useful often as leading its practitioners to think about art and to visit picture galleries, thus helping them to cultivate an æsthetic sense. But the snares of vanity are too strong to be resisted by the weak, and the cheap press hurries them to their doom. It has been well said that the chief use of the multiplication of cheap journals and increased facilities given to every one to " have his say," has been the increased facility they offer for the *discovery of* fools—since in their columns alone fools are allowed to " have their say." Certain it is that photographic papers have helped photographers to discover many fools who would otherwise have lain *perdus*—amateur writers upon optical matters, upon art, upon science, and what not. We would suggest that the common fool in future hesitate before discovering himself.

Let photographers take the modest and legitimate ground that photography is not an art but a science, and further, that in one invaluable branch—topography—the *machine pictures* selected by an artist must always be superior to others, for a topographer may sacrifice detail for breadth, or accuracy for general topographical sentiment. Let there be no misunderstanding about the use of the word artist. An artist is a man thoroughly trained in the practice of an art (photography is a science), who devotes his life to his art to the exclusion of everything else ; his sole end and aim being the production of æsthetic works, whose object is to give emotional pleasure. Art is personal,

and machine work can never be art. One must
understand something of music to get the best
work from a hand-organ, yet an organ-grinder
with musical tastes is no artist. If any photo-
grapher aspires to become an artist he must
cultivate some artistic method of expression,
such as painting, sculpture, literature, acting,
music, singing,—and practice it as his profes-
sion. Then, and not till then, will he be
recognized as an artist ; and then he may be
aggrieved to find that the masters of his pro-
fession allow but few even of such trained
practitioners the name of artist.

There is much good scientific work to be done
by photographers, and if I am permitted to re-
open the subject in another paper, I would sug-
gest some systematic work to be undertaken by
enthusiastic amateurs—work that would lead
them to a far higher level than any taking of
" pictures " during a short period of the year
will ever do ; and they will be relieved of keep-
ing up the pretentious title of artists, bickerings
will cease, and photography be more univers-
ally respected and advanced.

There was excuse until quite recently for men
who contended that photography was art. For
men are justified in fighting for a cause, pro-
vided they base their fight on knowledge *up to
date ;* and until quite recently it was justifiable
to contend that photography might be a fine
art in the hands of an artist. That position, in
the light of recent investigations, is untenable
and foolish ; but, like all old " truths," it will

be for a time perpetuated as a superstition amongst the vain and uncultured. Photography is an easily acquired *science*, and never can be anything else.

Finally, there are some who may say—" But Carmine a second-rate painter, or Stylus a third-rate etcher, says—photography is art, and that is sufficient answer." It is no more an answer than when third-rate scientists or first-rate theologians deny the theory of Natural Selection. What one or two men say on this side or that matters not a rap ; but the general consensus of opinion of a body of first-rate specialists upon their own subject matters much ; and the best artists are unanimous that photography is not art, and never can be, though till recently many able artists were doubtful. Art is personal ; photographs are machine-made goods, useful, as is machine-made furniture, machine-made fabrics, and perhaps—for the slums—machine-made music.

APPENDICES.

" *Very few poets* gets their inspiration from nature. The majority of them have read other poets, and they use the same ideas, clothed in different language. The painter has to go directly to nature, or he is a mere copyist. He cannot paint his picture like somebody else. He must tell his own story if he has any to tell. Please to look out of the window! You'll get something different from what you get out of books, for it never has been seen before!"

W. HUNT.

APPENDIX A.

SCIENCE AND ART.

(A Paper read at the Camera Club Conference, held in the rooms of the Society of Arts, London, on March 26th, 1889.)

MR. PRESIDENT, LADIES, AND FELLOW-PHOTOGRAPHERS:—Before beginning this paper I would fain ask of you two things—your attention and your charity, but especially your charity. The reception which you accord me, ladies and gentlemen, assures me you will give both, and I thank you beforehand.

Since all mental progress consists, as Mr. Herbert Spencer has shown, for the most part in differentiation—that is in the analysis of an unknown complex into known components— surely it were a folly to confuse any longer the aims of Science and Art. Rather should we endeavor to draw an indelible line of demarcation between them, for in this way we make mental progress, and Science and Art at the same time begin to gather together their scattered forces, each one taking under its standard those powers that belong to it, and thus becoming integrated, and necessarily stronger and more permanent; for evolution is integration and differentiation passing into a coherent heterogeneity. Now I do not mean to premise that this

confusion between science and art exists every-
where – it does not. But I feel sure that it
exists largely in the ever-increasing body of per-
sons who practise photography. The majority
of them have not thoroughly, nay, not even
adequately, thought the matter out. It is obvi-
ous then, according to the teachings of evolu-
tion, that, if we are to make progress, this
differentiation must be made, thoroughly under-
stood, and rigidly adhered to by every prac-
titioner of photography. Each one must have
his aim clearly stamped upon his mind, whether
it be the advancement of science or the creation
of works whose aim and end is to give æsthetic
pleasure. Proceed we now to analyze the dif-
ference between the aims and ends of Science
and Art. Let us first approach the subject from
the scientific standpoint.

Assuming that we have before us a living
man, let us proceed together to study him scien-
tifically, for the nonce imagining our minds to
be virginal tablets, without score or scratch.
Let us proceed first to record the color of his
skin, his hair and eyes, the texture of his skin,
the relative positions of the various orifices in
his face, the number of his limbs, the various
measurements of all these members. So we go
on integrating and differentiating until we find
that we have actually built up a science—eth-
nology. If we pursue the study, and begin to
compare different races of men with each other,
we find our ethnology extends to a more com-
plex anthropology.

We next observe that the eyelids open and
close, the lips open, sounds issue from the
mouth, and our curiosity leads us to dissect a
dead subject, and we find that beneath the skin,
fat, and superficial *fasciæ* there are muscles,
each supplied with vessels and nerves to their
common origins, and are led to the heart and
brain. In short, we find the science of anatomy
grows up under our hands, and if we go on with
our studies we are led into microscopy. Then
we begin to ponder on the reasons why the
blood flows, on the reasons why the *corrugator
supercilii* and *depressores anguli oris* act in weep-
ing, the *musculus superbus* in practical arro-
gance, and the *levator anguli oris* in snarling or
sneering. So we go on studying the functions
of all the organs we find in our man, and lo !
we are deep in physiology; and if we go deeply
enough we find the thread lost in the most
complex problems of organic chemistry and
molecular physics. And so we might go on
studying this man; and if our lives were long
enough, and if we had capacity enough, we
should be led through a study of this man to a
knowledge of all physical phenomena, so won-
derful and beautiful is the all-pervading princi-
ple of the conservation of energy, and so inde-
structible is matter. As we proceeded with our
studies we should have been observing, record-
ing, positing hypotheses, and either proving cr
disproving them. In all these ways we should
have been adding to the sum of knowledge.
And in the greatest steps we made in our

advancement we should have made use of our *constructive imagination*—the highest *intellectual* power, according to recent psychologists.

The results of these investigations, if we were wise, would have been recorded in the simplest and tersest language possible, for such is the language of Science. It is needless to point out that in these records of our studies, as in the records of all scientific studies, *too many* facts could not possibly be registered. Every little fact is welcome in scientific study, so long as it is true. And thus the humblest scientific worker may help in the great work; his mite is always acceptable. Such is, alas! not the case with that jealous goddess, Art; she will have nothing to do with mediocrity. A bad work of art has no *raison d'être;* it is worse than useless—it is harmful.

To sum up, then, "Science," as Professor Huxley says, "is the knowledge of the laws of Nature obtained by observation, experiment, and reasoning. No line can be drawn between common knowledge of things and scientific knowledge; nor between common reasoning and scientific reasoning. In strictness, all accurate knowledge is Science, and all exact reasoning is scientific reasoning. The method of *observation* and *experiment* by which such great results are obtained in Science is identically the same as that which is employed by every one, every day of his life, but refined and rendered precise."

Now let us turn to Art, and look at our

imaginary man from the artistic standpoint.
Assuming that we have learned the technique
of some method of artistic expression, and that
is part of the science we require, we will pro-
ceed with our work.

Let us look at the figure before us from the
sculptor's point of view. Now what is our
mental attitude? We no longer care for many
of the facts that vitally interested us when we
were studying the man scientifically; we care
little about his anatomy, less about his physiol-
ogy, and nothing at all about organic chemistry
and molecular physics. We care nothing for
his morality, his thoughts, his habits and cus-
toms—his sociological history, in fact; neither
do we care about his ethnological characters.
If he be a good model, it matters little whether
he be *Greek, Italian,* or *Circassian.* But we do
care, above all, for his type, his build, and the
grace with which he comports himself; for our
aim is to make a statue like him, a statue pos-
sessing qualities that shall give æsthetic pleas-
ure. For the *raison d'être* of a work of art ends
with itself; there should be no ulterior motive
beyond the giving of æsthetic pleasure to the
most cultivated and sensitively refined natures.

The first thing, then, we must do is to sit in
judgment on our model. Will he do for the
purpose? Are his features suitable? Is *he*
well modelled in all parts? Does he move
easily and with grace? If he fulfils all these
conditions we take him. Then we watch his
movements and seize on a beautiful pose.

Now with our clay we begin to model him.
As we go on with our work we begin to see
that it is utterly impossible to record all the
facts about him with our material, and we soon
find it is undesirable to do so—nay, pernicious.
We cannot model those hundreds of fine
wrinkles, those thousands of hairs, those myri-
ads of pores in the skin that we see before us.
What, then, must we do? We obviously *select*
some—the most salient, if we are wise—and
leave out the rest.

All at once the fundamental distinction
between Science and Art dawns upon us. We
cannot record too many facts in Science; the
fewer facts we record in Art, and yet express
the subject so that it cannot be better ex-
pressed, the better. All the greatest artists
have *left out* as much as possible. They have
endeavored to give a fine *analysis* of the model,
and the Greeks succeeded.

It is beside the question to show how Science
has exercised an injurious influence upon cer-
tain schools in art; but that would be very easy
to do. At the same time, the best Art has
been founded on scientific principles—that is,
the big physical facts have been true to nature.

To sum up, then, Art is the selection, arrange-
ment, and recording of certain facts, with the
aim of giving æsthetic pleasure; and it differs
from Science fundamentally, in that as few
facts as are compatible with complete expression
are chosen, and these are arranged so as to
appeal to the emotional side of man's nature,

whereas the scientific facts appeal to his intel-
lectual side.

But, as in many erroneous ideas that have
had currency for long, there lurks a germ of
truth, so there lurks still a leaven of Art in
Science and a leaven of Science in Art; but in
each these leavenings are subordinate, and not
at the first blush appreciable. For example, in
Science the facts can be recorded or demon-
strated with selection, arrangement, and lucid-
ity; that is the leaven of Art in Science.
Whilst in Art the big physical facts of nature
must be truthfully rendered; that is, the leaven
of Science in Art.

And so we see there is a relationship between
science and art, and yet they are as the poles
asunder.

II.

We shall now endeavor to discuss briefly how
our remarks apply to photography. Any· stu-
dent of photographic literature is well aware
that numerous papers are constantly being
published by persons who evidently are not
aware of this radical distinction between
science and art.

The student will see it constantly advocated
that every detail of a picture should be im-
partially rendered with a biting accuracy, and
this *in.all cases.* This biting sharpness being,
as landscape painters say, " *Quite fatal from
the artistic standpoint.*" If the rendering were
always given sharply, the work would belong

to the category of topography or the *knowledge*
of places, that is *Science*. To continue, the
student will find directions for producing an
unvarying quality in his negative. He will be
told how negatives of low-toned effects may be
made to give prints like negatives taken in
bright sunshine ; in short, he will find that
these writers have a *scientific ideal*, a sort of
standard negative by which to gauge all others.
And if these writers are questioned, the student
will find the *standard negative* is one in which
all detail is rendered with microscopic sharp-
ness, and one taken evidently in the brightest
sunshine. We once heard it seriously proposed
that there should be some sort of *standard
lantern-slide*. My allotted time is too brief to
give further examples. Suffice it to say, that
this unvarying *standard negative* would be
admirable if *Nature* were unvarying in her
moods; until that comes to pass there must be
as much variety in negatives as there are in
different moods in Nature.

It is, we think, because of the confusion of
the aims of Science and Art that the majority
of photographs fail either as scientific records
or pictures. It would be easy to point out
how the majority are false scientifically, and
easier still to show how they are simply devoid
of all artistic qualities. They serve, however,
as many have served, as topographical records
of faces, buildings, and landscapes, but often
incorrect records at that. It is curious and
interesting to observe that such work always

requires a *name*. It is a photograph of *Mr. Jones*, of *Mont Blanc*, or of the *Houses of Parliament*. On the other hand, a work of Art really requires *no name*,—it speaks for itself. It has no burning desire to be named, for its aim is to give the beholder æsthetic pleasure, and *not* to add to his knowledge or the *Science* of places, *i.e.*, topography. The work of Art, it cannot too often be repeated, appeals to man's emotional side ; it has no wish to add to his knowledge—to his *Science*. On the other hand, topographical works appeal to his intellectual side ; they refresh his *memory* of absent persons or landscapes, or they add to his *knowledge*. To anticipate criticism, I should like to say that of course in all mental processes the intellectua, and emotional factors are inseparable, yet the one is always subordinated to the other. The emotional is subordinate when we are solving a mathematical problem, the intellectual is decidedly subordinate when we are making love. Psychologists have analyzed to a remarkable extent the intellectual phenomenal but the knowledge of the components of the sentiments or the emotional phenomena is, as Mr. Herbert Spencer says, " altogether vague in its outlines, and has a structure which continues indistinct even under the most patient introspection. Dim traces of different components may be discerned ; but the limitations both of the whole and of its parts are so faintly marked, and at the same time so entangled, that none but very general results can be reached."

The chief thing, then, that I would impress upon all beginners is the necessity for beginning work with a clear distinction between the aims and ends of Science and Art. When the art-student has acquired enough knowledge—that is, *Science*—to express what he wishes, let him, with jealous care, keep the scientific mental attitude, if I may so express it, far away. On the other hand, if the student's aim is scientific, let him cultivate rigidly scientific methods, and not weaken himself by attempting a compromise with Art. We in the photographic world should be either scientists or pictorial photographers; we should be aiming either to increase knowledge—that is, science,—or to produce works whose aim and end is to give æsthetic pleasure. I do not imply any comparison between Science and Art to the advantage of either one. They are both of the highest worth, and I admire all sincere, honest, and capable workers in either branch with impartiality. But I do not wish to see the aims and ends of the two confused, the workers weakened thereby, and above all, the progress of Science hindered and delayed.

III.

Next I shall discuss briefly the ill-effects of a too sedulous study of Science upon an Art student.

The first and, perhaps, the greatest of these ill-effects is the *positive* mental attitude that Science fosters. A scientific student is only con-

cerned with stating a fact clearly and simply; he must tell the truth, and the *whole truth*. Now, a scientific study of photography, if pushed too far, leads, as a rule, to that state of mind which delights in a wealth of clearly-cut detail. The scientific photographer wishes to see the veins in a lily-leaf and the scales on a butterfly's wing. He looks, in fact, so closely, so microscopically, at the butterfly's wing, that he never sees the poetry of the life of the butterfly itself, as with buoyant wheelings it disappears in marriage flight over the lush grass and pink cuckooflowers of May.

I feel sure that this general delight in detail, brilliant sunshiny effects, glossy prints, etc., is chiefly due to the evolution of photography : these tastes have been developed with the art, from the silver plate of *Daguerre* to the double-albumenized paper of to-day. But, as the art develops, we find the love for gloss and detail giving way before platinotype prints and photo-etchings.

The second great artistic evil engendered by Science is the careless manner in which things are expressed. The scientist seeks for truth, and is often indifferent to its method of expression. To him, " Can you not wait upon the lunatic ?" is, as the late Matthew Arnold said, as good as " Canst thou not minister to a mind diseased ?" To the literary artist, on the other hand, these sentences are as the poles asunder, —the one in bald truth, the other literature. They both suggest the same thing ; yet what

æsthetic pleasure we get from the one, and
what a dull fact is, " Can you not wait upon the
lunatic ?" There are photographs and photo-
graphs ; the one giving as much pleasure as
the literary sentence, the other being as dull as
the matter-of-fact question. The student with
understanding will see the fundamental and
vital distinction between Science and Art as
shown even in these two short sentences.

And now, ladies and gentlemen, I do not
think I can do better than finish this section by
quoting another passage from the writings of
the late Matthew Arnold.

" *Deficit una mihi symmetria prisca.*—' The
antique symmetry was the one thing wanting
to me,' said Leonardo da Vinci, and he was an
Italian. I will not presume to speak for the
American, but I am sure that, in the English-
man, the want of this admirable symmetry of
the Greeks is a thousand times more great and
crying than in any Italian. The results of the
want show themselves most glaringly, perhaps,
in our architecture, but they show themselves
also in our art. *Fit details strictly combined,
in view of a large general result nobly con-
ceived:* that is just the beautiful *symmetria
prisca* of the Greeks, and it is just where we
English fail, where all our art fails. Striking
ideas we have, and well executed details
we have ; but that high symmetry which,
with satisfying delightful effect, contains them,
we seldom or never have. The glorious beauty
of the Acropolis at Athens did not arise from

single fine things stuck about on that hill, a
statue here, a gateway there. No, it arose from
all things being perfectly combined for a
supreme total effect."

CONCLUSION.

And now I must finish my remarks. I have
not perhaps told you very much, but if I have
succeeded in impressing upon beginners and
some others the vital and fundamental distinc-
tion between Science and Art, something will
have been achieved. And if those students
who find anything suggestive in my paper are
by it led to look upon photography in future
from a new mental attitude, something more
important still will have been attained. For,
in my humble opinion, though it is apparently
but a little thing I have to tell, still its effect
may be vital and far-reaching for many an
honest worker, and if I have helped a few such,
my labor will have been richly rewarded in-
deed.

APPENDIX B.

TOPOGRAPHY AND ART.

My friend, J. Harvard Thomas, a sculptor, and I, were one evening discussing the mental attitude from which scientific men regarded the pictorial and glyptic arts. To illustrate their view, Mr. Thomas told me a good story of the late Dr. W. B. Carpenter, the well known physiologist. My friend one evening found the doctor admiring and studying a beautiful topographical photograph of Fingal's cave, probably one of Mr. Valentine's justly world-famed series of views. Dr. Carpenter produced the photograph and began to point out its beauties. Mr. Thomas listened to him patiently and curiously as he went on to describe the geological formation of the basaltic rocks, going into ecstacies as he discoursed on the erosions of the tide and other physical phenomena. " I have stood just there," said Dr. Carpenter, pointing to a particular column of basalt, "and seen the tide go sweeping past me. Oh, yes; I like the old place apart from its scientific interest; it gave me a wonderful pleasure to be out there inhaling the sea breezes after hard work in my study."

"But it is not a picture," hazarded Mr.

Thomas. "That may be," said Dr. Carpenter, "I know nothing of that, but the photograph gives me great pleasure."

Now what we wish to discuss in this paper is, what gave Dr. Carpenter that pleasure in contemplating the photograph apart from its scientific interest? We may therefrom derive something suggestive. The answer to the question is not very complex. Nervous tissue that has once been used in a pleasurable way, though often exhausted at the time of use by its discharges, gradually becomes recharged and a fresh sense of tension is felt by the organism, this tension arousing in the brain emotions which prompt the organism to seek afresh those formerly experienced pleasures. Thus *desires* are begotten; the chief psychological factor in the origin of desire being our power of faintly reviving images of past experiences. Past pleasures and pain are revivable more or less vividly in proportion as they were all-absorbing and vividly impressed upon us at the time we received them, but they are always necessarily fainter and vaguer in outline than the original vivid impressions. This, then, accounts for the pleasure we derive from the *representation* of a place that we are familiar with.

This representation of whatever kind, whether painting or photograph, if tolerably accurate, faintly recalls the pleasurable feelings which were felt in that place at the time that we enjoyed ourselves there. For example, if we are confined to the house by sedentary

pursuits, and make it our practice to visit, say
Switzerland, in our holidays, we always feel a
thrill of pleasure on seeing Swiss pictures dur-
ing our absence from our playground; for the
photograph immediately calls up faint impres-
sions of the fresh, keen air, the trees, the gla-
ciers, the mountaineering excursions, and all
the diverse pleasures we experienced in those
delightful hours of rest. Gradually the desire
grows and strengthens to revisit the old haunts,
and is gratified on our next annual holiday. It
is probably for this reason that we buy photo-
graphs of places that we have visited; a curious
and interesting fact in this connection being,
that more photographs of hotels where honey-
moons have been spent are sold than any others
—at least, so I have been informed by one of
the widest known photographers in the world.

It seems to me that when we discuss artistic
work we must never forget the influence of
this love of places *per se*, and it is quite obvious
that it has nothing whatever to do with any
picturesque or artistic qualities belonging to
the place itself; this love of old haunts being
common to the lowest men and animals alike;
we observe it displayed by nesting birds every
season.

This knowledge gives us the key to the men-
tal attitude of the uncultured picture buyer.
If it is not the sentimentalism of the picture
that catches him, it is this topographical inter-
est that finally decides his purchase.

He buys poor work of some *locality* that he

knows; he commissions painters to paint views
of his newly acquired "place." It is this topo-
graphical interest that brings so many amateur
photographers into the field.

They delight in storing up views of places
they have had a good time in, and it is a harm-
less and pleasant pursuit, so long as they are
not vain and deluded enough to think that they
are producing works with artistic qualities.
But there are many simple persons who imag-
ine that their crude productions possess artistic
merits.

Especially liable are they to make this mis-
take if they happen to acquire easily good
manipulative ability. They are probably en-
couraged in their vanity by others with the
same vain and foolish natures as their own,
and they are finally confirmed in their credulity
by their *real* love of their own productions,
and by the too facile opportunities given them
of writing nonsense in amateur journals. For
a time all goes well with them, and they soon
begin to talk at their societies and to write in
their journals about art; a matter they have
never studied or sacrificed anything for all
their lives. Thus puffed up with self-conceit
these mentally infirm persons go on well
enough until they bring their work before some
able artist, and they are then enraged and
chagrined when he either passes it over silently
or with some conventional compliment. Prob-
ably they will think the artist insincere or
prejudiced, for they do *honestly* and *genuinely*

admire their own work themselves. The reason of this has been explained—they honestly admire their own photographs because on looking at them they are able to recall faint images of the pleasures experienced in the places photographed, whereas they forget that the artist to whom they show them *has never been to those places,* and has therefore *no faint images to revive.*

They forget, too, that the only qualities by which their work will appeal to the artist are those æsthetic qualities which they *necessarily* do not possess, since they have *never studied Art.*

Photographs taken to recall places that we have personally enjoyed do not command that sympathy that art work does because they are eminently *selfish* in origin, and are thus akin to all the other life-serving products; as food, which is essentially selfish in its nature, though pleasurable to the consumer. Art work on the other hand does not appeal to the life-serving functions, but to that love of the refined, the pure, and the noble, which is found in the highest men and the highest races to the greatest extent. I would not for a moment discourage the taking of these topographical views, for they undoubtedly give a sincere and pure pleasure to the producers, if to no one else; but I would beg those persons to act with ordinary sanity, to act as they would do in their own walks of life, and not delude themselves into the idea that they are ARTISTS, and so allow

themselves to be persuaded by insincere and ignorant Philistines into rushing into print and making themselves ridiculous in the eyes of artists who really know what they are about. The flood of nonsense poured forth lately by amateur and irresponsible writers—parsons, clerks, medical students, militia-men, and others—is a sad proof how silly men, who are quite sensible in their own vocations, can become when they lose their reason and discuss things they have *never honestly studied*. Such conduct is the hall-mark of the degenerate mattoid.

Nor have they even proved *by their works* that they have *average* artistic insight, uncultured though it must necessarily be. If a man wishes to cultivate the arts he must *sacrifice every thing*—worldly ambition, the accumulation of wealth, the glory of purple and fine linen, and peace of mind; he must also be prepared to be buffeted by the Philistines, to be misrepresented, abused, misunderstood, and slandered, for " every crown is a crown of thorns." If he is prepared to *sacrifice all* and follow his jealous mistress, he will, if he possess ability, one day begin to understand what Art is. But *without* this self-abnegation he will *never*, no matter how great be his original ability, enter into the chosen land.

I will add, however, that these topographical photographs, though in some cases primarily taken from selfish motives, may afterwards serve useful purposes, as do the avowed topographical photographs. Such work is invalua-

ble from the scientific point of view, as in the
study of geography, etc., apart from any special
interest they may have for the producer him-
self. For such purposes every detail should be
clearly given, as is done in the wonderful series
of topographical views published by Messrs.
Valentine, Wilson, England, Bedford, Payne,
Jennings, Green, Gibson, and others. Their
views are *invaluable* as topographical works, but
they are not works of art, and lest I should do
some of those photographers an injustice I must
add, that to my certain knowledge, some of
them lay no claim whatever to any artistic
merit in their productions, and such look with
amusement upon the pretentious operators who
regard themselves as artists.

The aim of the artist, it will be seen, is quite
distinct from the aims of all these other work-
ers. He selects his picture from nature purely
on account of certain æsthetic qualities which
he wishes to express—it little matters to him
whether the original scene be in Africa or Peru,
so long as it suits his purpose. So it comes
about that when he shows his picture he often
meets with sympathy from the most cultured,
for he appeals to them, not by local interest,
but by æsthetic qualities Thus, too, it often
follows that the more artistic the work, the
fewer will be the persons who really fully ap-
preciate it; for it is, I think, perfectly explica-
ble on psychological grounds that a man ap-
preciates works of art in proportion to his
innate artistic instincts, though he may never

have exercised those instincts in production itself. To *honestly* appreciate and feel a thrill of glow over a Corot or a Rembrandt. " Tell me a man's friends, and I will tell you the man," is far more profound than it may appear on the surface. Tell me what pictures, or books, or music, a man *honestly* delights in, and I will tell you that man's artistic nature, uncultured and undeveloped though it be. But this axiom does not imply that the admirer can ever attain to the production of works anywhere approaching those he admires; on the contrary, there are peculiar mental qualities required in production which the sympathetic admirer does not *necessarily* possess, although he may possess high mental qualities of quite another kind.

I think it may now be clear to many workers, quite apart from the pleasure they have in their photographic work, they honestly admire their own productions, and why they are often irritated and disappointed when they can get no sympathy from artists.

FINIS.

THE DEATH OF

Naturalistic Photography.

BY

P. H. EMERSON,

Author of " Naturalistic Photography."

" If offence come out of truth, it were better the offence come than the truth be concealed."

PETER HENRY EMERSON, an amateur photographer living in England, revolutionized artistic photography when, in 1886, he began to present his theory of "naturalistic photography." The camera, he held, should be used to reproduce human vision; since we cannot see everything clearly at one glance, the image should be out of focus except in the principal areas. He believed that photography was an art, and should be exhibited and appreciated as such. In 1891 he renounced these beliefs in this rare booklet, reproduced from a copy in the Royal Photographic Society, London.

A RENUNCIATION.

To all Photographers.

OVING Brethren that were, I salute you. I owe you one apology, oh! my friends, for in the earnestness of my heart I *partly* misled you. You, who stuck by me in storm and stress I shall never forget—if any of you, after this renunciation, seek advice, ask and you shall receive of my best. You, enemies, who will now rub your hands with small-souled glee, rub on, till it all ends in imaginary soft-soap. You, whom I have in mistaken zeal attacked, pray forgive and forget.

And now list. I, saner than ever, renounce and abjure all theories, teachings and views on art written, and first promulgated by me in sundry works, articles, etc., and finally collected in a volume, entitled "Naturalistic Photography." I cast them upon the dust-heap.

I am for the present and future neither idealist, realist, naturalist, nor impressionist—*photographic *impressionist*, indeed!—as though ALL graphic artists were

* "A term consecrate to charlatans," and especially to photographic impostors, pickpockets, parasites and vanity intoxicated amateurs.

not impressionists, and as if the photographic process could give aught but transcripts more or less literal. Shall I forsooth explain this burning of books?

List, you who have ears to hear and eyes to see.

In the fulness of my heart I dreamed a dream. I thought art might be taught by writing. I was wrong, I confess. I, even I, "the lover of nature,"—everyone is that now—preached that all art that did not conform to "truth to nature" principle was bad—that was a fatal sermon to many. From this followed again the idea—mistaken, alas!—that photography *pure*,—(not impure, on rough papers, touched up by clumsy hands)—was an art surpassing all black and white methods. *Eheu!* That this was ever believed! However, I was sincere, enthusiastic, but mistaken, and I was and am no amateur. I have by the sweat of my brow learned, under a master, something of this thing they call art. Being no amateur, I have therefore left the Camera Club, the home of the "amateur." But ye reasonable ones in photography—some of you *are that*, true and worthy sons of the goddess Science, who has little to do with the goddess Art—you will ask, and with right, why this thusness? I respect you true workers in science—ye Abneys, Dallmeyers, Hurters, Driffields, Vogels, Jones, Harrisons, Bolas, Waterhouses, Eders, and others. I will tell you, for the vulgar mob of pseudo-scientists have done naught but prove their ignorance and show signs of the itch—the itch for publicity and venom.

To you, then, who seek an explanation for my conduct, Art—as Whistler said—*is not* nature—is not necessarily the reproduction or translation of it—much, so very much, that is good art, some of the very best—is not

nature at all, nor even based upon it— *vide* Donatello and Hokusai.

The limitations of photography are so great that, though the results may and sometimes do give a certain æsthetic pleasure, the medium must always rank the lowest of all arts, *lower than* any graphic art, for the individuality of the artist is cramped, in short, it can scarcely show itself. Control of the picture is possible to a *slight* degree, by varied focussing, by varying the exposure (but this is working in the dark), by development, I doubt (I agree with Hurter and Driffield, after three-and-a-half months careful study of the subject), and lastly, by a certain choice in printing methods.

But the all-vital powers of selection and rejection are *fatally* limited, bound in by fixed and narrow barriers. No differential analysis can be made, no subduing of parts, save by dodging—no emphasis—save by dodging, and that is not pure photography, impure photography is merely a confession of limitations. A friend once said to me, " I feel like taking nearly every photograph and analyzing it." Compare a pen and ink drawing by Rico or Vierge, in Pennell's book. I thought once (Hurter and Driffield have taught me differently) that true values could be obtained and that values could be *altered at will* by *development*. They cannot ; therefore, to talk of getting the values in any subject whatever as you wish and of getting them true to nature, is to talk nonsense.

It is impossible, in most subjects, to alter your values *as you wish*, and to talk of such things now is mere emptiness and puffed-up humbug.

Some amateurs following Colonel Noverre's REVIVAL of

rough printing-papers LAST YEAR (1889), have thought that salvation lay in rough surfaces. Colonel Noverre's dust-heap was ransacked, and we have heard of a "new departure"—a newer "school," and all the bleat of the overweeningly vain "amateur."

If there can be no scientific basis for an art, as some have asserted, Meissonier can claim to be as artistic as Monet, and Monet as Meissonier. The sharp photographer can assert his artistic rights alongside of the veriest "blottist." So all opinions and writings upon art are as the crackling of thorns beneath the pot. In short, I throw my lot in with those who say that photography is a very limited art. I regret deeply that I have to come to this conclusion. Photography is first of all the *hand-maiden of art and science.* It has and will register new facts of light, form and texture. Pure photography is a scientific method of drawing, and scientists should work on until a true and literal scientific transcript of nature can be made—this by ortho-chromatics, etc.

It will interest some to hear what I think of some points that have been vexed questions in a war I have, I regret to say, stirred up. Composition, as understood by Burnet and others, I hold to be futility itself, though I can appreciate the attempts to meet the difficulties in this matter. The eternal principles of art I have heard so much of are mere catchwords.

Sharpness v. *Diffusion.*—If the work is for scientific purposes, work sharply; if for amusement, please your-self; if for business, do what will pay.

I have, I regret it deeply, compared photographs to great works of art, and photographers to great artists. It was rash and thoughtless, and my punishment is in

having to acknowledge this now. Think of the marvellous dexterity of the man who with pencil, pen and ink, or paint and brush, produces a masterpiece, the drawing equal to that of the lens, the tones in harmony, the colour delicate and marvellously beautiful. Read Rood's *Chromatics* for a hint of the manifold difficulties surrounding this subject. Then think of the amateur photographer who, if clever, can *in a few weeks* turn out good technical work.

It may be asked then what theories on art I have? I answer at present *none*. What artists I admire? I answer, all good artists and all good art. To what school do I now belong? None. What do I think of writings upon art and art criticisms? Mistakes.

A final word. Suggestions have been made that I get some of my ideas from a book, called "Naturalistic Painting." I have a letter in my possession from an artist, wherein is stated clearly and exactly that *Mr. Bate had read a paper of mine on *Naturalistic Photography* *before* his first article appeared in the "Artist." At the Society of Arts, the other day, a paper was read by Mr. Davison—an amateur without training, and with superficial knowledge—in which my *old* ideas were freely and impudently handed about and no credit given me. It was whispered about by my enemies that this person had originated some of the ideas of Naturalistic Photography. To enlighten the public I append a quotation from his letter to me on this point. There are plenty more confessions of "his lack of knowledge;" that his

* This does not imply that Mr. Bate took any ideas from my paper ; on the contrary, I feel sure his ideas were his own, as were mine.

articles were "drivel," it is his own word, and other con-
fessions of incompetence and proofs of plagiarism, if
necessary. He is now welcome to my cast-off clothes if
he likes—he or anybody else. It is with deep regret I
do this thing, and it is only as a duty to myself. I justify
myself by stating that I wrote privately to Mr. Davison,
expostulating with him for freely appropriating my ideas
and telling him that if he did not give me full credit at the
Society of Arts I should publish a history of the matter.
He never replied. He can publish my letter in full if he
likes. This was Mr. Davison's reply to a letter I wrote
to him and others asking them if they minded me thank-
ing them in public for their support. His reply is dated
from the Camera Club, 16th December, 1889, ONLY A
YEAR AGO. It is, "I AM GLAD AND PROUD
TO BE IDENTIFIED IN ANY WAY WITH
NATURALISTIC PHOTOGRAPHY, BECAUSE
I BELIEVE IN WHAT I UNDERSTAND IT
MORE AND MORE CLEARLY TO BE, BUT
I DOUBT VERY MUCH WHETHER ANY-
THING I HAVE DONE DESERVES RECOG-
NITION."

I sent a copy of Naturalistic Photography some time
ago for review, to the Editor of the journal of the Society
of Arts, and it got a bad notice. All the ideas offered
the other night were thus offered to the Society *previously.*
Lastly, a special speech, read from a paper by a friend of
mine, especially pointing out how I had originated these
ideas, was not reported as it was read, the printed report
giving altogether a different impression from what the
speaker said. Those who heard the original can refer
to the speech, as reported in the journal of the Society

of Arts—not Artists, as Mr. J. Pennell has aptly described it. This sort of treatment, which is nothing new to me, may excuse some of my bitterly written invectives.

Finally. Some of my friends to whom I have recently privately communicated my renunciation, have wished to know how it came about. Misgivings seized me after conversations with a great artist, after the Paris Exhibition; these were strengthened by the appearance of certain recent researches in psychology, and Hurter and Driffield's papers; and finally the exhibition of Hokusai's work and a study of the National Gallery pictures after three-and-a-half months' solitary study of Nature in my house-boat did for me.

L'ENVOI.

HAVING taken some earnest photographers a little way into the Art-world, I feel it my duty to say that, when I have *fully* reconsidered the limited art possibilities of photography and the general philosophy of art, I will write another book; in the meantime, let students avoid all spurious imitations.

EPITAPH.

---◆◆---

In Memory of

NATURALISTIC PHOTOGRAPHY,

WHICH RAN A SHORT BUT ACTIVE LIFE,

UPSET MANY CONVENTIONS

HELPED TO FURTHER MONOCHROME PHOTOGRAPHY TO THE

UTMOST OF ITS LIMITED ART BOUNDARIES,

STIRRED MEN TO THINK AND ACT FOR THEMSELVES,

PRODUCED MANY PRIGS AND BUBBLE REPUTATIONS,

EXPOSED THE IGNORANCE OF THE MULTITUDE,

BROUGHT OUT THE LOW MORALITY OF CERTAIN PERSONS IN THE

PHOTOGRAPHIC WORLD,

BROKE DOWN THE PREJUDICE OF THE OUTSIDE PUBLIC AGAINST

PHOTOGRAPHY'S VERY SLENDER ART CLAIMS,

ENCOURAGED MANY AMATEURS TO BABBLE AND MAKE THE WORDS

"ART," "TRUTH" AND "NATURE," STINK IN THE

NOSTRILS OF SERIOUS ARTISTS,

ENDING BY GIVING A FEW A BRUTAL SORT OF APPREHENSION

OF ART, AND DYING WHEN ITS

ALLOTTED TASK WAS DONE WITH A GIBE ON ITS LIPS,

FOR THE "AMATEUR," THE "PLAGIARIST,"

THE "PRATING TRUE-TO-NATURE MAN,"

THE "IMPRESSIONIST," THE "NATURALIST," THE "IDEALIST,"

AND THE HUMBUG.

THE HAND CAMERA—ITS PRESENT IMPORTANCE.

BY ALFRED STIEGLITZ.

(With illustrations by the Author.)

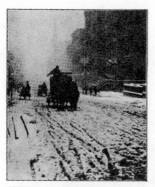

"WINTER, FIFTH AVENUE." By A. S.

PHOTOGRAPHY as a fad is well-nigh on its last legs, thanks principally to the bicycle craze. Those seriously interested in its advancement do not look upon this state of affairs as a misfortune, but as a disguised blessing, inasmuch as photography had been classed as a sport by nearly all of those who deserted its ranks and fled to the present idol, the bicycle. The only persons who seem to look upon this turn of affairs as entirely unwelcome are those engaged in manufacturing and selling photographic goods. It was, undoubtedly, due to the hand camera that photography became so generally popular a few years ago. Every Tom, Dick and Harry could, without trouble, learn how to get something or other on a sensitive plate, and this is what the public wanted—no work and lots of fun.

ALFRED STIEGLITZ *received his first public recognition as a photographer from P. H. Emerson in 1888. Within a few years he was world famous in photographic circles, and contributed many articles to photographic magazines. Stieglitz was convinced of the artistic possibilities of the camera, and spent his lifetime fighting for its recognition. In his own work he was constantly pushing technique to its limits. His advice on the use of the hand camera can still be read with profit. Reproduced from American Annual of Photography for 1897, p. 19-26.*

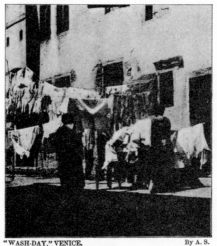

"WASH-DAY," VENICE. By A. S.

Thanks to the efforts of these persons hand camera and bad work became synonymous. The climax was reached when an enterprising firm flooded the market with a very ingenious hand camera and the announcement, "You press the button, and we do the rest." This was the beginning of the "photographing-by-the-yard" era, and the ranks of enthusiastic Button Pressers were enlarged to enormous dimensions. The hand camera ruled supreme.

Originally known under the odious name of "Detective," necessarily insinuating the owner to be somewhat of a sneak, the hand camera was in very bad repute with all the champions of the tripod. They looked upon the small instrument, innocent enough in itself, but terrible in the hands of the unknowing, as a mere toy, good for the purposes of the globe-trotter, who wished to jot down photographic notes

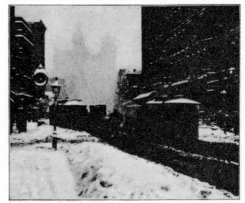

"A BLOCKADE," NEW YORK. By A. S.

THE LITERATURE OF PHOTOGRAPHY
AN ARNO PRESS COLLECTION

Anderson, A. J. **The Artistic Side of Photography in Theory and Practice.** London, 1910

Anderson, Paul L. **The Fine Art of Photography.** Philadelphia and London, 1919

Beck, Otto Walter. **Art Principles in Portrait Photography.** New York, 1907

Bingham, Robert J. **Photogenic Manipulation.** Part I, 9th edition; Part II, 5th edition. London, 1852

Bisbee, A. **The History and Practice of Daguerreotype.** Dayton, Ohio, 1853

Boord, W. Arthur, editor. **Sun Artists** (Original Series). Nos. I-VIII. London, 1891

Burbank, W. H. **Photographic Printing Methods.** 3rd edition. New York, 1891

Burgess, N. G. **The Photograph Manual.** 8th edition. New York, 1863

Coates, James. **Photographing the Invisible.** Chicago and London, 1911

The Collodion Process and the Ferrotype: Three Accounts, 1854-1872. New York, 1973

Croucher, J. H. and Gustave Le Gray. **Plain Directions for Obtaining Photographic Pictures.** Parts I, II, & III. Philadelphia, 1853

The Daguerreotype Process: Three Treatises, 1840-1849. New York, 1973

Delamotte, Philip H. **The Practice of Photography.** 2nd edition. London, 1855

Draper, John William. **Scientific Memoirs.** London, 1878

Emerson, Peter Henry. **Naturalistic Photography for Students of the Art.** 1st edition. London, 1889

*Emerson, Peter Henry. **Naturalistic Photography for Students of the Art.** 3rd edition. *Including* The Death of Naturalistic Photography, London, 1891. New York, 1899

Fenton, Roger. **Roger Fenton, Photographer of the Crimean War.** With an Essay on his Life and Work by Helmut and Alison Gernsheim. London, 1954

Fouque, Victor. **The Truth Concerning the Invention of Photography:** Nicéphore Niépce—His Life, Letters and Works. Translated by Edward Epstean from the original French edition, Paris, 1867. New York, 1935

Fraprie, Frank R. and Walter E. Woodbury. **Photographic Amusements Including Tricks and Unusual or Novel Effects Obtainable with the Camera.** 10th edition. Boston, 1931

Gillies, John Wallace. **Principles of Pictorial Photography.** New York, 1923

Gower, H. D., L. Stanley Jast, & W. W. Topley. **The Camera As Historian.** London, 1916

Guest, Antony. **Art and the Camera.** London, 1907

Harrison, W. Jerome. **A History of Photography Written As a Practical Guide and an Introduction to Its Latest Developments.** New York, 1887

Hartmann, Sadakichi (Sidney Allan). **Composition in Portraiture.** New York, 1909

Hartmann, Sadakichi (Sidney Allan). **Landscape and Figure Composition.** New York, 1910

Hepworth, T. C. **Evening Work for Amateur Photographers.** London, 1890

*Hicks, Wilson. **Words and Pictures.** New York, 1952

Hill, Levi L. and W. McCartey, Jr. **A Treatise on Daguerreotype.** Parts I, II, III, & IV. Lexington, N.Y., 1850

Humphrey, S. D. **American Hand Book of the Daguerreotype.** 5th edition. New York, 1858

Hunt, Robert. **A Manual of Photography.** 3rd edition. London, 1853

Hunt, Robert. **Researches on Light.** London, 1844

Jones, Bernard E., editor. **Cassell's Cyclopaedia of Photography.** London, 1911

Lerebours, N. P. **A Treatise on Photography.** London, 1843

Litchfield, R. B. **Tom Wedgwood, The First Photographer.** London, 1903

Maclean, Hector. **Photography for Artists.** London, 1896

Martin, Paul. **Victorian Snapshots.** London, 1939

Mortensen, William. **Monsters and Madonnas.** San Francisco, 1936

*****Nonsilver Printing Processes: Four Selections, 1886-1927.** New York, 1973

Ourdan, J. P. **The Art of Retouching by Burrows & Colton.** Revised by the author. 1st American edition. New York, 1880

Potonniée, Georges. **The History of the Discovery of Photography.** New York, 1936

Price, [William] Lake. **A Manual of Photographic Manipulation.** 2nd edition. London, 1868

Pritchard, H. Baden. **About Photography and Photographers.** New York, 1883

Pritchard, H. Baden. **The Photographic Studios of Europe.** London, 1882

Robinson, H[enry] P[each] and Capt. [W. de W.] Abney. **The Art and Practice of Silver Printing.** The American edition. New York, 1881

Robinson, H[enry] P[each]. **The Elements of a Pictorial Photograph.** Bradford, 1898

Robinson, H[enry] P[each]. **Letters on Landscape Photography.** New York, 1888

Robinson, H[enry] P[each]. **Picture-Making by Photography.** 5th edition. London, 1897

Robinson, H[enry] P[each]. **The Studio, and What to Do in It.** London, 1891

Rodgers, H. J. **Twenty-three Years under a Sky-light,** or Life and Experiences of a Photographer. Hartford, Conn., 1872

Roh, Franz and Jan Tschichold, editors. **Foto-auge, Oeil et Photo, Photo-eye.** 76 Photos of the Period. Stuttgart, Ger., 1929

Ryder, James F. **Voigtländer and I:** In Pursuit of Shadow Catching. Cleveland, 1902

Society for Promoting Christian Knowledge. **The Wonders of Light and Shadow.** London, 1851

Sparling, W. **Theory and Practice of the Photographic Art.** London, 1856

Tissandier, Gaston. **A History and Handbook of Photography.** Edited by J. Thomson. 2nd edition. London, 1878

University of Pennsylvania. **Animal Locomotion. The Muybridge Work at the University of Pennsylvania.** Philadelphia, 1888

Vitray, Laura, John Mills, Jr., and Roscoe Ellard. **Pictorial Journalism.** New York and London, 1939

Vogel, Hermann. **The Chemistry of Light and Photography.** New York, 1875

Wall, A. H. **Artistic Landscape Photography.** London, [1896]

Wall, Alfred H. **A Manual of Artistic Colouring, As Applied to Photographs.** London, 1861

Werge, John. **The Evolution of Photography.** London, 1890

Wilson, Edward L. **The American Carbon Manual.** New York, 1868

Wilson, Edward L. **Wilson's Photographics.** New York, 1881